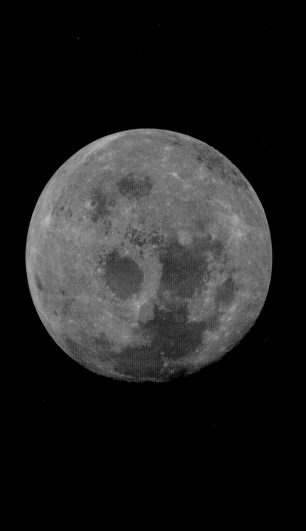

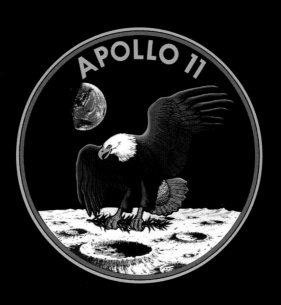

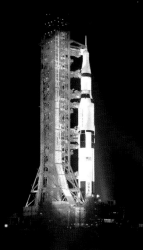

NORMAN MAILER

NFIRE

Page 1: A view of the moon, taken on the return portion of the Apollo 11 mission, reveals part of the far side of the moon. *Photo, NASA.*

We felt Apollo 11 was no ordinary flight, and we wanted no ordinary design... —Michael Collins, **Carrying the Fire** *Page 3:* Following a military tradition of heraldic emblems, each Apollo crew designed a mission patch, usually a symbolic image encircled by crewmembers' names. Collins's initial concept had an olive branch in the eagle's beak. Eventually the branch was moved to the talons to emphasize the mission's theme of peace. *Photo, NASA.*

Page 5: The Apollo 11 vehicle and its 400-foot-tall Launch Umbilical Tower were rolled out on May 20. Lit up with floodlights so preflight checks could continue around the clock, it was also a draw for thousands of visitors who would come to witness the sight. *Photo, NASA.*

Page 6: The distinctive white mass of Greenland dominates the North Atlantic Ocean in this view of Earth, photographed once the crew had left Earth's orbit for the three-day trip to the moon. *Photo, NASA.*

Page 11: **From Planet Earth, July 1969** Among the items left behind at Tranquillity Base was this 1-$\frac{1}{2}$-inch (4 cm) silicon disk, which was etched with messages from four U.S. presidents and the leaders of 73 nations on Earth. The disc was produced using processes similar to those used to make microchips; reduced 200 times, the individual letters were smaller than the head of a pin. *Photo, NASA.*

I believe that this nation should commit itself
to achieving the goal, before this decade is out, of landing
a man on the moon and returning him safely to the earth.
No single space project in this period will be more
impressive to mankind, or more important for the
long-range exploration of space; and none will be so
difficult or expensive to accomplish.

President John F. Kennedy
Special message to Congress on Urgent National Needs
May 25, 1961

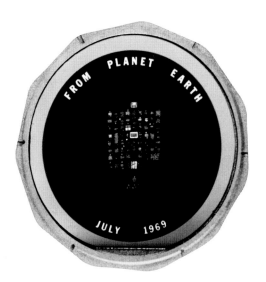

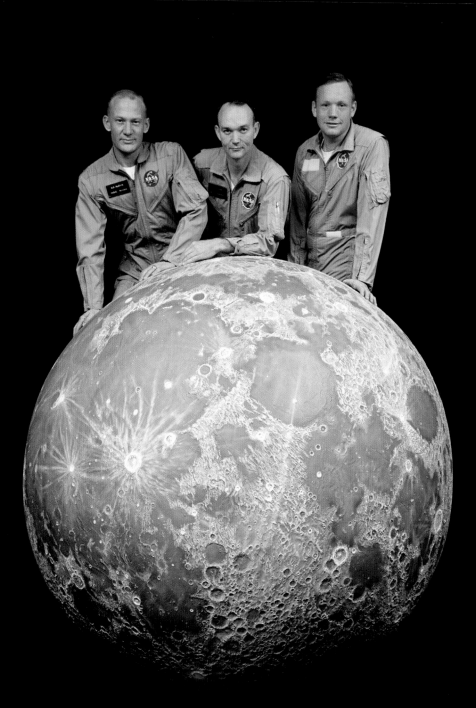

Introduction
COLUM McCANN

The aim of good writing is to briefly put the handcuffs on history. To arrest time. Stop movement. Clamp down memory. Put a headlock on life, if even just for a moment or two. And then — when life is still, caught, held — the handcuffs are swallowed, and the words are put together in an attempt to recreate life out of stillness, to make the silence breathe, to give an edge to the violence, or the beauty, so that years later, when a stranger comes along, he or she can step back into another time and have it come fiercely alive. This is the privilege of fiction. We become *alive* in a body, a time, a feeling, a culture that is not our own. We step into a new space. We adventure in the skin trade. We make new words: We become Mailers.

Mailer was the ultimate skin-trader. He wanted to be Norman, or Norman Kingsley at a stretch, but really, truly, honestly, he wanted to be everyone else. Gilmore. Marilyn. Miller. Ali. Eisenhower. Armstrong. Hemingway. Kennedy. He wanted to step from his body into a symphony of imagined bodies. Cummings. McLeod. Esposito. Rojack. Montague. Menenhetet. He took them on, warts and all, and then he slipped out of their skins and away. He was making layers of himself. At the heart of it was a selfishness to live as many lives as possible, coupled with the deepest possible empathy for others. He kept slipping into new times, and geographies, losing himself there. The only things worth doing were the things that might break his heart. Oswald. Picasso. Hitler. Even Jesus. The natural extension of the list is, in fact, that Norman

Opposite: The Prime Crew of Apollo 11 on April 13, 1969, posed around a six-foot model that mapped every major crater and mountain known to date. Left to right: Lunar Module Pilot Buzz Aldrin, Command Module Pilot Michael Collins, and Mission Commander Neil Armstrong. *Photo, Ralph Morse.*

K. Mailer, the little boy from the sandy streets of Long Branch, New Jersey, wanted to be the man on the moon. So — in the late '60s and early '70s — that's what he attempted to become: the man who wrote his own moon shot into existence.

*Originally published by Little Brown in 1971 as Of a Fire on the Moon, excerpted for this edition with the title MoonFire.

When it came time to write the book,* Mailer was at the top of his game. In his 40s, he was already the most celebrated and possibly the most feared author in America. There had been five National Book Award nominations in a row, in four different categories. He could command huge advances. His literary output was prodigious, promiscuous even. But controversy came behind him like a draft of wind: He got into bar brawls, his family life was a spinning top, the *Daily News* had its feelers out for little snippets of ruin. He had run for mayor of New York City and came in fourth out of a field of five. He'd lost a good deal of money in financing three experimental films. The begrudgers were beginning to talk about him being all washed up.

Mailer knew that fame was not a cheap whore he could call up from the street corner. There was work to be done. Books don't just write themselves. Ideas didn't just fall at his feet. But then the call came in from *Life* magazine. Not only was the money good, but it was the story of the century. The outer edges of mankind's possibility. The hottest Cold War battle ever. It would be the largest nonfiction piece the magazine had ever published — only Hemingway had ever been given as much space for the novella *The Old Man and the Sea.* The only problem for Mailer was that he wasn't invited to journey upstairs in the rocket ship: More than anything else he would have loved to be onboard Apollo 11, inside the goddamn thing, weightless,

soaring. Over a drink he might have told you wryly that he was too short, too fat, too Jewish to go that far, but if you stuck your hand through his rib cage and wrung his heart for the truth, he would have insisted on the necessity of a writer being there, at the pulse of the moment, the throb of the wound.

The fact that the powers that be didn't send a writer, that they didn't even *think* about it, was metaphor enough: American letters was losing its oxygen fast. But if he wasn't able to go to the moon physically, well, shit, he would go to the moon anyway. After all, what was the moon but a word? And who better than Mailer to examine the intricate helix of wounds and words?

So Mailer swallowed a little pride, checked his bank balance, and surrendered himself to history. He drove down NASA Highway 1 to hang out with the bullet-eyed boys at the Manned Spacecraft Center. He shouldered his way in amongst the scientists, the bureaucrats, and the astronauts themselves. He went looking for the story. Used his Harvard background in engineering to understand the mathematical dynamics. Ghosted his way into the heads of the computer geeks. Laid a hand on the bedspreads of the NASA wives. Listened to the evasions of the corporate clowns. Probed the little dusty corners for the details that nobody else would find. Yawned at the press conferences. Kept searching. Watched as men broke the skin of the sky, landed, splashed into the sea, and beamed for America.

His search sent him back home to Provincetown, where he stood at the edge of the ocean and talked to the violated moon. And then he sat down to write his book, his self-proclaimed "philosophical launch," where he hid behind the mask of a character called Aquarius, and then discovered what he had been

Opposite: Twenty hours and 59 minutes into the Apollo 11 flight, using up the last of the film on a magazine, Aldrin said, "Let me raise my visor and I'll smile." *Photo, NASA.*

looking for all along: Norman Mailer at his most honest. One of the central questions — one that seems almost quaint now in the 21st century — was whether the venture was noble or insane. "It was as if we had begun to turn the pocket of the universe inside out," he writes. To him, the moon shot was conceivably the first voyage of the first cancer of the world, or else it was the pinnacle of civilization's progress. In his philosophical wheelhouse, the choice was between celestial and satanic. This "braincase on the tip of a firecracker" was taking Mailer to the outer borders of his own skin. So he went out to know as much as he could, and — as all intelligent people do — began to hold a welter of contradictory ideas in the palms of his hands.

In the end — the deep-space end — he does what very few prose writers can accomplish in that he allows us to step into one of the great moments of history and properly understand it from head to toe, from the big to the small, from inside out. Turn the pages of this book — with the photographs assembled here for the first time — and you can get a good idea of the expedition and its vast scope. This is the world as Mailer was seeing it. Now delve into his prose and you will get the sense that he was correct, goddammit! He painted the pictures for us and now we're seeing them. Even from a quarter of a million miles away, Mailer somehow got it right. He used the techniques of fiction to illuminate a historical reality that was at turns good and bad and ugly.

The real beauty to be found in Mailer's text is not just in the way that he wants to vandalize your mind, and it's not just in the way that he slings his words so tempestuously together, or in the way his prose lights up the photographs, and it's not just in the way

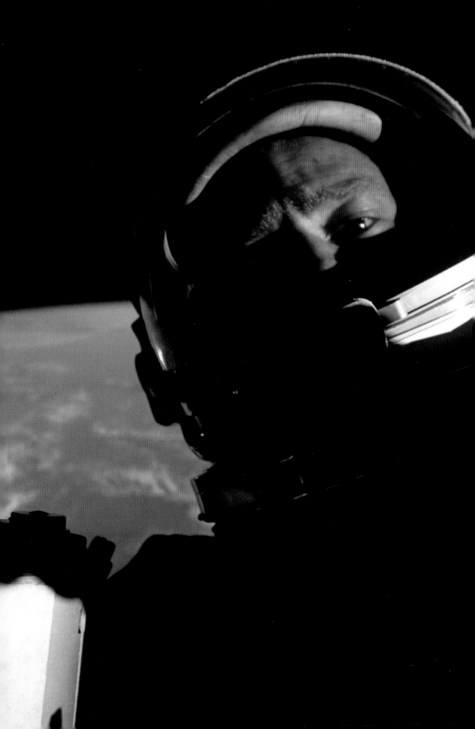

he understands the science of space, or the weight of history, or the breadth of mythology, and it's not just in the tiny detail where he finds God and the Devil in a press conference, and it's not just in his own ruminations on mortality, or the way he gives life to something as bland as a Florida motel room or the graffiti he draws on Wernher von Braun's dreams — it's also in the way Mailer himself emerges from the book. There's energy in the prose. There's ego. There's jealousy. There's a searing loneliness. But at its elemental core, Mailer comes home and confesses, and it's possibly one of the more profound and ignored confessions of recent literary times.

In the end, it is minutiae that makes history. At home in Provincetown, while he's trying to make sense of the moon shot, his friends bury a car in the ground. They do it as a lark, and because there doesn't seem all that much else to do, but Mailer knows exactly what it means: It's inward and it's aimless. He is as honest as can be: We're doomed unless, in some way, we once again ask for the very best from ourselves.

Mailer discovers that, like Ginsberg, he has seen the best minds of his generation destroyed. His overwhelming feeling is that his very people — his generation, his lifeblood — have thrown their beauty away. They have allowed corporate America to outflank them. While they have been stuffing their bongs and shucking their bras, the businessmen got the imaginative jump on them. They were inventing the predominant American spirit that would govern for the next 40 years. History has, in so many ways, corroborated his endbook confession. Out of that time came the baby boomers, then the ineffectual dreams of the Clinton era, and then — perhaps the culmination

If you are a fighter pilot, you want to get hold of the hottest thing you can. And having flown that, you ask yourself: "What else can I fly?" — Buzz Aldrin, **LIFE**, *July 4, 1969*

Following spread: Buzz Aldrin photographed by Command Pilot Jim Lovell on his first space walk, Gemini XII, November 11–15, 1966.

of it all — the brutal indifference of the Bush govern-ment. Mailer saw it coming, even back in the early '70s. He looked at the moon and found the dark side. (If only he had stayed around long enough to see Barack Obama sworn in he might have reinterpreted things yet again). Mailer's genius in this book is that he always wanted to be an everyman, but his further genius is that he could find the ordinary man in the everyman. And the book was a plea for literature to stand up and be counted. It's as if he was saying: If those square bas-tards can go to the moon, well we can too, so watch us fly, watch us.

I was only four years old when they shot the moon, so I have no recollection of it. In Ireland, where I was born, we associated the moon with John F. Kennedy. That's whose face we saw up there. But the idea that men had breached space didn't startle me all that much. It was just another country in the sky by the time I had a chance to think about it. Nowadays there is more computing power in my fridge than there is in the machines that managed to take the astronauts up in Apollo 11. I write this essay on a computer that NASA scientists would have swooned for. The software they used back then would be considered Neanderthal in an Xbox today. Yet they did it. They succeeded. What they accomplished was heroic beyond explanation. But there have been very few good books to give flesh and flair to that heroism.

We can be thankful, therefore, that one of our great writers was there. He caught the moon shot in flight. He caught himself in flight too. In fact he's still flying. Occasionally he stops to suck wind, Norman, but he's up there still, yes. Catch him at the rim of the world, still looking for another frontier, yes, Mailering.

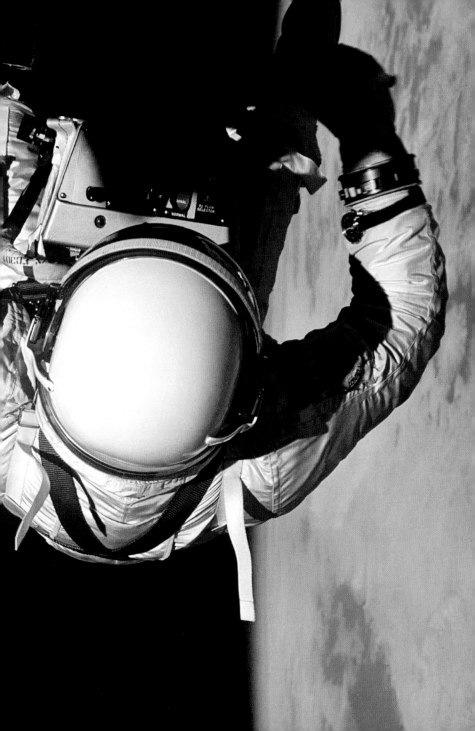

A Loss of Ego
NORMAN MAILER

Are we poised for a philosophical launch? There may be no way to do anything less. We will be trying after all to comprehend the astronauts. If we approach our subject via Aquarius, it is because he is a detective of sorts, and different in spirit from eight years ago. He has learned to live with questions. Of course, as always, he has little to do with the immediate spirit of the time. Which is why Norman on this occasion wonders if he may call himself Aquarius. Born January 31, he is entitled to the name, but he thinks it a fine irony that we now enter the Age of Aquarius since he has never had less sense of possessing the age. He feels in fact little more than a decent spirit, somewhat shunted to the side. It is the best possible position for detective work.

Opposite: Collins evaluates a mock-up of the Lunar Module cabin, 1963. *Photo, Ralph Morse.*

Following spread: By 1962 the achievements of Mercury set America's sights on a manned moon landing. The Mercury suit, while suitable for life inside the capsule, was inadequate for extravehicular activity. Here, inventor Allyn Hazard tests a moon-suit concept in 1962 in a crater in California's Mojave Desert. *Photo, Fritz Goro.*

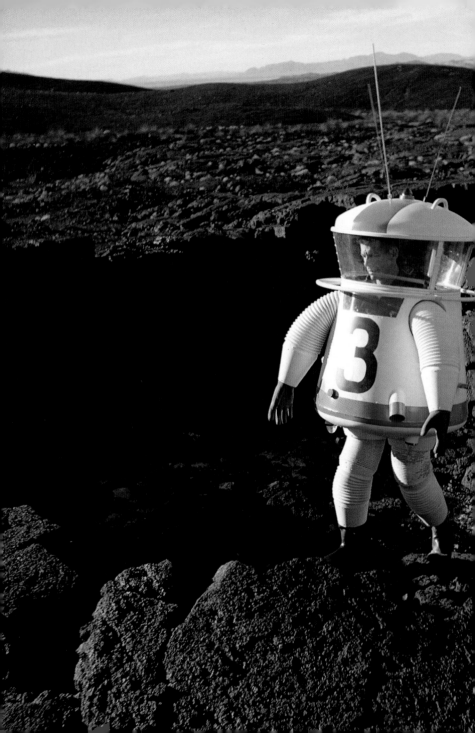

Now, it is the ~~last~~ end of the
a summer has passed ~~for~~
~~How long were the weeks~~
the heavens, and a first bark
america
~~continent~~ of space; a v
of black micro flow at l
~~If~~ a closed circle us
~~E a metaphor to me may~~
entombment ~~was~~ as p
Now,
~~navigate the buffet~~
~~aisle of a dream~~ ~~If~~ Yes, aq
~~center this hour, the s~~
one,

ptember moon. What
~~adieu~~. ~~He will remember~~
Empires foundered in ~~their~~
ian set foot on a new
with a plastic bowl
~~if~~ a bubble on his head.
~~present form of hate~~
~~reconnoiter~~ what
e?

~~of~~ ~~Space in the~~ long
rins is curious in
man of the astronauts has
so may not say too ~~three~~
~~so may not say three~~

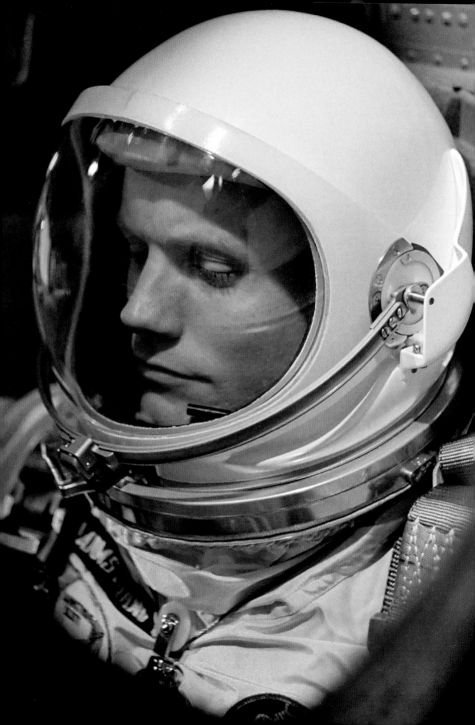

The Psychology of Astronauts

[The astronauts] they were there to answer questions about a phenomenon which even ten years ago would have been considered material unfit for serious discussion. Grown men, perfectly normal-looking, were now going to talk about their trip to the moon. It made everyone uncomfortable. For the relation of everyone to each other and to the event was not quite real. It was as if a man had died and been brought back from death. What if on questioning he turned out to be an ordinary fellow? "Well, you see," he might say, "having visited death, I come back with the following conclusions..." What if he had a droning voice? There was something of this in the polite unreality of the questioning. The century was like a youth who made love to the loveliest courtesan in Cathay. Afterward he was asked what he thought and scratched his head and said, "I don't know. Sex is kind of overrated."

Opposite: Neil Armstrong prepares for launch on March 16, 1966, in the Gemini VIII cockpit. Although Armstrong was a member of the second group of NASA astronauts and seemed poised for a prominent role in Apollo, he was one of the last to get a Gemini flight assignment. *Photo, NASA.*

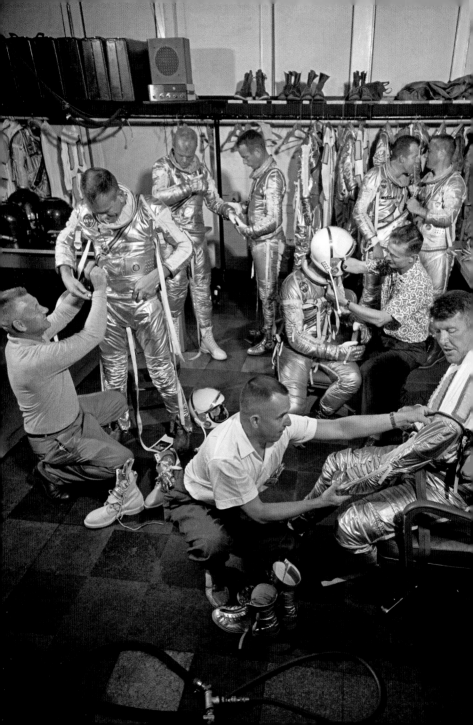

Well, let us make an approach to the astronauts. Aquarius sees them for the first time on the fifth of July, eleven days before the launch. They are in a modern movie theater with orange seats and a dark furrowed ceiling overhead, much like marcelled waves in a head of hair, a plastic ceiling built doubtless to the plans of one of the best sound engineers in the country. Sound is considerably ahead of smell as a fit province for scientific work, but since the excellence of acoustics in large and small concert chambers seems to bear more relation to old wood and the blessings of monarchs and bishops than to the latest development of the technical art, the sound system in this movie theater (seats 600) is dependably intolerable most of the time. The public address system squeals and squeaks (it is apparently easier to have communication with men one quarter of a million miles away) and one never gets a fair test of the aural accommodations. The walls and overhead are of plastic composition, and so far as one can tell, the tone is a hint sepulchral, then brightened electronically, finally harsh and punishing to that unnamed fine nerve which runs from the anus to the eardrum. As the sound engineers became more developed, the plastic materials provided for their practice by corporations grew acoustically more precise and spiritually more flattening — it was the law of the century. One was forever adjusting to public voices through the subtlest vale of pain.

Still this movie theater was the nearest approach to a diadem in the Manned Spacecraft Center. The theater was part of the visitors' center, where tourists could go through the space museum, a relatively modest affair of satellites, capsules, dioramas, posters and relics, now closed and given over to the installation of

The pressure suit which the Astronaut will wear into space...is a tailored rubber bag, a man-shaped balloon, and it is our last-ditch protection against disaster. — Walter Schirra, LIFE, August 1, 1960 Opposite: Members of Astronaut Group 1 try on the suits for the first time. *Clockwise from left:* Donald K. Slayton, John Glenn, Scott Carpenter, Gordon Cooper, Virgil Grissom, Alan Shepard (kneeling), and Walter Schirra. *Photo, Ralph Morse.*

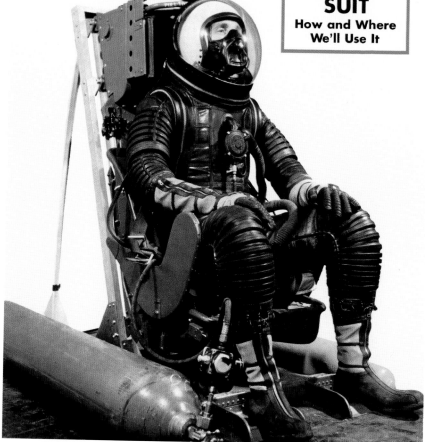

Collier's

FEBRUARY 28, 1953 • FIFTEEN CENTS

EXCLUSIVE

WORLD'S FIRST SPACE SUIT

How and Where We'll Use It

monitors and cables for the television networks, even as the gallery to the rear of the theater was now being converted into the Apollo News Center and would consist finally of endless aisles of desks, telephones and typewriters, plus one giant Buddha of a coffee urn. (Coffee is the closest the Press ever comes to *satori*.)

In the theater, perhaps eight rows back of the front seats, was a raised platform on which television cameras and crews were mounted. From the stage they must have looked not unrelated to artillery pieces on the battlement of a fort — in the front row were fifty photographers, which is to say fifty sets of torsos and limbs each squeezed around its own large round glass eye. Little flares of lightning flashed out of bulbs near their heads. The astronauts did not really have to travel to the moon — life from another planet was before them already. In the middle ranks, between the front row and the barricade of television cameras, were seated several hundred newspaper men and women come to Houston for the conference this morning. They were a curious mixture of high competence and near imbecility; some assigned to Space for years seemed to know as much as NASA engineers; others, innocents in for the big play on the moon shot, still were not just certain where laxatives ended and physics began. It was as if research students from the Institute of Advanced Studies at Princeton had been put in with a group of fine young fellows from an Army class in remedial reading. Out of such a bag would questions come to the astronauts. Wait! There will be samples.

The astronauts entered from the wings wearing gas masks, gray snout-nosed covers which projected out from their mouths and gave their profiles the intent tusk-ready slouch of razorback hogs. They were aware

Opposite: Before any candidates for the astronaut program had even been considered, the February 28, 1953, cover of *Collier's* unveiled the first space suit. By 1960 the B. F. Goodrich Company had developed the lightweight Navy Mark IV high-altitude pressure suit, which was adopted for the Mercury program. *Cover photo, Ralph Royle.*

Opposite and following spread: One of the original Mercury Seven, Slayton was grounded by a heart condition before he could fly. Pictured here in 1959, he rides an Air Bearing Orbital Altitude Simulator, designed to duplicate the tilting motions needed to maintain proper altitude or position during space flight. In 1963 he became the director of flight crew operations and, among other things, made all crew assignments during Gemini and Apollo. *Photos, Ralph Morse.*

of this — it was apparent in the good humor with which they came in. In fact, a joke of some dimensions had been flickering for a few days — the Press had talked of greeting them with white hospital masks. In the attempt to protect the astronauts as much as possible from preflight infection they were being kept in a species of limited quarantine — their contacts with nonessential personnel were restricted. Since journalists fit this category, today's press conference had installed Armstrong, Aldrin and Collins up on the stage in a plastic box about twelve feet wide, ten feet deep and ten feet high. Blowers within this three-walled plastic room blew air from behind them out into the audience: thereby, the breath of the astronauts could enter the theater, but the airborne germs of journalists would not blow back. It made a kind of sense. Of course the cause of the common cold was still unknown, but gross studies of infection would surmise a partial quarantine might be effective partially. However, the instrumentation of this premise was not happy. The astronauts looked a bit absurd in their plastic box, and the few journalists who had actually fleshed their joke by putting on masks caused the astronauts to grin broadly as though to dissociate themselves from the pyramids of precaution they were in fact obeying.

Once they sat down, their manner changed. They were seated behind a walnut-brown desk on a pale blue base which displayed two painted medallions in circles — NASA and Apollo 11. Behind them at the rear of the plastic booth stood an American flag; the Press actually jeered when somebody brought it onstage in advance of the astronauts. Aquarius could not remember a press conference where Old Glory had ever been

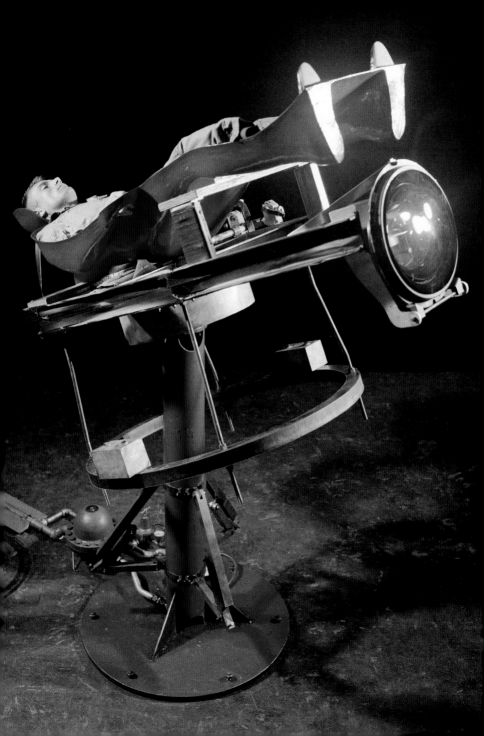

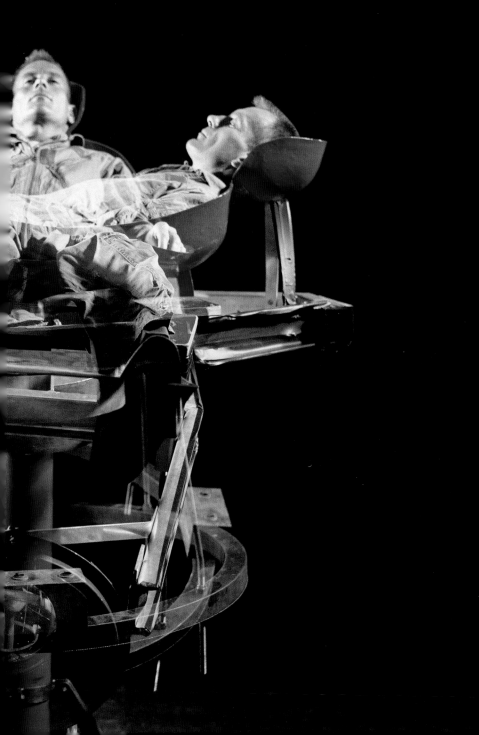

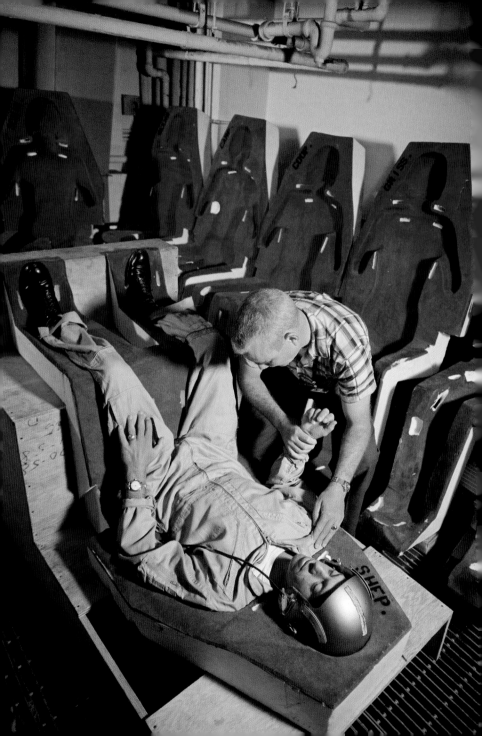

mocked before, but it had no great significance, suggesting rather a splash of derision at the thought that the show was already sufficiently American enough. In fact, between the steady reporters who worked out of Houston and the astronauts, there was that kind of easy needling humor which is the measure of professional respect to be found among teams and trainers.

So the entrance went well. The astronauts walked with the easy saunter of athletes. They were comfortable in motion. As men being scrutinized by other men they had little to worry about. Still, they did not strut. Like all good professional athletes, they had the modesty of knowing you could be good and still lose. Therefore they looked to enjoy the snouts they were wearing, they waved at reporter friends they recognized, they grinned. A reporter called back to Collins, "Now, you look good." It all had that characteristically American air which suggests that men who are successful in their profession do best to take their honors lightly.

Once they sat down, however, the mood shifted. Now they were there to answer questions about a phenomenon which even ten years ago would have been considered material unfit for serious discussion. Grown men, perfectly normal-looking, were now going to talk about their trip to the moon. It made everyone uncomfortable. For the relation of everyone to each other and to the event was not quite real. It was as if a man had died and been brought back from death. What if on questioning he turned out to be an ordinary fellow? "Well, you see," he might say, "having visited death, I come back with the following conclusions..." What if he had a droning voice? There

In the [centrifuge] tests so far, most of the Astronauts have experienced only about eight or nine Gs. Later on in the program, to make sure they can withstand emergency situations, the centrifuge will be speeded up to 20 Gs and the men will be spun over into what pilots call an "eyeballs out" situation. They do not look forward to it. — LIFE, *September 14, 1959 Opposite:* The 50-foot centrifuge at the Naval Air Development Center in Johnsonville, Pennsylvania, was fitted with fiberglass couches specially molded to each astronaut's body to help him withstand the impact. Here, in the "throne room," the fit of Alan Shepard's couch is checked by Air Force medical officer Dr. William Douglas. *Photo, Ralph Morse.*

To [simulate weightlessness], Dr. Jiro Oyama built this large animal centrifuge at NASA's Ames Research Center.... Leaving test animals spinning aboard the centrifuge long enough to become completely acclimated to more than twice the normal pull of gravity and then taking them off the machine, he can approximate the effects of zero gravity. — LIFE, February 21, 1969
Opposite and following spread: Photos, Ralph Crane.

Pages 44-45: John Stapp's pioneering rocket-sled G-force tests at Edwards Air Force Base sought to resolve the effects of acceleration and deceleration forces on humans. He began his work in 1947 and, on one of his last rides, survived more than 46 Gs. Here, a subject in protective goggles is shown at 1, 3, 6, and 9 Gs. Photos, Hulton Archive.

was something of this in the polite unreality of the questioning. The century was like a youth who made love to the loveliest courtesan in Cathay. Afterward he was asked what he thought and scratched his head and said, "I don't know. Sex is kind of overrated." So now people were going to ask questions of three heroes about their oncoming voyage, which on its face must be in contention for the greatest adventure of man. Yet it all felt as if three young junior executives were announcing their corporation's newest subdivision.

Perhaps for this reason, the quiet gaiety of their entrance had deserted them as they sat behind the desk in the plastic booth. Now it was as if they did not know if they were athletes, test pilots, engineers, corporation executives, some new kind of priest, or sheepish American boys caught in a position of outlandish prominence — my God, how did they ever get into this? It was as if after months in simulators with knowing technicians geared to the same code languages, they were now debouched into the open intellectual void of this theater, obliged to look into the uncomprehending spirits of several hundred media tools (human) all perplexed and worried at their journalistic ability to grasp more than the bare narrative of what was coming up. Yaws abounded. Vacuums in the magnetism of the mood. Something close to boredom. The astronauts were going to the moon, but everybody was a little frustrated — the Press because the Press did not know how to push into nitty-gritty for the questions, the astronauts because they were not certain how to begin to explain the complexity of their technique. Worse, as if they did not really wish to explain, but were obliged out of duty to the program, even if their privacy was invaded.

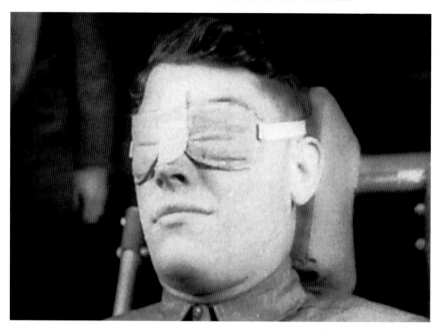

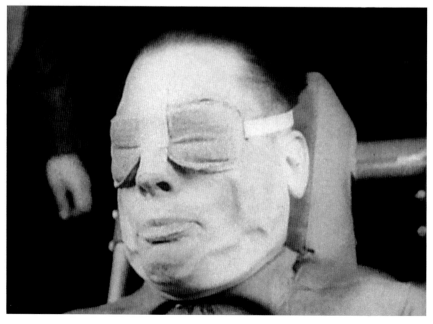

So the conference dragged on. While the focus of attention was naturally on Armstrong for commanding the flight, he seemed in the beginning to be the least at ease. He spoke with long pauses, he searched for words. When the words came out, their ordinary content made the wait seem excessive. He minted no phrases. "We are here"...a pause... "to be able to talk about this attempt"...a real pause, as if the next experience were ineffable but with patience would yet be captured... "because of the success of four previous Apollo command flights"...pause, as if to pick up something he had left out... "and a number of unmanned flights." A shy smile. "Each of those flights" — he was more wooden than young Robert Taylor, young Don Ameche, young Randolph Scott — "contributed in a great way"...deprecatory smile... "to this flight."

As a speaker he was all but limp — still it did not leave him unremarkable. Certainly the knowledge he was an astronaut restored his stature, yet even if he had been a junior executive accepting an award, Armstrong would have presented a quality which was arresting, for he was extraordinarily remote. He was simply not like other men. He would have been more extraordinary in fact if he had been just a salesman making a modest inept dull little speech, for then one would have been forced to wonder how he had ever gotten his job, how he could sell even one item, how in fact he got out of bed in the morning. Something particularly innocent or subtly sinister was in the gentle remote air. If he had been a young boy selling subscriptions at the door, one grandmother might have warned her granddaughter never to let him in the house; another would have commented, "That

It is a wild, sickening sensation. Your vision blurs....Unless you can stop all this multiple whirling by means of a single control stick in your hand, you will certainly vomit. — Virgil Grissom, LIFE, April 11, 1960 Opposite: In the vacuum of space, a craft that starts spinning or tumbling — or both — will continue until the pilot utilizes thrusters to bring the craft under control. The Multiple Axis Space Test Inertia Facility at the Lewis Research Center in Cleveland, Ohio, was the first simulator to effectively train the astronauts for this condition. *Photo, NASA.*

boy will go very far." He was apparently in commu-
nion with some string in the universe others did not
think to play.

Collins and Aldrin followed with their opening
remarks, and they had personalities which were more
comfortable to grasp. Aldrin, all meat and stone, was a
man of solid presentation, dependable as a tractor, but
suggesting the strength of a tank, dull, almost ponder-
ous, yet with the hint of unpredictability, as if, eighteen
drinks in him, his eyes would turn red, he would arm-
wrestle a gorilla or invite you to join him in jumping
out a third-story window in order to see who could do
the better somersault on the follow-through out of the
landing. This streak was radium and encased within
fifty psychical and institutional caskings of lead, but it
was there, Aquarius thought, perhaps a clue in the way
he dressed — very dressy for an astronaut — a green
luminous silk suit, a white shirt, a green luminous
tie. It clashed with the stolid presentation of his lan-
guage. Aldrin spoke in a deep slow comfortingly nasal
tone — a mighty voice box — his face was strong and
grim. The movie director in Aquarius would have cast
him on the spot for Major in Tank Cavalry. He had
big features and light brown hair, almost gold. His
eyes took a turn down like samurai eyes, the corners
of his lips took a right-angle turn down — it gave him
the expression of a serious man at home on a field of
carnage, as if he were forever saying, "This is serious
stuff, fellows, there's lots of blood around." So Aldrin
also looked like the kind of jock who could be head-
master of a prep school. He had all the locker-room
heartiness and solemnity of a team man. Although he
had been a pole-vaulter at West Point, it would have
been easy to mistake him for a shot-putter, a lacrosse

Opposite: Gus Grissom is strapped into the MASTIF in 1960 and spun simultaneously head over heels (yellow lines), on a horizontal plane (green lines), and on a vertical plane (red lines). The astronauts disliked these devices, but during Gemini VIII, Neil Armstrong and Dave Scott had to get themselves out of just such a situation. *Photo, Ralph Morse.*

Following spread: Mobility of the Mercury space suits was tested at Wright Patterson Air Force Base in Dayton, Ohio. Here, a test sub-ject pushes a circular palisade of yardsticks in 1962 to see how far the suit allows him to reach. *Photo, Ralph Morse.*

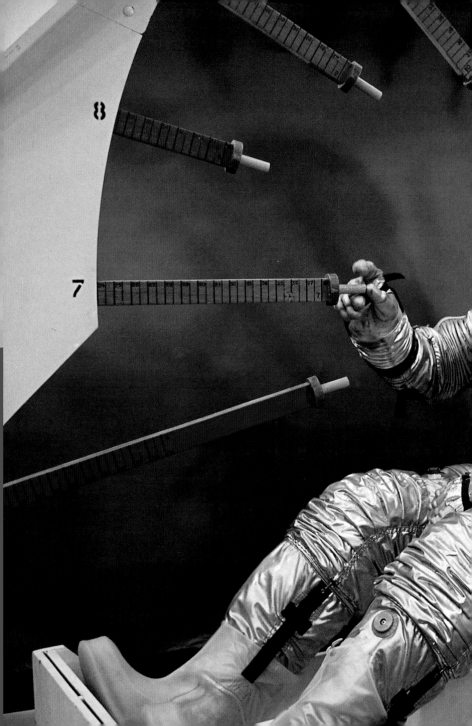

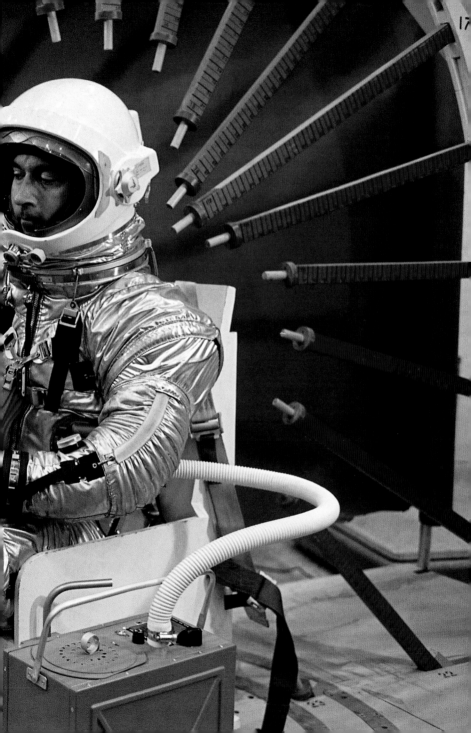

Opposite: A 1967 simulation of the first step on the moon. Since the early photo shoots of the Mercury program, it was not uncommon for painted work boots to stand in for flight boots still in development. *Photo, Ralph Morse.*

player or a baseball catcher. In football he would have probably been a linebacker. For this last, he was actually not big enough (since the astronauts were required to be no more than five feet eleven inches tall and could hardly be overweight), but he was one of those men who looked larger than his size for his condition was excellent — every discipline of his moves spoke of grim devoted unrelenting support given to all his body-world of muscle. From the back of the neck to the joints of the toes, from the pectorals to the hamstrings, the deltoids to the abdominals, he was a life given over to good physical condition, a form of grace, since the agony of the lungs when straining is not alien to the agony of the soul. Leave it that Aldrin was so strong he had a physical presence which was bigger than his bulk.

He talked like a hardworking drill. He had the reputation of being the best physicist and engineer among the astronauts — he had written a valuable thesis on Orbital Rendezvous Techniques at MIT, but he put no humor into his presentation, he was selling no soap. If you did not read technologese, you might as well forget every last remark for his words did not translate, not unless you were ready to jog along with him on technology road. Here is the way he gave himself to the Press: "We do have a few items on the Lem side of the house on this particular mission. We'll be picking up where Apollo 10 left off when they did their phasing maneuver. And at this point after departing the Command Module, coming down in the descent orbit, we'll be igniting the descent engine for the first time under a long burn condition when it is not docked with the Command Module. And executing this burn under control of a computer, being directed towards

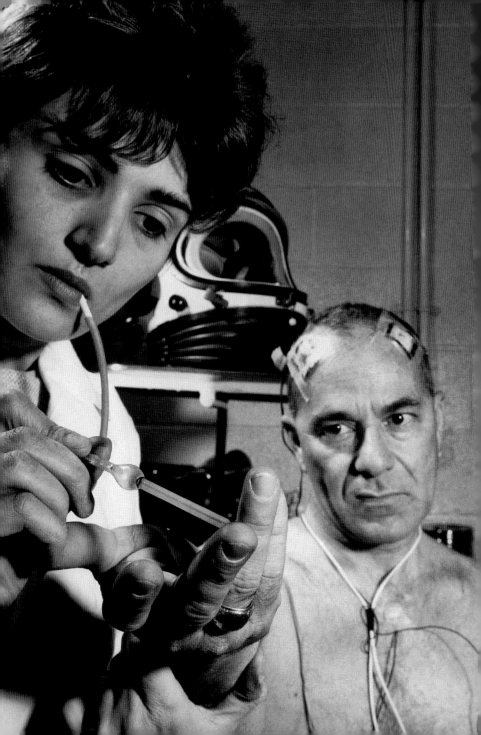

the various targets that are fed into the computer will be new on this flight. Also we'll be making use of the landing radar and its inputs into the computer. Inputs in terms of altitude and velocity updates which will bring us down in the prescribed conditions as we approach the surface of the moon. Of course, the actual control of the touchdown itself will be a rather new item in that it will be testing this man-machine interface to a very sophisticated degree. The touchdown itself will be the ultimate test on the landing gear and the various systems that are in the spacecraft. The environment of one-sixth G will be seen for the first time by crews and spacecraft. We'll also be exposed to thermal conditions that have not been experienced before. The two-man EVA is something that is a first in our program. Sleeping in the Lem on the lunar surface, which we hope to be able to do, will be another new item in that flight."

He went on to talk of star sightings and the powered ascent from the moon — that moment when, having landed successfully and reconnoitered the moon ground, they would be back in the Lem and ready to ascend — would the motor ignite or did the moon have a curse? Aldrin spoke of this as a "new item," then of rendezvous with the Command Module, which would return them to earth, of "various contingencies that can develop," of "a wider variety of trajectory conditions" — he was talking about not being able to join up, wandering through space, lost forever to life in that short eternity before they expired of hunger and thirst. Small hint of that in these verbal formulations. Even as the Nazis and the Communists had used to speak of mass murder as liquidation, so the astronauts spoke of possible personal disasters as "contingency." The heart

Opposite: The Hamilton Standard division of United Aircraft was the main contractor to develop the backpack life-support system for the new space suit. Here, a technician takes the blood count of space environment engineer Arnold Beck to gather human factors related to development of the suit. *Photo, NASA.*

Following spread: An early Reduced Gravity Walking Simulator at Langley in 1964 simulated the effects of walking in moon-like conditions. Using cables to hold five-sixths of a man's weight, it allowed test subjects to walk with only one-sixth of their weight bearing on an inclined board, which led to simpler, more realistic simulation techniques. *Photo, NASA.*

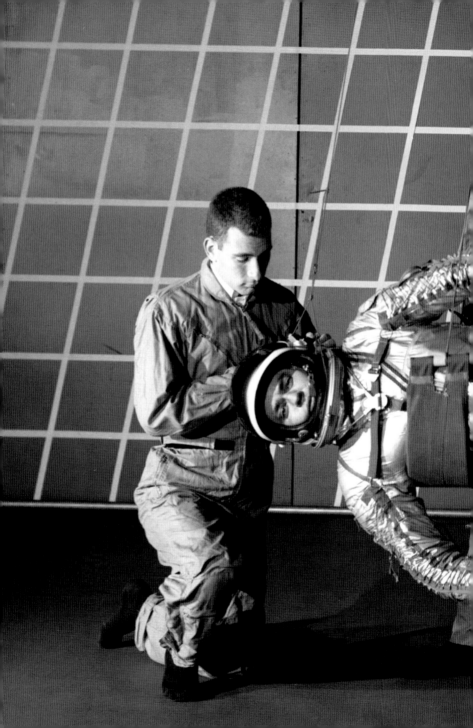

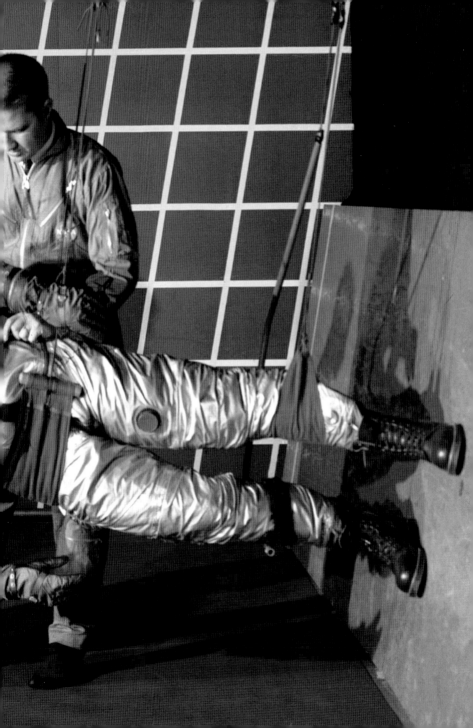

of astronaut talk, like the heart of all bureaucratic talk, was a jargon which could be easily converted to computer programming, a language like Fortran or Cobol or Algol. Anti-dread formulations were the center of it, as if words like pills were there to suppress emotional symptoms. Yet Aldrin, powerful as a small bull, deep as his grasp of Celestial Mechanics, gave off in his air of unassailable solemnity some incommunicable speech about the depth of men's souls and that razor's edge between the hero's endeavor and vainglory. Vainglory looked real to him, one might assume, real as true peril — he had the deep gloomy clumsy dignity of a man who had been face to face in some stricken hour with the depths of his own nature, more complex than he had hitherto known.

Collins, in contrast, moved easily; Collins was cool. Collins was the man nearly everybody was glad to see at a party, for he was the living spirit of good and graceful manners. Where Armstrong referred to Wapakoneta, Ohio, as his hometown, and showed a faint but ineradicable suspicion of anyone from a burg larger than his own, where Aldrin protected himself from conversation with the insulations of a suburban boyhood and encapsulement among his incommunicable fields of competency, Collins had been born in a well-set-up apartment off the Borghese Gardens in Rome. His father, General James L. Collins, was military attaché (and could conceivably have been having a drink around the corner in the bar at the Hassler to celebrate the birth of his son). Since the year was 1930, Dick Diver could have been getting his going-over from the Fascisti police in the basement of *Tender Is the Night.* No surprise then if Collins had a manner. It was in part the manner of Irish

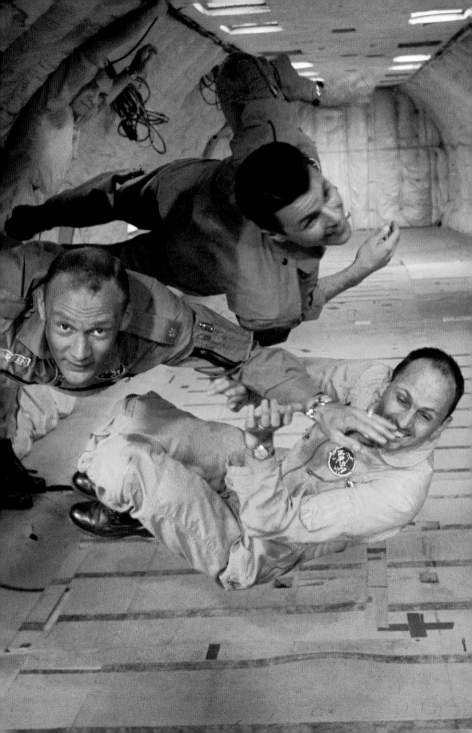

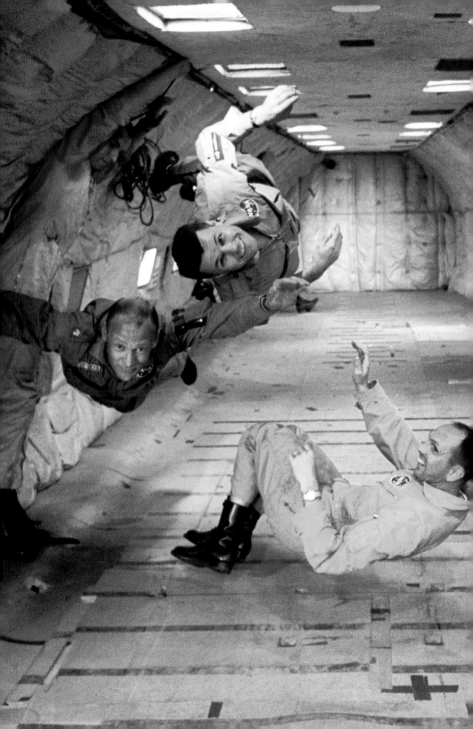

elegance — a man must be caught dead before he takes himself seriously. It was as if Collins were playing a fine woodwind which had the merriment and the sadness (now that the madness was gone) of those American expatriates for whom culture began in the Year One of *The Sun Also Rises*.

Indeed, if Collins was later to grow a mustache on the trip back, an act which increased his slight but definite resemblance to the young Hemingway, he had a personal style which owed more to Fitzgerald. It was Fitzgerald, after all, who first suggested that you could become the nicest man in the world. So Collins had that friendliness which promises it would be sacrilege to give offense in a social situation. It was apparently as unnatural for him not to make a small joke as it would have been offensive to Aldrin not to take on a matter in its full seriousness. Yet Collins had little opportunity to show his humor. It existed mainly in the fine light smiling presence he bestowed on the interview while the others were asked all the questions. Collins was the only one of the three not landing on the moon. So he would obviously be the one whose remarks would go into the last paragraph, where the layout man would probably lop them off. Therefore nobody had bothered to direct a question to him through all the interview.

Toward the end of the press conference, somebody asked of the astronauts at large, "Two questions. Firstly, what precautions have been taken at your own homes to prevent you from catching germs from your own family? And secondly, is this the last period that you will spend at home here with your families?" The Public Affairs Officer, Brian Duff, was quick to say, "Take a crack at that, Mike." It could not have been easy to have waited so long for so little. But Collins

Opposite: Any training for operations in space flight or on the moon that needed a high fidelity of simulation was done in NASA's stripped-down KC135 aircraft. Flown in a series of parabolas, the Vomit Comet, as it was affectionately known, gave the astronauts about 30 seconds of either zero-G or 1/6th-G near the top of each arc to work with engineers and other support personnel. Both Freeman and Bassett were killed in aircraft accidents before either had a chance to fly in space. *Photos, Ralph Morse.*

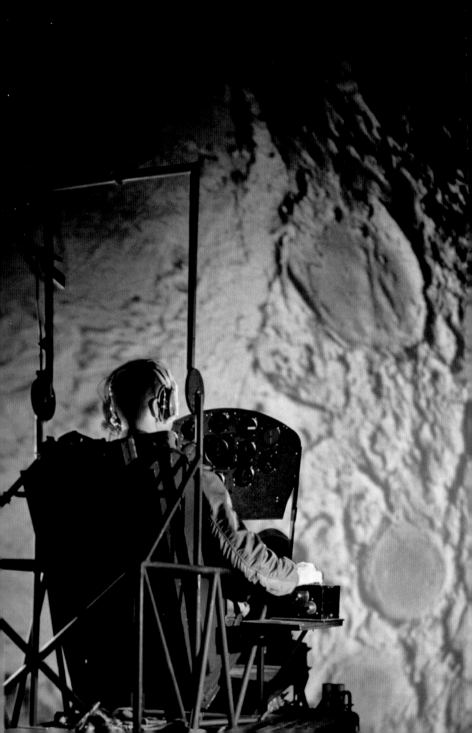

came up smiling, and said, "My wife and children have signed a statement that they have no germs and — and yes this will be the last weekend that we will be home with our families." It was not much of a joke but the press conference had not been much of a joke either, and the Press brightened, they laughed. Collins, quick not to offend the man who had asked the question, now added, "Seriously, there are no special precautions being taken."

His conversational manner was easy. It was apparent that of the three, he was the only one you could drink with comfortably. Since the ability to drink with your material is as important to a journalist as the heft of his hammer to a carpenter, a sense of dismay passed through the press corps — why hadn't NASA had the simple sense of press relations to put Collins in command? What a joy it could have been to cover this moon landing with a man who gave neat quotes, instead of having to contend with Armstrong, who surrendered words about as happily as a hound allowed meat to be pulled out of his teeth.

Collins would have been perfect. In combination with his manner, so obviously at ease with a martini, he had the trim build, the bald forehead and economical features of a college boxer, or a shortstop, or a quarterback. (In fact he was the best handball player among the astronauts and had been captain of his wrestling team at St. Albans.) He looked like copy, he talked like copy, and Armstrong had the sad lonely mien of a cross-country runner. Of course, since he also had the sly privacy of a man whose thoughts may never be read — what a vast boon was this to the Press! — one could, if picturing Armstrong as an athlete, see him playing end. He might, thus sly and

Opposite: A test run at Langley Research Center in 1966 on one of the Lunar Orbit and Letdown Approach Simulator's four maps. Conceived to provide pilots the visual cues they would encounter while navigating in the moon's orbit, LOLA turned out to be a $1.9-million experiment of little value, as navigating in lunar orbit proved to be a nonissue. *Photo, NASA.*

We'd had — I guess it was — the equivalent of a master's degree in geology over the six years. — Charlie Duke, **Apollo Lunar Surface Journal** *interview, 1992 Following spread:* Aldrin and Armstrong answer media questions on February 24, 1969, in Sierra Blanca, Texas. The tightly packed Apollo 11 schedule only permitted one day to brush up on geological training. *Photo, NASA.*

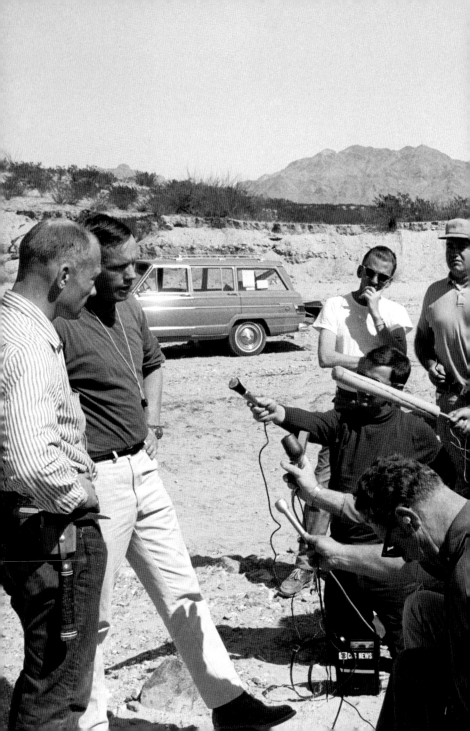

private, be difficult to keep up with on pass patterns. The story resided, however, with the two men who would land on the moon — it could reside nowhere else — but since Collins with a few smiles and a remark or two had become the favorite, a question and then another came his way at the end of the interview. Finally, the real question came.

"Colonel Collins, to people who are not astronauts, you would appear to have the most frustrating job on the mission, not going all the way. How do you feel about that?" The contradiction implicit in being an astronaut was here on this point — it was skewered right here. If they were astronauts, they were men who worked for the team, but no man became an astronaut who was not sufficiently exceptional to suspect at times that he might be the best of all. Nobody wins at handball who is not determined to win.

He answered quickly. "I don't feel in the slightest bit frustrated. I'm going 99.9 percent of the way there, and that suits me just fine." Growing up in Rome, Puerto Rico, Baltimore and Washington, Texas and Oklahoma, son of one of the more cultivated purlieus of the military grace, the code would be to keep your cool. The only real guide to aristocracy in American life was to see who could keep his cool under the most searing conditions of unrest, envy, ambition, jealousy and heat. So not a quiver showed. "I couldn't be happier right where I am," he concluded and the voice was not hollow, it did not offer a cousin to a squeak. Still nobody believed him. Somewhere in the room was the leached-out air of a passion submitted to a discipline. For a moment Collins was damnably like an actor who plays a good guy. Armstrong came in quickly. "I'd like to say in that

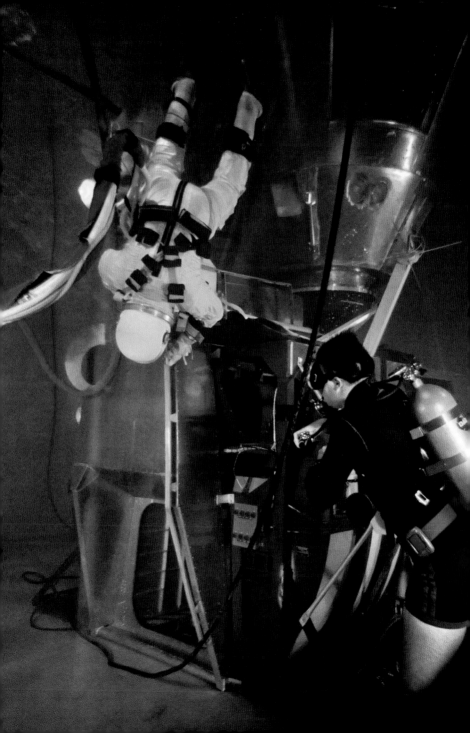

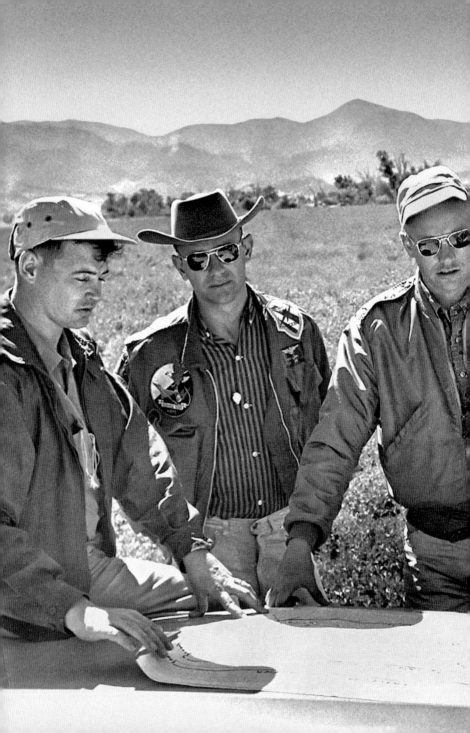

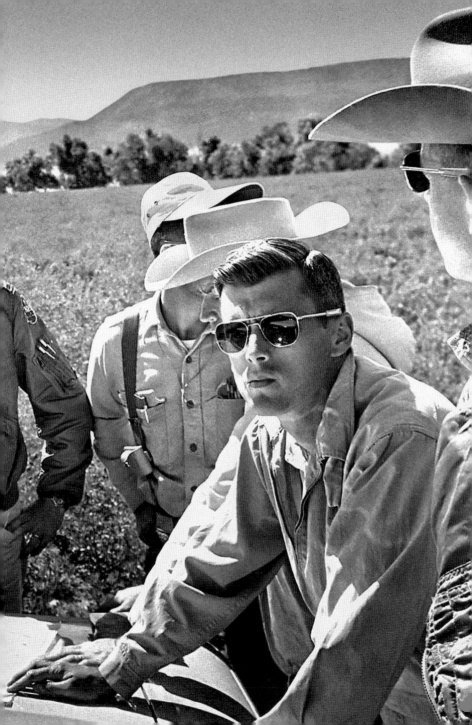

Opposite: The original prime crew of Apollo 8 — LMP Bill Anders, CMP Mike Collins, and CDR Frank Borman — enters the Command Module Simulator in 1967. A double exposure shows Collins (center) and Borman (right) inside the CMS. Due to a medical complication, Collins was replaced in July 1968 by Jim Lovell. *Photo, Ralph Morse.*

There, in the vast rooms lay the clamlike modules which will grow men like pearls in their downshut mouths. — Ray Bradbury, LIFE, November 24, 1967

Following spread: A Lunar Module Simulator (foreground) and Command Module Simulator (behind) at the Kennedy Space Center Flight Crew Training Facility, March 1, 1968. *Photo, NASA.*

regard that the man in the Command Module"... pause..."of course by himself"...another pause... "has a giant-sized job." When Armstrong paused and looked for the next phrase he sometimes made a sound like the open crackling of static on a pilot's voice band with the control tower. One did not have the impression that the static came from him so much as that he had listened to so much static in his life, suffered so much of it, that his flesh, his cells, like it or not, were impregnated with the very cracklings of static. "He has to run Buzz's job and my job"...static..."along with his own job simultaneously"...static..."in addition act as relay to the ground"...pause and static.... "It's at least a three-man job and" — he murmured a few words — "Michael is certainly not lacking for something to do while he's circling around." Then Armstrong flashed a smile. One of his own jokes came. His humor was pleasant and small-town, not without a taste of the tart. "And if he can't think of anything else, he can always look out the window and admire the view."

Now came a question from a reporter who was new on the job: "From your previous experience in the two and a half hours or so that you're atop the rocket before actual blast-off, is this a period of maximum tension, rather like being in a dentist's waiting room?"

A temporary inability to understand the question was finally replaced by this speech. "It's one of the phases that we have a very high confidence in," Armstrong answered with his characteristic mixture of modesty and technical arrogance, of apology and tight-lipped superiority. "It's nothing new. It's the thing that's been done before," now static while he searched for the appropriate addition, "and done very

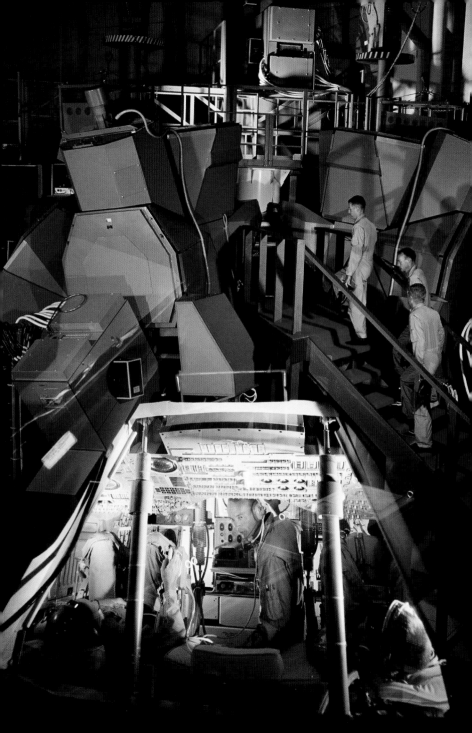

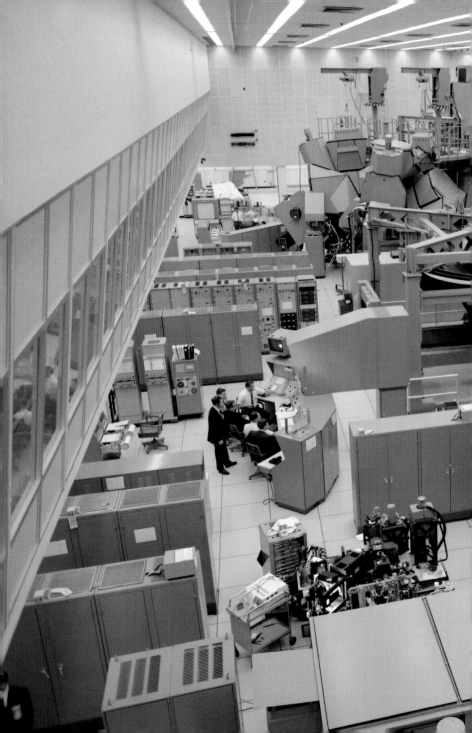

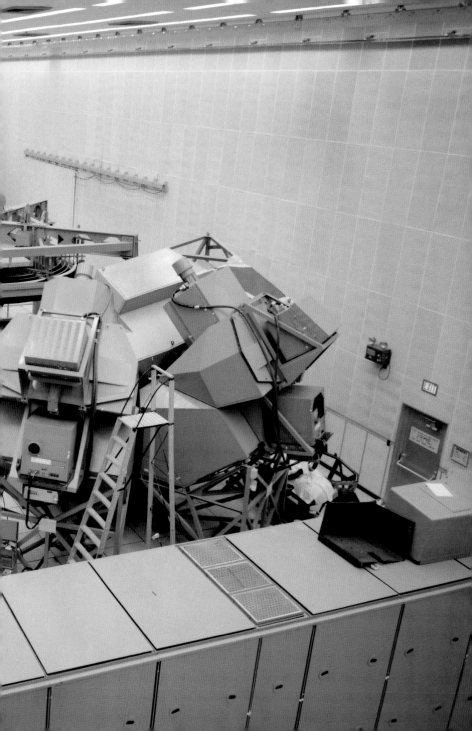

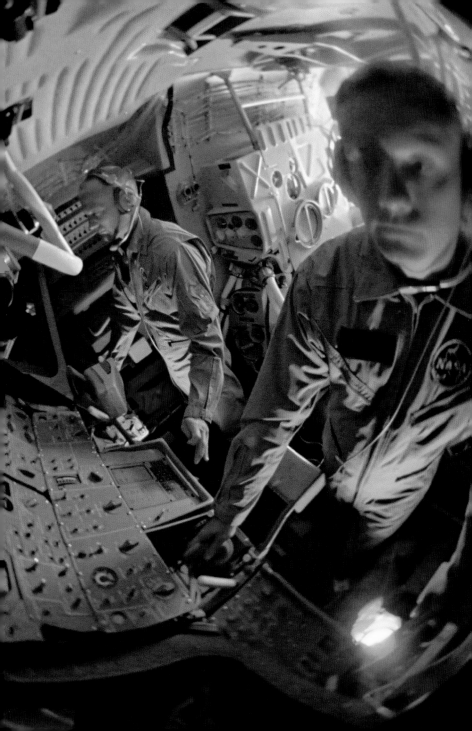

well on a number of occasions, and we're quite sure this girl will go," he said solemnly, pleasantly, lightly, carefully, sadly, sweetly. He was a presence in the room, as much a spirit as a man. One hardly knew if he were the spirit of the high thermal currents, or that spirit of neutrality which rises to the top in bureaucratic situations, or both, both of course — why should Armstrong have a soul less divided than the unruly world of some billions of men? Indeed contradictions lay subtly upon him — it was not unlike looking at a bewildering nest of leaves: some are autumn fallings, some the green of early spring. So Armstrong seemed of all the astronauts the man nearest to being saintly, yet there was something as hard, small-town and used in his face as the look of a cashier over pennies. When he stopped to think, six tired parallel lines stood out on his forehead, and his hair was very straight, small-town hair-colored humorless straight, his pupils were very small, hardly larger than buckshot, you could believe he flew seventy-eight combat missions off the *Essex* near Korea. He was very thin-mouthed, almost as thin and wide a mouth as Joe E. Brown, yet with no comic spirit, or better, or worse, the spirit of comedy gave orders to the mouth most of the time. Much like President Nixon or Wernher von Braun (whom we are yet to meet) he would smile on command. Then a very useful smile appeared — the smile of an enterprising small-town boy. He could be an angel, he could be the town's devil. Who knew? You could not penetrate the flash of the smile — all of America's bounty was in it. Readiness to serve, innocence, competence, modesty, sly humor, and then a lopsided yawing slide of a dumb smile at the gulfs of one's own ignorance, like oops am I small-town dumb! — that was also in it. Aquarius

Opposite: A fish-eye view into an LMS with Armstrong in the foreground and Aldrin behind. Out of the 1,000-plus hours of training each of them did for Apollo 11, 285 were spent in LM simulators. *Photo, Ralph Morse.*

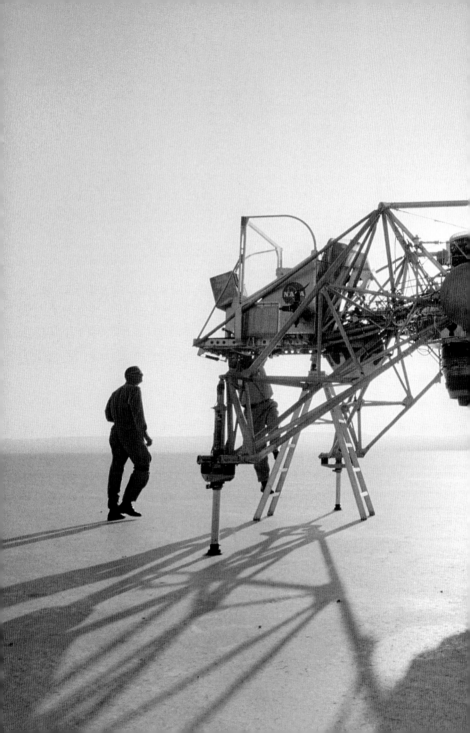

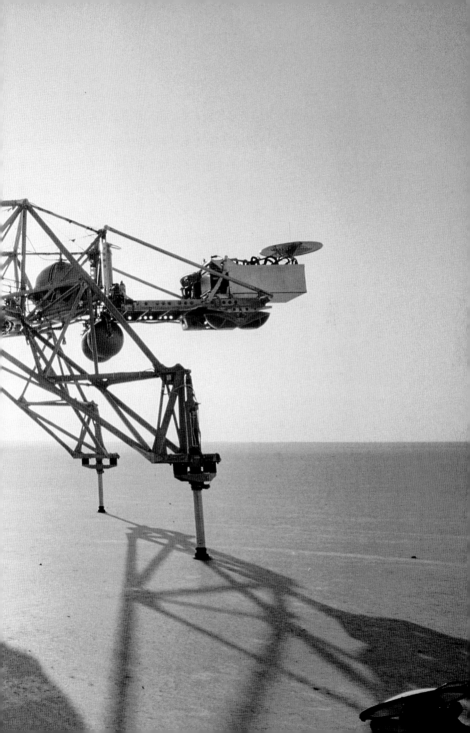

There had been only one Columbus — there were ten astronauts at least who could do the job. — Norman Mailer

Previous spread: Armstrong approaches a Lunar Landing Research Vehicle at sunset in 1964 at Edwards Air Force Base. Nicknamed the "flying bedstead," the spiderlike LLRV and the later Lunar Landing Training Vehicle, were equipped with a General Electric CF700-2V turbofan engine that could support five-sixths of the vehicle's weight. Remaining lift was provided by a pair of hydrogen-peroxide rockets, which simulated operation of the LM's descent engine and gave the pilot a seat-of-the-pants feel. *Photo, Ralph Morse.*

The machines were notoriously difficult to control, however, and on May 6, 1968, Armstrong lost control of the LLRV-1, ejecting to safety before it crashed to the ground. *Photo, Bettmann/Corbis.*

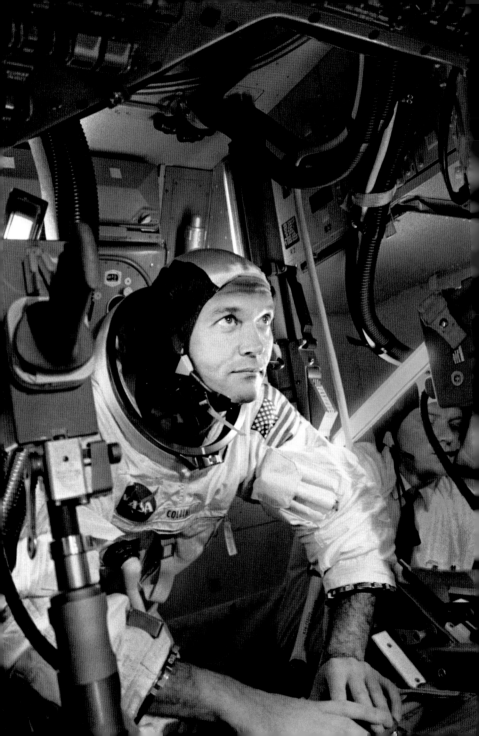

decided it was not easy to trust him then — the smile was a vehicle to remove Armstrong from the scene. But when he spoke, all ambition was muzzled. He spoke with the unendurably slow and triple caution of a responsibility-laden politician who was being desperately careful to make no error of fact, give no needless offense to enemies and cross no conflicting zones of loyalty among friends. Add the static, and he was no happy public speaker. At communicating he was as tight as a cramped muscle.

Perversely, it became his most impressive quality, as if what was best in the man was most removed from the surface, so valuable that it must be protected by a hundred reservations, a thousand cautions, as if finally he had such huge respect for words that they were like tangible omens and portents, zephyrs and beasts of psychic presence, as if finally something deep, delicate and primitive would restrain him from uttering a single word of fear for fear of materializing his dread. So, once, men had been afraid to utter the name of the Lord, or even to write it in such a way as to suggest the sound, for that might be enough to summon some genie of God's displeasure at so disrupting the heavens. Armstrong of course did not brandish an ego one could perceive on meeting; where Aldrin gave off the stolid confidence of the man who knows that problems can be solved if properly formulated and appropriately attacked (which is to say attacked in good condition!) and where Collins offered the wiry graceful tension of a man who will quietly die to maintain his style, Armstrong could seem more like a modest animal than a man — tracer hints of every forest apprehension from the puma to the deer to the miseries of the hyena seemed to stalk at the edge of that small-town

People think we're baked in heat chambers and whirled in centrifuges until our eyeballs fall out, and there is a little of that, but essentially we are learning an incredibly complex array of machines...and what to do if some of it doesn't work as advertised. —Michael Collins, LIFE, July 4, 1969 Opposite: In the event of a solo return to Earth, Collins had to know how to operate Columbia on his own. Though the CMS could not reproduce the motions of space flight, all the nonpropulsive systems worked like their counterparts in the real ship—even the sounds they would hear and the views they would see. *Photo, NASA.*

[Aldrin's] was a life given over to good physical condition, a form of grace.... [Armstrong was] a veritable high priest of the forces of society and scientific history.... Collins was cool...the living spirit of good and graceful manners ... the man everybody was glad to see at a party. —Norman Mailer
Armstrong, Collins, and Aldrin inspect CM-107 (Columbia) on a walk-through egress test on June 10, 1969, at Kennedy Space Center's Launch Pad 39A a few weeks before launch. Still on a heavy training schedule, spacecraft visits by the astronauts were infrequent.
Photo, NASA.

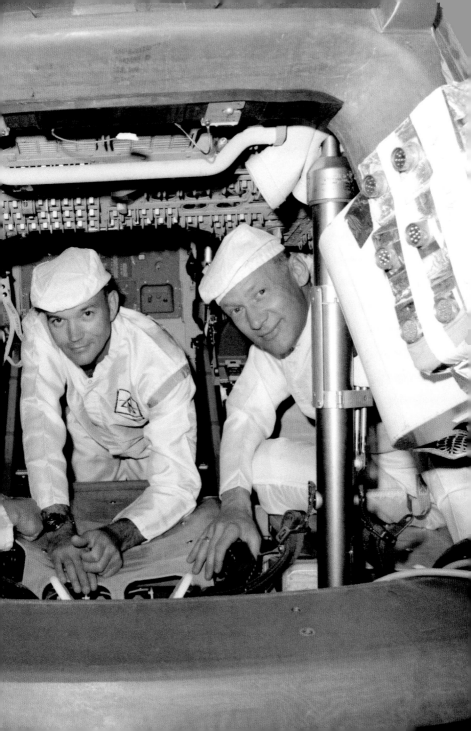

clearing he had cut into his psyche so that he might offer the world a person. But his thoughts seemed to be looking for a way to drift clear of any room like this where he was trapped with psyche-eaters, psyche-gorgers and the duty of responding to questions heard some hundreds of times.

On the other hand, he was a professional and had learned how to contend in a practical way with the necessary language. Indeed, how his choice of language protected him!

"Mr. Armstrong, at the time you are down on the moon, what will be your overriding consideration and what will be your main concern?"

"Well," said Armstrong, "immediately upon touchdown our concern is the integrity of the Lunar Module itself"...nnnnnnnhr went the sound of the static.... "For the first two hours after touchdown we have a very busy time verifying the integrity of the Lunar Module and all of its systems"...nnnnhr.... "A great deal of technical discussion...between spacecraft and ground during a time period when most people will be wondering, well what does it look like out there?...We will be eager to comment"... nnnnhr..."but reluctant to do so in the face of these more important considerations on which...the entire rest of the lunar mission depends."

Aldrin, the formalist, had said just previously, "I think the most critical portion of the EVA will be our ability to anticipate and to interpret things that appear not to be as we expected them to be, because if we don't interpret them correctly then they will become difficult." It was the credo of the rationalist. Phenomena are only possessed of menace when they do not accommodate themselves to language-controls. Or, better, to

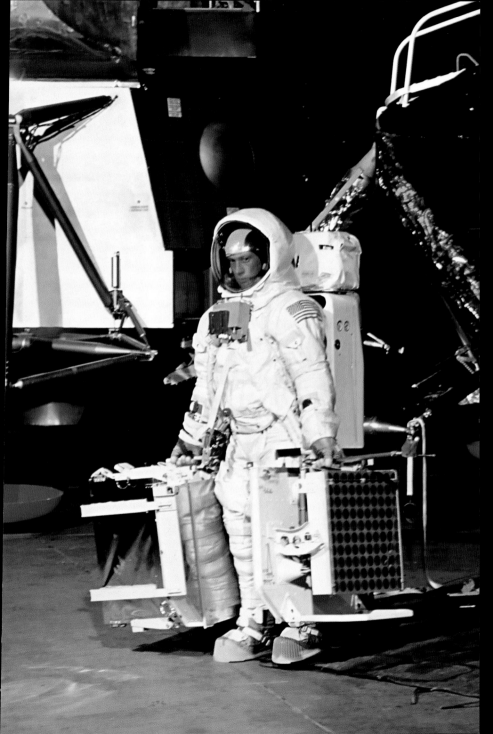

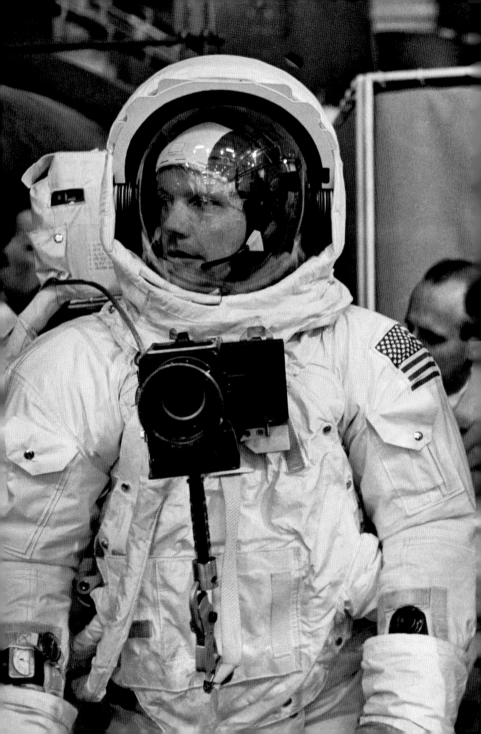

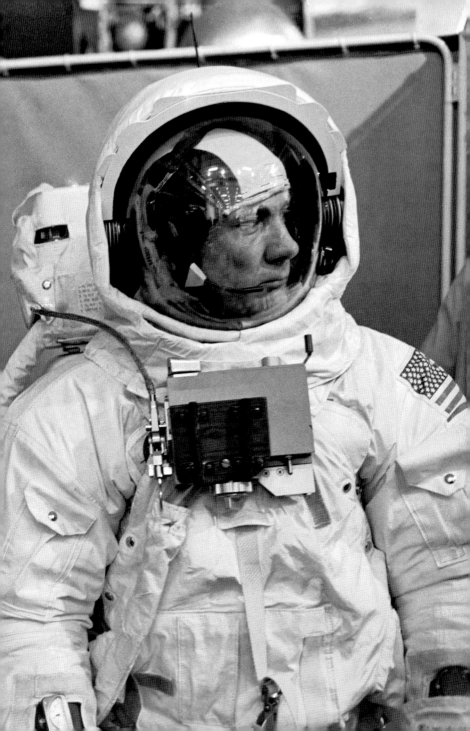

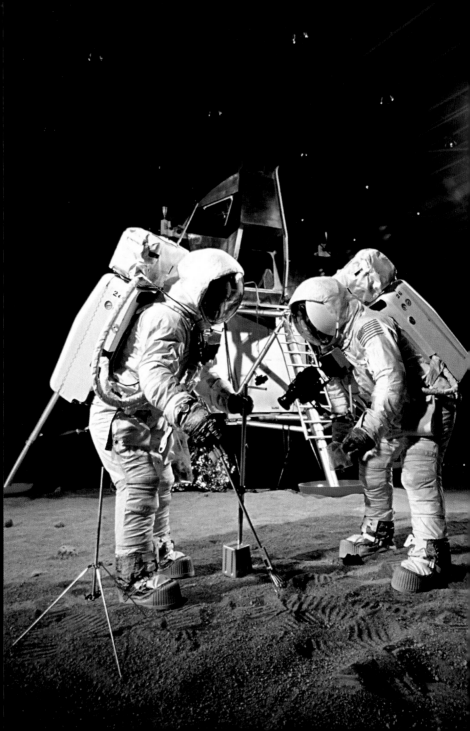

initial-controls. EVA stood for Extravehicular Activity, that is for action taken outside their vehicle, the Lem. EVA therefore referred to their walk on the moon; but the sound of the letters E, V, A might inspire less perturbation than the frank admission that men would now dare to walk on an ancient and alien terrain where no life breathed and beneath the ground no bodies were dead.

It was, of course, a style of language all the astronauts had learned. There were speeches where you could not tell who was putting the words together — the phrases were impersonal, interlocking. One man could have finished a sentence for another. "Our order of priorities was carefully integrated into the flight plan... there is no requirement on the specific objectives that we're meeting on the surface to go great distances from the spacecraft, and to do so would only utilize time that we now have programmed doing things in the specific mission objectives." Sell newspapers with that kind of stuff! The quote could belong to any one of a dozen astronauts. In this case it happened to be not Aldrin but Armstrong.

Only on occasion did the language reveal its inability to blanket all situations. Mainly on personal matters. There came a question from one of the remedial readers. "Tell us very briefly how your families have reacted to the fact that you're taking this historic mission."

"Well," Aldrin deliberated, "I think in my particular case, my family has had five years now to become accustomed to this eventuality, and over six months to face it very closely. I think they look on this as a tremendous challenge for me. They look upon it also as an invasion somewhat of their privacy and removing

NASA presented the astronauts as robots. In fact, they are not robots. They are men who have an extraordinary balance between discipline and daredevilry. Robots could not have gone to the moon, because a robot breaks down the moment there's a fluctuation in the current. —Norman Mailer Opposite: Aldrin (left) and Armstrong (right) practice documented sampling in an indoor training facility. The procedure consisted of photographing a rock before disturbing it, transfering the specimen to an individual sample bag using tongs or a scoop, and then photographing the spot where the rock had been. On the moon, they ran out of time before they could do any documented sampling. *Photo, NASA.*

of my presence away from the family for a considerable period of time." He spoke glumly, probably thinking at this moment neither of his family nor himself — rather whether his ability to anticipate and interpret had been correctly employed in the cathexis-loaded dynamic shift vector area of changed field domestic situations (which translates as: attractive wife and kids playing second fiddle to boss astronaut number two sometimes blow group stack). Aldrin was a man of such powerful potentialities and iron disciplines that the dull weight of appropriately massed jargon was no mean gift to him. He obviously liked it to work. It kept explosives in their package. When his laboriously acquired speech failed to mop up the discharge of a question, he got as glum as a fastidious housewife who cannot keep the shine on her floor.

They could not, of course, restrain the questions which looked for ultimate blood. "James Gunn, BBC. You had mentioned that your flight, like all others, contains very many risks. What, in view of that, will your plans be" — a British courtesy in passing — "in the extremely unlikely event that the Lunar Module does not come up off the lunar surface?"

Armstrong smiled. His detestation of answering questions in public had been given its justification. Journalists would even ask a man to comment on the emotions of his oncoming death. "Well," said Armstrong, "that's an unpleasant thing to think about." If, as was quite possible, he had been closer to death than anyone in the room, and more than once, more than once, that did not mean the chalice of such findings was there to be fingered by fifty. "We've chosen not to think about that up to the present time. We don't think that's at all a likely situation. It's simply

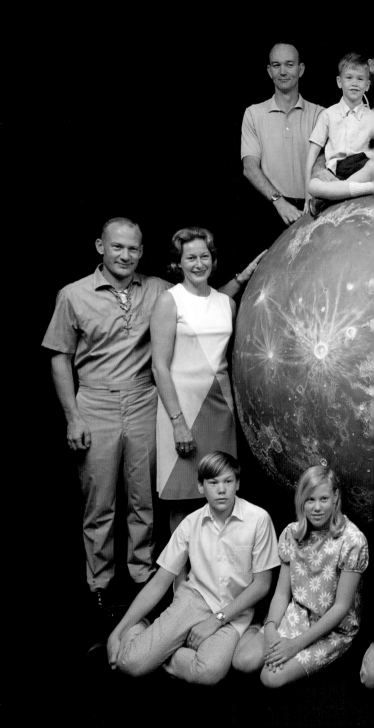

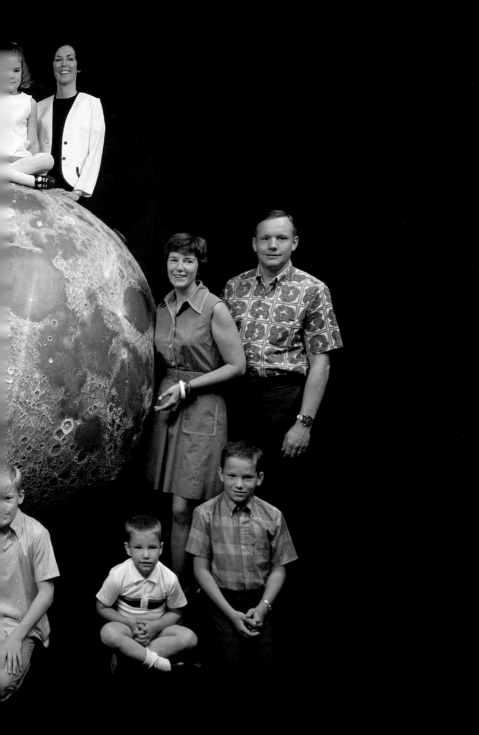

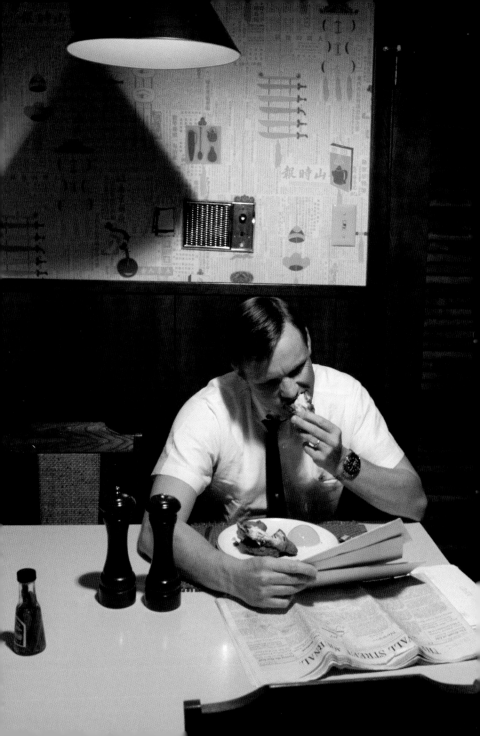

a possible one." He had, however, not answered the question. If he put in twelve and more hours a day in simulators, if there were weeks when they worked seventy and eighty hours a week at the abrasive grind of laying in still more hierarchies of numbers and banks of ratio in their heads, well, they were accustomed to hard work. So the grind today of being interviewed in full press conference, then by the wire services, then by magazine writers and finally for the television networks, a fourteen-hour day before it would all be done, and of the worst sort of work for them — objects on display to be chipped at by some of the worst word-sculptors ever assembled in southeastern Texas — well, that would still be work they must perform to the best of their duty.

Being an astronaut was a mission. Since the political and power transactions of the age on which NASA's future was — put no nice word on it — hung, were not in spirit religious, the astronauts did not emphasize their sense of vocation. But being an astronaut was a mission and therefore you were obliged to perform every aspect of your work as well as you could. At a press conference you answered questions. So Armstrong now finally said in answer to what they would do if the Lunar Module did not come up off the lunar surface, "At the present time we're left without recourse should that occur."

When the conference was done, there was only a small pattering of applause from the Press. The atmosphere had been equal to any other dull press conference in which a company had unveiled a new and not very special product. Resentment in the Press was subtle but deep. An event of such dimensions and nothing to show for it. The American cool was becoming

"If you tell Neil that black is white, he may agree with you just to avoid argument," says an acquaintance. "No, most likely he won't say anything at all," says someone else. "He'll smile at you and you'll think he is agreeing. Later on you'll remember that he didn't say a word." — LIFE, *July 4, 1969 Previous spread:* LIFE *magazine gave a personal side to its in-depth coverage of NASA's space program, with regular features on the private lives and families of the astronauts. Its exclusive coverage began in 1958 with the Mercury astronauts and now turned its eye to the men behind Apollo 11. Clockwise from the top: Mike and Pat Collins with children Mike, 6, Kate, 10, and Ann, 7; Neil and Jan Armstrong with sons Ricky, 11, and Mark, 6; and Buzz and Joan Aldrin, with children Mike, 13, Jan, 11, and Andy, 10.*

Opposite: Armstrong eats breakfast at home in Houston. *Photo, Ralph Morse.*

a narcotic. The horror of the Twentieth Century was the size of each new event, and the paucity of its reverberation.

But what if you're unable to get off the moon? "Unpleasant thing to think about."

* * *

It was the answer Aquarius thought about after the conference was done, for that was the nearest anyone had come to saying that a man could get killed in the pits of this venture. And yes, they did think about it. A man who was in training for six months to go to the moon would be obliged to think about his death. Yet, if to contemplate the failure of the ascent stage of the Lunar Module to rise off the moon was unpleasant for Armstrong to think about, did that derive automatically and simply because it would mean death, or was it, bottomless taint of the unpleasant, a derivation deep out of the incommensurable fact that the moon ground would be the place where his body must rest in death? People who had nearly died from wounds spoke of the near death as offering a sensation that one was rising out of one's body. So had spoken Hemingway long ago, writing in Paris, writing in Spain, probably writing in apartments off the Borghese Gardens near where Collins had been born. Now was there to be a future science of death, or did death (like smell and sound and time — like the theory of the dream) resist all scientists, navigators, nomenclature and charts and reside in the realm of such unanswerables as whether the cause of cancer was a malfunction of the dream? *Did* the souls of the dead choose to rise? Was the thought of expiring on the moon an abyss of

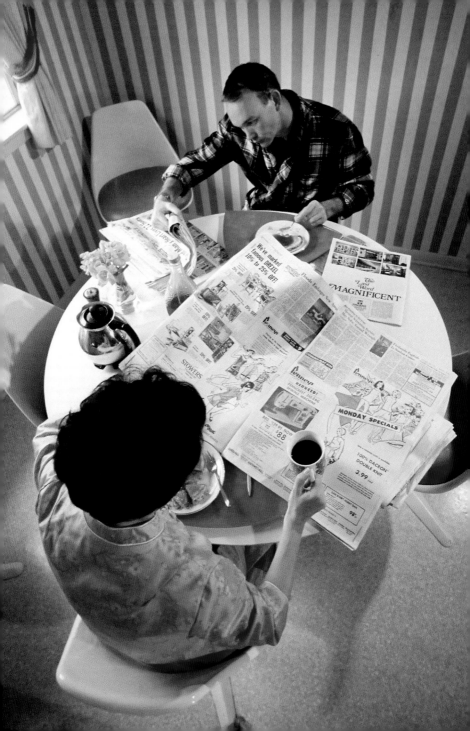

unpleasantness because the soul must rest in the tomb-
less vacuums of a torso dead on the moon and there-
fore not able to voyage toward its star? A vertigo of
impressions, but Aquarius had been living at the edge
of such thoughts for years. It was possible there was
nothing more important in a man's life than the hour
and the route and the power of his death, yes, cer-
tainly if his death were to launch him into another
kind of life. And the astronauts — of this he was con-
vinced — would think this way, or at least would have
that vein of imagination in some inviolate and non-
communicatory circuit of their brain; somewhere, far
below the language of their communication, they must
suspect that the gamble of a trip to the moon and back
again, if carried off in all success, might give thrust for
some transpostmortal insertion to the stars. Varoom!
Last of all over the years had Aquarius learned how to
control the rapid acceleration of his brain. Perhaps as
a result, he was almost — in these first few days of cov-
ering the astronauts in Houston — fond of the banal-
ity of their speech and the anodyne of technologese.

Aquarius was wondering if the glints and notes
of these cosmic, if barely sketched, hypotheses about
earth, moon, life, death, the dream and the psychol-
ogy of astronauts would be offered the ghost of a cor-
relative. Aquarius was contemplating again the little
fact that man had not done so very much with Freud's
theory of the dream — had the theory of wish fulfill-
ment shown a poor ability "to anticipate and interpret
things that appear to be not as we expected them to
be"? Did that old Freudian theory of the dream bear
the same relation to the veritable dimensions of the
dream that a Fourth of July rocket could present to
Saturn V?

Opposite: Mike and Pat
Collins at the breakfast
table of their suburban
Houston home, March
1969. *Photo, Ralph
Morse.*

* * *

One eminent geologist flatly calls Aldrin "the best scientific mind we have sent into space." Says Ted Guillory, a flight plan writer at the Houston Manned Spacecraft Center, "Boy, he's really something. He carried a slide rule on his Gemini flight on the rendezvous and I sometimes think he could correct a computer. . . . He's one of the few people who can figure out all these rendezvous things in his head." — LIFE, July 4, 1969 Opposite: Even at parties, Aldrin couldn't resist discussing Lunar Orbit Rendezvous, the subject of his doctoral thesis at MIT prior to joining NASA. Photo, Ralph Morse.

Following spread: The last preflight press conference at the Kennedy Space Center was on July 14, 1969, and done on closed-circuit television to minimize crew exposure. Deke Slayton is sitting to the left. Photo, NASA.

Since the astronauts were being guarded against infection, they were seen next behind the protection of a glass wall in the visitors' room at the Lunar Receiving Laboratory. An entire building had been constructed to quarantine them on their return, a species of hospital dormitory, galley and laboratory for the moon rocks. Since for twenty-one days after their return they would not be able to be in the same room with their families, or with the NASA technicians and officials who would debrief them, a chamber like the visitors' room in a prison had been built with a plate-glass partition hermetically sealed from floor to ceiling running down the middle. Dialogue through the glass wall proceeded through microphones.

Now, for the rest of the day, the astronauts would receive the other media layers here: TV, radio, wire service, magazines, etc. Now the magazine writers could sit within a few feet of their subjects, and yet — as if suggesting some undiscovered metaphysical properties of glass — they were obliged at the same time to feel a considerable distance away. Perhaps the full lighting on the astronauts and the relative gloom on the writers' side of the enclosure may have suggested the separation of stage and audience, but probably the effect was due most to the fact that laying-on of hands through that glass, so certainly shatterproof, could never occur, and so there was a dislocation of the sense of space. The astronauts were near enough to sit for a portrait, but — through the glass — they were as far away as history.

There was a new intimacy to the questions however. The setting was of aid, and besides, the magazine

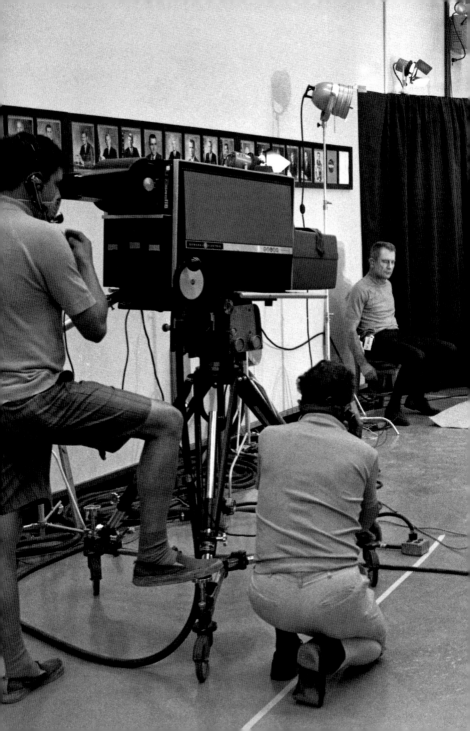

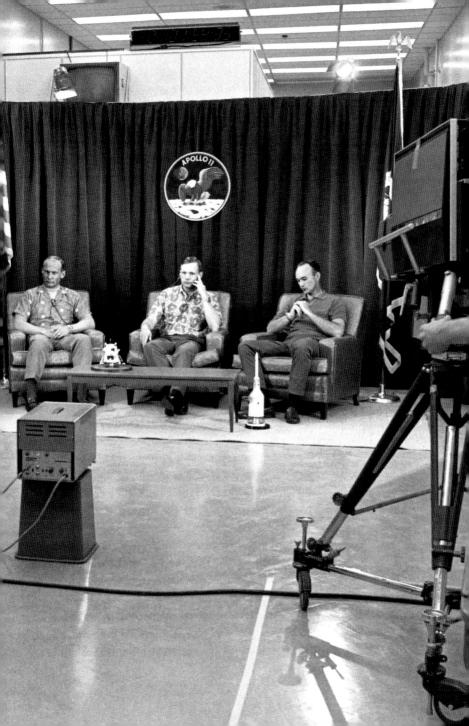

writers were in need of more. One of them took up immediately on the question which had bothered Aquarius, but the approach was practical now. How indeed would the astronauts spend their time if they found they could not get off the moon? Would they pray, would they leave messages for their family, or would they send back information on the moon? Such were the alternatives seen by the questioner.

Opposite: NASA's pencil portraits of the Apollo 11 crew, 1969. *Illustration, NASA/Space Walk.*

Aldrin had the happy look of a linebacker who is standing right in the center of a hole in the line as the runner tries to come through. "I'd probably spend it working on the availability of the ascent engine."

That brought a laugh, and there would be others to follow, but the twenty or so magazine writers had the leisure to ask their questions out of a small group, and so there was not the itch of the newspaperman to look for a quick lead and therefore ask brutal or leading or tendentious questions. Indeed there was no need to ask any question whatever just so that the journalist and his newspaper could be identified as present at the conference. (Such identifications give smaller newspapers and their reporters a cumulative status over the years with public relations men.) No, here the magazine writers could take their time, they could pursue a question, even keep after the astronaut. Covertly, the mood of a hunt was on. Since they would have more time to write their pieces, by severer standards would they be judged. So they had to make the astronauts come to life whether the astronauts wished to exhibit themselves or not.

Will you take personal mementos? Armstrong was asked. "If I had a choice, I guess I'd take more fuel," he said with a smile for the frustration this might cause the questioner.

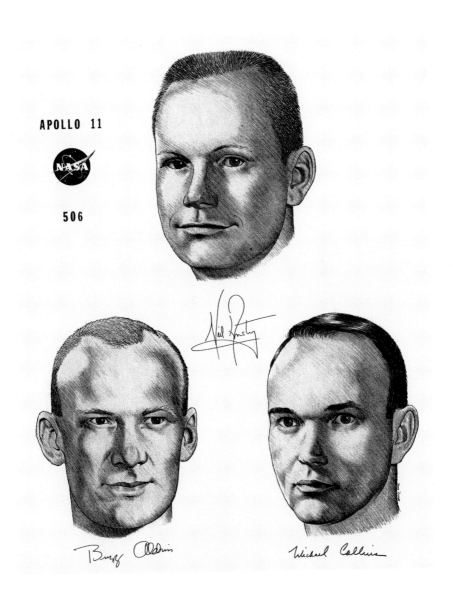

APOLLO 11

506

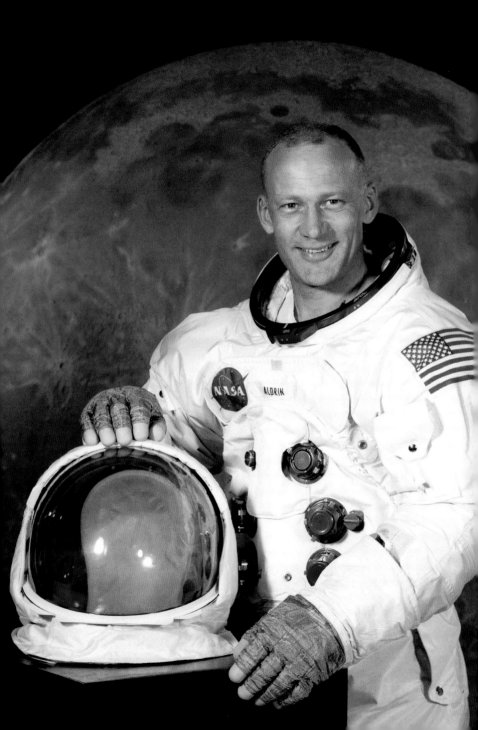

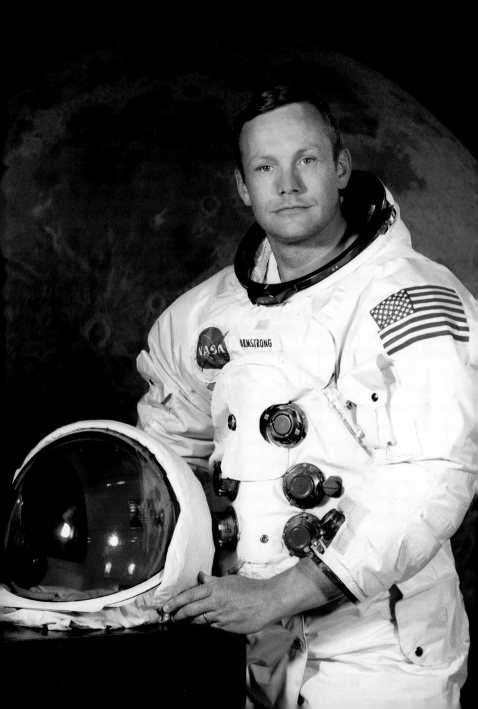

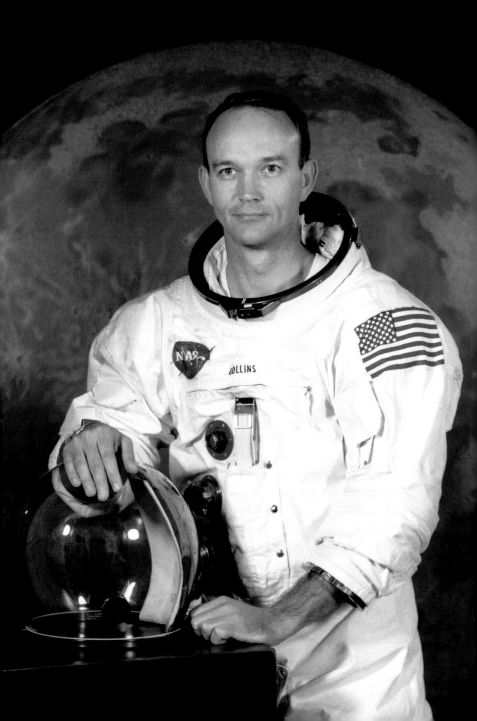

The magazine writers kept pushing for personal admission, disclosure of emotion, admission of unruly fear — the astronauts looked to give replies as proper and well-insulated as the plate glass which separated them. So Armstrong replied to a question about his intuition by making a short disclaimer, which concluded, "Interpret the problem properly, then attack it." Logical positivism all the way was what he would purvey. Don't make predictions without properly weighted and adequate inventories of knowledge. Surely he trusted his intuitions, the questioner persisted. "It has never been a strong suit," said Armstrong in a mild and honest voice. Obviously, the natural aim of technology was to make intuition obsolescent, and Armstrong was a shining knight of technology. But, in fact, he had to be lying. A man who had never had strong intuitions would never have known enough about the sensation to disclaim its presence in himself.

Would he at least recognize that his endeavor was equal in magnitude to Columbus' adventure?

He disclaimed large reactions, large ideas. "Our concern has been directed mainly to doing the job." He virtually said, "If not me, another." If they would insist on making him a hero, he would be a hero on terms he alone would make clear. There had been only one Columbus — there were ten astronauts at least who could do the job, and hundreds of men to back them up. He was the representative of a collective will.

Previous spread and opposite: Preflight portraits of Aldrin, Armstrong, and Collins, May 1969. Note that only Armstrong and Aldrin have the distinctive, clothcovered visor assemblies that will protect them from the bright sunlight and unblocked ultraviolet radiation from the sun when they're outside the LM. *Photos, NASA.*

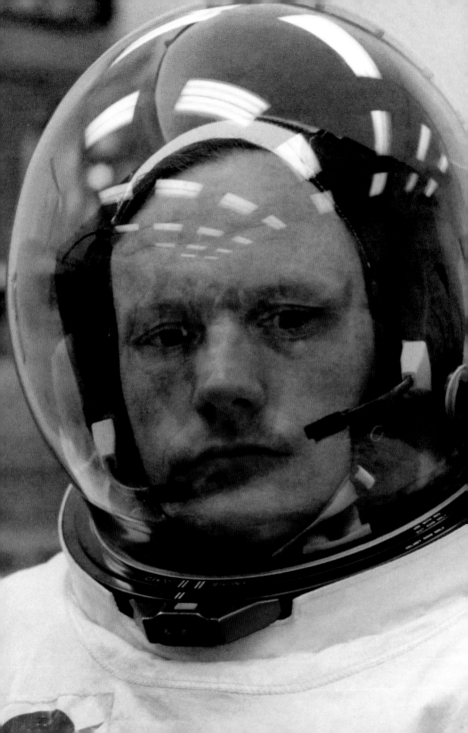

The Iron of Astronauts

It was rather that the astronauts were the core of some magnetic human force called Americanism, patriotism or Waspitude, and if they were finally the men of all the men on earth to take the first step on the way to the stars, who was to say it was not the first step back to the stars, first step back to joining that mysterious interior material of the stars, that iron of communion with cosmic origins? Indeed, who could be absolutely certain that the astronauts were not men finally forged out of some powerful equivalent in their blood of the stars' iron... men created out of some impulse so deep that the metaphor of iron is re-engaged....

Armstrong seemed of all the astronauts the man nearest to being saintly... —Norman Mailer Opposite: Armstrong suits up, July 16, 1969, morning of launch, Operations and Checkout Building at the Kennedy Space Center. Inside the bubble helmet, he wears his Communications Carrier, better known as the "Snoopy Cap," named after the Charles Schultz *Peanuts* character who became the symbol of NASA's quality assurance program after the Apollo 1 fire. *Photo, NASA/NARA.*

Apollo 11 mission transcript, 03:00:29:46 Fred Haise [In Mission control]: *Even* Pravda *in Russia is headlining the mission and calls Neil "The Czar of the Ship." I think maybe they got the wrong mission.*
Opposite: Armstrong, followed by Collins and Aldrin, waves to a small crowd of well-wishers outside the transfer van. *Photo, Neil Leifer.*

Turning over scientific ideas he had not considered in years, he was startled by the sudden disclosure that "any piece of iron you pick up on earth is likely to be older than four and a half billion years because it's made of the interior of some star." (The remark was dropped in passing by Dr. Edward Anders at the Lunar Science Press Conference in Houston in January 1970.) Sieving the transcript for lunar gold, Aquarius was struck and struck again. If iron was the interior of the stars, iron was also — its molecules aligned in one direction — nothing less than the seat of magnetism. That suggested some intimate relation between the stars of the farthest galaxies and the turn of a magnet in one's hand. But, then there was always in the force of the smallest magnet as intimate a sense of some stirring in far-off dominions as there is a capture of the sea in the roaring of a snail shell held next to the ear.

Yet if every magnet had an invisible field of force surrounding it like a mood, that exact field we experience in our fingertips as we keep another piece of iron from touching the magnet, so a metal wire cutting across that field (any metal — it can be one of the ways to define a metal!) will have a sudden electric current passing through it. No physicist has ever explained the phenomenon satisfactorily, yet on that phenomenon is built the generator: all the electric power of the world can be seen as the translation from physics to electrical engineering of the controlled interruption of a magnetic field. So if magnetism derives ultimately from some communion in the interior of the stars, electricity may be nothing less than the interruption of that communion. Yet run a current through a wire wrapped around a bar of iron, and the iron bar will become a magnet. Electricity, passed through a

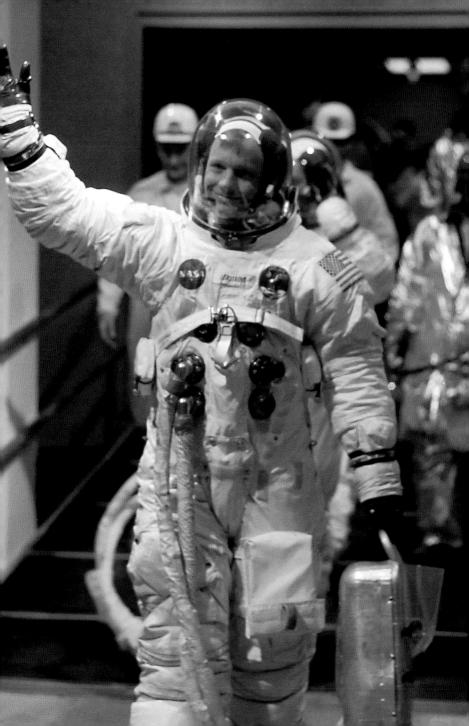

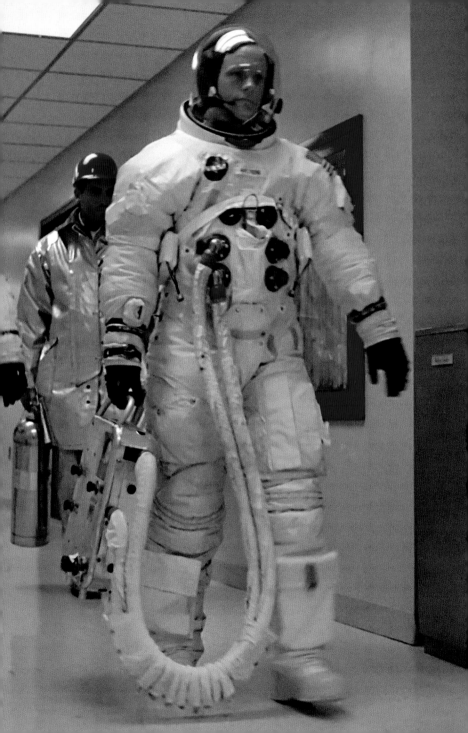

coil, becomes the agent by which such magnetism is restored. It leaves one to think of iron as a spine on which electricity breaks and restores the resonance of the stars.

Now we speak of the iron of astronauts. What is one to do with the metaphor? Iron in its finished state, ground and polished, is a material of much strength, near to impenetrable surface, shining appearance, limited flexibility, and must be kept insulated from the corrosion of the atmosphere, usually by a thin layer of oil: astronauts are men of much personal strength, moral and physical, ground and polished to a turn by years of training, the depths of their character are kept hidden by the impenetrable qualities of their personal surface, and they shine in appearance. (Indeed, eleven of the sixteen astronauts who had been up in space and were still active had blue eyes. To better the item, fifteen of the sixteen had blue, gray, green or hazel-colored eyes. Only Collins had dark-brown eyes.) That their flexibility is limited can be demonstrated by their powers of description before superlative sights and well-functioning equipment. That they were insulated from the caustic atmosphere of America could be taken for granted. A fine layer of public relations put oil over all unnatural exposure.

But the measure was not to be found in formal properties. It was rather that the astronauts were the core of some magnetic human force called Americanism, patriotism or Waspitude, and if they were finally the men of all the men on earth to take the first step on the way to the stars, who was to say it was not the first step back to the stars, first step back to joining that mysterious interior material of the stars, that iron of communion with cosmic origins? Indeed, who could

Opposite: If a diver rises from the depths too fast, the sudden pressure drop can cause nitrogen in the blood to form bubbles, leading to a painful and serious condition, the bends. As the astronauts rose through the atmosphere, they also felt a rapid drop in pressure. To counter this, crews began breathing pure oxygen hours before lift-off. As he walks to the transfer van, Neil Armstrong is carrying a portable oxygen supply to keep nitrogen out of his system. Before leaving the van, they will switch to fresh oxygen supplies. To ensure that the crew receives the correct "suitcases," the transfer tanks had white hoses as seen here, in contrast to the black hoses used at the launch pad. *Photo, NASA/NARA.*

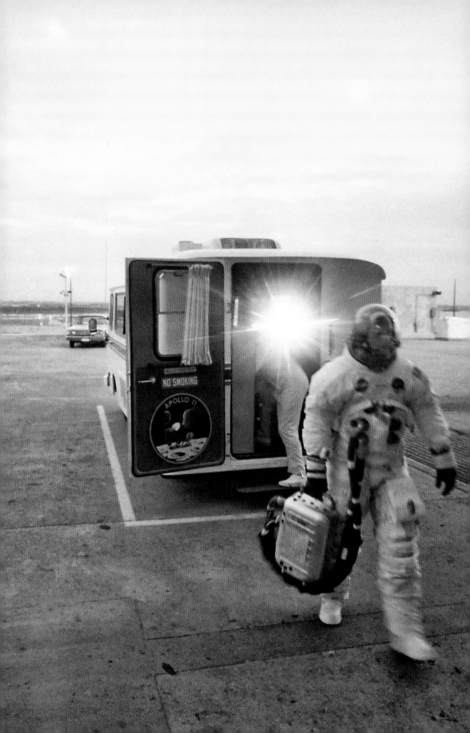

be absolutely certain that the astronauts were not men finally forged out of some powerful equivalent in their blood of the stars' iron — but in fact there is iron in the compounds of the blood — men created out of some impulse so deep that the metaphor of iron is re-engaged; we may yet have to lean on the notion that the astronauts, strange, plasticized, half-communicating Americans, might still be the spine on which electricity breaks and restores the resonance of the stars.

It was at the least a thought that the mysteries of America, the urgencies of the national itch to dominate the world, the contrasts and harsh comedies of race and war and pollution, the schizophrenia of the land growing more Faustian and more Oriental each season with **ABM** and million-footed folk-rock festivals at the poles, yes, all the incomprehensible contradictions of America might yet come to focus on the possibility that races were at war in America like forces from the cosmos, and it was no accident we were on our way first to the moon, no, that had begun to shape itself in the cauldrons of the stars, and so the astronauts could even be men with a sense of mission so deep it was incommunicable even to themselves, as if they had signed on as the core, no, rather as the most finished product of a human ore whose purpose — despite all thoughts it had found that purpose — was yet undiscovered.

Which is to say that one could also hold the thought that the real function of the Wasp had not been to create Protestantism, capitalism, the corporation or a bastion against Communism, but that the Wasp had emerged from human history in order to take us to the stars. How else to account for that strong,

Opposite: Captured by a remote camera, the crew arrives at the pad where Saturn V waits, filled with nearly six million pounds of explosive propellant. Except for a few technicians, there is no one else within three miles (5 km). *Photo, Ralph Morse.*

severe, Christian, missionary, hell-raising, hypocritical, ideologically simple, patriotic, stingy, greedy, God-fearing, nature-despoiling, sense-destroying, logic-making, technology-deploying, brave human machine of a Wasp?

Opposite: Two hours, 40 minutes to launch, the crew takes its last steps on Earth, from the elevator of the Launch Umbilical Tower across the swing arm at the 320-foot level. The close-out team, led by Günter Wendt, waits in the White Room to help them into the Command Module. Upon arrival, Collins opened a brown paper bag and pulled out a tiny trout nailed to a plaque, a parting gift for Wendt, an avid fisherman. It was only one of a number of similar exchanges in the final moments before the hatch was closed. *Photo, NASA/NARA.*

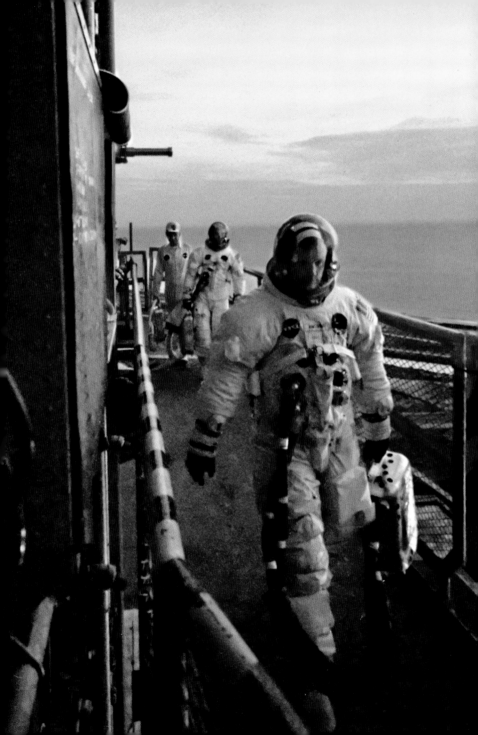

The ideal thing is to have 100% secrecy and all the money we need. When the Kremlin wants ballistic missiles it tells the scientist to meet the schedule and doesn't worry about public relations. Here... Congressmen must believe in what we're doing and they won't until the public believes in us. — Wernher von Braun, LIFE, November 18, 1957 The day after NASA was established by law on July 29, 1958, Wernher von Braun's fiftieth Redstone rocket had a successful launch in the South Pacific. Then the director of the Development Operations Division of the Army Ballistic Missile Agency in Huntsville, Alabama, Von Braun and his team were tapped to build the rocket that would beat the Russians to the moon. He was named director of the George C. Marshall Space Flight Center when it opened at the Redstone Arsenal in 1960. There he would become the chief architect of Apollo's Saturn V. *Photo, Hulton Archive.*

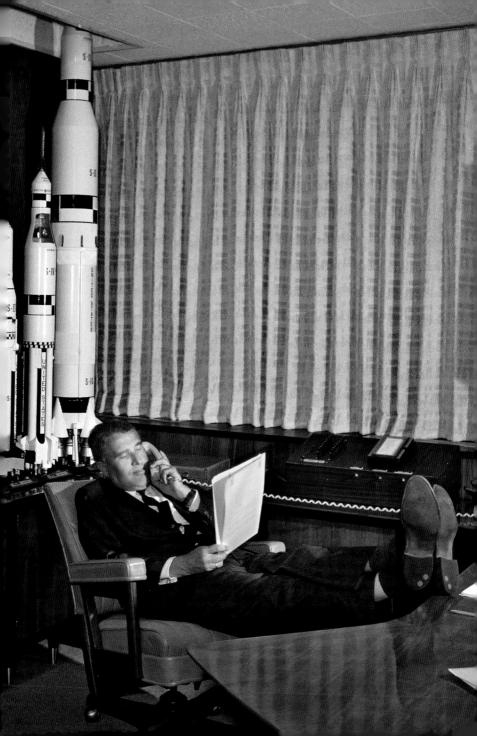

By the night which follo
lavnch, Aquarius was back i
~~liftoff~~ had provided him with sense
mania of apocalypse, the ev
dark, the oppression of Nasa
entered cis lungs like the
~~helped to drive him in the~~ wa
Depression. Everything ~~was~~ wa
had once sneered at the row
beds in the snakby motel of
~~but he~~ was not to baby ~~again~~ ob
of thousands (count them!)
~~Representatives~~ who had des
Terry plains
~~at the~~ near Manned Spac
~~celestial~~
brain which would pilot
 trips from the East

Come] the Future's Face

the ~~lateness~~ day of the
~~auton,~~ as f [~~the dome~~]
is not unlike the very
heat of Houston in the July
day off NASA ~~Road One~~ ~~[bright in July]~~
~~well of~~ a burnt-out tile)
He plummeted into profound
~~gabled~~ rough on his return. & the
~~ed velvet~~ king-sized
highway, he now discovered
~~cush and~~ human avalanche
reporters and corporation
~~ded~~ on the ~~beach decks of~~
~~appeared~~ to be nearly
fleglit he, miserable
d somehow had a muused

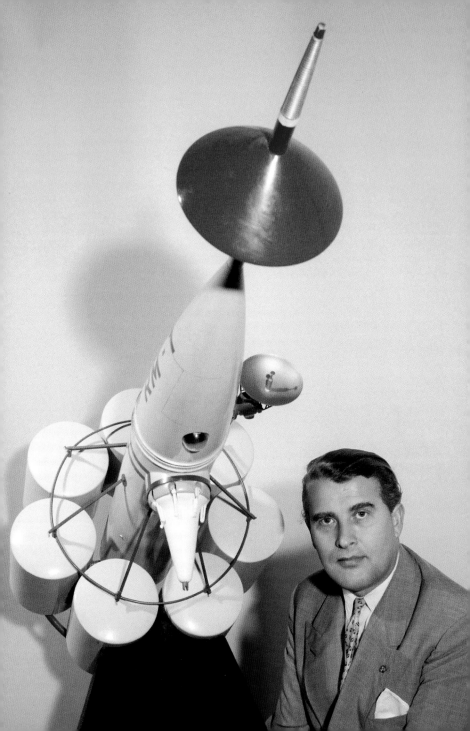

Some Origins of the Fire

In the distance she glowed for all the world like some white stone Madonna in the mountains, welcoming footsore travelers at dusk. Perhaps it was an unforeseen game of the lighting, but America had not had its movie premieres for nothing, nor its Rockettes in Radio City and fifty million squares tooling the tourist miles over the years to Big Town to buy a ticket to spectacle and back home again. If you were going to have a Hollywood premiere and arc lights, a million out to watch and a spaceship which looked across the evening flutter like the light on the Shrine of Our Lady outside any church in South Brooklyn or Bay Ridge, then by God you might just as well have this spectacle on the premiere trip to the moon. That deserved a searchlight or two!

Opposite: Early on, Von Braun recognized the value of public relations. A groundbreaking run of special issues for *Collier's* magazine in the early '50s was followed by a role as an on-camera technical consultant for Walt Disney. Von Braun is pictured here with the rocket ship he developed for the first Disney space film; an estimated 42 million viewers tuned in to watch *Man in Space* when it aired on ABC on March 9, 1955. *Photo, Ralph Crane.*

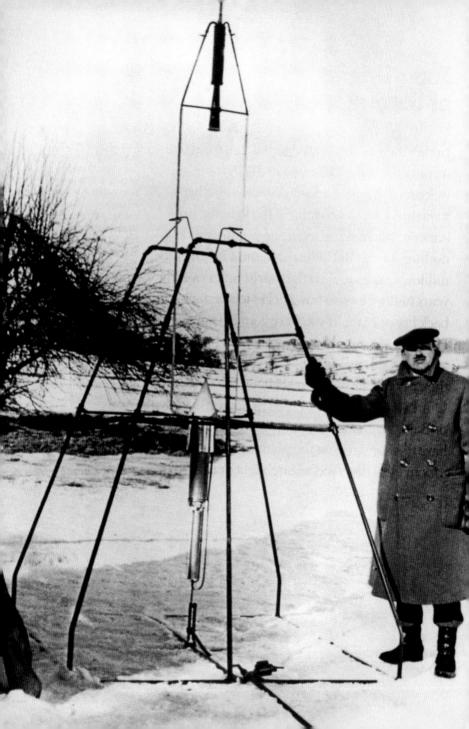

We move on to Florida and the launch. If Aquarius had spent a week in Houston, he was to put in ten days on Cape Canaveral. He was loose in some real tropics at last with swamp and coconut palms. It was encouraging. Technology and the tropics were not built to hide everything from each other.

Let us take the tour. On Merritt Island and old Cape Canaveral, now Cape Kennedy, the Space Center has been installed, a twenty-mile stretch between the Intracoastal Waterway and the Atlantic, a terrain of marshland and scrub where raccoon, bobcat and alligator are still reported, and moors and truncated dunes lie low before the sea. It is country beaten by the wind and water, not dissimilar to Hatteras, Chincoteague and the National Seashore on Cape Cod, unspectacular country, uninhabited by men in normal times and normal occupations, for there are few trees and only occasional palms as ravaged and scabby as the matted backside of a monkey, a flat land of heat and water and birds, indeed birds no less impressive to Aquarius than ibis, curlew, plover and tern, hawks and vultures gliding fine as squadrons in formation, even bald eagles, ospreys and owls. In the brackish water are saltwater trout, redfish, largemouth bass and bream. It is country for hunting, for fishing and for men who seek mosquitoes; it was next to uninhabited before the war. Now, first spaceport — think on it! first *space*port — of an industry which pays salaries to perhaps so much as half a million men and some women before it is through, and has spent more than four billion dollars a year for average the last few years, a spaceport which is focus to the aerospace industries, a congeries of the richest corporations supplying NASA. Yet this port to the

How many more years I shall be able to work on the problem I do not know. . . . There can be no thought of finishing — for aiming at the stars, both literally and figuratively, is a problem to occupy generations. — Dr. Robert Goddard, letter to H. G. Wells, 1932 Opposite: As early as 1912, Dr. Robert Goddard — father of modern rocket propulsion and an early proponent of space flight — dreamed of sending a rocket to the moon. He launched his first liquid fuel rocket on March 16, 1926, in Massachusetts. *Photo, NASA.*

Considered a nuisance by neighbors, and ridiculed by the media, Goddard moved his research to Roswell, New Mexico, with support from Charles A. Lindbergh and Harry Guggenheim in 1930. The day after Apollo 11's launch, *The New York Times* ran a correction to a 1920 editorial that had mocked Goddard, acknowledging its misinformed position. *Photo, NASA.*

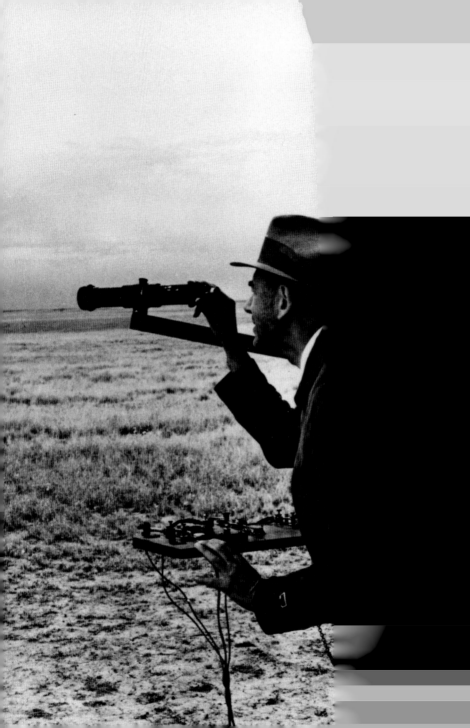

moon, Mars, Venus, solar system and the beyond is a first clue to space, for it is surprisingly empty, mournful beyond belief for the tropics, and its roads through the Air Force Base and the Space Center pass by empty marshes, deserted dune grass and lonely signs. Every quarter-mile or so along that low grassy ridge toward the side of the sea is a road sign pointing to an old launch complex which on exploration turns out to consist of an unoccupied road and a launching tower for rockets no longer fired, and so left to commune by itself on a modest field of concrete, a tall, rust-red vertical structure of iron girders surrounded by abandoned blockhouses and utility sheds. To Aquarius the early history of the Space Program is contained in these empty launch towers, now as isolated and private as grain elevators by the side of railroad tracks in the flat prairies of Nebraska, Kansas and the Dakotas, the town low before them, the quiet whine of the wind like the sound of surf off a sea of wheat. It was the grain elevator which communed on prairie nights with the stars. Here in the cricket-dinning tympani of Florida's dunes and marshes, the launching towers of rockets now obsolete give that same sense of the sentinel in a field of space, stand already as monoliths and artifacts of a prehistoric period when rockets usually exploded in the first few hundred feet of their flight.

Yes, the Cape has given a turn to Aquarius. If at Houston he still remained attached to a somewhat disembodied ego (which felt like a balloon on a tether) — if for all his extorted admiration at the self-sufficiency of NASA and its world, he could still not quite like it, quite rid himself of the idea that finally space travel proposed a future world of brains attached to wires, his ego was therefore of use. He would pull in

Opposite: Before joining NASA, German rocket engineer Wernher von Braun — principal designer of the deadly V-2 rockets that terrorized London in World War II — was one of the scientists who surrendered to American forces at the end of the war. His tests of the V-2, including this one on October 24, 1946, were conducted at the White Sands Proving Grounds in New Mexico, as part of an effort to develop future rocket technologies. *Photo, Bettmann/Corbis.*

Following spread: After six prior launches in the Bumper series at White Sands, Bumper V-2 was the first missile launch from the newly established Joint Long Range Proving Ground at Cape Canaveral, Florida, on July 24, 1950. The Bumper rockets were the first two-stage rockets, combining a WAC Corporal rocket with a V-2, and were the first man-made objects to enter outer space. *Photo, NASA.*

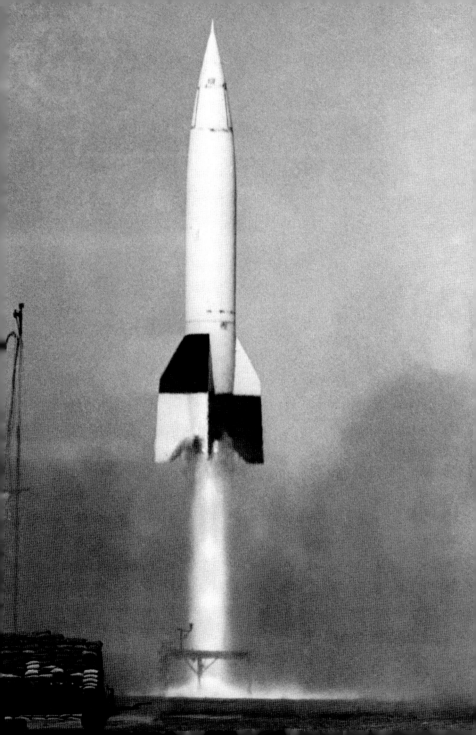

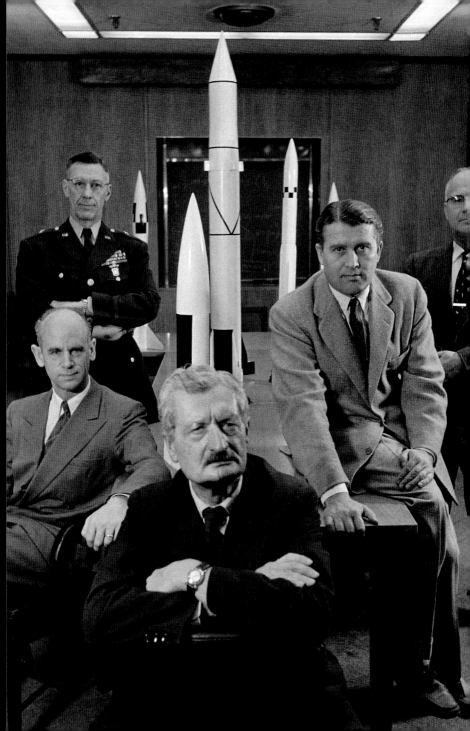

the string from time to time to criticize what he saw. If he were heard to utter "This is not unimpressive," when encountering some perfection of cooperation or technique, he was also ready to whisper — in his heart at least — that the Manned Spacecraft Center was not the coziest home for the human heart. Indeed, it was so cold that one could finally walk away from it like from a chill corridor in a dream. The beauties of MSC went on in the minds of technicians, but the soul of a visitor felt locked in the vault with an air conditioner. So it was attractive to think that one could end the dream, unlock the door and walk away.

That was hardly possible on the Cape. If the abandoned launch towers and the hot lonely ocean breeze opened vistas of the West and thoughts of how many of the most important events in America seemed to take place in all the lonely spaces — as if the Twentieth Century had become the domain of all the great and empty territories (the Saharas, the Siberias and the Minutemen in the buried silos of the West) — that was forced to give way to a sense of huge activity and gargantuan dimensions. If MSC near Houston was a brain, then Cape Kennedy was the body, and at Launch Complex 39, up twenty miles to the north of Cocoa Beach and Canaveral, were found the bones and muscles of a Colossus. Here the big components of Saturn V came in by cargo plane, came by ship through the Panama Canal and by barge through the Gulf, came from Los Angeles and Sacramento, from Huntsville in Alabama to Michoud in Louisiana, and from Michoud to the Cape; here at Complex 39 the parts were assembled in a mammoth cube of an edifice with a smaller box attached, the Vehicle Assembly Building, 526 feet high, a building just about as large

Opposite: German scientists and engineers brought to the U.S. via the controversial Operation Paperclip made enormous contributions to America's military arsenal — and eventually to the development of the Saturn V. American General H. N. Toftoy (back, left) was instrumental in bringing the Von Braun team to the U.S. and, later, to the Ballistic Missile Agency. Counterclockwise from left: Ernst Stuhlinger, Hermann Oberth, Wernher von Braun, and Eberhard Rees; Redstone Arsenal; Huntsville, Alabama; 1956. *Photo, Hank Walker.*

Von Braun's teacher and one of the founding fathers of modern rocketry, Transylvania-born Hermann Oberth did not leave Germany for America via Operation Paperclip. However, in 1955 he came to Huntsville to work for Von Braun. Here, on a trip to Frankfurt, Germany, on November 7, 1958, Oberth was quoted as saying their efforts would have a spaceship to the moon "in around five years." *Photo, Bettmann/Corbis.*

Debus . . . proved out a pleasant Junker gentleman with dueling scars on his mouth and bags under his eyes — the sort of aristocratic face and gracious if saturnine manner, which belongs to an unhappy German prince from a small principality. — Norman Mailer Dr. Kurt Debus, director of the Kennedy Space Center during the buildup to Apollo, uses a periscope to follow the flight-readiness test of the Apollo 7 Saturn 1B from the safety of a blockhouse in 1968. Debus had been a member of the Von Braun team at Huntsville until 1961, when he was picked to lead the development, construction, and operation of what later became the Kennedy Space Center. *Photo, NASA.*

as the combined volume of the Merchandise Mart in Chicago and the Pentagon. Covering eight acres, enclosing 129 million cubic feet, the Vehicle Assembly Building was nonetheless windowless, and decorated from the outside in huge concentric rectangles of green-gray, and charcoal-gray, ivory-gray and light blue-gray; it looked like a block of wood colored by an Op Art painter, but since it was over fifty stories high, it also looked like the walls of a gargantuan suburban department store. If by volume it was when built the largest building in the world, the Vehicle Assembly Building, as one saw it standing on the flat filled-in marshes of the Cape, had to be also a fair candidate for the ugliest building in the world. Viewed from any external approach it was the architectural fungoid of them all.

Once inside, however, it was conceivably one of the more beautiful buildings in the world. Large enough to assemble as many as four moongoing Apollo-Saturn vehicles at once, it was therefore open enough to offer interior space for four tall bays, each of these niches tall enough to house the full rocket, which was thirty-six stories high. Since the rocket in turn sat on a transporter, called a crawler, of some dimension itself, the doors to the four bays were each over forty stories and therefore high enough and wide enough to take in through their portals the UN Building or the Statue of Liberty. Yet for all its size, the VAB was without decoration inside, rather a veritable shipyard and rigging of steel girders which supported whole floors capable of being elevated and lowered, then rolled in and out like steel file drawers in order to encircle each rocket with adjustable working platforms from either side. Since some of these platforms had three

One of the boldest scientific projects ever concocted, the U.S. scheme for a man-made moon was racing furiously and purposefully ahead in an almost desperate attempt to meet its deadline. — LIFE, *June 3, 1957* Opposite: Spearheaded by the civilian-run research division of the U.S. Naval Research Laboratory in Washington, D.C., Project Vanguard intended to send the first artificial satellite into space at the onset of the International Geophysical Year (July 1957–December 1958). *LIFE* magazine sent photographer Hank Walker to document its development in the spring of 1957. The surprise launch of Russia's Sputnik 1 on October 4, 1957, thrust Vanguard, as well as the Explorer program, into the international spotlight. The Space Race was on. *Photo, Hank Walker.*

complete stories contained within them, the interior of the VAB was a complexity of buildings within buildings which had been first maneuvered then suspended ten and twenty and thirty stories above the ground. Because the sides were usually open, one could look out from the platforms to other constellations of girders and buildings and could look down from whichever great height to the floor of the VAB, sometimes as much as forty stories below. Note however: one was still inside a closed space, and the light which filtered through translucent panels rising from floor to ceiling was dim, hardly brighter than the light in a church or an old railroad terminal. One lost in consequence any familiar sense of recognition — you could have been up in the rigging of a bridge built beneath the dome of some partially constructed and enormous subterranean city, or you could have been standing on the scaffolding of an unfinished but monumental cathedral, beautiful in this dim light, this smoky concatenation of structure upon structure, of breadths and vertigos and volumes of open space beneath the ceiling, tantalizing views of immense rockets hidden by their clusters of work platforms. One did not always know whether one was on a floor, a platform, a bridge, a fixed or impermanent part of this huge shifting ironwork of girders and suspended walkways. It was like being in the back of the stage at an opera house, the view as complex, yet the ceiling was visible from the floor and the ceiling was more than fifty stories up, since above the rockets were yet some massive traveling overhead cranes. To look down from the upper stages of the rocket, or from the highest level where the crew would sit, was to open oneself to a study of the dimensions of one's fear of heights. Down, down, a

Opposite: Scientists on the Vanguard project had to devise a "Lilliputian payload" of 10,5 pounds that could effectively transmit data back to Earth. Here, engineer Roland Van Allen solders components to a plastic telemetering card, which will combine the signals from 48 separate instruments inside the satellite into one radio message. *Photo, Hank Walker.*

long throw of the soul down, down again, still falling was the floor of the building, forty floors below. The breath came back into the chest from an abyss. And in one corner of the floor like a stamp on the edge of a large envelope was a roped-in square of several hundred tourists gawking up at the yellow cranes and the battleship-gray girders.

Taken originally on a tour by a guide, Aquarius had spent the good part of a day in this building, and was back again twice to be given a more intimate trip and a peek into the three stages and the Command and Service Module of Apollo 12, which was then being prepared for its flight in November. Looking into any portion of the interior of a rocket was like looking into the abdominal cavity of a submarine or a whale. Green metal walls, green and blue tanks, pipes and proliferations of pipes, black blocks of electrical boxes and gray blocks of such boxes gave an offering of those zones of silence which reside at the center of machines, a hint of that ancient dark beneath the hatch in the hold of the bow — such zones of silence came over him. He could not even be amused at the curtained walls of white and the in-sucking wind of the dust collectors and the electrical shoe polishers, the white smocks and the interns' caps they were obliged to put on before they could peer through the hatch of the Command Module and see the habitation of the astronauts. A gray conical innerland of hundreds of buttons and switches looked back at him, and three reclining seats vaguely reminiscent of instruments of torture. Three dentists' chairs side by side! Yes, he could have found the white outfits they were wearing a touch comic — if dust they were to protect the machine against, then garments they could wear, but

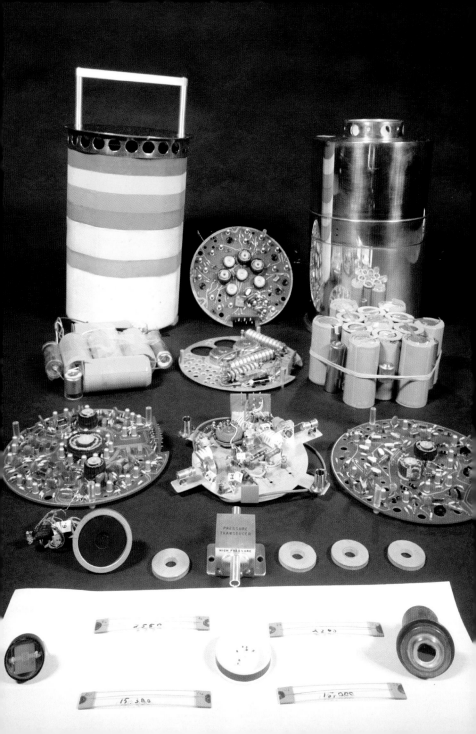

why white, why the white hospital walls? And thought that of course they would keep it like the sterile room in a delivery ward, for indeed there was something about space which spoke of men preparing to deliver the babies they would themselves bear. The aim of technique was to parallel nature, and the interior of the VAB was the antechamber of a new Creation.

So, it was probably the Vehicle Assembly Building which encouraged Aquarius to release the string of the balloon and let his ego float off to whatever would receive it. It was not that he suddenly decided to adopt the Space Program, or even approve it in part, it was just that he came to recognize that whatever was in store, a Leviathan was most certainly ready to ascend the heavens — whether for good or ill he might never know — but he was standing at least in the first cathedral of the age of technology, and he might as well recognize that the world would change, that the world *had* changed, even as he had thought to be pushing and shoving on it with *his* mighty ego. And it had changed in ways he did not recognize, had never anticipated and could possibly not comprehend now. The change was mightier than he had counted on. The full brawn of the rocket came over him in this cavernous womb of an immensity, this giant cathedral of a machine designed to put together another machine which would voyage through space. Yes, this emergence of a ship to travel the ether was no event he could measure by any philosophy he had been able to put together in his brain.

Yet all the signs leading to the Vehicle Assembly Building said VAB. VAB — it could be the name of a drink or a deodorant, or it could be suds for the washer. But it was not a name for this warehouse of

Opposite: Several miniature "packages," one shown here, fit inside the 20-inch Vanguard satellites to measure the extreme ultraviolet radiation during solar flare-ups, or Lyman alpha. A transparent model shows how the instruments for one satellite fit into the metal framework. *Photo, Hank Walker.*

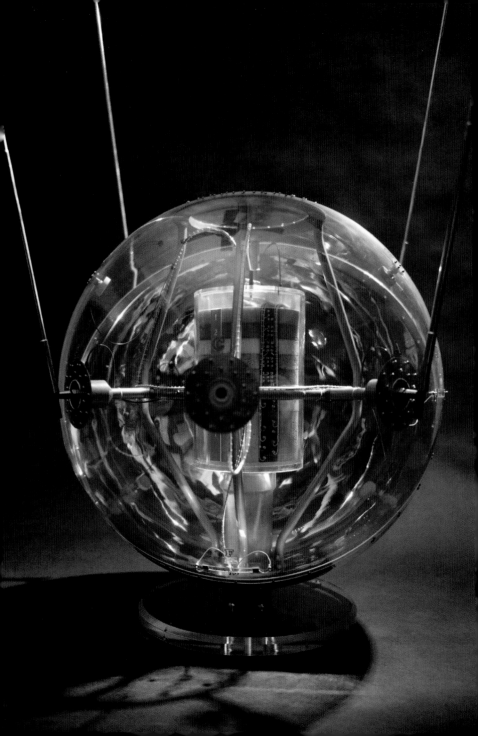

the gods. The great churches of a religious age had names: the Alhambra, Santa Sophia, Mont-Saint-Michel, Chartres, Westminster Abbey, Notre Dame. Now: VAB. Nothing fit anything any longer. The art of communication had become the mechanical function, and the machine was the work of art. What a fall for the ego of the artist. What a climb to capture the language again!

It occurred to him on the instant that one's fear of height must be at least a partial function of the importance of one's ego. Or was it a direct function of that part of one's ego which was useless? A man was presumably ready to take any drop when the ego was finally congruent to the soul and all the signs said go. Yes, one would have to create a psychology to comprehend the astronaut. For a beginning, however, it would be good to recognize how simple he must become. Do not dominate this experience with your mind was the lesson — look instead to receive its most secret voice. He would be, perforce, an acolyte to technology. What a gruel. By whatever measure, he was now forced to recognize the ruddy good cheer and sense of extraordinary morale of the workers in the VAB. As they passed him in the elevators, or as he went by them in the halls and the aisles, a sense of cooperative effort, of absorption in the work at hand, and anticipation of the launch was in the pleasure of their faces. He had never seen an army of factory workers who looked so happy. It was like the week before Christmas. As at the Manned Spacecraft Center they seemed to be ranked by the number of admission badges they wore. The smiles of the ones who wore the most seemed to thrive the most, as if they were not identification tags which reduced them to parts of a machine, but rather

Opposite: A transparent model shows how the instruments for one satellite fit into the metal framework of the Vanguard satellites. *Photo, Hank Walker.*

149

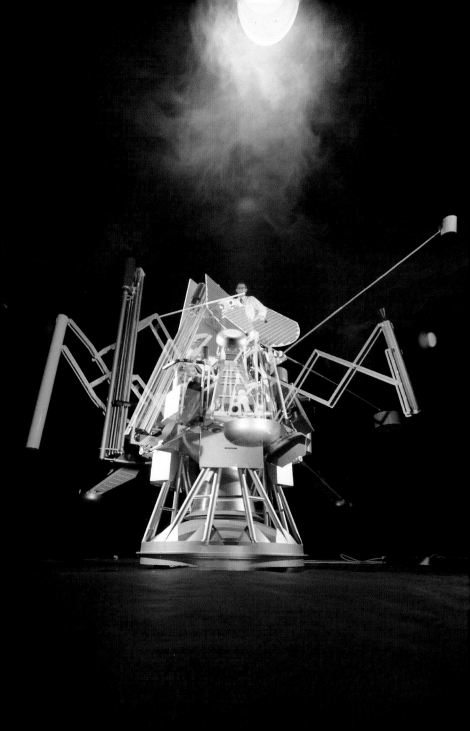

were combat ribbons, theater-of-war ribbons. Trade-union geezers, age of fifty, with round faces and silver-rimmed spectacles strutted like first sergeants at the gate for a three-day pass.

So Aquarius began to live without his ego, a modest quiet observer who went on trips through the Space Center and took in interviews, and read pieces of literature connected to the subject, and spent lonely nights not drinking in his air-conditioned motel room, and thought — not of himself but of the size of the feat and the project before him, and by the night before the launch, he was already in orbit himself, a simple fellow with a mind which idled agreeably, his mind indeed out in some weightless trip through the vacuum of a psychic space, for a mind without ego he was discovering is kin to a body without gravity. He was there now merely to observe, to witness. And the days went quietly by. We would pick him up on the night before the launch, but we may not be able to. He is beginning to observe as if he were invisible. A danger sign. Only the very best and worst novelists can write as if they are invisible.

* * *

Saturn V would take off from a plain of gray-green moor and marsh, no factory or habitation within three and a half miles. Saturn V had almost six million pounds of fuel. So it would take the equivalent of thirty thousand strong men to raise it an inch. It would take liquid oxygen, liquid hydrogen and a very high grade of kerosene called RP-1. It had hydrazine, unsymmetrical dimethylhydrazine and nitrogen tetroxide in the Service Module. It was in effect

By spring of 1963 a spiderlike. . .object is expected to land gently upon the moon's surface. . . . With electronic sight and touch more sensitive than man's, the machine, called Surveyor, will transmit to earth direct information on what the moon looks like close up and what it is made of. The full-scale, 11-foot model of Surveyor. . . is already being studied at Jet Propulsion Laboratory of California Institute of Technology. Hughes Aircraft Company will build seven for NASA,— at a probable cost of $50 million. —LIFE, April 2, 1961 *Opposite:* Surveyor 1 didn't actually reach the moon until 1966, but its objectives were met. Close-ups of the footpads and how they interacted with the lunar surface, transmitted via the television cameras mounted on the unmanned craft, were critical to understanding the nature of the surface and its ability to support the far heavier Lunar Module. *Photo, Hank Walker.*

a bomb, thirty-three feet wide — the length of a long living room. Corporation executives earning $50,000 a year just begin to think of a thirty-three-foot living room for themselves. And it was the height of a football field set on end. Sometimes they described it as a thirty-six-story building (ten feet to a floor) but a football field was clear measure of size, and this bomb, 363 feet high, 33 feet wide at the base, would blow if it blew with a force kin to one million pounds of TNT. That was like an old-fashioned bombing raid in World War II — one thousand planes each carrying one thousand pounds of bombs. So Saturn V would devastate an area if ever it went. Flight Control, the Press Site and the VIP stands were located therefore three and a half empty miles away across barren moors which, having been built by dredging fill into marshland, looked as if a bomb had gone off on them already.

On the night before the launch of Apollo 11, in the heart of Brevard County, in that stretch which runs from Melbourne through Eau Gallie, and Cocoa, to Titusville, on the coastal strip from Patrick Air Force Base through Cocoa Beach and Cape Canaveral to the Cape Kennedy Air Force Station and above to the Space Center and Launch Pad 39, through all that several hundred square miles of town and water and flat swampy waste of wilderness, through cultivated tropical gardens, and back roads by rivers lined with palms, through all the evening din of crickets, cicadas, beetles, bees, mosquitoes, grasshoppers and wasps some portion of a million people began to foregather on all the beaches and available islands and causeways and bridges and promontories which would give clear view of the flight from six miles and ten miles and fifteen miles away. Tomorrow most of them would need

A spinning sphere undergoes a test, its four radio antennas describing colorful circles. With its instruments inside, [the] satellite whirls 322-1/2 times per minute while engineer Alexander Simkovich watches for any wobble. Tiny weights may be placed to adjust balance and make the satellite spin through space perfectly.
— LIFE, *June 3, 1957*
Opposite: Photo, Hank Walker.

field glasses to follow the flight up from the pad and out of sight over the sea down a chain of Caribbean isles, but they would have a view — they knew tonight that if the skies were clear they would have their view because they were encamped only where the line of sight was unimpeded to Launch Pad 39 on the horizon. There one could certainly see Apollo 11 on her Saturn V, see her for seven, nine, eleven miles away; she was lit up.

A play of giant arc lights, as voluminous in candlepower as the lights for an old-fashioned Hollywood premiere, was directed on the spaceship from every side. On U.S. 1 in Titusville, eleven miles from Cape Kennedy across Merritt Island and the Banana and Indian rivers, all that clear shot across the evening waters, at an artillery range of twenty thousand yards, two hundred football fields away, by an encampment of tourists up from southern Florida, Everglades, Miami and the Keys; in from Tampa, and Orlando; down from Daytona, St. Augustine, Gainesville and Jacksonville; come from Fort Myers and Fort Lauderdale, from Sarasota, St. Petersburg, Lakeland, Ocala and Tallahassee, come from all the towns of Georgia and points farther north and west as well as every itinerant camper in the area from all of the ambulatory camping-out families of the fifty states, and tourists down on economy flights for a week in cheap hot summer Florida and now slung out in the back seats of rented cars, on U.S. 1 in Titusville, in an encampment of every variety of camper, was a view of the spaceship across flat land and waters, and she looked like a shrine with the lights upon her. In the distance she glowed for all the world like some white stone Madonna in the mountains, welcoming footsore

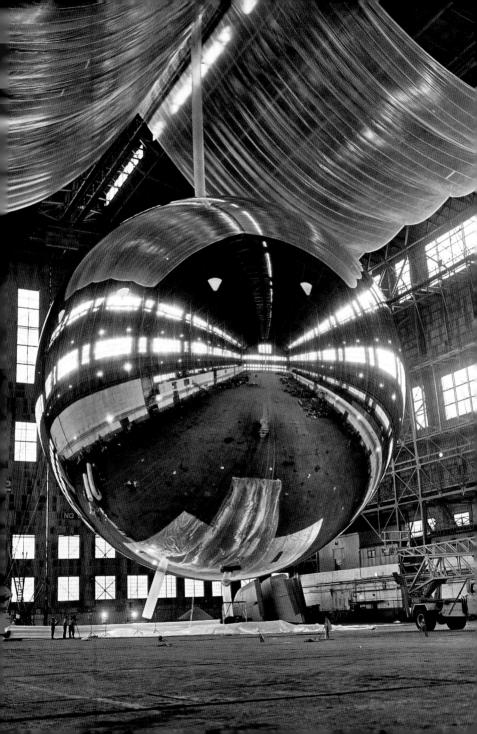

travelers at dusk. Perhaps it was an unforeseen game of the lighting, but America had not had its movie premieres for nothing, nor its Rockettes in Radio City and fifty million squares tooling the tourist miles over the years to Big Town to buy a ticket to spectacle and back home again. If you were going to have a Hollywood premiere and arc lights, a million out to watch and a spaceship which looked across the evening flutter like the light on the Shrine of Our Lady outside any church in South Brooklyn or Bay Ridge, then by God you might just as well have this spectacle on the premiere trip to the moon. That deserved a searchlight or two! And the campers stared across the waters in their bivouac off Route 1 in Titusville, campers sat on the banks of the Indian River at twilight and waited for the tropical night to pass its hold on the hours.

There were new industries in America these years. After five decades of suspense movies, and movies of the Wild West, after the adventures of several generations of men in two world wars and Korea and Vietnam, after sixteen years of *Playboy* and American iconization of the gravity-defying breast and the sunripened buttock, after ten years of the greatest professional football, after a hundred years and more of a tradition that the frontier was open and would never close, and after twenty more perplexing technological years when prosperity came to nearly every White pocket, and technology put out its plastic, its superhighways, its supermarkets, its appliances, its suburbs, its smog, and its intimation that the frontier was damn shut, shut like a boulder on a rabbit burrow, America had erupted from this pressure between its love of adventure and its fear that adventure was not

Opposite: A scientist wearing protective goggles simulates the effects of air friction on a missile's reentry into the earth's atmosphere at NACA's Langley, Virginia, facility. Landing a man on the moon was a possibility by 1958, but the question of how to return him safely to Earth was still years away from being answered. *Photo, NASA.*

completely shut down; America had spewed out on the road. The country had become a nation of campers, of cars toting trailers, of cars pulling tenttrailers, of truck-campers, top-of-car tent packs, Volkswagen buses converted to ambulatory bedrooms, jeeps with Chic Sale houses built on the back, Land Rovers with bunks, Broncos with more bunks — any way a man could get out of the house with his buddies or his family or his grandmother, and take to the road and find some ten by twenty feet of parking grass not posted, not tenanted, and not too muddy, he would camp. All over America in the summer the night fields were now filled with Americans sleeping on air mattresses which reposed on plastic cloth floors of plastic cloth tents — what a sweet smell of Corporate Chemical, what a vat and void to mix with all the balmy ferny chlorophylls and pollens of nature! America the Sanitary, and America the Wild, went out to sleep in the woods, Sanitary-Lobe and Wild-Lobe nesting together neatly, schizophrenic twins in the skull case of the good family American.

So they were out tonight, some portion of a million, all drawn on the lines of sight in Brevard County, and on every highway and causeway in the area the ground was covered with cars and campers, the shelter-roof extension of one family's tent near to topping the picnic blanket spread out behind the tailgate of the next station wagon, and the open trunk lid of a twelve- or fifteen-year-old Dodge convertible (rusty, top all rent, peeling friction tape and dirty white adhesive tape chasing a flap of a patch) stood next to both, part of the family sleeping in the trunk, the others with their good dirty feet out the windows. It was hardly just middle-class America here tonight,

Orbits are not difficult to comprehend. It is gravity which stirs the depths of insomnia.
— Norman Mailer

Opposite: Objects float in weightlessness during high-speed parabolic flight as the plane noses over from a fast climb. In zero gravity, the slightest breath of air, the tiniest of touches, can get things moving. *Photo, Luis Marden.*

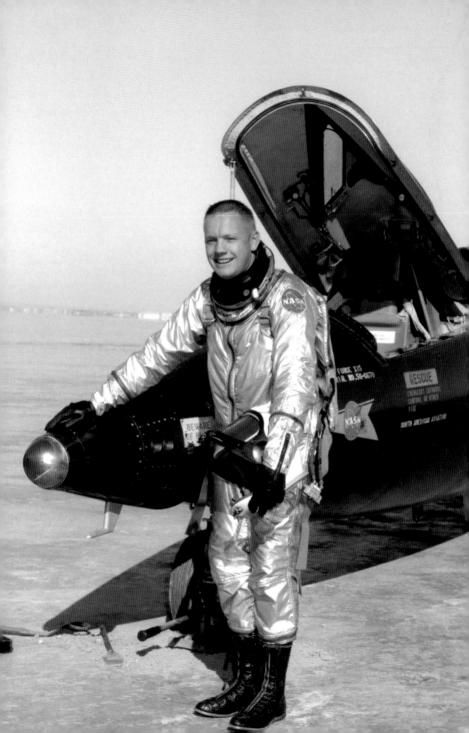

It's a spectacular sight. . . . As the X-15 reaches the top of its vast arc, I hardly notice that I am almost weightless. Without even thinking, I press the mike button and find myself saying, "This is fantastic. This is really fantastic." And from way down on the earth, more than 131,000 feet below, I hear Neil's matter-of-fact reply: "Roger." —*Robert White, LIFE, August 22, 1960* Neil Armstrong as an X-15 test pilot, Dryden, 1962. In addition to the insight the flights provided about hypersonic flight, which was vital for the safe return of crews from the moon, the program also made use of what Armstrong later described as "probably the best simulator that had ever been built up to that time." *Photo, NASA.*

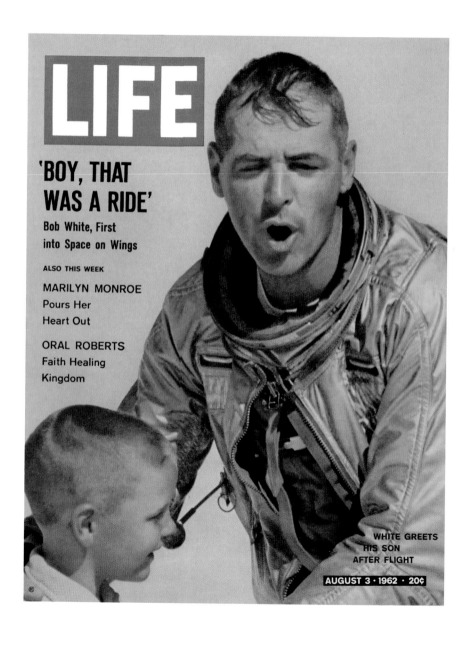

LIFE

'BOY, THAT WAS A RIDE'

Bob White, First
into Space on Wings

ALSO THIS WEEK

MARILYN MONROE
Pours Her
Heart Out

ORAL ROBERTS
Faith Healing
Kingdom

WHITE GREETS
HIS SON
AFTER FLIGHT

AUGUST 3 · 1962 · 20¢

rather every echo of hard trade-union beer-binge paunch-gut-and-muscle, and lean whippy redneck honky-tonk clans out to bird-watch in the morning with redeye in the shot glass. There were tourists and not inelegant campers which spoke of peanut butter and jelly, watercress, and cucumber — suburban campers — but there was also the raw gasoline of expectation in the air, and families of poor Okies. One felt the whole South stirring on this night. Quiet pious Baptists, out somewhere on their porches (kin to some of the redneck and Okie — Okie for Okeechobee! — and working class here) seemed to be waiting over an arc of a thousand miles, certainly all the way from Cape Kennedy across Florida along the Gulf of Mexico to Houston and the Manned Spacecraft Center and back again, all across that belt of Fundamentalist piety, hot dry tempers burning like closed-up balefire against the humidity of the swamps, religion and lust to work their combat in the tropical nights, yes all over the South they had to be praying, yes even more than everywhere for the safety of this shot, the astronauts part of that family of concern which White Southerners could share with each other out of the sweet deep wells of their Christian hearts, what was left of them. It was not hard to have a vision of mothers and grandmothers looking like spinsters, silver-rimmed glasses to shield your skin from their eyes of burning faith, predictable turkey wattles on the neck: they would be praying for America tonight — thoughts of America served to replace the tender sense of the Virgin in Protestant hearts. And out here on the campgrounds of Brevard County, out on all the scorched shoulders and oil-coated grass of the available highway, were men

Opposite: Built by North American Aviation, and flown out of the Dryden Flight Research Center at Edwards Air Force Base starting in 1958, the rocket-powered X-15 was the fastest airplane ever built and the first winged craft to leave Earth's atmosphere. Test pilots included Scott Crossfield, Bob White (*LIFE* cover), Neil Armstrong, and Joe Walker, who manned the first plane to achieve sub-orbital flight on July 19, 1962. *Photo, Lawrence Schiller/*LIFE.

getting ready to drink with their wives, middle-aged, green-eyed Southern mill workers with sunburned freckled skin, reddish hair, hard mechanic's muscles in their forearms, wife a trinity of worrying mother, fattening slattern and give-me-a-drink-and-I'll-holler-happy sort of bitch. Dutiful work, devotion to family and property, their sloven property! mingy propriety, real raucous bust-outs — that sort of South, married out of high school, oats half-sown like three quarters of all America over thirty, and their boys on the hunt through the encampment looking for opposite numbers, other boys or — Gods of fornication with them! — girls without bank locks on their bloomers. You can expect nothing less on a night so filled with heat, human meat, bubbles of fear, prayer soft as love and tropical sex in every sauce. And that mill worker with red hair and gray-green eyes, red sunburn, red peeling skin on his knotty forearms — he could be an astronaut in another life. He looks like an older version of Neil Armstrong, maybe, he looks like some of them, like Gordon Cooper for sure, or Deke Slayton, or Walt Cunningham of Apollo 7, yeah, the mill worker is tonight an American all drenched in pride and fear and sorrow — his wild rebel yell guaranteed to diminish each year, is riding the range with awe tonight. He has worked with machines all his life, he has tooled cars to the point where he has felt them respond to his care, he has known them and slept beside them as trustingly as if they were hunting dogs, he knows a thousand things about the collaboration between a man and a machine, and he knows what can go wrong. Machines — all the old machines he has known — are as unreasonable as people. And here, tomorrow, going up three men of whom he could

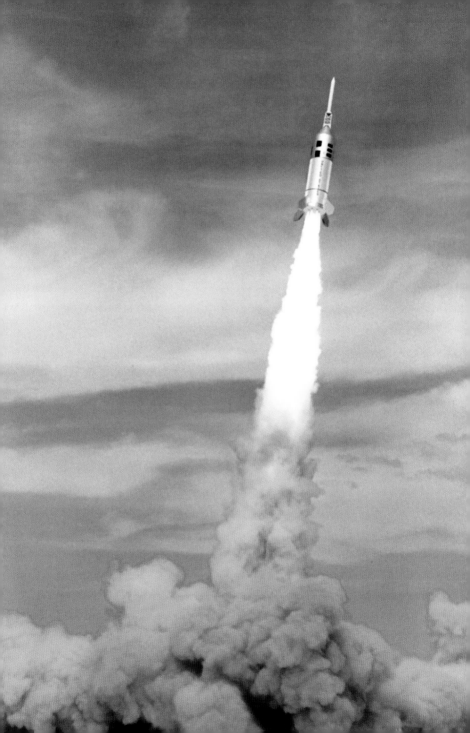

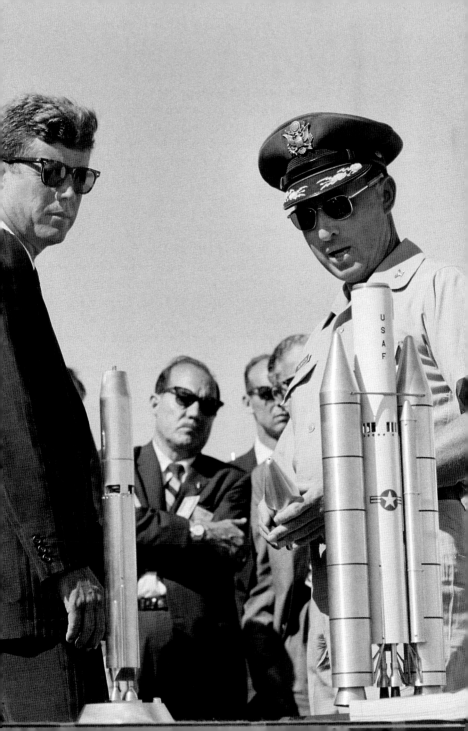

have been one if he had a) not been a drunken fool half his life b) not married young c) had an education d) had twice as many guts and e) been full of real luck rather than cursed family luck, could have been going up with them in a machine with millions of parts, eighty percent electronics which he does not put his hand to, no grease, nut, wrench and arm in electronics. Yes, could have been going up in a machine no man could ever sleep next to, or trust, not a machine with millions of parts, and ten million fingers worked on them — how much evil, error and deception in millions of fingers? — he is thinking of his wife, why she alone when drunk and in full lunatic cohabitation with the all-out rays of the full moon was a hundred thousand fingers of evil herself! and his bowels come near to dropping out of him with awe at the daring of the act in the morning. He has spent his life with machines, they are all he has ever trusted with affectionate trust for he has had a nose for their treacheries (more than he can say for women), and now, twelve hours from now, in the full light of nine-thirty in the morning, that Apollo-Saturn is going to go up. He will see a world begin where machines are king and he does not know whether to cry from pride or the all-out ache that he does not really comprehend the new machinery.

And the wife sipping the booze, hot and much too funky is her flesh on this hot night, listening to transistor radio Red has bought her, is moony and full of tears at the heroism of male craziness tomorrow. She wishes — floodgates of middle-age sorrow — some crack of that holy lightning in her womb: too late now! and trying to love up a warmth for Red, married all these nineteen years, she rears up on the very pinpoint

of spite. She has powers, her family has powers, there's Indian blood in both her grandmas, and bruises, sorrows, slights, and nights of the loveliest now lost in the disappearing wahoo of studs she will never see again, our redneck Molly abloom in this encampment, she thinks on that pinpoint of spite of a curse she could put and will not on the launch tomorrow. For if Saturn were ever to burst and explode — she sees the flames across the sky: All witch and bitch on a holiday, such pictures encourage the lapping of gentle waters in her. Whereas putting wax on the tip of the needle, and capping the curse, leaves dull lead in her chest. Not to mention the future woman troubles of her gut. She stoppers the bottle and looks on a slant at Red — there'll be an angle soon by which to pick a fight.

And men and women, tired from work and travel, sat in their cars and sat outside their cars on aluminum pipe and plastic-webbing folding chairs, and fanned themselves, and looked across the miles at the shrine. Out a car window projected the sole of a dirty foot. The big toe pointed straight up to Heaven in parallel to Saturn V.

Opposite: On September 12, 1962, President Kennedy visited Houston. A crowd of more than 45,000 filled the outdoor Rice University Stadium for what would become one of his most enduring public addresses. Afterward President Kennedy visited NASA's Manned Spacecraft Center at 6040 Telephone, Houston, Texas, where he was given a 40-minute classified briefing before touring the facility and climbing inside an early version of the Lunar "Bug." *Photo, Bob Gomel.*

* * *

Aquarius passes these sights like a stranger. He feels in such surroundings a foreigner equally as much as he feels American. It is his country, but he merely traverses it. His feet do not take root.

Studying the encampments on the roadside this plump and burgeoning night, he is thinking of the party he has attended at the Royal Oak Country Club in Titusville. A full occasion. Wernher von Braun has

A few weeks ago I stood outside a concrete blockhouse at Cape Canaveral and watched a huge Atlas-D missile thunder off the launch pad only 3,000 feet away. As it arched into the night sky, its flaming exhaust lighting up the whole Cape, I wished I could be sitting up there on its nose. . . . This was the first time I had watched an Atlas take off. It was like seeing my own future. — Deke Slayton, LIFE, February 29, 1960 *Opposite:* Deke Slayton's special assignment on the Mercury project was to study the Atlas rocket, which would ferry the astronauts into orbit. His first launch visit in 1960 is documented by *LIFE* magazine's Ralph Morse, who used a special camera to produce the intermittent trail of the missile's path. *Photo, Ralph Morse.*

spoken there earlier. Wernher von Braun has in fact arrived and left by helicopter. Von Braun, the *deus ex machina* of the big boosters! He is of course a legend. If you ask the man on the street: Who is the head of NASA, he will probably not quite know what NASA is. If you ask: Well, who heads the Space Program, he is not likely to tell you James E. Webb was Administrator of NASA from 1961 to 1968, nor does he figure to know that in the summer of 1969 it is Dr. Thomas O. Paine who is ultimately responsible for all the NASA installations: Headquarters in Washington; Ames Research Center for space flight research at Moffet Field, California; Electronic Research Center at Cambridge; Flight Research Center at Edwards, California; Goddard Space Flight Center for unmanned satellites at Greenbelt, Maryland; Jet Propulsion Laboratory at Pasadena; Langley Research Center at Hampton, Virginia; Lewis Research Center at Cleveland; Nuclear Rocket Development Station at Jackass Flats, Nevada; KSC Western Test Range Operations Division at Lompoc, California; Wallops Station, Wallops Island, Virginia; NASA Pasadena Office; and of course the Manned Spacecraft Center at Houston; the George C. Marshall Space Flight Center at Huntsville, Alabama; and Kennedy Space Center itself on Cape Kennedy and Merritt Island. No, he will not have heard of Dr. Paine, nor of Dr. George E. Mueller who heads the Manned Spacecraft Program, which is to say is in charge of everything to do with men in rockets as opposed to unmanned rockets, and so has authority over the directors of every space center and laboratory concerned with manned flight. Nor is anyone too likely to have heard of Dr. Gilruth, nor necessarily of Dr. Kurt H. Debus

at Kennedy Space Center where he is Director and so in charge of every mammoth launching as well as planning, designing, developing and utilizing the launching facilities. No, they have heard only of Von Braun. Since his formal title is Center Director of George C. Marshall Space Center at Huntsville, Alabama, and he is therefore on an organizational level equal only to Debus and Gilruth, whereas Dr. Mueller and Dr. Paine are his most definite superiors in this hierarchy of NASA stations, divisions, laboratories, operations, facilities, centers and hegemonies, he can hardly by any organizational measure be the Boss, but to the public sense of these affairs, to the Press and to a corps of space workers, he is the real engineer, the spiritual leader, the inventor, the force, the philosopher, the genius! of America's Space Program. Such is his legend in the street. That is the positive side of his reputation; it is enormous; say, rather it is immense. Yet he has that variety of glamor usually described as fascinating, which is to say, the evocation of his name is attractive and repellent at once, because no one forgets for an instant that he worked on the v-2 rockets at the German Rocket Research Center at Peenemünde, second only to General Dornberger, and so was implicated on one occasion by giving an orientation lecture to the Leader himself, who stood and stared and did not say a word when rockets were later fired for him on test stands. It was expected that Hitler with his love of the cosmic, the primitive, the apocalyptic and the more audible wars of Hell and Heaven would be enthusiastic about the extraordinary sound of rocket motors. The future of the rocket program at Peenemünde was indeed even dependent in 1939 upon just such hopes

I don't know about prudence. I'm not sure that being the head of NASA is really a job for a prudent man. — Thomas O. Paine, quoted in **The New York Times,** *June 8, 1969* Opposite: Pictured here on a visit to Cape Canaveral in 1962, Paine succeeded James Webb as NASA administrator in 1969. He headed the agency for 15 crucial months that included Apollo 10, 11, 12, and, importantly, the recovery from the Apollo 13 accident. *Photo, Bob Gomel.*

as Hitler's ecstatic reaction. But the Fuehrer did not say a word until lunch, when he stated, "*Es war doch gewaltig*," which may be translated as, "That was sensational." (Göring, who visited a week later, was openly enchanted. Rocket propulsion for railroad and passenger cars, air-planes, airships! and ocean liners! was what he saw next.)

Opposite: The launch of Gemini X, July 18, 1966, with a time-exposure of the erection of the Titan, taken days earlier, superimposed. The mission, commanded by John Young, marked Michael Collins's first time in space. The mission called for rendezvous with two different Agena Target Vehicles, two EVAs, and several experiments. *Photo, NASA.*

Then in 1943, after an audience with Hitler, Von Braun was granted the very high honor of a titular professorship. That much was ineradicable from Von Braun's record, but he had also had the opposite honor of being arrested and jailed for two weeks in an SS prison by Heinrich Himmler himself. One of the accusations: Von Braun was not really interested in rockets for war so much as for space exploration. It took General Dornberger's intercession with Hitler to spring Von Braun from Stettin Prison. Without Von Braun, said Dornberger to Hitler, there would be no V-2. Then in 1945 Von Braun had managed with considerable skill to move about five thousand employees and their families, and some of their papers, documents and drawings, to the Harz Mountains in the south of Germany where they could be captured by Americans rather than Russians.

Von Braun had not been out of higher headquarters since. While the U.S. Army test-fired V-2's at the White Sands Proving Grounds in New Mexico, he served as adviser. Five years later, still working for the Army, he directed the development of the Redstone and Jupiter missiles. For NASA he had created the launch vehicle for the Apollo program, the famous, the monumental, the incomparable three-stage Saturn V, that launch vehicle we have already glimpsed at the VAB, a booster the size and weight of

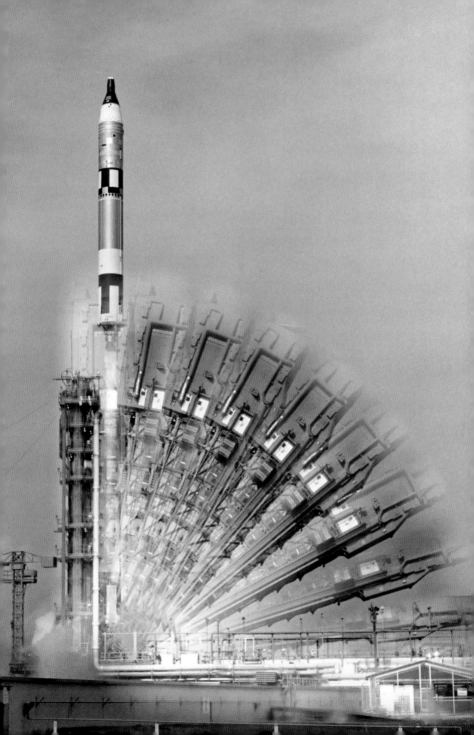

With existing [missile] hardware we could put a man into orbit in a year. But don't ask me how we'd get him back. — Wernher von Braun, LIFE, November 18, 1957

Once President Kennedy had set the challenge, NASA administrators could not decide how Apollo should fly to the moon: via a single, giant booster that would shed spent stages along the way; or multiple launches of components to be assembled in Earth's orbit. A third method, called Lunar Orbit Rendezvous, promised weight savings and the possibility to achieve the lunar goal with a single Saturn V rocket, but it was often ridiculed as dangerous because it required two spacecrafts to meet up while traveling at great speed in lunar orbit. This idea eventually won out in 1962 after being championed by engineer John Houbolt, pictured here in 1962. *Photo, NASA.*

a full Navy destroyer, a rocket to deliver seven and a half million pounds of thrust at blast-off, Saturn V, 281 feet long, 33 feet wide, designed to put — we may be Germanic in metaphor here — designed to put its *little brother*, the 82-foot Apollo spacecraft implanted on top of it, into Trans-Lunar Injection, which is to say: on its way to the moon. In terms of size, the Apollo spacecraft was no more than a witch's hat perched on Saturn V's Instrument Unit of a head!

Yet since this launch vehicle in all its three stages did not have fuel to burn for even eighteen minutes, all six million pounds of fuel consumed in bursts of two and a half minutes and six and a half minutes, then two minutes and six minutes, near to five million pounds of fuel being burned in the first 150 seconds, whereas, in contrast, the Command Module would be in flight for eight days; since Saturn V in relation to the complexity of the electronic vitals and conceptions on the Command Module was relatively simple in design, Saturn V hardly more by the severest measure than a mighty mortar of a firework to blast an electric brain into space, why then was Von Braun so worshiped, why, if the true technology, the vertiginous complexity of the engineering feat of putting a man on the moon and back belonged rather in sum of work and intimate invention to echelons of electronic engineers out at MSC, North American and Grumman and too many other places to name? Well, the brute but inescapable answer if one studies the morphology of rockets is that man worships his phallus in preference to a drop of his seed. Yeah and yea. Saturn V was guts and grease, plumbing and superpipes, Lucifer or the Archangel grinding the valves. Saturn V was a furnace, a chariot of fire. One could witness some

Bringing two spacecraft together in a rendezvous in space will be like maneuvering a boat into a moving dock in the middle of the night with only a half pint of gas. But thanks to simulators the guesswork will be cut to a minimum. — Neil Armstrong, LIFE, September 25, 1964 *Opposite:* A mere three years after Houbolt completed a preliminary sketch of LOR procedures in 1961, astronauts were training on rendezvous docking simulators at Langley. *Photo, Ralph Morse.*

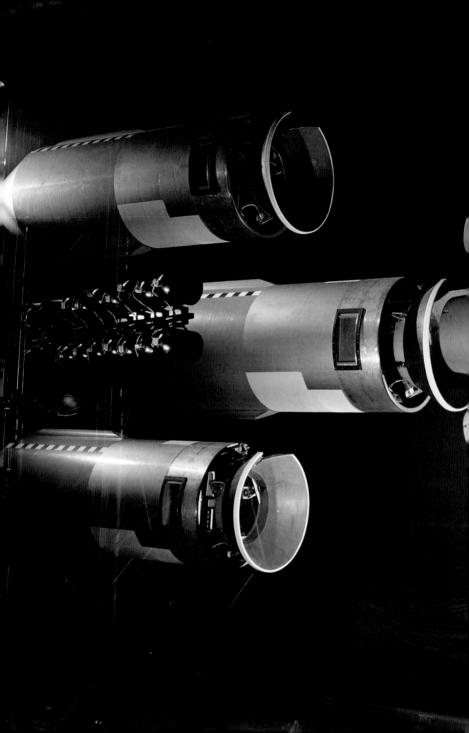

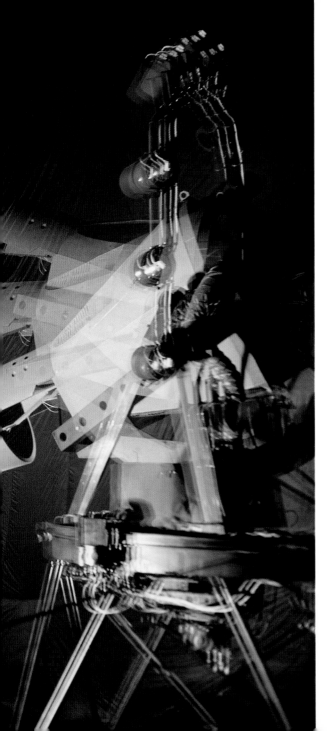

A primary objective for the Gemini missions was the demonstration of rendezvous and docking, an essential element of the LOR technique. An elaborate simulator provided docking practice to an unmanned Agena target fitted with a docking collar. On March 16, 1966, Neil Armstrong and Dave Scott were the first to succeed at this new technique on Gemini VIII. *Photo, Ralph Morse.*

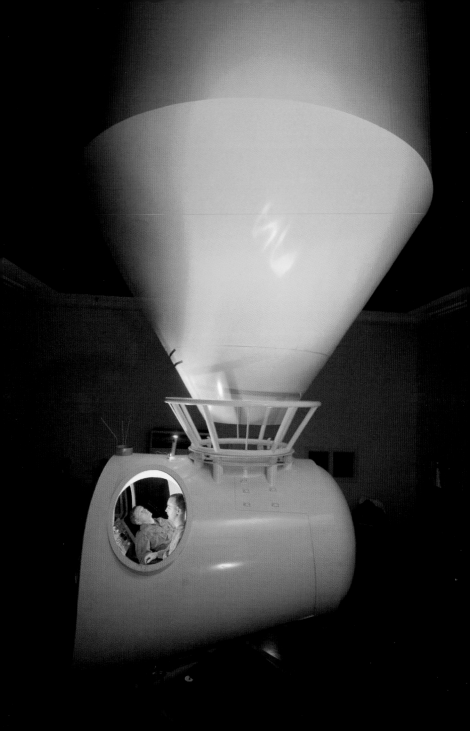

incandescent entrance to the heavens. But Apollo 11 was Command Module and therefore not to be seen. It spoke out of a crackling of static, or rolled like a soup can, a commercial in a sea of television, a cootie in a zoo of oscillating dots.

We may, then, absorb the lesson: Electricity is an avatar of hate which gives pain to the senses, emits static, electronic hum, neon flicker, light glare, shock, heat radiation. Whereas thoughts of the sun and royal spectacle are in the mystery of a flame. So Von Braun was the heat in rocketry, the animal in the program. By public estimate he had been a Nazi — that was glamor enough. Who could begin to measure the secret appeal of the Nazis by now? It was a fit subject for Aquarius to begin to brood upon: America was this day mighty but headless, America was torn by the specter of civil war, and many a patriot and many a big industrialist — they were so often the same! — saw the cities and the universities as a collective pit of Black heathen, Jewish revolutionaries, a minority polyglot hirsute scum of nihilists, hippies, sex maniacs, drug addicts, liberal apologists and freaks.

Crime pushed the American public to give birth to dreams of order. Fantasies of order had to give way to lusts for new order. Order was restraint, but new order would call for a mighty vault, an exceptional effort, a unifying dream. Was the conquest of space then a potential chariot of Satan, the unique and grand avenue for the new totalitarian? Aquarius was not certain. It was possible that neo-Nazism and technology were finally inimical to each other, but it was all to be considered again and again. It was complex. At this instant, he would not have minded the return of his ego. Meanwhile, here was Von Braun for study.

Opposite: Gemini astronauts Jim McDivitt (left) and Frank Borman practice attaching their craft to the nose cone of the mother ship in a LOR simulator, 1964. *Photo, Ralph Morse.*

Following spread: With a great many interdependent stages to a mission, no single person in NASA, let alone journalists, could really understand them all. To aid in the public understanding of the mission, a series of illustrations was produced in 1966 detailing its major phases. *Illustrations, NASA.*

LIFT OFF

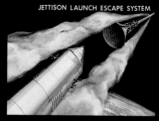

JETTISON LAUNCH ESCAPE SYSTEM

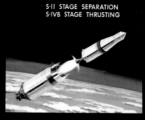

S-II STAGE SEPARATION
S-IVB STAGE THRUSTING

TURNAROUND OF C S M

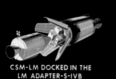

CSM-LM DOCKED IN THE
LM ADAPTER-S-IVB

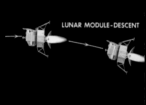

DOCKING AND SEPARATION
OF SPACECRAFT FROM S IV

TRANSFER TO LM

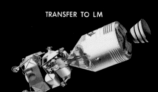

LM SEPARATION

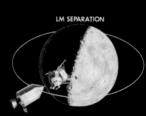

LUNAR MODULE-DESCENT

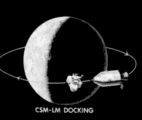

ASCENT STAGE LIFTOFF

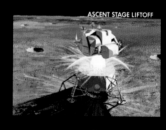

CSM-LM DOCKING

LM ASCENT-CSM DOCKED

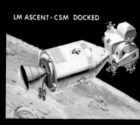

CM-SM SEPARATION

ENTRY-COMMAND MODULE

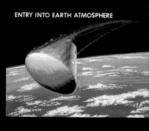

ENTRY INTO EARTH ATMOSPHERE

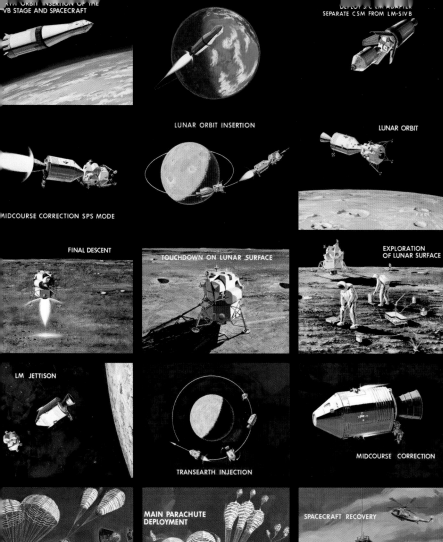

RTH ORBIT INSERTION OF THE VB STAGE AND SPACECRAFT

DEPLOY S C LM ADAPTER SEPARATE CSM FROM LM-SIVB

LUNAR ORBIT INSERTION

LUNAR ORBIT

MIDCOURSE CORRECTION SPS MODE

FINAL DESCENT

TOUCHDOWN ON LUNAR SURFACE

EXPLORATION OF LUNAR SURFACE

LM JETTISON

TRANSEARTH INJECTION

MIDCOURSE CORRECTION

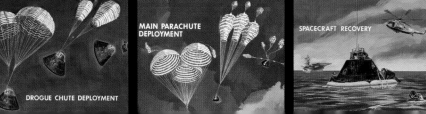

MAIN PARACHUTE DEPLOYMENT

SPACECRAFT RECOVERY

DROGUE CHUTE DEPLOYMENT

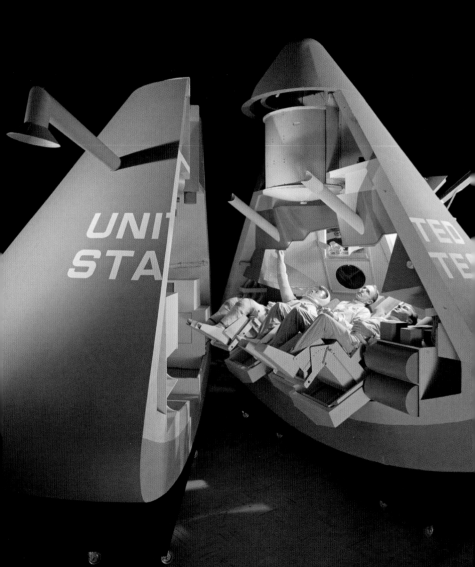

Yes, he had come in by helicopter to the Royal Oak Country Club in Titusville. The roads were crowded and it was incontestable that on this night, this night above all, hours before the mightiest launching of his life, Von Braun's hours were of value to him and to others. Still, the impression had to arise that he would have arrived by helicopter in any case. The helicopter had become the vehicle of status of that Praetorian Guard now forming of generals, state troopers, admirals, Republican congressmen with wives-on-junket, governors from he-man states, he-man senators, law-and-order mayors, traffic-crisis monitors and VIPs on state visits to troublesome cities. The helicopter was there to signify: a man engaged in *flag* activity was dropping in on the *spot*. So the helicopter was a status symbol as special as a Junior League Ball. Not everybody who was moderately rich and powerful in American life would necessarily want to go to the ball or ride in the bubble, but for that matter not everybody who was thus rich and powerful was welcome at either.

Under whose auspices then had Von Braun descended? We can pretend to investigate. A large publishing corporation long associated with the Space Program had invited corporation presidents of important firms to voyage out for a few days on a trip to Houston to meet astronauts, then on to Kennedy to see the launching. A private speech by Von Braun was one of the features of the junket, and they waited for him now in a hexagonal banquet room finished in varieties of walnut-colored wood, a fit meeting place for American gods and cousins of the gods, since the shape of the chamber gave an echo of clans meeting in a wooded glen. Talismans in the form of intricate hex

Electronic equipment for observation, navigation, communication and survival will line the craft's shell. . . and above them will hang a hatch through which they will climb to step out, at last, on the surface of the moon. —LIFE, *April 27, 1962 Opposite:* In early 1962 the basic design of the Command Module had been realized, but the notion of Lunar Orbit Rendezvous was still not yet widely accepted. Here, North American Aviation's mock-up of the 12-foot-high (3.7-m-high) manned section of the 100-ton (90-t) Apollo moon-landing craft was configured to serve as command module and to make the moon landing. *Photo, Fritz Goro.*

From 1963 to 1966, Little Joe II rockets were used in five tests of the CM abort and earth-landing systems. Here, a Little Joe receives its payload at White Sands Launch Complex 36 in 1965. *Photo, NASA.*

Opposite: Though space flight equipment is elaborately engineered, and therefore very expensive, what really increases costs is the rigorous testing each piece and system must endure to prove flight readiness. Command Module mock-ups, called "boilerplates," were built for egress training, and to test the parachutes that would slow the craft's descent once it reentered Earth's atmosphere. The boilerplates were crude but matched the real thing in one important respect: weight. Here, a recovery team inspects the aftermath of a drop test out of a high-flying aircraft in 1964. Photo, NASA.

signs were inlaid in the wood of the walls around the room below the ceiling. Yet the walls, as though aware the gods were American, their powers corporate, were finished pale in stain, and therefore not excitative to the bottled emotions of business leaders. In any case, the golf course abutted the premises, and some of the guests left the bar and waited for the helicopter outside, standing in the steamy air of evening on that stiff rubbery thick-bladed Florida grass so much an overnight product of hyperfertilizer, turf-planting and the tropics that it felt like plastic underfoot.

It was a not untypical American gathering. Doubtless, equivalent Soviet meetings were similar. It did not matter how high or prominent these people had become, how far some of them had traveled from their beginnings. Time was still the same awkward, embarrassed, well-scrubbed air of a church social. Americans might yet run the world, they were certainly first on the way to the stars, and yet they had never filled the spaces between. Americans were still as raw as an unboiled potato. It hardly mattered if Americans were rich or poor. When they got together, they did not know what to say to each other. It is part of the double life of Americans, the unequal development of the lobes in the national schizophrenia. Men whose minds worked with an admirable depth of reference and experience in their business or occupation were less interesting in a social gathering, at least in this social gathering where they were plucked up from a more familiar core of small talk and deposited on the rubber-mat turf of the Royal Oak. It was almost a reflection of the national belief that a man who worked thoroughly at his job was given dispensation from the obligation to have a good time. So conversation took

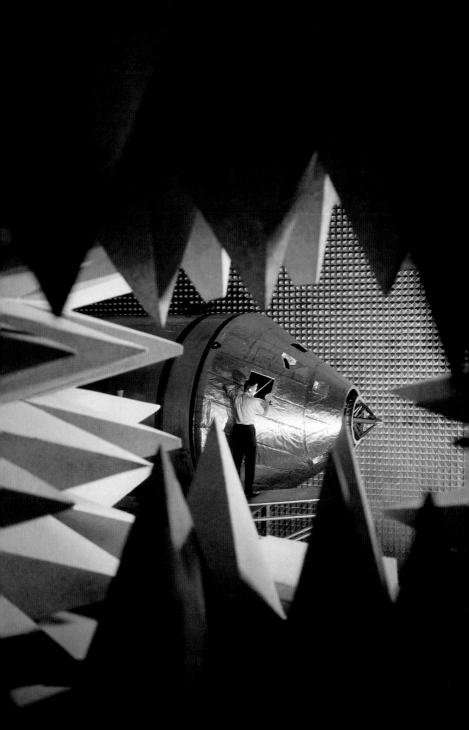

overloaded steps over successive hills, and that was all right, the point of the evening was that they would hear Von Braun and be able to refer to it afterward. The American family travels to strange states and places in order to take their photographs and bring them back, as if the photographs will serve in future years as data-points, crystals of memory to give emotional resonance to experience which was originally without any. The data-point will give warmth in old age. So Von Braun would be a data-point tonight. It would not matter if a good time was not otherwise had. Aquarius' mind, brooding through these familiar thoughts, was brought up short with the radically new idea that perhaps some instinct in American life had been working all these decades to keep the country innocent, keep it raw, keep it crude as a lout, have it indeed ready to govern the universe without an agreeable culture to call its own — for then, virgin ore, steadfastly undeveloped in all the hinterworld of the national psyche, a single idea could still electrify the land. Culture was insulation against a single idea, and America was like a rawboned lover gangling into middle age, still looking for his mission.

Since Aquarius on evenings like this would look for the nutrient in liquor the way a hound needles out marrow from a bone, he was nose-deep into his second drink, and hardly saw the helicopter come in. A sense of presence overhead, fore and aft lights whirruping like crickets in the dusk, a beating of rotors in a wheat-flattened gust, and it was down, a creature. Nothing inspired so fine a patriotic cocktail of mild awe, mild respect, and uncorrupted envy as the sight of Praetorians emerging from an insect the size of an elephant which *they* commanded.

To make sure communications are maintained between the lunar module and the command craft, [an anechoic chamber] simulates space in terms of radio waves. If the multiple electronic systems interfere with each other, the fault can be safely located and corrected prior to flight. —LIFE, *November 24, 1967* Opposite: Photo, Ralph Morse.

In a test of the effects of high sound vibration on performance, [an airman] riding beside a cluster of giant speaker horns on a tilting seat that he controls with a lever is being blasted with the simulated roar of multimillion-pound-thrust rocket engines of the future.
— LIFE, October 2, 1964

Opposite: The seven-and-a-half-million-pound thrust of the Saturn V booster could exceed 175 decibels, noise levels that could rupture ear drums and cause immediate hearing loss. Sound tests ensured that appropriate insulation would be built into the command module.
Photo, Fritz Goro.

The guests immediately made their way inside. Von Braun, dressed in a silver-gray suit, white shirt and black tie looked more impressive tonight than the day before at a press conference. That had taken place in front of several hundred correspondents with movie cameras, television, and ushers in the audience holding portable microphones to amplify and record all questions the Press might ask for posterity. Von Braun had been on a panel with Dr. Mueller, Dr. Debus, Dr. Gilruth and a director from Langley, but half the questions had gone to Von Braun. He seemed sensitive to the fact that the Press made jokes about his past. There was one tale every reporter had heard — "Tell me, Dr. von Braun," a correspondent said, "what is there to keep Saturn V from landing on London?" Von Braun walked out of the room. But the story was doubtless apocryphal; it smacked of reporters' bile. Journalists were often vicious in their prior comments about VIPs they were going to interview, as if to compensate for the uxorious tone of the restrained questions they would finally ask. Aquarius had been with a small pack who had gone to talk to Dr. Debus, director of all launching operations at Kennedy and a former colleague of Von Braun's. "Just give the Nazi salute and he'll holler 'Heil Hitler!'" they all promised each other, but Debus to their consternation proved out a pleasant Junker gentleman with dueling scars on his mouth and bags under his eyes — the sort of aristocratic face and gracious if saturnine manner which belongs to an unhappy German prince from a small principality. The questions of the Press were predictably unctuous, and trading notes afterward, they quoted Debus respectfully. He had given them the best of lines; when asked if he were planning a

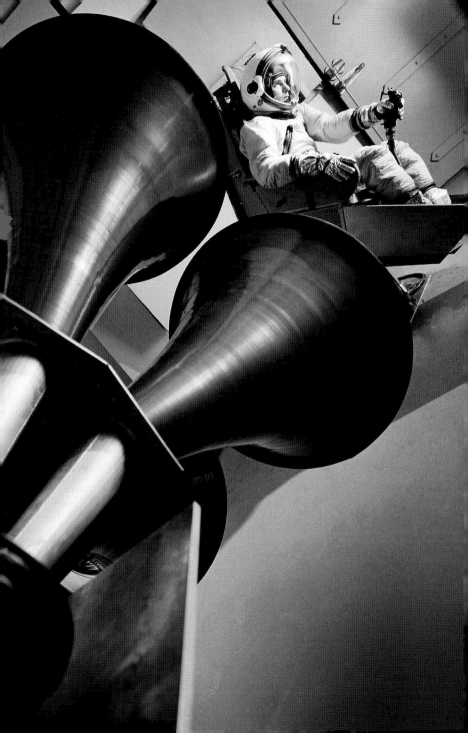

Under a static-free dome, a scientist performs a welding procedure on an Apollo heat-shield fragment, 1966. *Photo, NASA.*

Following spread: By 1966, NASA had approved North American Aviation's design for the Apollo Command Module. Here, workers at their plant in Downey, California, install wire harnesses that will carry electrical currents throughout the CM. *Photo, Ralph Morse.*

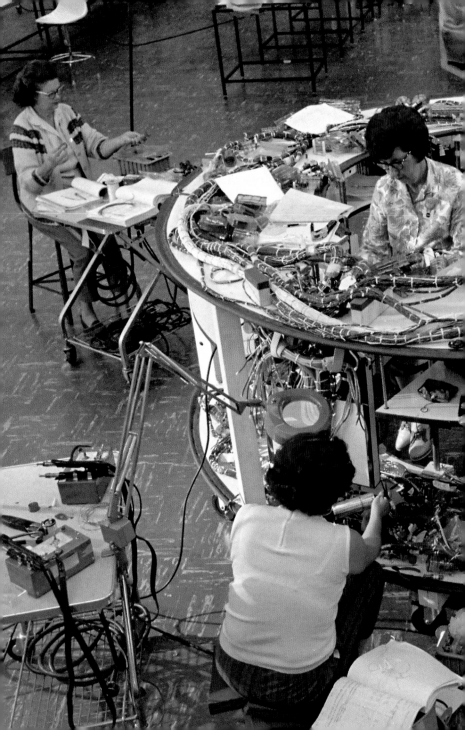

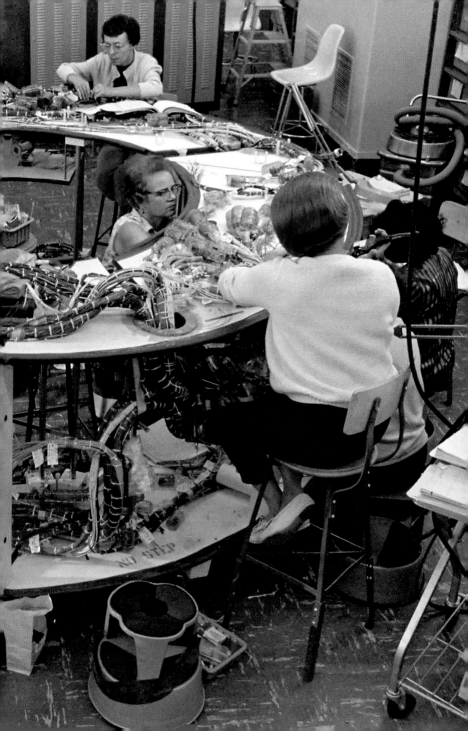

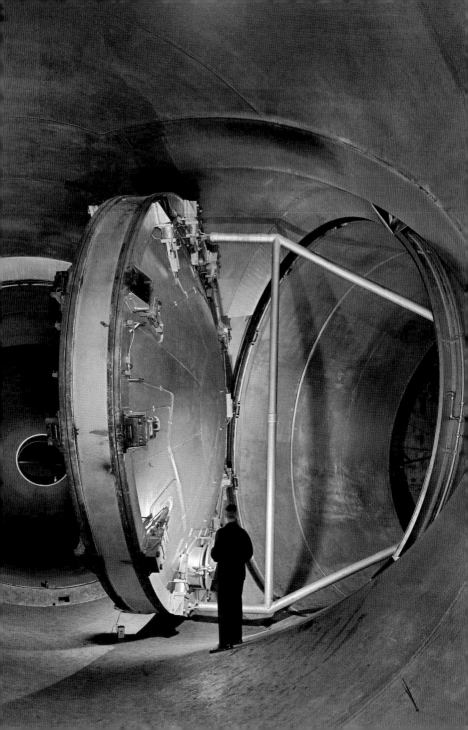

celebration while the astronauts were on the moon surface he had smiled and cleared his throat with a cultivated sound. "No," he had said, "no champagne in the refrigerator." Debus was not afraid of the Press.

But Von Braun was too prominent, and had — although his official position was nominally no more elevated than his countryman's — much too much to lose. A press conference, no matter how many he had had, was a putative den of menace. So his eyes flew left and right as he answered a question, flicking back and forth in their attention with the speed of eyes watching a Ping-Pong game, and his mouth moved from a straight line to a smile, but the smile was no more than a significator, a tooth-filled rectangle. Words were being mouthed like signal flags.

Since he had, in contrast to his delivery, a big burly squared-off bulk of a body which gave hint of the methodical ruthlessness of more than one Russian bureaucrat, Von Braun's relatively small voice, darting eyes and semaphoric presentations of lip made it obvious he was a man of opposites. He revealed a confusing aura of strength and vulnerability, of calm and agitation, cruelty and concern, phlegm and sensitivity, which would have given fine play to the talents of so virtuoso an actor as Mr. Rod Steiger. Von Braun had in fact something of Steiger's soft voice, that play of force and weakness which speaks of consecration and vanity, dedication and indulgence, steel and fat.

Still he did not do badly at his press conference. If he had started nervously, there was an exchange where he encountered his opposition. A correspondent from East Berlin asked him in German to answer a question. There had been a silence. For an instant Von Braun had not known exactly what to do, had in

Opposite: The supersonic wind tunnel at the Lewis Research Center in Ohio, pictured here in 1956, was used to evaluate heat-shield shapes for Mercury and later programs. *Photo, NASA.*

Following spread: Calculated to reach up to 5,000 degrees Fahrenheit, the atmospheric friction caused by reentry was a major concern for North American Rockwell in the design of the CM's heat shield. Here, a 1966 heat tolerance test checks the layers of ablative material that would purposely burn away to dissipate the temperature gain. *Photo, NASA.*

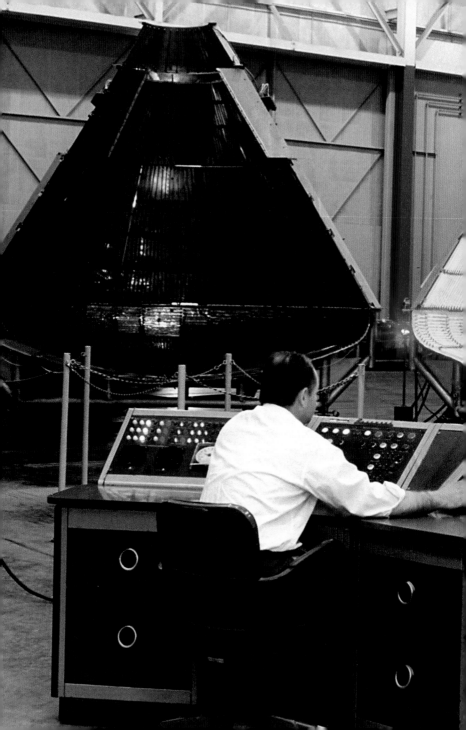

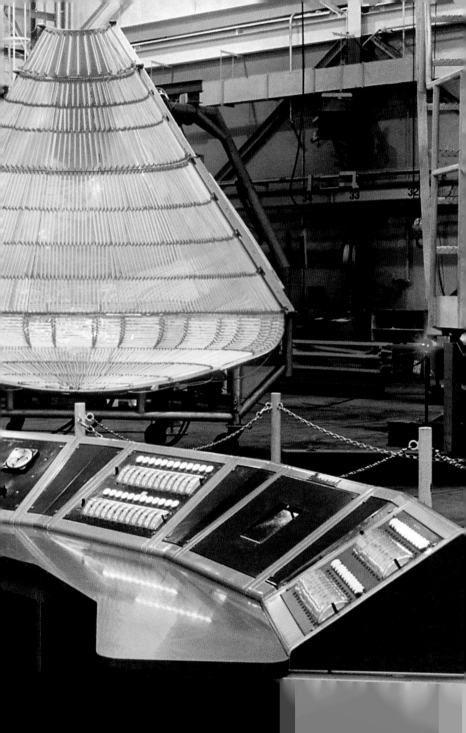

fact stolen a look at Mueller. NASA was sensitive about origins. Two of the three directors in the center of the Manned Spacecraft Program were, after all, German. And there was no joy in emphasizing this, since those few liberal congressmen who were sympathetic to the needs of the space budget would only find their way harder if Von Braun and Debus were too prominent.

Von Braun fielded the difficulty as follows: He translated the question into English. Then he gave a long detailed answer in English (which succeeded in boring the Press). Then, taking an equally long time, he translated his answer back to German. Finally, he took a nimble step away from this now somnolent situation by remarking, "I must warn the hundred and thirty-four Japanese correspondents here at Cape Kennedy that I cannot do the same in Japanese." The remark drew the largest laugh of the afternoon, and thereby enabled him to prosper. The contest in press conferences is to utter the remark which will be used as the lead quotation in wire-service stories, and Dr. George Mueller, anxious to establish his centrality on this panel, and his eminence over his directors, answered every question helpfully, giving facts, figures, prognostications of future activity. He was a one-man mine of pieces of one-line information with follow-up suitable for heads, leads, paragraph leads and bottom-of-the-page slugs, but Von Braun picked up the marbles. In fact he had the subtle look of a fat boy who has gathered the shooters in many a game.

When asked how he evaluated the importance of the act of putting a man on the moon, Von Braun answered, "I think it is equal in importance to that moment in evolution when aquatic life came crawling up on the land." It drew a hand of applause. It would

BLOWTORCH PROVES NO MATCH FOR APOLLO 11 INSULATION: Cape Kennedy, Florida—Model Grace Laird keeps her cool as Dr. Larry Blair of the Johns-Manville Research and Engineering Center melts a coin she holds on a mitt made of a unique space-age insulation used to back up the reentry head shield of the Apollo 11 command module. Grace's hand is protected from the searing flame of the propane torch by a quarter-inch thickness of the insulation—one of several J-M insulations used in various components for the lunar missions, including command and service modules, the lunar module, Saturn V launch vehicle, and the mobile launcher. —Johns-Manville press release, 1969. Opposite: Photo, NASA.

Opposite: A full-scale model of the LM was used for the astronauts to practice egress and the descent down the EVA ladder — a late addition to the design. *Photo, J. R. Eyerman.*

Previous spread: Originally called the Lunar Excursion Module, NASA officials decided to cut the frivolous-sounding "excursion" from the name. So, the LEM became the LM, albeit without any change in pronunciation. This 1963 model was hauled out to the desert and photographed with models posed as if to ask the question, What is this strange shape? — a question that was, no doubt, on the minds of many. *Photo, Lawrence Schiller.*

get the headline. Some of the Press literally stood up.

Thus, he was sound, sensible and quick as mercury. Yet his appearance had been not as impressive then as now tonight at the Royal Oak. Then he had been somehow not forceful enough for the public image, small voiced, almost squeaky for a man with so massive a frame. Whereas, here at the Country Club, shaking hands, he had obvious funds of charisma. "You must help us give a *shove* to the program," he said to Aquarius on greeting. (This was virtually what Debus had said on parting.)

Yes, Von Braun most definitely was not like other men. Curiously shifty, as if to show his eyes in full would give away much too much, he offered the impression of a man who wheeled whole complexes of caution into every gesture — he was after all an engineer who put massive explosives into adjoining tanks and then was obliged to worry about leaks. Indeed, what is plumbing but the prevention of treachery in closed systems? So he would never give anything away he did not have to, but the secrets he held, the tensions he held, the very philosophical explosives he contained under such supercompression gave him an air of magic. He was a rocketeer. He had lived his life with the obsession of reaching other planets. It is no small impulse. Immediate reflection must tell you that a man who wishes to reach heavenly bodies is an agent of the Lord or Mephisto. In fact, Von Braun, with his handsome spoiled face, massive chin and long and highly articulated nose, had a fair resemblance to Goethe. (Albeit none of the fine weatherings of the Old Master's head.) But brood on it: the impulse to explore the universe seems all but to suppose a divine will or a divine displeasure, or — our impurities matched only

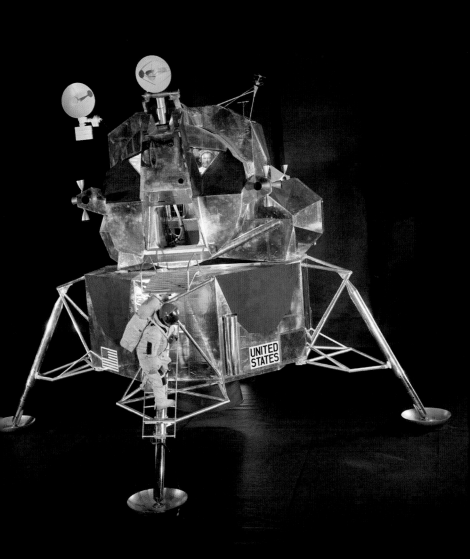

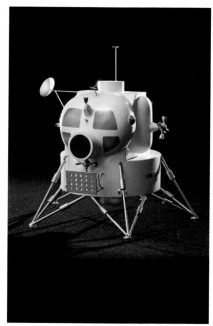

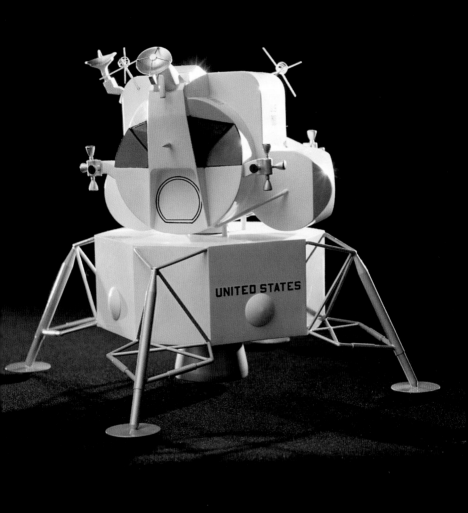

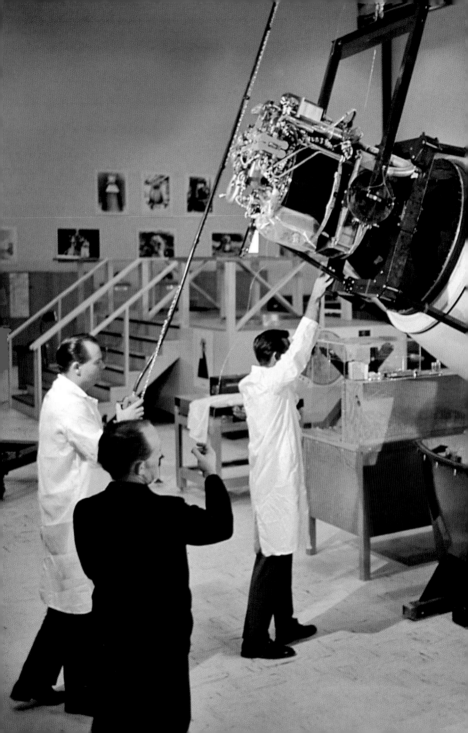

Previous spread: Though the moon shot was NASA's to claim, almost everything for Apollo was built by companies in the vibrant aerospace industry. Grumman, best known for making sturdy warplanes that could withstand carrier landings, got the $350 million contract to develop the Lunar Module. Throughout the early '60s, the design of the LM evolved rapidly: from an early wood-and-paper clip model (early 1962, left) to Grumman's contract-winning design (July 1962, center). By 1965 (right), seats, the front docking port, and large windows had been eliminated. *Photo, Yale Joel.*

Technicians at Thompson Ramo Wooldridge in Redondo Beach, California, prepare a LM descent engine. All the engines on the Apollo spacecraft used hypergolic propellants — liquids that immediately burn when brought together — a means of making propulsion systems extremely reliable and almost fail-safe. *Photo, TRW.*

Suspended in an anechoic chamber, a copper 1/6-scale model LM is positioned for an electromagnetic radiation test in 1964. *Photo, NASA.*

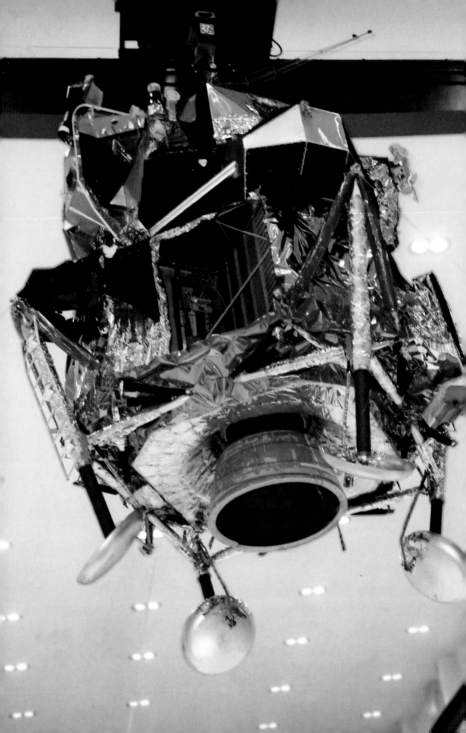

by our corruptions — some mixture of the two. What went on in Von Braun's mind during a dream? "Yes," he said with a smile, "we are in trouble. You must help us."

"Who are you kidding?" said Aquarius, the good American. "You're going to get everything you want."

Whether the intimacy was too abrupt, or Von Braun's reaction disclosed too much — his eyes gleamed with sudden funds of pleasure at the remark — he quickly looked discomposed, and as quickly left the conversation by failing to forward a remark in return. Then he waved some ambiguous good-by and moved quickly across the room. If his sense of friend and foe was good — a reasonable assumption to make about a man like Von Braun — it was obvious he did not think Aquarius would make such a good friend.

The banquet was roast beef. Ice creams and sauces for dessert. Coffee. The spoon on the glass. The publisher of the publishing corporation was talking. "We are signally honored tonight to have with us," he began, "one of the true fathers of space, Dr. Hermann Oberth, who, with Dr. Goddard and a Russian named Tsiolkovsky, is really and truly one of the originators of the whole concept of the exploration of space." An old man, seventy-five at least, with white hair and a white bushy mustache stood up. He had the birdlike self-sufficiency of the old, a vain sly white old bird, as if he were not only cousin to an old condor but had bought the nest as well. There was a smattering of applause. His name meant little outside of rocketry circles, but the speaker had used his presence for a joke. "I heard earlier tonight that at least two men in this room, one of whom you'll hear

The Lunar Module was the pioneer man-carrying machine of the deep vacuums of space...brought up from earth like an embryo in the womb of the SLA...irregular from every angle, as knotted and bumped and pouched as a comic-strip of Popeye...after a fight.
— Norman Mailer

Opposite: Unlike the sturdy lines of the main Apollo spacecraft, streamlined to aid its passage through Earth's atmosphere, the Lunar Module was a true spacecraft, capable only of flying through space. It was a two-part ship with the crew occupying only the upper section. The foil-covered lower section rests on the moon still, awaiting our return. Here, the Lunar Module 5, soon to be known as *Eagle*, has its landing gear folded in tight while being moved for mating with the adapter on April 4, 1969. *Photo, NASA.*

from later, are students of his. They said in response to his comment that he was a very good teacher, that at least they weren't dropouts; one of them is Dr. von Braun." The laugh came on that. Of all the nations in the world, America had possessed the firmest patriotic firmament; the common culture had never been rich enough to corrode it. Not till recently. Now, dropouts were pits in the shining surface. This then offered the suggestion that Von Braun was a regenerator of the shining surface. Therefore, the audience was not to be at ease during his introduction, for the new speaker, who described himself as a "backup publisher," went into a little too much historical detail. "During the Thirties he was employed by the Ordnance Department of the German government developing liquid fuel rockets. During World War II he made very significant developments in rocketry for his government."

A tension spread in this audience of corporation presidents and high executives, of astronauts, a few at any rate, and their families. There was an uneasy silence, an embarrassed pall at the unmentioned word of Nazi — it was the shoe which did not drop to the floor. So no more than a pitter-patter of clapping was aroused when the speaker went quickly on to say: "In 1955 he became an American citizen himself." It was only when Von Braun stood up at the end that the mood felt secure enough to shift. A particularly hearty and enthusiastic hand of applause swelled into a standing ovation. Nearly everybody stood up. Aquarius, who finally cast his vote by remaining seated, felt pressure not unrelated to refusing to stand for *The Star-Spangled Banner.* It was as if the crowd with true American enthusiasm had finally declared,

The interior of the VAB was a complexity of buildings within buildings...it was conceivably one of the more beautiful buildings in the world. —Norman Mailer Opposite: The view from inside the massive Vehicle Assembly Building: 525 feet (160 m) tall, 715 feet (218 m) wide, and 518 feet (158 m) long. The largest single-story building on Earth—and fourth largest by volume—the VAB is so cavernous that industrial-strength fans must keep the air circulating to prevent rain clouds from forming in its interior. *Photo, Michael Rougier.*

"Ah don' care if he is some kind of ex-Nazi, he's a good loyal patriotic American." Von Braun was. If patriotism is the ability to improve a nation's morale, then Von Braun was a patriot. It was plain that some of these corporation executives loved him. In fact, they revered him.

He was the high priest of their precise art — manufacture. If many too many an American product was accelerating into shoddy these years since the war, if planned obsolescence had often become a euphemism for sloppy workmanship, cynical cost-cutting, swollen advertising budgets, inefficiency and general indifference, then in one place at least, and for certain, America could be proud of a product. It was high as a castle and tooled more finely than an exquisite watch.

Now the real and true tasty beef of capitalism got up to speak, the grease and guts of it, the veritable brawn, and spoke with fulsome language in his small and well-considered voice. He was with friends this occasion, and so a savory, a gravy of redolence came into his tone, his voice was not unmusical, it had overtones which hinted of angelic superpossibilities one could not otherwise lay on the line. He was when all was said like the head waiter of the largest hofbrau house in Heaven. "Honored guests, ladies and gentlemen," Von Braun began, "it is with a great deal of respect tonight that I meet you, the leaders and the captains of the mainstream of American industry and life. Without your success in building and maintaining the economic foundations of this nation, the resources for mounting tomorrow's expedition to the moon would never have been committed.... Tomorrow's historic launch belongs to you and to the men and women who sit behind the desks and administer

Opposite and page 225: The interior view of the concentric-steel work platforms that technicians stand on during assembly of the rocket, from the top of the platform down and the ground level up. *Photos, Michael Rougier.*

The 52-story cube and the three towering steel skeletons...jutting from the Florida flatlands suggest a 20th-century return to the massive monument building of past ages. —Fortune, *February 1966* Following spread: With construction of the Kennedy Space Center's Vehicle Assembly Building and Launch Complex 39's A and B pads complete, Apollo's rollout tests with the AS-500F began on March 25, 1966. The nonflying version of the Saturn V had been stacked on one of three massive Mobile Launch Platforms, featuring a red, open-framework Launch Umbilical Tower that supplied services to the upper reaches of the vehicle. A massive Crawler-Transporter bearing the load of the MLP and rocket—a hefty 8,400 tons (7,600 t)—trekked for nine hours along a three-and-a-half-mile crawlerway. *Photo, NASA.*

your companies' activities, to the men who sweep the floors in your office buildings and to every American who walks the street of this productive land. It is an American triumph. Many times I have thanked God for allowing me to be a part of the history that will be made here today and tomorrow and in the next few days. Tonight I want to offer my gratitude to you and all Americans who have created the most fantastically progressive nation yet conceived and developed." He went on to talk of space as "the key to our future on earth," and echoes of his vision drifted through the stale tropical air of a banquet room after coffee — perhaps he was hinting at the discords and nihilism traveling in bands of brigands across the earth. "The key to our future on earth. I think we should see clearly from this statement that the Apollo 11 moon trip even from its inception was not intended as a one-time trip that would rest alone on the merits of a single journey. If our intention had been merely to bring back a handful of soil and rocks from the lunar gravel pit and then forget the whole thing" — he spoke almost with contempt of the meager resources of the moon — "we would certainly be history's biggest fools. But that is not our intention now — it never will be. What we are seeking in tomorrow's trip is indeed that key to our future on earth. We are expanding the mind of man. We are extending this God-given brain and these God-given hands to their outermost limits and in so doing all mankind will benefit. All mankind will reap the harvest....What we will have attained when Neil Armstrong steps down upon the moon is a completely new step in the evolution of man." (Which would lead Aquarius days later to wonder at the origin of Armstrong's first speech on the moon.) "It will

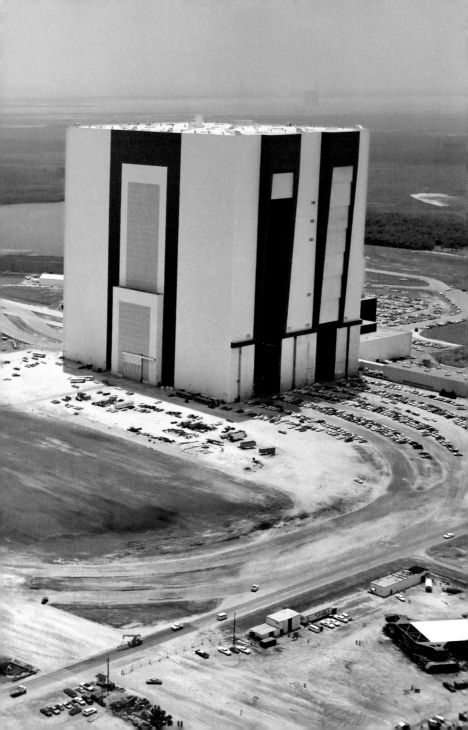

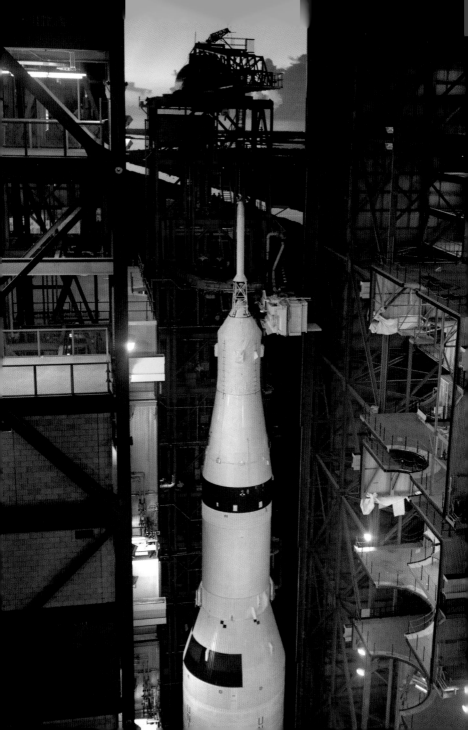

cause a new element to sweep across the face of this good earth and to invade the thoughts of all men."

He was almost done with his formal remarks. Out of his big bulk and his small voice he would offer miracles. That was his knowledge of America, no mean knowledge. Prosperity satisfies those who are rich in culture. But in lands where the geography like the people is filled with empty space, then faith in miracles is the staple of the future.

"Every man achieves his own greatness by reaching out beyond himself, and so it is with nations. When a nation believes in itself as Athenians did in their Golden Age, as Italians did in the Renaissance, that nation can perform miracles. Only when a nation means something to itself can it mean something to others. We are truly faced with the brightest prospects of any age of man. Knowing this, we can watch the launch tomorrow with a new dimension of hope. We can cheer the beginning of a new age of discovery and the new attainment that spans the space distances and brings us nearer to the heavens."

His speech while quietly apocalyptic was not without gloom for the audience. They were heavy with food, and a band or a juke-box was blasting in some big room next to the hexagonal room. The country club couples of Titusville and Brevard County were having a good time next door. But it seemed to Aquarius that Von Braun's remarks had plunged the collective intelligence of these corporation men back into some of their problems.

Yes, Aquarius was thinking, ideas were what Americans cared about, and the biggest ideas were doubtless the best, but what a price had been paid. For now manufacturers and consumers chased frantically

Four Saturn rockets can be assembled simultaneously . . . before being hauled to the launching pad. Using the VAB keeps the pad free until the rocket is ready to fly. Under the old system the rocket and spacecraft were mated and checked out right on the pad. If anything went wrong with either of them the pad was tied up for months. —LIFE, June 10, 1966 Opposite: The first unmanned test launch of the Apollo/Saturn V flew on November 9, 1967. Here, Apollo 4's AS-501 begins the rollout from its dock at the VAB to Launch Complex 39A. *Photo, NASA.*

Opposite: While the third stage of the Saturn V (built by McDonnell Douglas in California) was small enough to be transported via the wide-bodied Super Guppy airplane, the first (built by Boeing) and second (built by North American) stages of each Saturn rocket were too large for air transit. Here, a 138-foot first stage is transported a short distance via trailer at Boeing's Michoud, Louisiana, plant to an adjacent canal where it will be loaded onto a self-propelled barge for the trip out to Lake Borgne, then around the rim of the Gulf of Mexico, up Florida's Atlantic Coast, and across the Banana River to Cape Kennedy. *Photo, NASA.*

after fashion. It did not matter how cheap and shameful the execution. The bargain stereo could not last a month, the washing machine with the plastic console would break in a week — all that had been purchased was the idea. Something was happening to Americans. They were a guilty crew, guilty of new ideas, new license, sacrilege, cynicism, bad faith. As a result, they were always in a rush to purchase a new idea. When people were not willing to die for an old idea, they would rush to a new one. Guilty to the nose, guilty to the ears, they were even apathetic about blaming the fabricators, for they were guilty themselves. Everybody had been cheated so many times; everybody had cheated others so often. It was hard to remain angry that one had been defrauded. It was even hard to get angry. So food and ruminating drink lowered the audience from the excellence of Von Braun's achievement to the shoddy dimensions of their own.

The question period cheered this same audience however. Then Von Braun could speak of lunar jeeps, and space costs reduced by flying stages which could be used over and over in travel from earth to manned laboratories in earth orbit. He would be eloquent a little later about nuclear rockets the size of battleships which might be assembled in earth orbit and then voyage to Mars. While he talked of other planets, the audience grew warm again. It was the moon which was cold. When applause subsided, the publisher cried out in his cheerful voice, "I have a question. Will you be fired if you don't get on that helicopter and greet the senators and Cabinet members who are waiting?" Von Braun made a point of staying for two more full questions, then took his departure. The sound of

helicopters rose over the room. Aquarius would have thought the evening concluded, but as he was learning again, he would never understand Americans. Another speaker, a representative of American business, rose and gave a humorous introduction to a man as massive and slow-speaking as Lyndon Johnson who proceeded to get up and tell jokes in an absolutely assured drawl. The audience seemed happy with them. "I was in an airport not long ago and sitting next to a woman smoking a cigar. I asked her how long she'd been smoking cigars. And she said ever since her husband had come home and found one in her ashtray in the bedroom."

The couple in front of Aquarius, young, stingy, ambitious and very respectable, were laughing. The husband scowled at the wife and said with existential humor, "I wouldn't laugh at that joke if I was you."

"Why not?" responded the wife with the serenity of total practicality. "I've never done it."

Yes, they were all good Americans and they would listen to jokes and be a little relieved Von Braun was gone (although they would treasure the experience), and as new jokes came along, Aquarius began to look again into his drink and brood on Von Braun's remarks. He had declared that reaching the moon would be the greatest event in history since aquatic life had moved up onto land, and that was a remark! for it passed without pause over the birth and death of Christ. Indeed Von Braun had said even more in a newspaper interview. "Through a closer look at Creation, we ought to gain a better knowledge of the Creator." Man was voyaging to the planets in order to look for God. Or was it to destroy Him?

Of course, in the interview, Von Braun had been

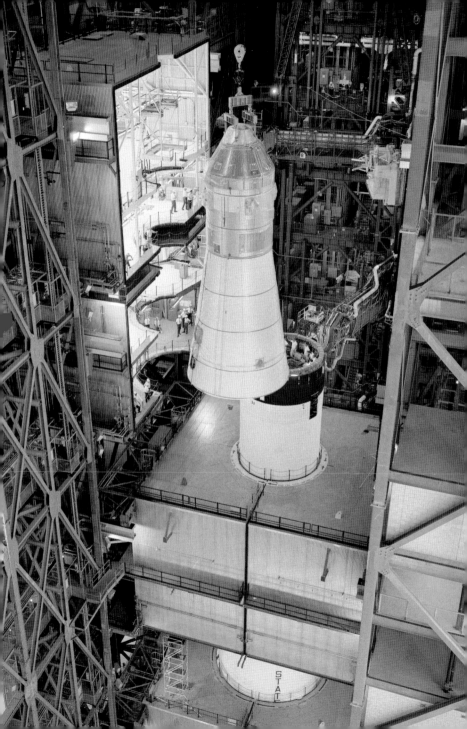

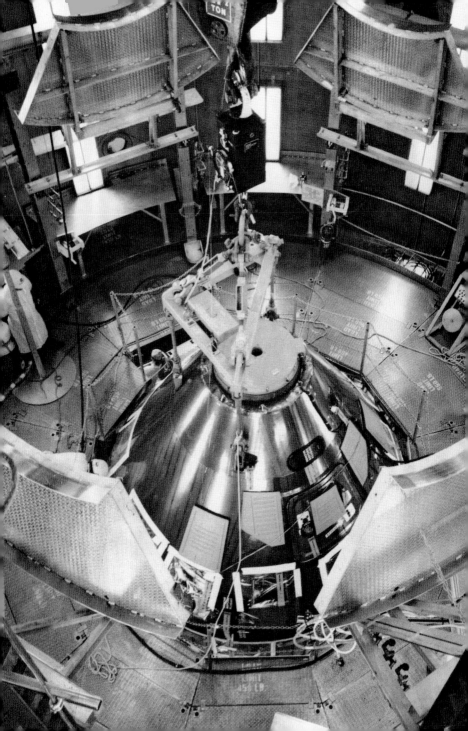

careful to add, "It could very well be that the Lord would…send His Son to the other worlds to bring the gospel to them — I believe the good Lord is full of such tremendous compassion that He will take whatever steps are necessary to bring the truth to His Creation." While Aquarius had always assumed that compassion did not move by steps but seemed rather to bathe the wounded with its grace, this was after all no ordinary piety. It was possible Von Braun was sincere. Still what a grip he had on the jugular of the closet missionary in every Wasp. If he had dumped his private finds on American religious opinion into a computer and cranked it up for response, the words could not have come back better. On the other hand, Aquarius had believed for years in ideas not altogether dissimilar. Once, tentatively, he too had undertaken the doubtful liberty to state in an interview what he thought of God. God, he had presumed to suggest, was an embattled vision: God had created man in order that man might fulfill God's vision, but His vision of the future was at war with other visions of existence in the universe. Some of those other visions were not only out in the stars, and in the galaxies, but were right here, intimate, on earth. God was, for instance, at war with the Devil. Certainly the Devil had a most detailed vision of existence very much opposed to His own. In any case the war had gone on for so long that nearly everything human was inextricably tangled. Heroism cohabited with technology. Was the Space Program admirable or abominable? Did God voyage out for NASA, or was the Devil our line of sight to the stars?

NASA. The word had derived from NACA —National Advisory Committee for Aeronautics, which became

Opposite: Apollo 11's CSM-107, soon to take humans on a journey to the moon for the first manned lunar landing, is installed in the altitude chamber of the Manned Spacecraft Operations Building at Kennedy on February 3, 1969. *Photo, NASA.*

Opposite: On March 21, 1969, two months before rollout, workers at Kennedy Space Center add an extra three feet (1 m) to Apollo 11's growing Saturn V rocket. Dwarfed even by the relatively small S-IVB stage upon which they stand, they are about to stack Saturn's Instrument Unit — a ring that carries a collection of computers, gyroscopes, and sequencers that will control the rocket throughout its flight. *Photo, NASA.*

Following spread: In the event of an emergency on the pad, the astronauts and close-out team could slip down a 205-foot Teflon-lined slide to a subterranean blast bunker located west of the launch pad. The igloo-shaped blast room is outfitted with foam-rubber contour seats and chemical toilets, and enough food to feed 20 men for 24 hours. *Photo, Ralph Morse.*

the National Aeronautics and Space Administration, or NASA. It was an unhappy sound. Just think of NASA-ism. NASA would have no deliberate relation whatso-ever to Nazi. But we are not a schizophrenic land for nothing. Deep in the unconscious where each sound leaves first its murmur and then its roar at a combus-tion of hitherto unconnected meanings, NASA had to stand for something. You bet.

Listening to the jokes, Aquarius was still brooding about Nazism. For the philosophy of the Folk, detest-ing civilization, claiming to be in love with the primi-tive, had nonetheless killed millions of men in the most orderly technological fashion yet devised. Nazism had been not one philosophy, but two — and each philosophy was utterly opposed to the other. It was primitive, it was vertiginously advanced. It gave brave men a sense of nobility in their hearts — it had been utterly heartless. It spoke of clean futures and buried Germany (for a time!) in vomit and slime and swill. Now its ghosts were pacing on every battlement of every surviving palace, now its ghosts were bub-bling in the tubes of every laboratory, burning in the wires. Nazism had been an assault upon the cos-mos — why think of it as less? That is why it moved as the specter behind every civilized transaction. For it had said: civilization will stifle man unless man is delivered onto a new plane. Was space its amputated limb, its philosophy in orbit?

Now the speaker was telling a joke about a Texan in Alaska who had mixed up his respective missions with a woman and a bear. Big was the laugh from the audience. And out on the beaches and the causeways and riverbanks, another audience was waiting for the launch. America like a lazy beast in the hot dark was

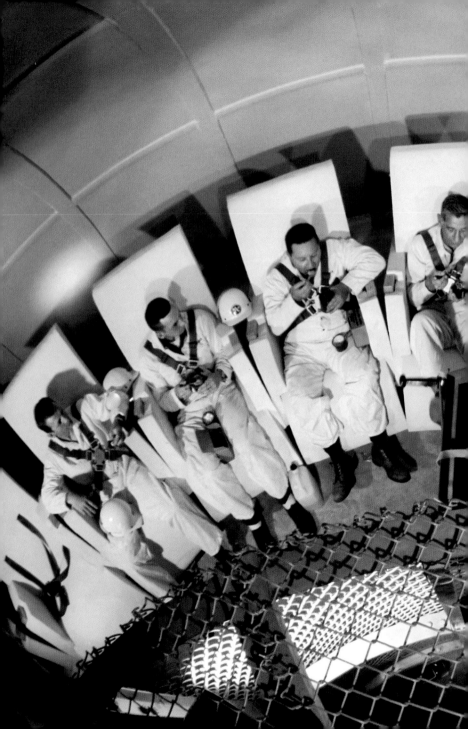

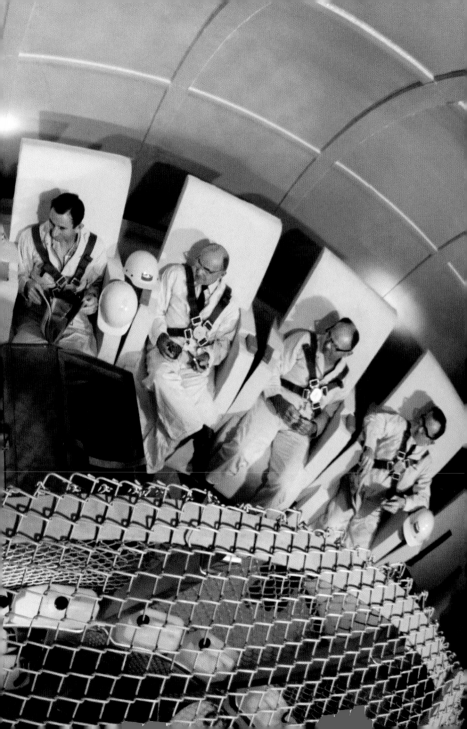

waiting for a hint in the ringing of the night. Questions drowned Aquarius. In bed by two in the morning, he would be up by four. An early start was necessary, for traffic on the road to the Press Site would be heavy.

* * *

Everybody complained that the tension accompanying the preparations for Apollo 11 had been less than launchings in the past. Cocoa Beach itself had altered. The old days of honky-tonks on the strip of highway and rockets threatening to carve a furrow down the beach were now gone. Money had come in and industry, space technicians and their families, Supermarkets, motels, churches and real estate developments had been put up. In the restaurants, public address systems broke into the mood of a meal to call patrons to the phone. The paper doilies under the plate carried legends: AMERICA'S SPACE PROGRAM BENEFITS ALL MANKIND — *Your Souvenir of Apollo 11 Lunar Landing*. Better Color Television. Water Purification at Less Cost. New Paints and Plastics. Lunar Walker for the Handicapped. Laser Surgery. Solar Power. So forth. Cocoa Beach had been one of the five places on the Atlantic Seaboard which deserved the title "Wild West of the East," but Cocoa Beach deserved it no longer. As the doily revealed, it was part of the Brevard Economic Development Council. Until the last few days when the Press arrived in hundreds then thousands, there had been monotonous hours when it was necessary to remind oneself that three men were leaving for the moon in less than a week. But in the dark morning before dawn on the sixteenth, in the black hour of 4 A.M., the night air a wet and lightless forest

Never had the space program produced so massively spectacular a sight as the earthbound voyage of Saturn V. As tall as a 36-story building, the big rocket stood adjacent to a mobile launch tower that was even taller as the entire rig inched along on top of the world's biggest tractor.
—LIFE, *June 10, 1966*
Opposite: The Apollo 11 rollout begins through the 40-story-high doors of the VAB on May 20, 1969. Nearly two months were needed at Launch Complex 39A to test fuel and electrical connections before launch. *Photo, Flip Schulke.*

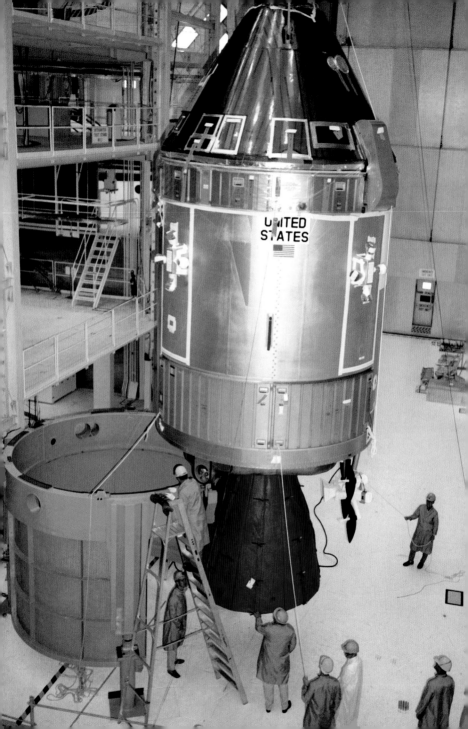

in the nose, one was finally scared. It was not unlike awakening in a convoy with invasion of a foreign beach scheduled for the hours ahead, an awakening in the dark of the sort one will always remember, for such nights live only on a few mornings of one's life. Somewhere not so far from here, the astronauts were getting up as well. And the ghosts of old Indians.

In that long-ago of prairie spaces when the wind was the message of America, Indians had lived beneath the moon, stared at the moon, lived in greater intimacy with the moon than any European. Who could say the ride of the Indian with whisky in his veins was not some conflagration of messages derived from the silences of the moon? Now tonight were the ghosts of old Indians awakening in the prairies and the swamps? Did the echo of the wind through the abandoned launch towers of the Cape strike a resonance across two thousand miles to the grain elevators by the side of railroad tracks in the mournful empty windings of the West?

The country had been virgin once, an all but empty continent with lavender and orange in the rocks, pink in the sky, an aura of blue in the deep green of the forest — now, not four centuries even spent, the buffalo were gone, and the Indians; the swamps were filled; the air stank with every exhaust from man and machine. All the while we had been composing our songs to the moon and driving the Indian onto the reservation, had we also been getting ready to go to the moon out of some deep recognition that we had already killed the nerve which gave life to the earth? Yet the moon by every appearance knew more about disease and the emanations of disease than the oldest leper on earth. "Of what can you dream?" said the

Opposite: In essence, the Apollo spacecraft was a miniplanet that provided everything three men needed for nearly two weeks in interplanetary space: air, water, power, propulsion, food, and a means of navigating between worlds. Here, covered in a protective blue plastic, *Columbia* is lifted from a work stand to be mated to the adapter that houses the Lunar Module — a final preparation in the Manned Spacecraft Operations Building before being stacked on top of the Saturn V. *Photo, NASA.*

moon. "I am battered beyond belief and you think to violate me now?"

Driving through the night, passing again the families and tourists who were waiting for morning on the banks of the causeway, showing a Press Pass to the guard at the gate and being waved on in silence, yes near to conspiratorial silence, there was the tangible sense of time running in parallel, the million-headed witness now traveling to a point where the place would cross the time and the conscious eye of the nation would be there to witness this event. By television would they witness it. That would be an experience like getting conceived in a test tube.

Out at the Press Site, Saturn V was visible across the near distance of three and a half miles. It was the nearest Aquarius had approached on this long night, and it was indeed the nearest anyone would come but the launching crew and the three astronauts. As Apollo-Saturn stood on its concrete pad six thousand yards away across a lagoon from the small grandstand built for the Press, its details now visible, it looked less like a shrine, but all the more a presence. A squad of floodlights played upon it, and their beams reflecting from the thin night haze displayed a fan of separate lights across the sky on down into the surface of the lagoon, a bending and glancing of rays worthy of a diamond upon a mirror. In the black wet night, back of the floodlamps, lightning flickered, so regularly that one might have been looking at a lighthouse rotating its flare — somewhere down the horizon, a potency of storm was speaking up in the response of the Caribbean. Long far-off rolls of thunder. Staring across the water, Aquarius took a long study. His binoculars appeared to lock him into collaboration with

We're not really talking about the space program anymore. . . . You wouldn't speak about Columbus's voyage as the sailpowered water craft program. What Columbus's journey was all about had nothing to do with water. It was the extension of man's dominion . . . new societies. — Thomas O. Paine, NASA administrator, quoted in The New York Times, *June 8, 1969* Opposite: On July 11 technicians stand atop a mobile service structure as it pulls away. In five days the crew of Apollo 11 will walk down Swing Arm 9, through the White Room at its end, and enter *Columbia. Photo, NASA.*

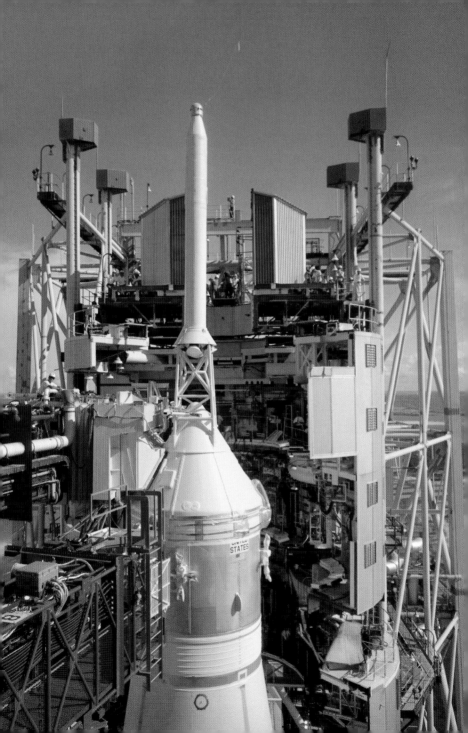

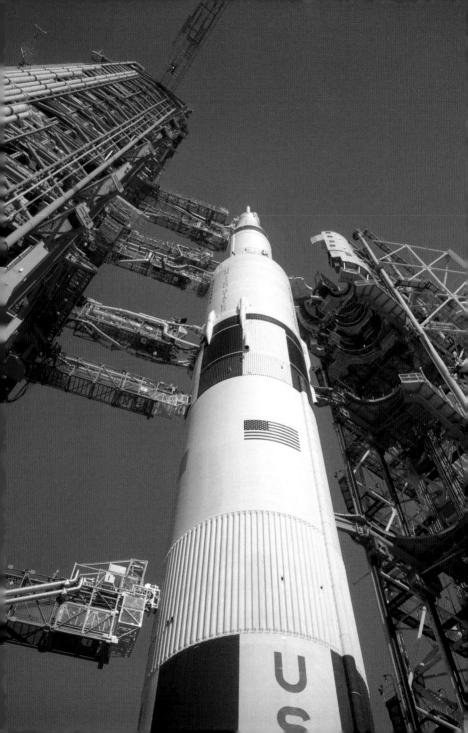

Saturn V, as if the rocket had the power to keep those binoculars pressed to his nose, as if finally Aquarius and Saturn V were now linked into some concupiscence of mission like a onenight stand which might leave its unexpected consequence upon him. What a vehicle was the spaceship! A planet-traveler massive as a destroyer, delicate as a silver arrow. At the moment it lifted off from the earth it would be burning as much oxygen as is consumed by half a billion people taking their breath — that was twice, no, more than twice the population of America.

What a deep breath must then have been concentrated into the liquid oxygen they were passing into its tanks right now, a liquid oxygen cooled to 297 degrees below zero and thereby turning air to cloud at every hint of contact with the pipes which were in turn contained within other pipes two feet thick to insulate the fuel. Model of an ogress, umbilical cords of every thickness and sinuosity, snakes and cables and ropes and constrictors thick as tree trunks passed in cluster from swing-arms and the walkways of the launching tower into the thin-skinned walls of the rocket; a Medusa's head of umbilicals loading fuel, charging batteries, testing circuits; a complexity of interrelation between the launching tower and the rocket so simplified by the swing-arms that Apollo-Saturn resting on her pad did not look distraught but calm, like a silver-white ship standing erect by an iron tree with nine horizontal branches. There were clouds about both, strings of small firm well-puffed little clouds drifting off at right angles from the rocket at each place where an umbilical from an oxygen pipe had been disconnected; the clouds gave Saturn V the brow of a philosopher in contemplation above his thought,

Opposite: Among the systems tests conducted on pad 39A were a series of countdown demonstration tests involving all personnel required for launch. Here, on July 2, the 402-foot-tall Mobile Service Structure (right) moves away from the launch pad by a transporter, leaving the craft to be supported at its base by the four hold-down arms of the launch platform, and tended by the swing arms of the Launch Umbilical Tower.

Following spread: More than 300,000 cars, carrying an estimated one million visitors, descend upon Brevard County the day before launch. *Photo, NASA.*

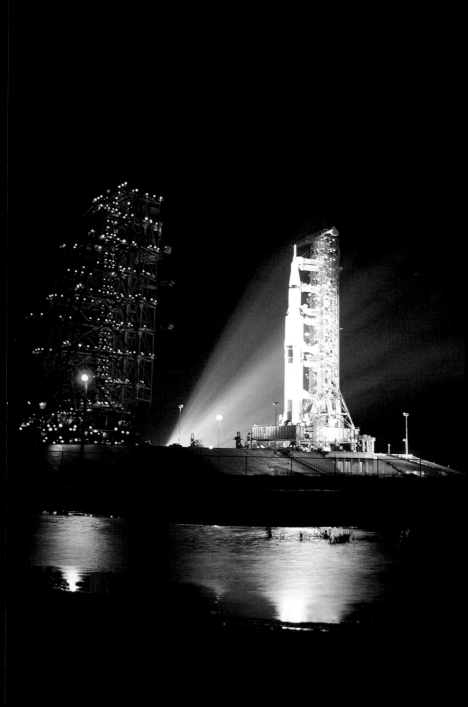

yes, the cloud belonged to Saturn V, it nuzzled at it, a new cloud not many hours old. And the light from the floodlamps reflected from the white icy skin of the wall.

Sainted Leviathan, ship of space, she was a planetary traveler.

Opposite: The night before launch. *Photo, Neil Leifer.*

Following spread: Journalists await the 9:32 A.M. launch at KSC's Press Site. *Photo, Neil Leifer.*

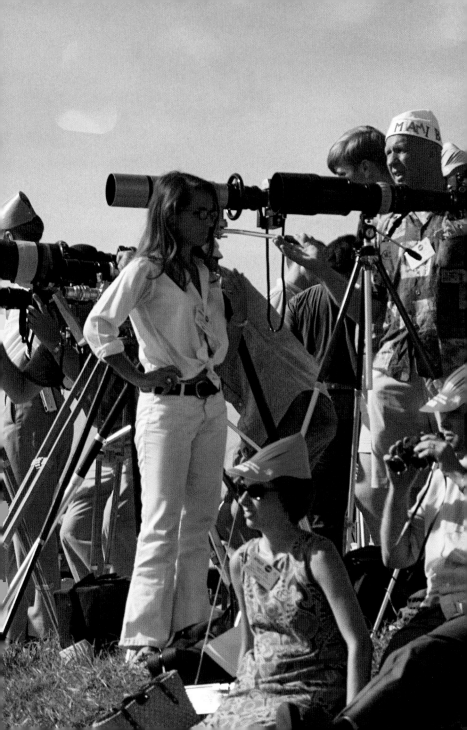

On this morning. . . the VIPs will be sitting in bleachers. He knows there is a good haul there — all of two hundred congress- men . . . four hundred foreign ministers, attachés and military aviation officials, two hundred and seventy-five leaders of commerce and industry. . . . The voice of duty has suggested to Aquarius that he should be there to study them, record their expressions, comment on the part of history they command and their relation to the part of history now being born, but his liver will simply not permit it. He is here to see the rocket go up, not to stand and look at Very Important People and take notes in a notebook while he sweats in the heat. — Norman Mailer Lady Bird and Lyndon Johnson watch the liftoff with Vice President Spiro Agnew. *Photo, NASA.*

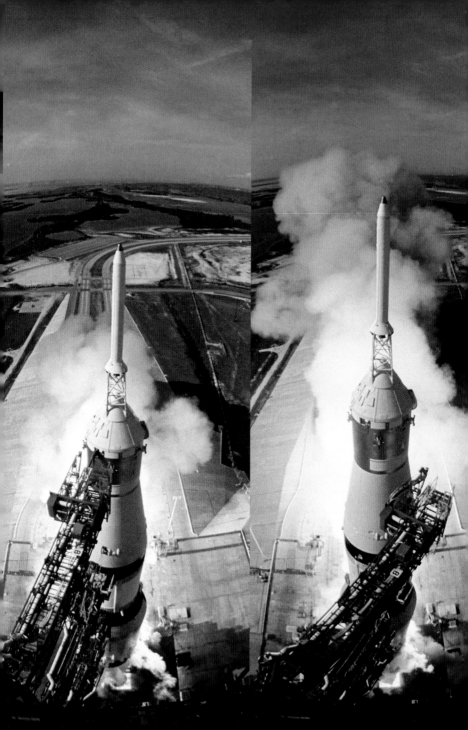

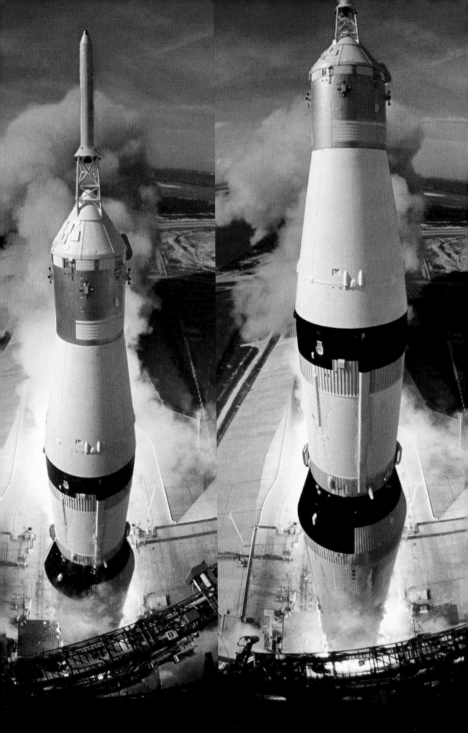

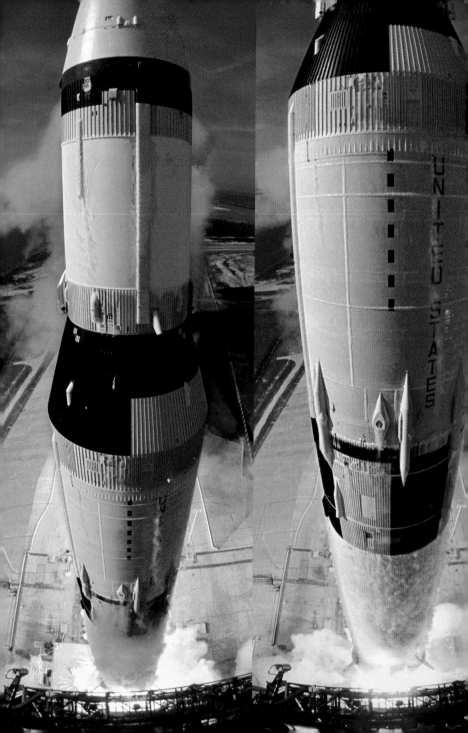

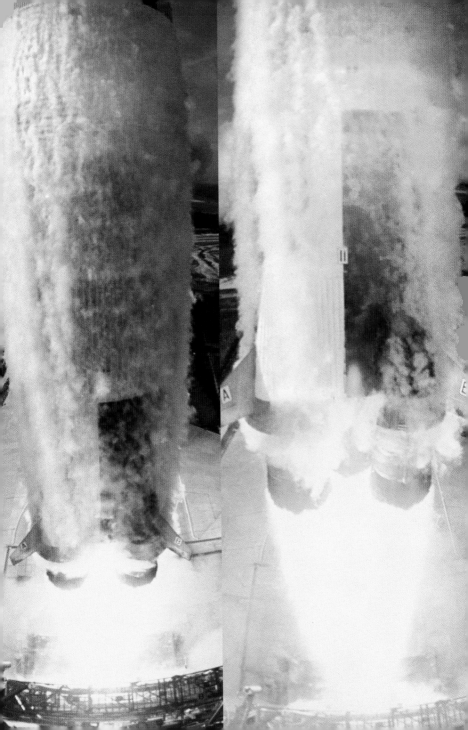

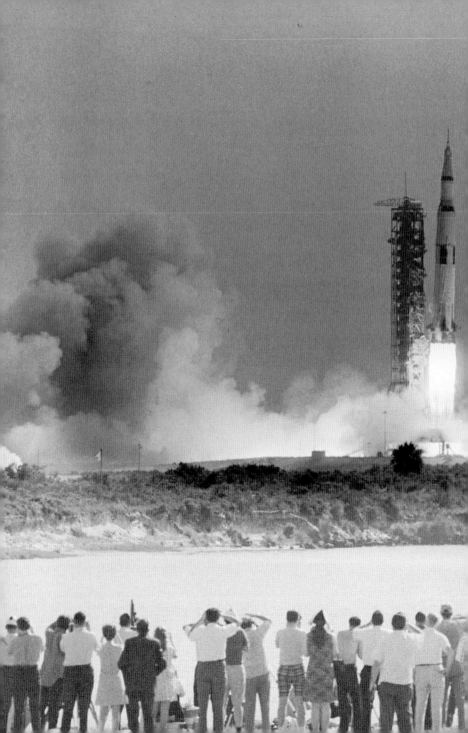

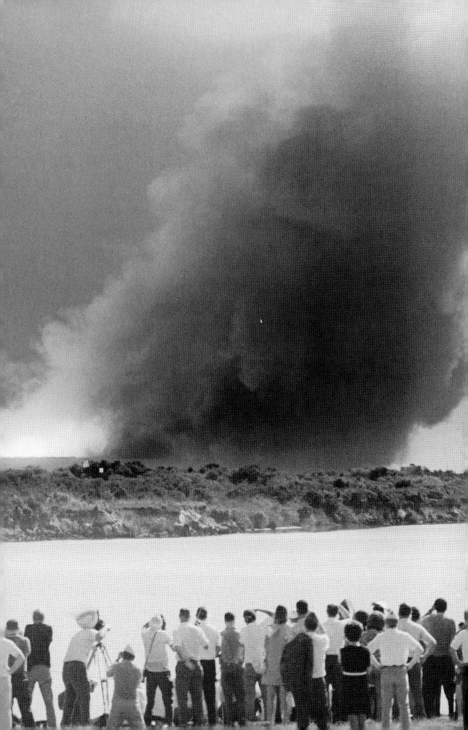

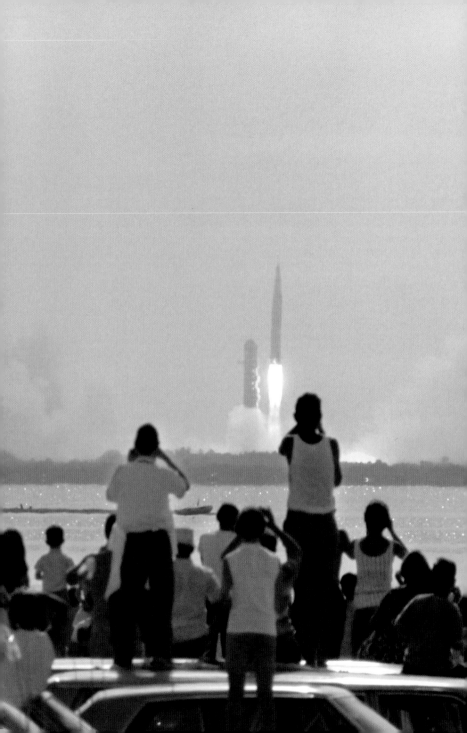

A Dream of the Future's Face

Flames flew in cataract against the cusp of the flame shield, and then sluiced along the paved ground down two opposite channels in the concrete, two underground rivers of flame which poured into the air on either side a hundred feet away, then flew a hundred feet further. Two mighty torches of flame like the wings of a yellow bird of fire flew over a field, covered a field with brilliant yellow bloomings of flame, and in the midst of it, white as a ghost, white as the white of Melville's Moby Dick, white as the shrine of the Madonna in half the churches of the world, this slim angelic mysterious ship of stages rose without sound out of its incarnation of flame and began to ascend slowly into the sky, slow as Melville's Leviathan might swim, slowly as we might swim upward in a dream looking for the air.

Pages 256–259: Triggered by the first motion of the rocket, five 22-ton swing arms that had been supplying the vehicle had to detach and pull away in a matter of seconds. Most of the tanks that comprised Saturn V's bulk contained extremely cold propellant that caused ice to build up on the skin during fuelling. After ignition, intense vibrations shook off the ice, and clouds of water vapor from the humid Florida air formed along the rocket's length. *Photos, Ralph Morse. Last photo, NASA/ NARA.*

Previous spread: Photo, Bettmann/Corbis.

Opposite: Photo, Ralph Crane.

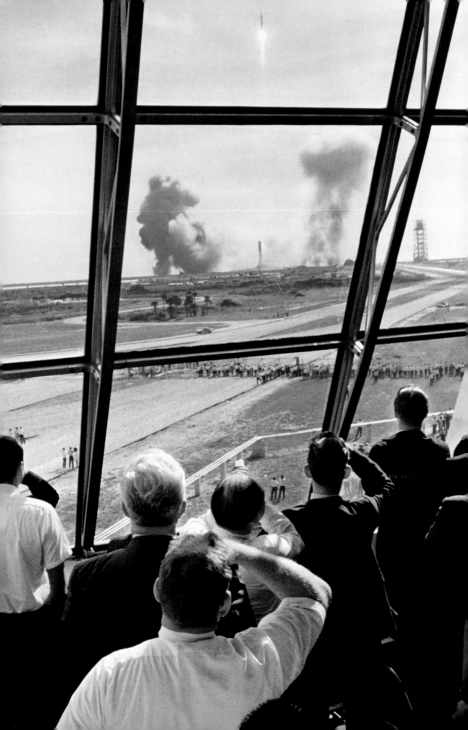

On this morning, with two hours to spend before the launch, he chooses not to get into another bus — not another bus this day! — to travel to the other side of the Vehicle Assembly Building where the VIPs will be sitting in bleachers. He knows there is a good haul there — all of two hundred congressmen, Sargent Shriver, Mr. and Mrs. James E. Webb, William W. Scranton, Jack Benny, Cardinal Cooke, Daniel Patrick Moynihan, Johnny Carson, Gianni Agnelli, Senator Javits, Leon Schacter of the Amalgamated Meat Cutters and Butcher Workers, Prince Napoleon of Paris, four hundred foreign ministers, attachés and military aviation officials, two hundred and seventy-five leaders of commerce and industry, Vice President Agnew, Lady Bird and former President Lyndon B. Johnson, plus Barry Goldwater in slacks and a red golfing shirt. The last two will shake hands for the cameras before this is all over — space will prove bigger than both of them. The voice of duty has suggested to Aquarius that he should be there to study them, record their expressions, comment on the part of history they command and their relation to the part of history now being born, but his liver will simply not permit it. He is here to see the rocket go up, not to stand and look at Very Important People and take notes in a notebook while he sweats in the heat. No, some sense of his own desire to dwell near the rocket, to contemplate its existence as it ascends, and certainly some sense of his own privacy, some demand of his vanity — aware of how grubby he looks and feels — now bids him to stay with his own sweaty grubs, the Press and photographers gathered in the grandstand bleachers and out on the small field before the lagoon which separates them from the blast-off of Apollo 11. Besides he dislikes

Opposite: In the Launch Control Center, all but a few invited guests fixed their eyes on the monitors until Saturn V cleared the tower. It took 12 seconds to rise clear of the tower, at which point Houston took control of the mission. *Photo, NASA.*

the VIPs, dislikes most of them taken one by one, and certainly dislikes them as a gang, a Mafia of celebrity, a hierarchical hive. He is still sufficiently a Manichean to believe that if Saturn V goes up in perfect launch, it will not be the fault of the guests. No, some of the world's clowns, handmaidens and sycophants and some of the most ambitious and some of the very worst people in the world had gotten together at the dignitaries' stand. If this display of greed, guilt, wickedness and hoarded psychic gold could not keep Saturn V off its course, then wickedness was weak today. Or did wickedness crowd to the witness stand to cheer evil on its flight? It did not matter how the reporter's mind turned, it was filled with nothing but the most fruitless questions today. He discovered he was thirsty.

So in preference to taking the bus and taking notes on the guests, he stood in line for another large part of an hour waiting for a cold drink. In back of the Press Site, more than a hundred radio and TV trailers were now arrayed behind one another in ranks and rows of huge white ruminants, the very sacred cows of American technology. Yet there was only one trailer reserved for food. It was next to heartwarming to discover another piece of poor planning in the icy efficiencies of the Space Program — small surprise that it had to do with a creature comfort like food. The trailer was inadequate to the needs of the Press — over a hundred waited in line, more than a hundred walked away in disgust. The line drifted forward about as fast as a tide works up a beach. The trailer interior consisted of a set of vending machines for chiliburgers, hamburgers, pastries — all people wanted were cold drinks. So the line crawled, while everyone waited for the same machine. Nobody

I've noticed in the reporting that those under 16...want to know about escape velocity and they want to know about the lunar trajectory velocity, and those over 30 or so say, "Don't tell me all that, I just don't understand. Tell me when we get there." — Walter Cronkite, CBS News Space Headquarters, July 16, 1969 Opposite above: Veteran space-reporter Walter Cronkite led the exhaustive CBS News coverage of the event. *Television still, CBS.*

Opposite middle and below: The "Voice of Apollo," NASA public affairs officer Jack King, narrated the countdown from Launch Control. CBS correspondent Morley Safer interviews British physicist Sir Bernard Lovell at the Jodrell Bank Centre for Astrophysics. *Television stills, CBS.*

was about to have machine-vended chiliburgers at half-past eight in the morning. But so many demands on the iced-drink machine caused malfunctions. Soon, two vending machine workers were helping to service the machine. Still it took forever. Coins had to go into their slot, change be made, cups filled, tot of cracked ice dropped, syrup poured, then soda. Just one machine. It was pure American lunacy. Shoddy technology, the worst kind of American shoddy, was replacing men with machines which did not do the work as well as the men. This crowd of a hundred thirsty reporters could have been handled in three minutes by a couple of countermen at a refreshment stand in a ball park. But there was an insidious desire to replace men everywhere with absurd machines poorly designed and abominably put together; yes, this abominable food vending trailer was the proper opposite number to those smug and complacent VIPs in their stands a half mile away; this was the world they had created, not the spaceship. They knew nothing about the spaceship but its value in the eyes of the world — that was all they had to know. The food vending trailer was their true product. When they mouthed their portions of rhetoric, when they spoke, lo! their mouths poured forth cement — when they talked about poverty and how poverty could be solved by the same methods and discipline and effort devoted to space, he would have liked to say to them: Solve your food vendors first! Solve your shoddy appliances first! your planned obsolescences! — then you may begin to think of how to attack the poverty of others. He was in a fury at the complacency of their assumption that they could solve the problems of the poor. His favorite man, Lyndon Johnson, was telling Walter

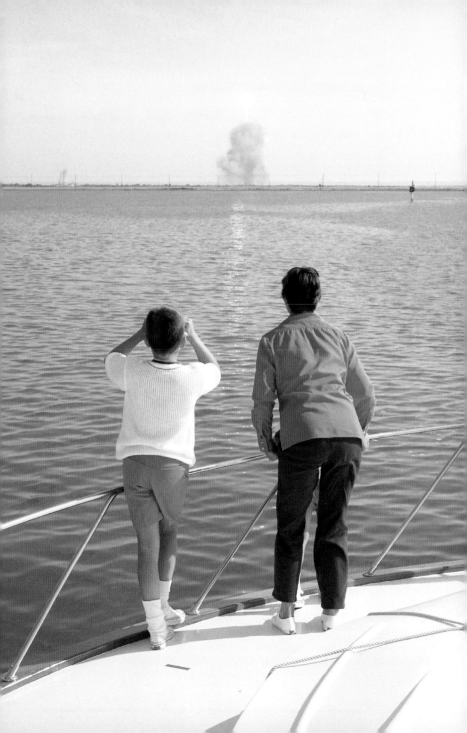

Cronkite on television, "There's so much that we have yet to do — the hunger in the world, the sickness in the world. We must apply some of the great talent that we've applied to space to these problems." Yes, his mouth poured forth cement.

Once Aquarius had gone — in payment for a professional debt and so against his will — to a show at the Jewish Museum in New York. Over the years, a photographer named Clayton had taken photographs of the poor, of the very poor, of Southern Black faces so poor they were tortured by hunger. Remarkable faces looked back at him, the faces of saints and ogres, of emaciated angels and black demons, martyrs, philosophers, mummies and misers, children with the eyes of old vaudeville stars, children with faces like midgets and witches, children with eyes which held the suffering of the lamb. But they were all faces which had gone through some rite of passage, some purification of their good, some definition of their remaining evil — how loyal could evil be to people so poor?

* * *

The voice of the Public Affairs Officer came out of the loudspeaker mounted on a speaker's platform on the grass in front of the grandstand.

Because of the distance, no one at the Press Site was to hear the sound of the motors until fifteen seconds after they had started. Although the rocket was restrained on its pad for nine seconds in order for the motors to multiply up to full thrust, the result was still that the rocket began to rise a full six seconds before its motors could be heard. Therefore the lift-off itself seemed to partake more of a miracle than a mechanical phenomenon, as if all of huge Saturn itself had begun silently to levitate, and was then pursued by flames.
— Norman Mailer

Opposite: At least 3,493 journalists from 55 countries attended the launch. Here, *LIFE* photographer Henry Groskinsky focused on the launch pad from the Press Site. *Photo, John Iacono.*

Following spread: The Apollo 11 moon shot. *Photo, Garry Winogrand.*

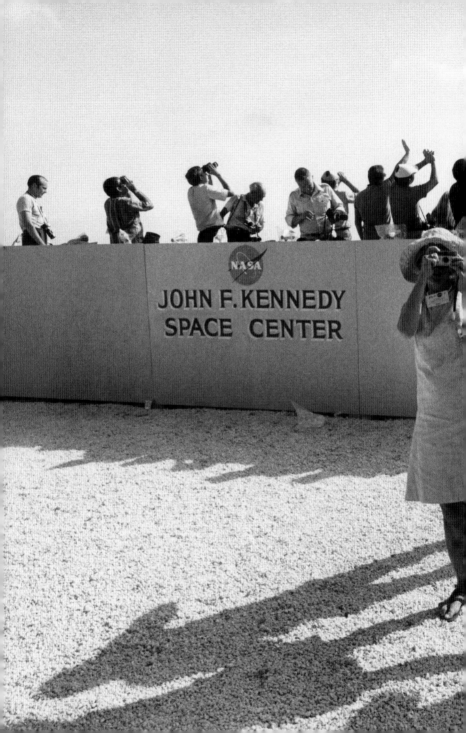

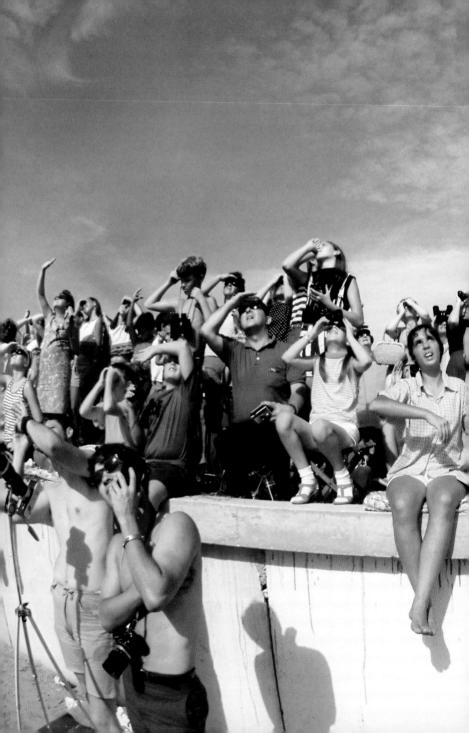

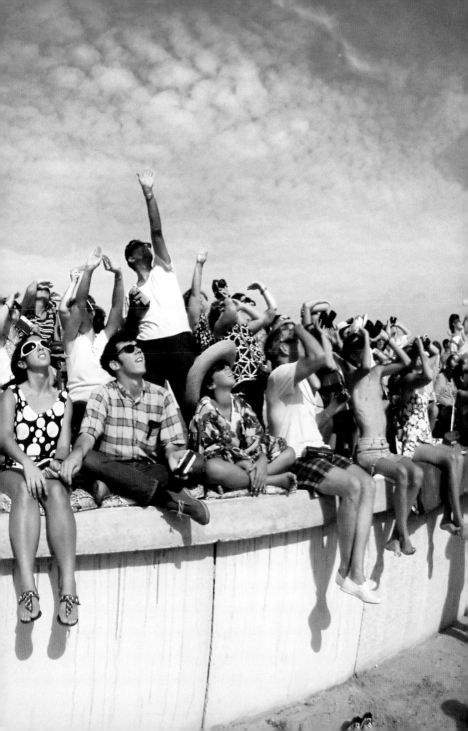

Many thousands of
feet up it went through
haze and the fire
feathered the haze in
a long trailing caress,
intimate as the wake
which follows the path
of a fingerling in inches
of water. Trailings of
cloud parted like lips.
Then a heavier cloud
was punched through
with sudden cruelty.
Then two long spumes
of wake, like two large
fish following our
first fish — one's heart
took little falls at the
changes. "Ahhh," the
crowd went, "Ahhh," as
at the most beautiful of
fireworks, for the sky
was alive, one instant
a pond and at the next
a womb of new turns:
"Ahhh," went the crowd,
"Ahhh!" — Norman
Mailer Previous spread:
Photo, Ralph Crane.

Dr. Kurt Debus, director,
Kennedy Space Center,
left, ends a flurry of
handshakes in the
Launch Control Center
after the successful
launch. Photo, NASA.

This is Apollo-Saturn Launch Control. T minus 61 minutes and counting—T minus 61 minutes on the Apollo 11 countdown, and all elements are Go at this time. Astronaut Neil Armstrong has just completed a series of checks on that big Service Propulsion System engine that sits below him in the stack. We want to assure ourselves before lift-off that that engine can respond to commands from inside the spacecraft. As Neil Armstrong moved his rotational hand controller we assured ourselves that the engine did respond by swiveling or gimbaling.

Opposite: Left to right, Charles Mathews, NASA deputy associate administrator, Office of Manned Space Flight; Wernher von Braun, director, Marshall Space Flight Center; George Mueller, NASA associate administrator, Office of Manned Space Flight; and Lt. Gen. Sam Phillips, director of the Apollo Program. *Photo, NASA/NGS.*

Aquarius felt chopped into fragments. The combination of waiting in line at the mechanical vendor, of undergoing Lyndon B. Johnson homiletics, batting his eyes against the heat, subduing his rage, passing through the disembodied experience of recall! — those Black faces in the photographs had been a sure planet apart from the faces of his fellow grubs in the Press Site at the white-painted grandstand — and now the voice on the public address system, bringing to the journalists of the world some of the intimate details of the countdown. Somewhere — not very far away in fact — some giant conception was being delivered, and the doctors were careful to provide many a detail.

We'll also check out the tracking beacons in the Instrument Unit that travels as a guidance system for the Saturn V during the powered phase of flight. Now 59 minutes 48 seconds and counting.

Yes, his brain was so chopped in fragments that he felt as if he had awakened with a hangover (which he had not quite) and had done nothing since but smoke and drink coffee, neither of which he had gone near, for he

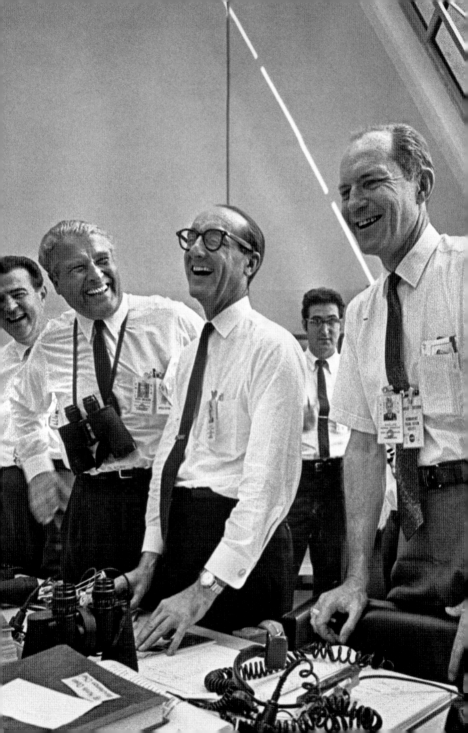

had not taken a cigarette in years and coffee was never his drink until night.

The Test Supervisor, Bill Schick, has advised all hands here to the Control Center and spacecraft checkout people that in about thirty seconds that big swing-arm that has been attached to the spacecraft up to now will be moved back to a parked position some five feet away from the spacecraft. It's coming up now in five seconds, the swing-arm will come back. Mark the swing-arm now coming back from the spacecraft. Countdown proceeding satisfactorily...

The voice was clear only if one forced oneself to listen to it. He tried to picture the scene in the Launch Control Center with hundreds of men scanning hundreds of consoles and computers, but there was not a real interest. He found himself going for a walk along the grass. Between the grandstand and the lagoon was a field about the size of a Little League baseball park and the photographers had all set themselves up at the edge of the water, their cameras with telephoto lenses set on tripods so that they looked from behind like a whole command of Army surveyors taking a lesson in their instrument. And the object on which they were focused, Apollo-Saturn, looked gray and indistinct across the air waves of heat shimmering off the lagoon.

Astronaut Buzz Aldrin in the middle seat. He's been working with the Spacecraft Test Conductor on setting up proper switch settings in preparation for pressurizing the reaction control system. These are these big thrusters on the side of the Service Module. There are actually sixteen of them in four quadrants around the Service Module. They are used for maneuvers in space.

Opposite: During the first seconds of flight, Saturn V's four outer engines were gimbaled slightly to nudge the vehicle away from the tower, just in case one of the swing arms was slow to retract or a gust of wind blew the vehicle closer. Once clear of the LUT, the vehicle began a slow roll, 18 degrees clockwise around its vertical axis, so that once the "pitch program" began at 31 seconds, it would start tipping down in its intended direction. *Photo, NASA.*

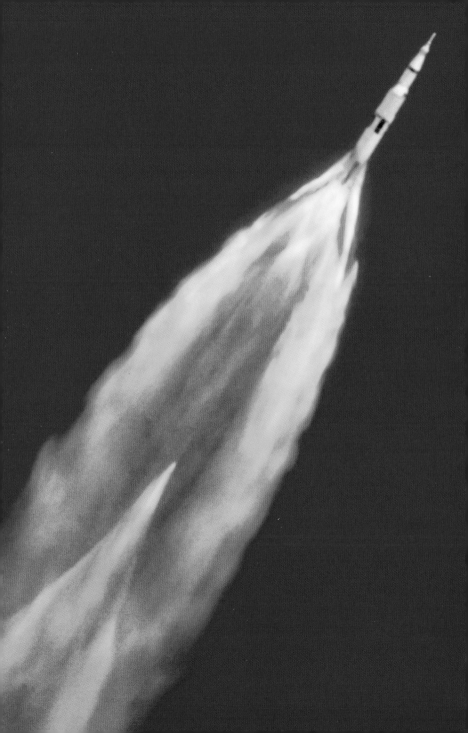

Shielding her eyes against the morning sun, Jan Armstrong watches the contrail of her husband's spaceship hang in the sky. *Photo, Vernon Merritt.*

Following spread: At 2 minutes, 41.7 seconds into the flight, the first-stage engines shut down. Once the first stage had been cut loose, forward-facing rockets mounted in the conical fairings at the base of the stage fired to push it backward, out of the way for the firing of the second-stage engines. With 2,114 tons (nearly 2,000 t) of propellant consumed, the first stage began the long fall to its final resting place at the bottom of the Atlantic. *Photo, NASA.*

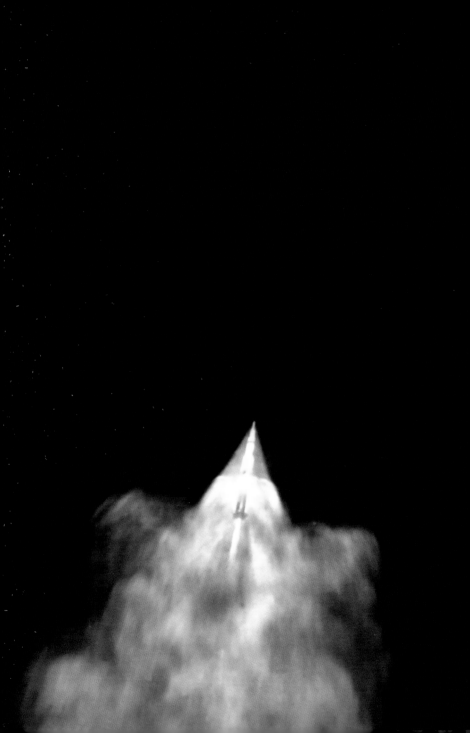

To the right of the photographers was a small grove of pure jungle. Recollections of his platoon on a jungle trail, hacking with machetes entered his head. A hash of recollections. He had thought he would be concentrating on the activities at the Launch Pad, the Control Center, in the Command Module, he had expected to be picturing the vitals of the rocket, and the entrance of the fuels into it, but he was merely out of sorts and with a headache, and waiting for the time to pass. He felt somehow deprived that he could feel so little. People had told him over and over that the sight of a large rocket going up was unforgettable and the sound would be remarkable, the ground would shake. It had begun to sound like an experience as mysterious and thoroughgoing as those first reverberations which had come to him in his early teens that there was a world of sexual intercourse out there, and it was unlike anything you and I had ever done. So, ridiculous as this, just as an adolescent would want his first real sexual hour to be at least approximately equal to his imagined pageant, so now Aquarius was cranky that nothing in his mood was remotely ready for the experience he had been promised. The damn astronauts weren't even real to him. He had no sense at all of three psyches full of awareness on the edge of the horizon. Just that gray stick out there.

Opposite: Spectacular fireworks signal the ignition of an array of rocketry that pulls the two halves of the Saturn V apart two minutes, 43 seconds into the flight. Four seconds later, the engines of the second stage ignite to begin the push to orbit. Half a minute on, and the huge interstage ring falls away from the bottom of the second stage, closely followed by the escape tower, which would have pulled the Command Module out of the way in the event of an emergency early in the flight. With the escape tower gone, the CM's five windows are now uncovered.
Photo, NASA.

Coming up shortly will be a key test here in the firing room as far as the launch vehicle people are concerned. It's some final checks of the destruct system aboard the three stages of the Saturn V launch vehicle. In the event during powered flight that the vehicle strayed rather violently off course, the range safety officer could take action to destroy the vehicle which

From the moment of lift-off the clock started ticking to splashdown and a final mission elapsed time of 8 days, 3 hours, 18 minutes, 35 seconds. Once the crew reached Earth's orbit, they checked the health of the spacecraft and took star sightings to refine the navigation data in their onboard computer. The interior of Columbia's cabin was photographed by personnel at every stage of the CSM closeout. Pictured here is the lower equipment bay, where Collins would carry out his navigational duties. *Photo, NASA.*

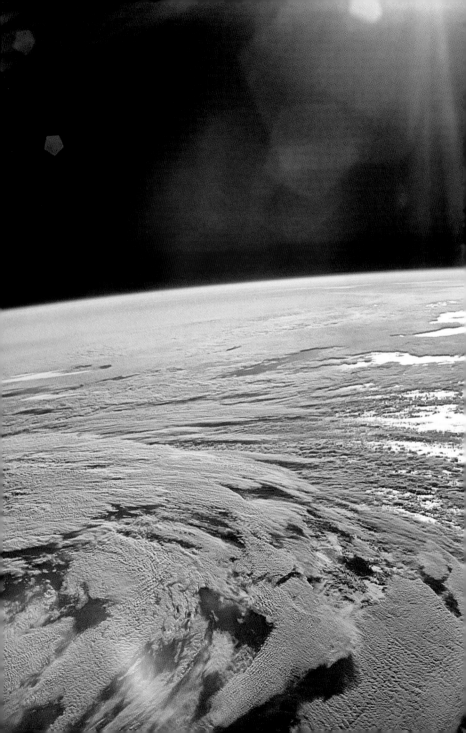

obviously would occur after the astronauts were separated by their escape tower from the faulty vehicle.

He remembered the questions he had asked in the VAB. How would they destroy the rocket if something went wrong? Why a longitudinal set of explosives lined up, as if in the seam of a tin can, would burst the stages. The belly of the rocket would open like a Caesarian. A flood of burning fuel would burst into the sky.

This is Apollo-Saturn Launch Control. We've passed the eleven-minute mark. Now T minus 10 minutes 54 seconds on our count-down for Apollo 11.

He began to look for a place from which to watch. The grandstand had a roof which would obstruct the view once the rocket was high in the air. But, standing on the field, he felt a hint too low. Finally he took up a careful position a few steps from the ground in a wing of additional bleachers. He was still not properly ready for the spectacle. Yes, the future spoke of a human species which would live on diets and occasional feasts, and would travel to spectacles to feel extraordinary sensations. They might even look at photographs of starving Black faces in order to generate some of their deepest thoughts. But he knew now why he was so irritated with everything and why he could not feel a thing. It was simple masculine envy. He too wanted to go up in the bird.

This is Apollo-Saturn Launch Control. We've passed the six-minute mark in our countdown for Apollo 11. Now 5 minutes 52 seconds and counting. Spacecraft Test Conductor Skip Chauvin now has completed the status check of his personnel in the

MISSION ELAPSED TIME 00:01:19:57 COLLINS: *Jesus Christ, look at that horizon!* **ARMSTRONG:** *Isn't that something?. . . Get a picture of that.* **COLLINS:** *Ooh, sure, I will. [Brief pause.] I've lost a Hasselblad.... Has anybody seen a Hasselblad floating by? It couldn't have gone very far, big son of a gun like that.*

Opposite: Occasionally the crew had time to take pictures out the windows, as seen in this view of Earth, south of Hawaii. Their high-quality Hasselblad electric cameras had no view-finders, but with some preflight practice the astronauts became proficient at proper aiming, focus, and f-stop settings. *Photo, NASA.*

Following spread: About 10 minutes after Translunar Injection (S-IVB), Mexico, with Baja California on the left. *Photo, NASA.*

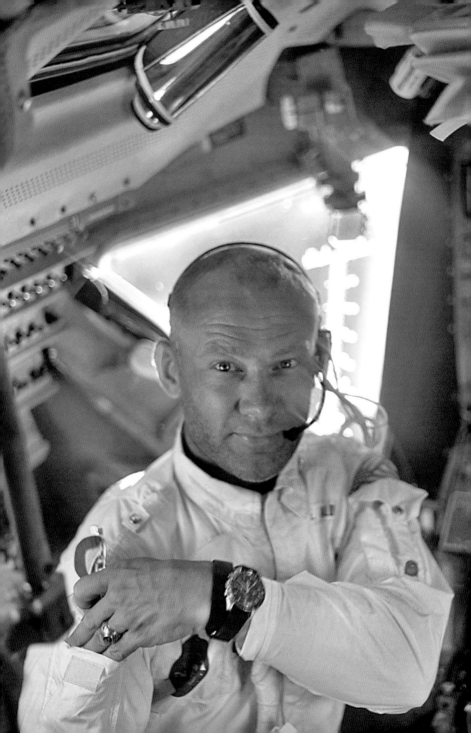

control room. All report they are *GO* for the mission. Launch Operations Manager Paul Donnelly reports *GO* for launch. Launch Director Rocco Petrone gives a *GO*. We're 5 minutes 20 seconds and counting. We took a good look at *EAGLE*, and it looks good. The Spacecraft Test Conductor for the Lunar Module reported that *EAGLE* was *GO*. The swing-arm now coming back to its fully retracted position as our countdown continues. T minus 4 minutes 50 seconds and counting. Skip Chauvin informing the astronauts that the swing-arm now coming back.

Nobody was talking a great deal. If something went wrong, they would all be implicated. Who would know which evil had entered the ripe oven of space technology? Aquarius took note of himself. Yes, his throat was dry.

We're now passing the four-minute thirty-second mark in the countdown—still *GO* at this time. Four minutes 15 seconds—the Test Supervisor now has informed Launch-Vehicle Test Conductor Norm Carlson you are *GO* for launch. We're now hitting the four-minute mark. Four minutes and counting. We are *GO* for Apollo 11. We'll go on an automatic sequence at 3 minutes and 7 seconds. Three minutes 45 seconds and counting. In the final abort checks between several key members of the crew here in the Control Center and the astronauts, Launch Operations Manager Paul Donnelly wished the crew on behalf of the launch team "Good luck and Godspeed." Three minutes 25 seconds and counting. We're still *GO* at this time. We'll be coming up on the automatic sequence in about 10 or 15 seconds from this time. All still *GO* at this time. Neil Armstrong reported back when he received the good wishes, "Thank you very much. We know it will be a good flight." Firing command coming in now. We are on the automatic sequence. We're approaching the

The Command Module was at once a workshop, a submarine, a pilot-house...a cockpit, a radio station...an observatory...a bedroom. —Norman Mailer Opposite: During the third day of their coasting flight to the moon, Armstrong photographed Aldrin during a scheduled inspection of the LM cabin. Photo, NASA.

002:08:28 ALDRIN: *Okay. For those of you that don't know, this is where we log most of our data for each of the LM maneuvers...it's on this timeline that we have all our procedures. But we obviously have to hold these in place in zero-G, so we make use of the Velcro patches on the back and on the table so we can attach these down here...* *Following spread: As Aldrin worked to prepare* Eagle's *cabin for arrival at the moon, he and cameraman Armstrong gave the viewers on Earth a tour of the LM cabin. Television stills, NASA.*

three-minute mark in the count. T minus 3 minutes and counting. T minus 3 — we are GO with all elements of the mission at this time.

He had his binoculars to his eyes. A tiny part of him was like a penitent who had prayed in the wilderness for sixteen days and was now expecting a sign. Would the sign reveal much or little?

Industry has taken a crack at it, and the solution is to dehydrate the food, then pack it in air-tight containers. All the Astronaut has to do is open the bag and add water — with a hose attachment like the one shown [here] with one day's menu: scrambled eggs, orange juice and milk; lunch of grape juice, curried chicken, carrots and rice pudding (at top left); dinner of shrimp cocktail, beef with mushroom gravy, mixed vegetables and chocolate pudding. — LIFE, *September 27, 1963* Opposite: An early menu of Gemini-era dehydrated food. *Photo, Ralph Morse.*

...all is still GO as we monitor our status for it. Two minutes 10 seconds and counting. The target for the Apollo 11 astronauts, the moon. At lift-off we'll be at a distance of 218,096 miles away. Just passed the two-minute mark in the countdown. T minus 1 minute 54 seconds and counting. Our status board indicates that the oxidizer tanks in the second and third stages now have pressurized. We continue to build up pressure in all three stages here at the last minute to prepare for lift-off. T minus 1 minute 35 seconds on the Apollo mission, the flight that will land the first man on the moon. All indications coming in to the Control Center at this time indicate we are GO. One minute 25 seconds and counting. Our status board indicates the third stage completely pressurized. Eighty-second mark has now been passed. We'll go on full internal power at the fifty-second mark in the countdown. Guidance system goes on internal at 17 seconds leading up to the ignition sequence at 8.9 seconds. We're approaching the sixty-second mark on the Apollo 11 mission. T minus 60 seconds and counting. We have passed T minus 60. Fifty-five seconds and counting. Neil Armstrong just reported back, "It's been a real smooth countdown." We have passed the fifty-second mark. Forty seconds away from the Apollo 11 lift-off. All the second-stage tanks now pressurized. Thirty-five seconds and counting. We are still GO with Apollo 11. Thirty seconds and counting. Astronauts reported, "Feels good." T

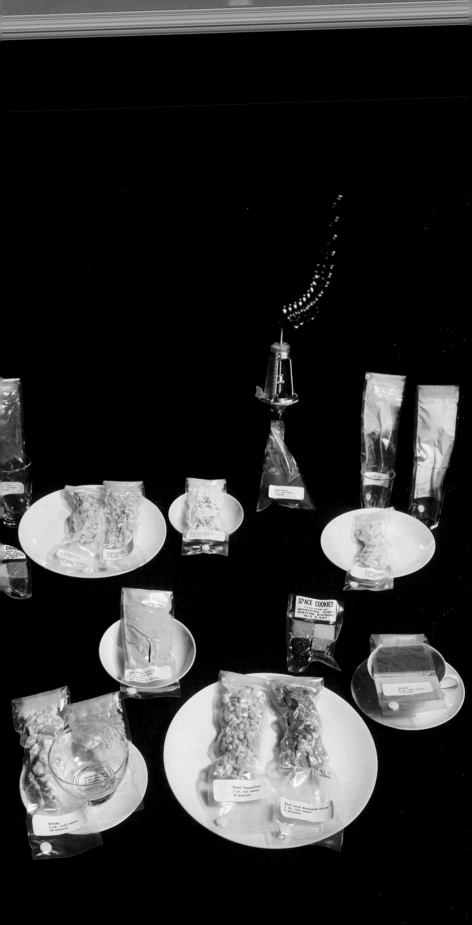

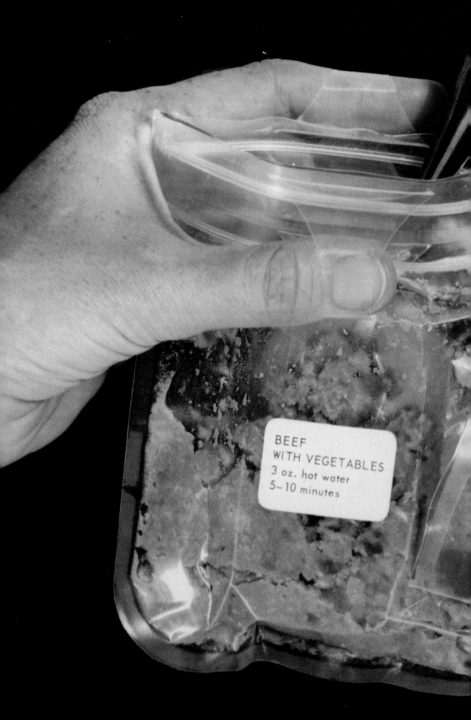

BEEF
WITH VEGETABLES
3 oz. hot water
5–10 minutes

My appetite was off on the first two or three days of the flight, I would say. After that, it was close, if not equal, to my usual ravenous ground appetite.
— *Mike Collins, Apollo 11 Debriefing, July 31, 1969* Unlike the space program's early days, some of Apollo 11's foods, including this package of beef with vegetables, could be eaten with a spoon. "The new foods," Armstrong stated in the July 31 debriefing, "are significantly improved and welcome additions to the menu." Collins later admitted to the *Los Angeles Times* that "for about a year, I have been trying to get huevos rancheros on the flight menu, but it has been found that they don't dehydrate very well." *Photo, Bettmann/Corbis.*

Nashville Banner

Apollo Reaches For Moon

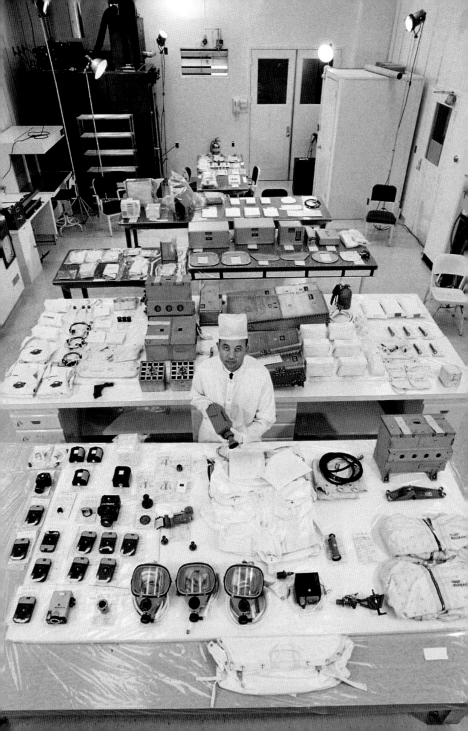

minus 25 seconds. Twenty seconds and counting. T minus 15 seconds, guidance is internal, 12, 11, 10, 9, ignition sequence start, 6, 5, 4, 3, 2, 1, zero, all engines running, *LIFT-OFF*. We have a lift-off, 32 minutes past the hour. Lift-off on Apollo 11.

But nobody watching the launch from the Press Site ever listened to the last few words. For at 8.9 seconds before lift-off, the motors of Apollo-Saturn leaped into ignition, and two horns of orange fire burst like genies from the base of the rocket. Aquarius never had to worry again about whether the experience would be appropriate to his measure. Because of the distance, no one at the Press Site was to hear the sound of the motors until fifteen seconds after they had started. Although the rocket was restrained on its pad for nine seconds in order for the motors to multiply up to full thrust, the result was still that the rocket began to rise a full six seconds before its motors could be heard. Therefore the lift-off itself seemed to partake more of a miracle than a mechanical phenomenon, as if all of huge Saturn itself had begun silently to levitate, and was then pursued by flames.

No, it was more dramatic than that. For the flames were enormous. No one could be prepared for that. Flames flew in cataract against the cusp of the flame shield, and then sluiced along the paved ground down two opposite channels in the concrete, two underground rivers of flame which poured into the air on either side a hundred feet away, then flew a hundred feet further. Two mighty torches of flame like the wings of a yellow bird of fire flew over a field, covered a field with brilliant yellow bloomings of flame, and in the midst of it, white as a ghost, white as the white of Melville's Moby Dick, white as the shrine of the

APOLLO REACHES FOR MOON — The Nashville Banner, *July 17, 1969*
Previous spread: Joan Aldrin reads the day's headlines in her Houston kitchen the day after launch. *Photo, Lee Balterman.*

Opposite: The Apollo 11 Command Module Stowage List contained approximately 350 items, with a total weight of around 830 pounds (386 kg). All objects that would go into flight were handled in a clean room by Ed Hoskins and his Flight Crew Support Team. Here, in 1968, Hoskins is surrounded by the gear that the Apollo 7 crew carried on their ten-day mission in Earth's orbit. *Photo, Ralph Morse.*

Madonna in half the churches of the world, this slim angelic mysterious ship of stages rose without sound out of its incarnation of flame and began to ascend slowly into the sky, slow as Melville's Leviathan might swim, slowly as we might swim upward in a dream looking for the air. And still no sound.

Then it came, like a crackling of wood twigs over the ridge, came with the sharp and furious bark of a million drops of oil crackling suddenly into combustion, a cacophony of barks louder and louder as Apollo-Saturn fifteen seconds ahead of its own sound cleared the lift tower to a cheer which could have been a cry of anguish from that near-audience watching; then came the earsplitting bark of a thousand machine guns firing at once, and Aquarius shook through his feet at the fury of this combat assault, and heard the thunderous murmur of Niagaras of flame roaring conceivably louder than the loudest thunders he had ever heard and the earth began to shake and would not stop, it quivered through his feet standing on the wood of the bleachers, an apocalyptic fury of sound equal to some conception of the sound of your death in the roar of a drowning hour, a nightmare of sound, and he heard himself saying, "Oh, my God! oh, my God! oh, my God! oh, my God! oh, my God! oh, my God!" but not his voice, and the sound of the rocket beat with the true blood of fear in ears, hot in all the intimacy of a forming of heat, as if one's ear were in the caldron of a vast burning of air, heavens of oxygen being born and consumed in this ascension of the rocket, and a poor moment of vertigo at the thought that man now had something with which to speak to God — the fire was white as a torch and long as the rocket itself, a tail of fire, a face, yes now the rocket looked like a thin and

It is almost unbelievable that the culmination of a $20 billion program is to be recorded in such a stingy manner.
— Maxime Faget, MSC director of Engineering and Development, in a February 27, 1969, NASA internal memo

Television from the moon was not originally high on the agenda of the engineering-dominated NASA. It was only in the last few months prior to Apollo 11 that pressure from the media, some NASA staff, and a few astronauts led to the decision to actually broadcast the event live. Westinghouse supplied two television cameras: a color unit for the CM, and a lighter-weight black-and-white unit for use on the lunar surface. This 4,5 pound RCA model, pictured with lead developer Dick Dunphy in 1968, never made it to the moon. *Photo, NASA.*

pointed witch's hat, and the flames from its base were the blazing eyes of the witch. Forked like saw teeth was the base of the flame which quivered through the lens of the binoculars. Upwards. As the rocket keened over and went up and out to sea, one could no longer watch its stage, only the flame from its base. Now it seemed to rise like a ball of fire, like a new sun mounting the sky, a flame elevating itself.

Many thousands of feet up it went through haze and the fire feathered the haze in a long trailing caress, intimate as the wake which follows the path of a fingerling in inches of water. Trailings of cloud parted like lips. Then a heavier cloud was punched through with sudden cruelty. Then two long spumes of wake, like two large fish following our first fish — one's heart took little falls at the changes. "Ahhh," the crowd went, "Ahhh," as at the most beautiful of fireworks, for the sky was alive, one instant a pond and at the next a womb of new turns: "Ahhh," went the crowd, "Ahhh!"

Now, through the public address system, came the sound of Armstrong talking to Launch Control. He was quieter than anyone else. "Inboard cutoff" he said with calm in his voice.

Far in the distance, almost out of sight, like an all-but-transparent fish suddenly breaking into head and tail, the first stage at the rear of the rocket fell off from the rest, fell off and was now like a man, like a sky diver suddenly small. A new burst of motors started up, some far-off glimpse of newborn fires which looked pale as streams of water, pale were the flames in the far distance. Then the abandoned empty stage of the booster began to fall away, a relay runner, baton just passed, who slips back, slips back. Then it began to tumble, but with the slow tender dignity of a thin slice

The suit costs $100,000 and the taxpayer is going to have to pay for dozens of them. But considering the work and material that goes into it and the unearthly wear and tear it is going to get, it may be an off-the-gantry bargain.
—LIFE, *August 9, 1968*

Opposite: Custom-fitted suits made of 21 layers of carefully chosen synthetics provided protection against fire, overheating in direct sunlight, excessive cooling in deep lunar shadow, punctures, abrasion, and, of course, the lunar vacuum. Photographed here in a Dover, Delaware, assembly plant, the various layers are displayed—from the outermost fireproof Beta fiber (on the suited subject) to the alternating layers of aluminized plastic (black) and Beta cloth (blue) in the front row, all the way back to the inner layer of nylon chiffon. *Photo, Ralph Morse.*

Opposite: Aldrin's suit, the Torso Limb Assembly, shown here with its accessories, clockwise from top: communications carrier cap, pressure helmet, fecal containment device, bio-harness belt, bio-harness sensors and leads, EVA overshoes, EVA gloves, liquid cooling garment with pressure relief valve assembly lying on top, wristwatch (Omega Speedmaster), and urine collection assembly. Collins's suit differed somewhat from those of his crewmates because he was not expected to venture outside the spacecraft: It had two fewer gas connectors, no water connector, and a less bulky cover layer on the TLA. *Photo, NASA.*

of soap slicing and wavering, dipping and gliding on its way to the floor of the tub. Then mighty Saturn of the first stage, empty, fuel-voided, burned out, gave a puff, a whiff and was lost to sight behind a cloud. And the rocket with Apollo 11 and the last two stages of Saturn V was finally out of sight and on its way to an orbit about the earth. Like the others he stayed and listened to the voices of the astronauts and the Capcom through the P.A. system.

PUBLIC AFFAIRS OFFICER: At 3 minutes, downrange 70 miles, 43 miles high, velocity 9,300 feet per second.

ARMSTRONG: We've got skirt sep[aration].

CAPSULE COMMUNICATOR: Roger, we confirm. Skirt sep[aration].

ARMSTRONG: Tower is gone.

CAPCOM: Roger, tower.

PAO: Neil Armstrong confirming separation and the launch escape tower separation.

ARMSTRONG: Houston, be advised the visual is Go today.

On the way back to Cocoa Beach there was a monumental traffic jam, and Aquarius had time to look at objects by the road. There was a parked trailer with a twelve-foot inflated rubber rocket — it looked like a condom with a painted tip. Down its length ran a legend.

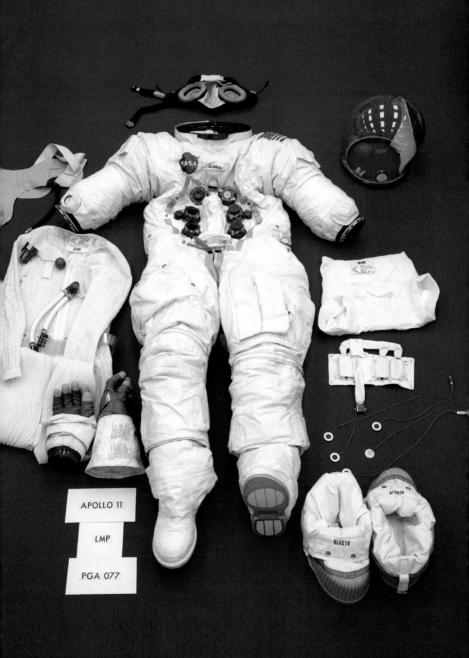

APOLLO 11

LMP

PGA 077

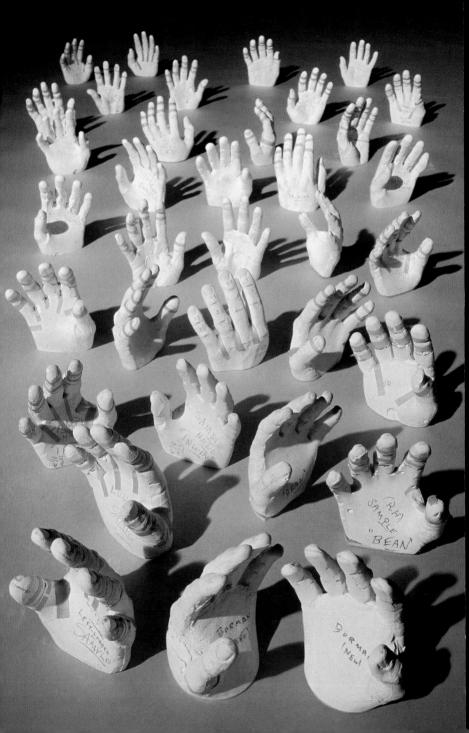

GOOD

LUCK

A

P

O

L

L

O

I I

Montg.

Ala.

Opposite: Plaster casts used to make custom gloves for each astronaut. The hands were held in the rest position, fingers and thumb slightly curved inward, since gloves in this position are easiest to use. *Photo, Ralph Morse.*

The radio was playing in the car. Fred Something-or-other from the Titusville Chamber of Commerce was talking fast. "And when the folks who were visiting this launch here go home, I want them to tell every-body how beautiful it was from Titusville." "Folks,"

Everything from space-suits to pipe welds was X-rayed prior to mission to ensure that foreign objects were not embedded in the flight contents. Here, an X-ray of Armstrong's lunar overshoes ensured that there were no needle points or pins that could puncture the pressure suit. *X-ray, NASA/ Lotzmann.*

Following spread: A detail of Aldrin's left glove shows the lunar-surface checklist sewn onto the gauntlet. *Photo, NASA.*

<u>LMP (CDR)</u>

ENVIR FAM (TV DEPLOY)
DEPLOY SWC
EVA & ENVIR EVAL-(BULK S)
 LEAN/REACH/WALK
 BEST PACE/START/STOP
 FAST PACE/TRACTION/DUST
 PENE-PHOTO FOOTPRINT
 SCUFF/COHESION/ADHESION
 GEN EVA EVAL
 LIGHT-UP/DOWN/CROSS SUN
 COLOR/CONTRAST/TEXTURE
 REFLECT/ROCKS/CRATERS
 GEN EVAL/PHENOMENA
 PANORAMA
LM INSPECT - QUAD I
 PHOTO BULK SAM AREA
 UNSTOW ALSCC

PANORAMA
OFF-LOAD EASEP/DEPLOY PSE
CLOSE-UP PHOTOS
DOCUMENTED SAMPLE COL:
 SRC TO STRUT
 UNSTOW SRC
 CORE TUBE (HOOK BAG)
 UNSTOW SCOOP & TONGS
 DESCRIBE & COL SAM-
 FEATURE/ASSOC
 AGE/AMOUNT
CLOSE-UP PHOTOS/CASETTE
COLLECT ENVIR/GAS SAM
 BULK SAM/CORE TUBE
CLEAN EMU/INGRESS(PHOTO)

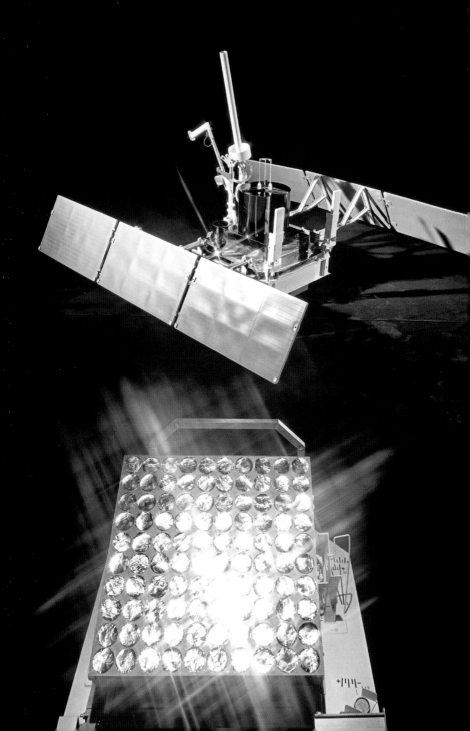

said an announcer, "get in on the Apollo 11 Blast-off Sale." The radio had lost no time.

America — his country. An empty country filled with wonders.

Aquarius did not know how he felt. He was happy all afternoon and went surfboarding for the first time, not even displeased that it was harder than he thought to stand up.

In the evening he left Cocoa Beach to fly back to Houston where he would cover the trip to the moon and back. On the flight, everybody was drunk, and the hostesses were flip and hippy and could have been drinking themselves. The Southern businessmen were beaming.

In the late edition he brought with him, Aquarius read that the Reverend Abernathy together with a few poor families had watched the launching from the VIP area, after making a request of Dr. Thomas O. Paine, Administrator of NASA, for special badges. "If it were possible for us not to push the button tomorrow and solve the problems with which you are concerned, we would not push the button," Dr. Paine said.

Answered the Reverend Abernathy after the launch, "This is really holy ground. And it will be more holy once we feed the hungry, care for the sick, and provide for those who do not have houses."

Aquarius thought more than once of how powerful the vision of Apollo-Saturn must have been for the leader of the Poor People's Crusade. Doubtless he too had discovered that his feet were forced to shake. However, Aquarius was not yet ready to call this hallowed ground. For all he knew, Apollo-Saturn was still a child of the Devil. Yet if it was, then all philosophers flaming in orbit, the Devil was beautiful indeed. Or

Opposite: Two experiments to be left behind on the moon by the crew of Apollo 11. The Passive Seismometer, top, was designed to pick up geologic vibrations on the lunar surface. The Laser Ranging Retro-Reflector, below, had a set of so-called corner-cube reflectors that sent laser pulses back to the Earth-bound observatories that sent them. Measurement of the round-trip travel time for a single pulse gave a precise distance between the Earth and the moon. Such measurements are still being made and have proved very useful in determining the relative motions of the Earth and moon and of Earth's crustal plates, and in important tests of Einstein's General Theory of Relativity. *Photo, Yale Joel.*

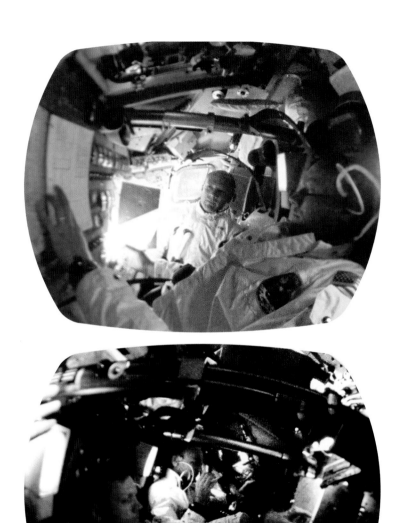

rather, was the Devil so beautiful because all of them, Johnsons, Goldwaters, Paines, Abernathys, press grubs and grubby Aquarius, were nothing but devils themselves. For the notion that man voyaged out to fulfill the desire of God was either the heart of the vision, or anathema to that true angel in Heaven they would violate by the fires of their ascent. A ship of flames was on its way to the moon.

Opposite: Aldrin and Armstrong in the CM prior to transfer to the LM. *Television stills, NASA/Copp.*

A Trajectory to the Moon

The astronauts, lying on their backs, unable to see out the Command Module for the first few minutes with the heat shield covering their windows like a blanket, would feel this dynamic pressure at a minute and twenty seconds after lift-off, fifteen seconds after breaking through the sound barrier. Acceleration would continue, and as in a centrifuge or a mechanical whip, their body-weight would go up to 2 G's, 3 G's, to close to four times their own weight, their eyes would feel a mean pressure, but 4 G's was not intolerable for an astronaut — they were familiar with high-speed dives in test planes and gravity simulators.

Opposite: Fifty-six minutes, 32 seconds after the hatch opened, Aldrin compared what happened when he pushed his boot through the soil to what was seen when the unmanned Surveyor experimenters commanded the mechanical scoop to do the same. Designed to get close-up information about the character of the lunar surface, its ability to support the LM's weight, and what the astronauts might expect when they walked on it, Surveyor I landed on the Ocean of Storms on June 2, 1966. *Photo, NASA/JPL.*

If there is a crossing in the intellectual cosmos where philosophical notions of God, man and the machine can come together it is probably to be found in the conceptual swamps which surround every notion of energy. The greatest mystery in the unremitting mysteries of physics must be the nature of energy itself — is it the currency of the universe or the agent of creation? The basic stuff of life or merely the fuel of life? the guard of the heavens, or the heart and blood of time? The mightiest gates of the metaphysician hinge on the incomprehensibility yet human intimacy of that ability to perform work and initiate movement which rides through the activities of men and machines, and powers the cycles of nature.

Still, the laws describing the behavior of energy are sound, they are usually simple — they may be called fundamental for their results do not vary. If, on consideration, it might still be a mystery why a liquid, a solid or a gas can store energy which is capable of prodigies of work once the forces are released, still the precise results of such liberation of energy have been well studied. In three centuries, physics has moved out of the rough comprehension that shifts in matter from solid to liquid, or liquid to gas, involve discharges of energy, to an application of that knowledge onto half the working technology of the world. So the employment of such principles in the design of rockets has been no great work for physics. The physics is simple.

The burning gases which push out of the throat of the rocket engines push back against the rocket itself. Therefore, the rocket can rise, thereby can it defy gravity once the push produced by the expansions of the burning fuel is greater than the pull of gravity upon the ship. Therefore it does not matter

Surveyor 7 sent back 6,000 pictures of the highlands near the Tycho Crater, an aspect of the moon's southern surface never seen before. This magnificent picture, stretching eight miles from the camera, is an accurate composite fashioned from 219 of Surveyor's individual frames. —LIFE, *January 26, 1968 Opposite:* The Apollo 11 target area — or "landing ellipse"—is, on average, one of the least hazardous places to land on the moon. There are craters, there are some large rocks, but in between there are plenty of good places to land. The chances were excellent that Armstrong would be able to find a place to put down. Tycho is a site of enormous scientific potential but with so much rugged ground that even sending the last of the unmanned Surveyors to the rim was a considerable risk. *Photo, NASA/JPL.*

if the rocket is on the ground or in the clouds — it does not lift by pushing against the earth, or in flight by pushing against the air, no, it is rather the simple push of the escaping flames against the ship itself which gives thrust to the voyage. Once entered into that bay of space between the earth and the moon where the effects of gravity are hardly to be noticed, so the weight of the ship and the men in it are hardly to be noticed.

But that will be later. On the ground, the full force of gravity is present: if the ship weighed six and a half million pounds, it would need as much force, and a little more to lift it. In fact, its thrust would be designed to reach up to seven million seven hundred thousand pounds in those nine seconds before the four hold-down arms were released and the rocket began to rise. It could have risen with less force, it could theoretically have drifted upward at the very moment the thrust was minutely greater than the force of gravity, but that was an impractical mode of ascent, for the smallest loss of thrust at such a critical moment would have obliged the rocket to collapse back and topple on its pad. It was the life experience of such rocket engineers as Von Braun, rather than the laws of physics, which decreed that Apollo-Saturn be chained to its base until the thrust upward was a million two hundred thousand pounds greater than its weight. For that reason, it was manacled by four giant metal hold-down arms. You can be certain there had been cracks in the early forgings of test metals of the hold-down arms for they were not easy to design, being massive in size yet required to let go their million-pound grip on the split part of an instant. The unlatching interval for the four arms had to be all but simultaneous — the

Surveyor's success brought closer the day when astronauts will board the Saturn rocket to attempt the first American man landing on the moon. . . . Its gentle touchdown — and the photographs and other data it is radioing back — have already given the scientists confidence in their design for the Lunar Excursion Module.
— LIFE, *June 10, 1966*

Previous spread: The footpad of Surveyor 5, which landed in Mare Tranquillitatis on September 11, 1967. The camera, mounted to the craft's exterior, does not move, but takes pictures reflected in the mirror, which turns and tilts in all directions. *Photo, NASA/JPL.*

Opposite: Rocco Petrone, director of Launch Operations at Kennedy Space Center, indicates the Apollo 11 landing site on a lunar nearside map on July 12, 1969. *Photo, Jim Kerlin.*

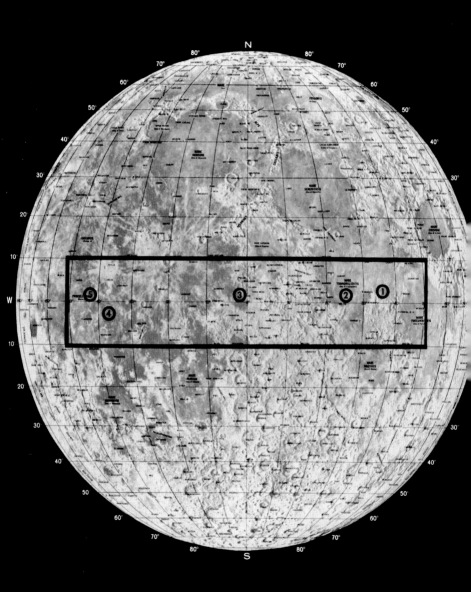

separation was geared not to exceed one-twentieth of a second for its duration: in fact if any of the four arms had failed to complete their operation in more than a fifth of a second, the liberation would have been effected by properly placed explosives. With one million excess pounds pushing it, Saturn V was hardly to be kept back on one side while being released on the other — it would have begun to pitch over — yet note that even with all four hold-down arms sprung at once, the rocket ship was still restrained for the first few inches of travel. Something exactly so simple as eight tapered pins had each to be drawn through its own die — as the vehicle rose through the first six inches of flight, each die was obliged to straighten the taper in its own iron pin — the eight dies to travel up with the ship, the eight shucked pins to be left in their fastenings on the hold-down brackets. If not for such a simple mechanism, Apollo-Saturn might have leaped off its pad fast enough to set up a resonance, then a vibration strong enough to shake the ship and some thousands of its instruments too critically. For consider: if when empty, the space vessel weighed less than half a million pounds, it was now carrying a weight of fuel twelve times greater than itself. But there were no bones or muscles in this fuel, nothing in the fuel to hold the ship together, just liquids to slosh and shake and seek to distort the rigidity of the structure. Most of the spaceship was nothing but its own fuel tanks, and there were few places where the hide of the rocket was more than a quarter of an inch in thickness and sometimes so thin as one-twenty-fifth of an inch, and aluminum alloy at that, places where the fuel tank was literally the skin. Of course the ship had corrugations in its surface for stiffening and bulkheads for bracing,

You could feel the tension. . . . The people knew this was the big one. There was a certain amount of, let's say, static electricity in the air. — Rocco Petrone, quoted in **The New York Times, 1969,** *on the Apollo 11 launch Opposite:* Map of the moon's nearside, including the five sites nominated for the first landing. Only one of these sites would be visited, with Apollo 11 landing at Site 2 in the east. *Map, NASA.*

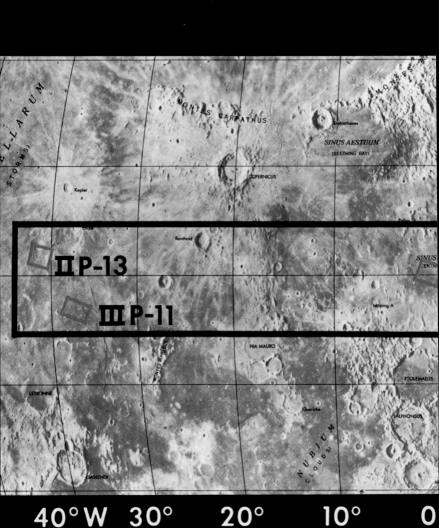

II P-13

III P-11

40°W 30° 20° 10° 0

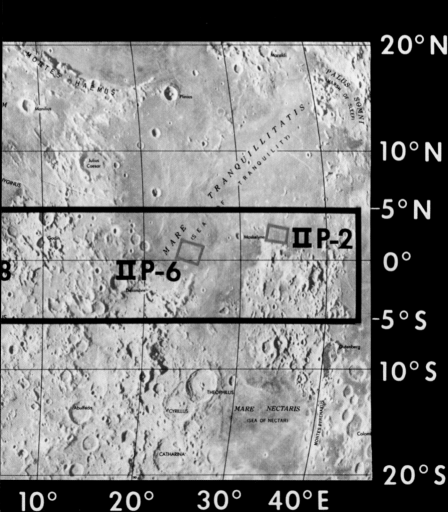

which also served neatly as baffle plates to reduce the sloshing of the fuels. Even so, one would look to reduce every quiver in so delicate a structure — the restraining pins performed just such a function for the first half-foot of ascent.

In the course of this act, at an instant when the spaceship was not yet three-quarters of an inch off the ground, specific switches on the hold-down arms tripped loose a pneumatic system which gave power to surges of compressed gas which ran in pipes up the great height of the launching tower: the gas tripped the couplings of the five service bridges still connected to the rocket. Their umbilicals now detached, these arms pulled away as the ship began to rise. Six inches up, and loose from the pins, the stages of Apollo-Saturn climbed up the stories of the Mobile Launcher, climbed up on its self-created base of flame, up past the flying withdrawal of its bridges and its umbilicals. To clear the tower, to be free of any sudden gust of wind which might lash it sideways, a yaw maneuver, programmed into the rocket, was initiated one second after lift-off, and turned the nose a few degrees from the vertical further away from the tower. For the onlookers three and one-half miles away, the rocket appeared to waver, then stagger. In fact, it did.

There was wind blowing, and the rocket had been designed not to fight wind (it was not stressed for that) but to give way to wind, to relinquish the trajectory it was on, and compute a new trajectory from the slightly different position where the gust had just left it. So separate commands kept issuing from the Instrument Unit at the top of Saturn, sometimes every half-second, and the motors kept responding with little spurts and sags of speed. The result was a series of lurches

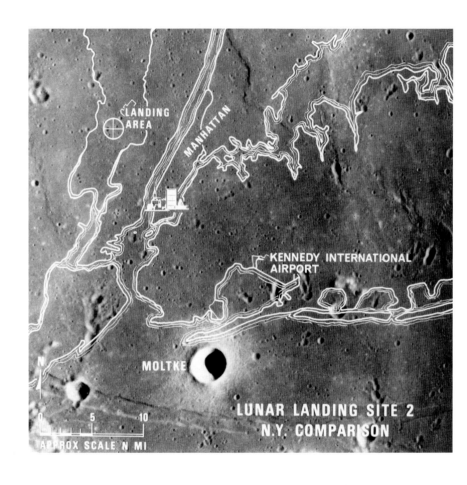

LANDING
AREA

MANHATTAN

KENNEDY INTERNATIONAL
AIRPORT

N

MOLTKE

0 5 10

APPROX SCALE N MI

LUNAR LANDING SITE 2
N.Y. COMPARISON

and bumps in the first few seconds. "Very rough," said Collins afterward, "very busy....It was steering like crazy. It was like a woman driving her car down a very narrow alleyway...She keeps jerking the wheel back and forth...a nervous, very nervous lady... I was glad when they called Tower Clear because it was nice to know there was no structure around when the thing was going through its little hiccups and jerks." That was after eight seconds. At close to twelve seconds, the four outboard engines were swiveled through a few degrees, a pitch maneuver was initiated, and a roll. The roll would end in twenty seconds, the shift in pitch would continue for two minutes and twenty-five seconds by which time the rocket would be climbing no longer straight up, but rather at a reasonable angle close to twenty-five degrees from the horizontal, and would have already passed through the severest structural strains of its trip. The astronauts, lying on their backs, unable to see out the Command Module for the first few minutes with the heat shield covering their windows like a blanket, would feel this dynamic pressure at a minute and twenty seconds after lift-off, fifteen seconds after breaking through the sound barrier. Acceleration would continue, and as in a centrifuge or a mechanical whip, their body-weight would go up to 2 G's, 3 G's, to close to four times their own weight, their eyes would feel a mean pressure, but 4 G's was not intolerable for an astronaut — they were familiar with high-speed dives in test planes and gravity simulators.

Besides they were lying on their backs — the blood would not drain from their heads. All this while, the noise of the rocket motors, if sounding like a prelude of apocalypse to the spectators on the ground, was no more than a quiet rumble in the sealed conical volume

Opposite: A map of the New York City vicinity is superimposed on the area near the landing site to show scale. The landing ellipse is about the same width as crater Moltke but four times its length; the area explored on foot was was only the size of a soccer field. *Photo, NASA.*

Following spread: On each of the orbits that the CSM made around the moon, it traveled across the nearside from east to west. During the Powered Descent, the LM also approached the landing site from the east. About three minutes into the Powered Descent, Armstrong checked the time as they passed over the crater Maskelyne W (renamed Wash Basin by the astronauts). They went over the crater about three seconds earlier than planned, which prompted Armstrong to tell Houston, "Our position checks downrange show us to be a little long." Nine minutes and 22 seconds later, they were on the ground at Tranquility Base, almost four miles (around 6 km) beyond their target. *Photo, LPI.*

of the Command Module. If not for the five numbered Launch Vehicle Engine Lights on a dial before them, they could not know if a single motor went out; the volume of sound in the cabin was not high enough to distinguish the difference.

Indeed there was not that much in those moments for the astronauts to do. The first eleven and a half minutes would be spent in reaching up into an earth orbit. The firing of the motors, their cutoff, the guiding commands and the separation of the stages would take place as part of a sequence which had already been programmed into the Instrument Unit of the launch vehicle. The astronauts were effectively in automatic flight. They would have no need to touch a flight control unless something went wrong. Indeed their work in these early minutes was to watch the dials and so be on the alert for the first hint of any malfunction in a system or subsystem vital to this portion of the trip. Listen to how little is said by them through the first three minutes of flight. Of course they are flying on their backs and the weight of their intense acceleration lies like lead on their tongue.

Opposite: July 16, 3 hours. Like a car kept in a garage, *Eagle*, the LM, had been kept within the adapter section at the top of the rocket. Three hours after launch, it was time to pull it out of its garage, and Mike Collins maneuvered *Columbia* around to face *Eagle* before easing in to dock with the LM.

ARMSTRONG: Rolls complete and a pitch is program. One Bravo.
CAPCOM: All is well at Houston. You are good at one minute ... Stand by for Mode 1 Charlie Mark Mode 1 Charlie.
ARMSTRONG: 1 Charlie.
CAPCOM: This is Houston, you are Go for staging.
ARMSTRONG: Inboard cutoff.
CAPCOM: Inboard cutoff.
ARMSTRONG: Staging and ignition.
CAPCOM: 11, Houston. Thrust is Go all engines. You are looking good.
ARMSTRONG: Roger. Hear you loud and clear, Houston.

Opposite: Prior to docking, Collins used a target mounted on top of *Eagle* to ensure that *Columbia* was correctly positioned. *Photo, NASA.*

Following spread: Two hours before final descent on July 20, Apollo 11's *Columbia* and *Eagle* have separated and are making their final pass over the landing site, 31 miles (50 km) northwest of Moltke Crater (the largest crater at left). Shining against the moon's craggy surface, *Columbia* will be in the care of Command Module Pilot Michael Collins for 28 hours while Armstrong and Aldrin make their way down to the surface and back. *Photo, NASA.*

In these three minutes from lift-off the rocket ship had accelerated from a rate of travel of a few inches a second to almost ten thousand feet a second, it was now forty-three miles high and seventy miles away and traveling at about one hundred miles a minute or six thousand miles an hour. It had burned half a million gallons of fuel weighing almost five million pounds and had already dispensed with its first stage, an object 138 feet long, and 63 feet wide at its fins, a short-lived stage which was more than three-quarters of its weight and half of its volume. Now, it was about to fire the ullage rocket or opening gun of the second stage. What speed, what acceleration, what onrush!

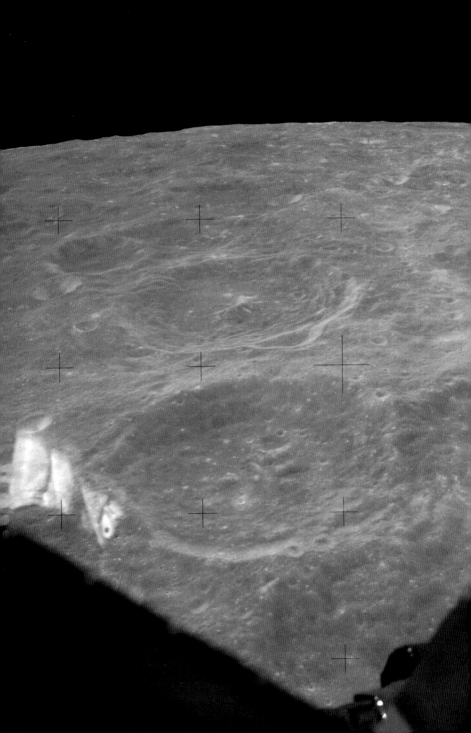

The Ride Down

Further and further away from the earth coasted Apollo 11 at an initial translunar velocity fifty times greater than the fastest auto ever to scream past five hundred miles an hour on the salt flats at Bonneville; and in the Command Module, freed of the sensation of weight, objects traveled as freely as the men, flashlights switched on, then given a twist, spun like illumined beacons on a tower, free-floating as they revolved, crumbs from the bread of a sandwich hovered for hours like motes of dust the size of flies.

Opposite: Four days into the mission, Armstrong and Aldrin were coasting around the moon's far side in the LM, now separated from Collins in the CM. With a few moments to spare, Aldrin took a shot out the window, using the film magazine that would contain their now-famous photographs of the lunar surface, Magazine S. In the foreground is the crater Hartmann and beyond it, Green; each just over 37 miles (60 km) in diameter. *Photo, NASA.*

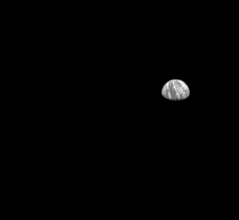

Conceive of a sinner who is a Catholic and devout. What complexity in his feeling for the Church, what pieties of observance live between his sins. He has to make such intricate shows of concealment to his damned habits. Yet how simple is the Church's relation to him. Extreme Unction will deliver his soul from a journey through hell.

So it is with physics and engineering. Physics is the church, and engineering the most devout sinner. Physics is the domain of beauty, law, order, awe and mystery of the purest sort; engineering is partial observance of the laws, and puttering with machines which never work quite as they should work: engineering, like acts of sin, is the process of proceeding boldly into complex and often forbidden matters about which one does not know enough — the laws remain to be elucidated — but the experience of the past and hunger for the taste of the new experience attract one forward. So bridges were built long before men could perform the mathematics of the bending moment.

Now, Apollo 11 has had a trip up from earth with bumps and blasts, clockwork and sharp explosions, communications and fires hot as five thousand degrees Fahrenheit in the furnace of the engines and it has been a trip which on the one hand amounted to no more than a passage through the simplest laws of acceleration in classical physics, but represented on the other a fair climax to the best and most complex engineering techniques of the century, yes, Apollo 11 after this voyage from earth to earth orbit, and from orbit (via its last burn) into Trans-Lunar Injection, yes, Apollo 11, much in debt to engineering, and still trailing the ghosts of the earth's atmosphere, now pushed its nose toward the moon (or toward a rendezvous with

Opposite: Photographed from inside the LM, a gibbous Earth from lunar orbit prior to the descent. The crew's conventional Hasselblad 500EL cameras were equipped with a Zeiss Planar f-2.8/80 mm lens (bayonet-mounted 60 mm and 250 mm lens were also available), and they could be fitted with magazines containing either black-and-white or color 70-mm-wide film developed by Kodak at NASA's request. Along with a conventional 500EL, a specially modified "Data Camera" was used for the lunar surface views, fitted with a glass Reseau plate. Attached to the back of the camera body, the plate's engraved crosses formed a grid that would be exposed on every frame to provide a means of determining angular distances between objects in the field of view. *Photo, NASA.*

Opposite: Standing at Armstrong's station, Aldrin prepares *Eagle* for landing on July 19, 1969. Over his left shoulder are rows of circuit breakers to route power to the craft's electrical circuits and protect them from overload. While Collins piloted the CM, Armstrong positioned himself in the connecting tunnel, handling the color TV and, on occasion, the Hasselblad: "That'll be the most unusual position a cameraman's ever had, hanging by his toes from a tunnel and taking the picture upside down," Aldrin commented. *Photo, NASA.*

the circling moon three days out) and the final burn of its third stage completed, passed over at a speed of 25,000 miles an hour from the sweat-yards, crooked contracts, closet Mafia and mud-lanes of engineering to the rare temples of physics where one law at a time was enshrined, and one could observe the pure effects of that law. Now, the spaceship, all motors off, coasted up to the moon, lifting on its own momentum against all the loosening bonds of earth's powers of desire to pull all flying bodies back to it, Apollo 11, shining templar of alloy, ascended in all delight as pure exhibit of Newton's Laws of Motion. How beautiful they were. The First Law interned the mystery of the ages for it stated that "every body continues in its state of rest, or of uniform motion in a straight line, except when it is compelled by external force to change that state." That was a way of saying bodies at rest and bodies in uniform motion were in the same state. Indeed they were, once one could recognize that bodies everywhere were in motion, all bodies, the earth, the sun and the stars. Rest did not exist, rest was relative, a special condition of uniform motion — no easier place to grasp that phenomenon than in the fastest travels of man, for the more rapid the vehicle, the less was the sensation of speed. One passed from a sense of rest sitting in a chair on the ground to a cognition that it was only the sense of rest one knows in balance with the movement of larger parts of the universe. Further and further away from the earth coasted Apollo 11 at an initial translunar velocity fifty times greater than the fastest auto ever to scream past five hundred miles an hour on the salt flats at Bonneville; and in the Command Module, freed of the sensation of weight, objects traveled as freely as the men, flashlights switched on, then given

a twist, spun like illumined beacons on a tower, free-floating as they revolved, crumbs from the bread of a sandwich hovered for hours like motes of dust the size of flies.

It is a picture of great happiness, of harmony, of souls at rest and evil matter released from the bondage of its weight, but the laws of motion like the laws of morality invoke every notion of balance. Newton's Second Law was harsh and just, as severe as the Third, which has been already encountered and taught us — if we did not know — that for every action there is an equal and opposite reaction. So the Second Law stated that the rate of change in a motion must be proportional to the force applied. One could not cheat life. One did not accelerate for nothing, nor slow one's speed without braking force and heat. As a body moved away from the earth, so, too, did its speed diminish, for the force of gravity weakening, it was still a force to be applied against the effort to escape. Therefore Apollo 11 moved at a half, a quarter, finally a tenth of its greatest speed as it ascended to escape the gravity of the earth and enter the new field of the gravity of the moon. It was like a ball being rolled up a hill — if it reached the crest it would go over and roll down the other side no matter how slowly it was traveling over the crest. In fact, it was easy to think of the earth as being at the center of a bowl, and objects seeking to escape the earth's gravity would have to be fired out at an initial speed sufficient to travel up the wall of the bowl and roll over the lip — that initial speed was almost seven miles a second for all objects which would escape the earth, and at almost seven miles a second (and a little more) was Apollo 11 fired up — the rest of the trip was given over to the hours and the days of

03:06:44 COLLINS: *The Sea of Fertility doesn't look very fertile to me.* Opposite: July 19, around lunchtime. With the spacecraft safely in orbit around the moon, there was time for some sightseeing past the angular outline of the Lunar Module. Under a noon sun, the features on the lunar surface become washed out and difficult to perceive. Nonetheless, this view to the north of the flightpath shows a chain of craters more than 62 miles (100 km) long, running across the floor of Mendeleev, a large far-side crater. *Photo, NASA.*

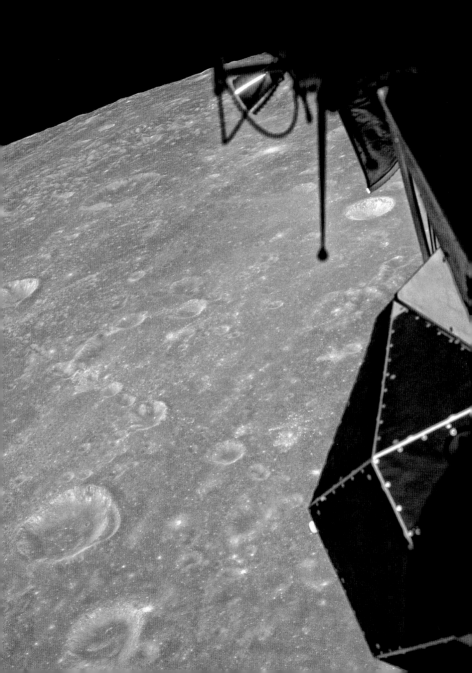

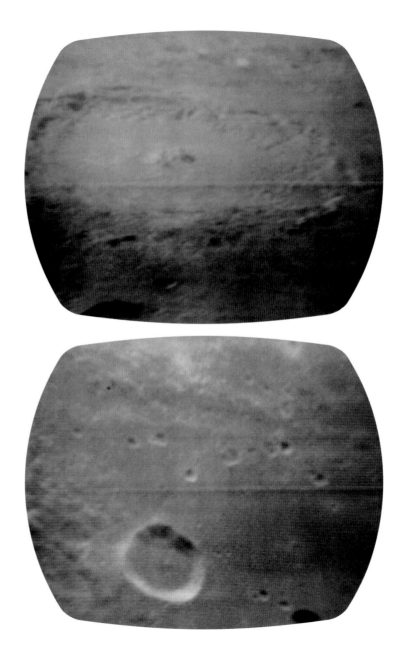

the long coast in space as the speed of the spacecraft diminished from thirty-five thousand feet a second to three thousand feet a second, yes, the ship of space was still moving at the respectable speed of half a mile a second when it passed finally out of the last lingering lulling attraction of the earth and moved over the lip into the bowl of the moon's gravity somewhere at an unmarked point about one hundred and eighty seven thousand nautical miles from the earth. And the computers moved over in the calculations with it. Now the force of the moon's gravity would draw the spacecraft with its three men nearer and nearer to it, now the descent to the moon had begun.

Opposite: Poised against the moon's horizon and well to the south of their flight path was Langrenus, a great 82-mile (132-km) ring on the edge of the Sea of Fertility. Less than three hours after their arrival at the moon, the crew broadcast TV pictures showing the surface below. Aldrin pointed out the 13,5-mile (22-km) crater Webb to the TV audience. It was one of their landmarks leading up to the landing site. *Television stills, NASA.*

Following spread: Two similar craters, Sabine and, beyond it, Ritter, each about 18 miles (30 km) in diameter, had become familiar landmarks during training for the LM's return to orbit. The center of Sabine is about 62 miles (100 km) beyond the landing site. Aldrin would call out both about four minutes into the LM ascent. *Photo, NASA.*

'sequence of time expos...

It's quite an eerie ~~(unscientefic)~~ ~~so untech~~ the transcript. We ca... view they must have b... moon was three times nea... ~~nine hours ago~~ the hour of sleep, when th... ~~night before~~ three times i... larger, and the sun by ~~was from the view of a sp...~~ period in eclipse, and ti... times the size of the ~~earth~~...

They had had glimp... course, there had been o... the way up, but the ol... full of glare. In the fla... black space, ~~was hard on visibility of gl...~~

III

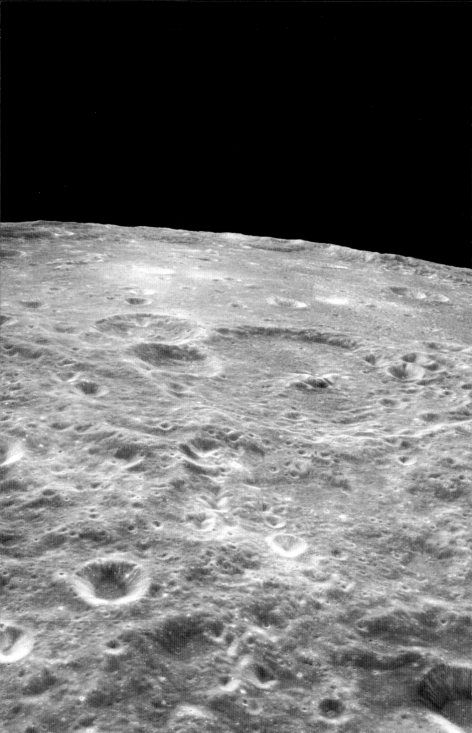

The Near Side
and the Far Side

As she turned about the earth, the moon kept herself like a subject before the king — her face was always presented, her back always hidden — so from earth one saw only her face. The far side had remained a mystery until the first unmanned Soviet spaceships passed around the satellite and sent back photographs by television. Since then Apollo 8 and Apollo 10 had taken scores of pictures. Now, the far side of the moon was no longer a complete mystery. But it was different from the face seen on earth, it was powerfully different, and the astronauts would soon see the far side — they were indeed approaching toward rendezvous with the leading edge of the moon.

If they have difficulty on the surface of the moon, there is nothing I can do. . . . They know and I know and Mission Control knows that there are certain categories of malfunctions where I just simply light the motor and come home without them. —Michael Collins, LIFE, *July 4, 1969 Opposite:* A high oblique view of the lunar far side features crater Schuster, right of center, with a prominent central peak at latitude 4° N, 146° E. The two distinct craters in the center of the frame are Schuster N and, beyond it, Schuster R. *Photo, NASA.*

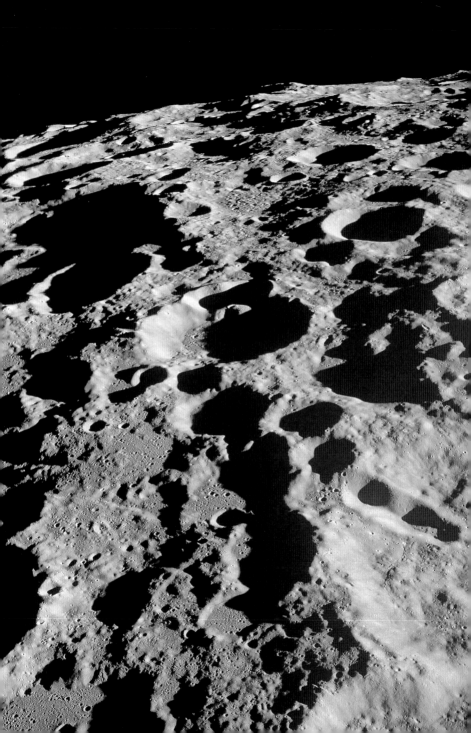

On the fourth morning, a half hour after the usual routine of awakening on consumable updates, sleep reports, drift checks, REFSMMATs, fuel cell purges, PTC maneuvers and radiator-flow checks, there was finally a conversation about their port of call. They had traveled through the night, their speed accelerating as they came nearer to the pull of their destination, and at 71 hours, 31 minutes out, a half hour less than three days from the time of lift-off, on seven-thirty of this fourth morning, they were now no more than 11,000 nautical miles away and traveling at a velocity of 4,141 feet per second.

Opposite: The moon's far side, photographed by Mike Collins while alone in lunar orbit, is strikingly different from the side we see from Earth. It is an ancient and rough landscape where the scars of impacts superimpose one another. *Photo, NASA.*

ARMSTRONG: Houston, you read Apollo 11?
CAPCOM: Roger, 11. We're reading you loud and clear now …
COLLINS: Roger. What sort of F-stop could you recommend for the solar corona? We've got the sun right behind the edge of the moon now.

When there was no answer, the spacecraft spoke again.

ALDRIN: It's quite an eerie sight. There is a very marked three-dimensional aspect of the corona coming from behind the moon glares.
CAPCOM: Roger.
ALDRIN: And it looks as though — I guess what gives it that three-dimensional effect is the earthshine. I can see Tycho fairly clearly — at least if I'm right-side up — I believe it's Tycho in moonshine, I mean in earthshine. And of course I can see the sky is lit all the way around the moon …
CAPCOM: Roger. If you'd like to take some pictures, we recommend you using magazine uniform which is loaded with high-speed black and white film. Interior lights off. We're recommending an F-stop of 2.8 and we'd like to get a sequence of time exposures.

It's quite an eerie sight. What an absence of technology in the remark! We need not even guess at what a panorama they had. Armstrong was later to report: "Of all the spectacular views...the most impressive to me was on the way toward the moon when we flew through its shadow." The moon was three times nearer than it had been at the hour of sleep nine hours ago when the shades were drawn. Three times nearer, it was three times larger, and filled their circular window — the sun was behind and so throwing a halo several times the size of the satellite.

They had had glimpses of the moon before, of course, there had been occasions to study it all the way up, but the occasions were imperfect and full of glare. In the flaring lights of sun and black space, every reflection from the spacecraft dazzling in their eyes, as hard on visibility as driving into the sun, there were no stars to see (except with every difficulty we have noted) and the moon was often no more than an area of darkness in the brilliant haze.

But now the sun was back of the moon and the halo, like a nineteenth-century painting of heaven, was three-dimensional to their eyes, a borealis of golden light with shafts and vales and mansions of light and gardens of light back of the moon. And in the center of the celestial corona was the land of their visit, visible at last, the moon now as clear to the eye as earth on the night of the fullest moon, no, far more bright than that, brighter far, for the moon was now in earthshine. The light of the earth reflected on the blue-gray face of moon highlands and deserts and craters, the earth reflected back a light eighty times more intense than the brightest light of the full moon. It was like the light at early evening....

Opposite: In 1902 French cinematographer Georges Méliès produced a 14-minute film loosely based on novels by Jules Verne and H. G. Wells called *A Trip to the Moon (Le voyage dans la lune).* Widely acclaimed as the first science-fiction film, it depicts a group of astronomers taking a trip in a bullet-shaped spacecraft to the moon. Their landing, in which their craft hits the man in the moon squarely in the eye, has become one of the enduring cinematic images of the era. *Film still, Méliès.*

ARMSTRONG: Houston, it's been a real change for us. Now we are able to see stars again and recognize constellations for the first time on the trip. The sky is full of stars, just like the nights out on earth...

Yes, there was the moon before them, as visible finally as lands of the horizon in the endless twilight nights of a northern summer, the satellite of the earth, a body mysterious beyond measure, unique in the solar system, a moon whose properties and dimensions resisted all categories of classification between planet and satellite, that moon whose origins remained a mystery, whose lunar features were shaped — no one could prove quite how they had been shaped — the moon lay revealed beneath them in its multiplicity of design. Whether dead record of the forces at work in the heavens, or something else not altogether so dead, there beneath them turned some darkened world of blue and silver-gray with color of a subtlety in its corners, and craters luminous to the eye. It was an eerie sight, eerie as a presence, eerie as a strange and desert shore emerged across a dream of sky and glassed-up surface of waters. How to row? How to breathe? The blue and desert shore approached across the impalpable space, cathedrals of light bent around the rim of its edge.

What a land was now there for study! If dead, the death was with dimension. It was a heavenly body which gave every evidence of having perished in some anguish of the cosmos, some agony of apocalypse — a face so cruelly pitted with an acne would have showed a man whose skin had died to keep his heart alive. What a burble of lavas and crusts, of boils on the pop and buds in frozen blight; what a scale

Opposite: Scientific interest in the moon's true surface can be traced back to the first noted occasions when telescopes were brought to bear on its face. Initially, it was Thomas Harriot and Galileo Galilei who made the first sketches of its rough surface. Through the centuries, mapmakers like Riccioli, Hevelius, and a German duo, Beer and Mädler, used the telescope to refine our knowledge of the moon's terrain. This early 20th-century Persian illustrated manuscript page shows Ottoman astronomers using early telescopes to study the moon and stars. *Illustration, artist unknown, University Library Istanbul, Dagli Orti.*

of extinguishments; what a mystery of lines and rays and rills which ran from the coil of one burned-out crater to another; the moon was like a crazy old-fashioned computering machine with a tangle of wires all burned, a mute battleground of blows and hits and concussions and impacts from every flying or voyaging body or particle or radiation of the solar system and beyond. The moon spoke of holes and torture pots and scars and weals and welds of molten magma.

Punched-out, eviscerated, quartered, twisted, shucked, a land of deserts shaped in circles fifty and eighty miles across, a land of mountain rings higher some than the Himalayas, a land of empty windings and endless craters, craters within craters which resided within other craters which lived on the mountainous rim of very large craters, craters the size of an inch and craters to the depth of a mile, craters so vast Grand Canyon could have resided as a crater within the crater: There is a crater known as Newton and it is eighty-five miles wide and almost thirty thousand feet deep — the rim lifts up thirteen thousand feet above all surrounding mountains, and there are chains of mountains so high and vast they are called the Alps and the Apennines or the Caucasus and the Carpathians. There were also clefts, flattened rounds, ghost craters on the plain whose existence was distinguished only by a ring of lighter colorings as if the moon, every other death already available to her, was also a photographic plate of explosions, impacts and holocausts from other places. Scoops out of the lunar soil were to be seen, and pocks and cracks and scums of wrinklings on the plains, domes and bowls and hollow cones, blackheads and whiteheads, walled terraces and cataracts of random rock, hundred-mile spews of boulder, eggcups, table

A land of mountain rings higher some than the Himalayas...the moon spoke of holes and torture pots and scars and weals and welds of molten magma....The moon was either the subject of vast meteoric bombardments...or the child of regimens of boiling and cooling... upheavals and subsidences. —Norman Mailer Opposite: Almost all of the moon's far side is the product of ancient bombardment. A typical impact crater is Daedalus, which spans nearly 58 miles (93 km), and is a classic of its type with a well-formed cluster of mountains at its center. It is a testimony to the moon's extraordinary antiquity that even a crater that is relatively fresh is thought to be more than three billion years old. *Photo, NASA.*

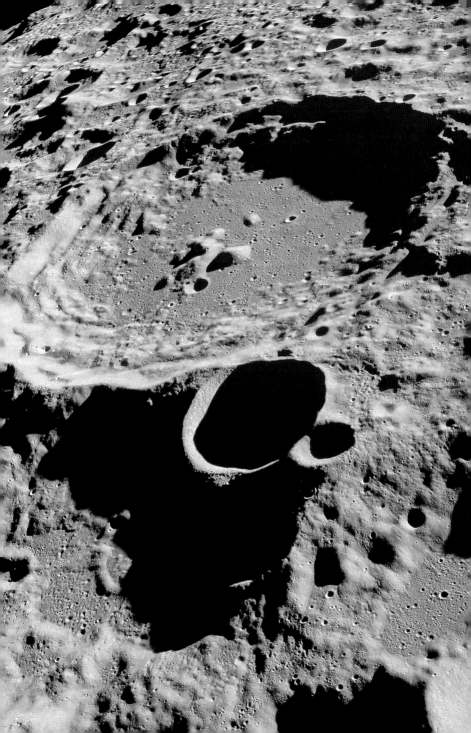

mountains and rims, mudholes, clamholes, spouts, gashes, splinterings of formation faults and extrusions, chains of craters, long mysterious slashes, long as endless roads from one vast crater to another, dark craters and bright craters, craters bright as phosphorescence in a moonlit sea, and long mysterious inexplicable networks of rays — there was no better word nor way to comprehend why lines flew out across the surface, thousands of lines from certain craters, lines straight, and lines which wobbled, lines which stopped short and lines which seemed to skim from peak to peak like a pencil drawn across the grain of a rough plank, lines which continued as a hundred separate little flutterings, and thick lines, thick as brush strokes scumbled across the ridges of an old oil canvas, then lines which wove in and out of valleys — these lines, these rays, hundreds of miles long, even thousands of miles long, were without vertical dimension, they were not ridges or grooves, it was merely that they possessed some special property on the moon soil — they reflected light in a different way, as if they were a different kind of moon dirt and dust, an overlay or powder of some species of mind or order which had visited the moon after the early mind of the moon was gone, some species of hieroglyphic to record the history of relation between the moon and the earth, yes, studying the moon was enough to encourage curious thought, for the moon was a phenomenon, the moon was a voice which did not speak, a history whose record all revealed could still reveal no answers: Every property of the moon proved to confuse a previous assumption about its property.

Yes, the moon was a centrifuge of the dream, accelerating every new idea to incandescent states. One takes a breath when one looks at the moon.

Opposite: Informed by the science-fiction genius of Robert A. Heinlein and the illustrative vision of space artist Chesley Bonestell, the 1950 movie *Destination Moon* molded the public's impression of space travel for a generation. *Poster art, Chesley Bonestell/ private collection.*

Produced by George Pal and directed by Irving Pichel, *Destination Moon* attempted to make its vision of a flight to the moon as scientifically accurate as possible, a goal it shared with *2001: A Space Odyssey*, Stanley Kubrick's work of 18 years later. *Film still, George Pal Productions.*

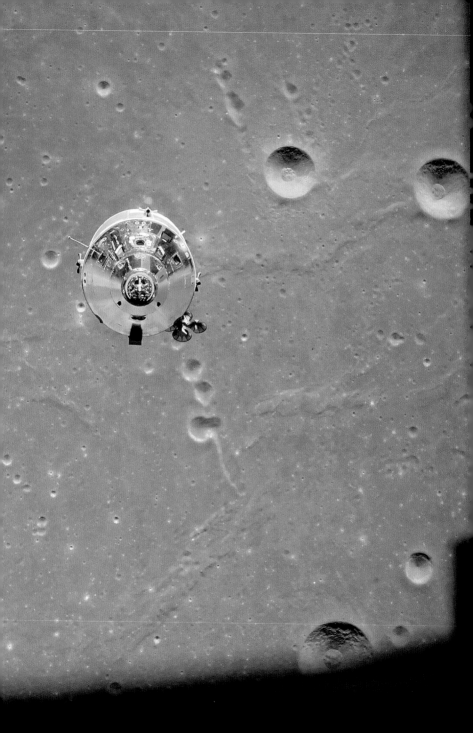

* * *

It was large for a moon; relatively, it was the largest moon of any planet — its mass was one-hundredth of the earth. Ganymede, the major moon of Jupiter, had a mass only one-twelve-thousandth of its planet, and Titan, the greatest of Saturn's satellites, weighed in at the ratio of 1 to 4700. Even Triton, heaviest of all moons, was only one-two-hundred-and-ninetieth of the mass of Neptune. For further comparison our moon had a diameter larger than a quarter of the earth's whereas other moons in the solar system varied from one-ninth to one-thirtieth. So it was easy to think of moon and earth as a double planet. Indeed, there was no clear evidence the moon had been torn from the womb of the earth — it could as easily have begun as a separate body and wandered through space until that apocalyptic hour when it was captured.

The astronauts had lived with the moon: for years in increasing tempo they had studied lunar atlases, worked through geology, read the theories of the vulcanists and the impact men — in their privacy and their sleep they brooded upon it, we may assume, more perhaps than they knew, for the meanings of the moon were arrayed in all the caverns of sleep — was the moon a dead body or the dwarfed equal of earth? The nearer one came to a full contemplation of such mysteries, the greater was the temptation to think not at all. Perhaps in consequence, the astronauts were back immediately into talk of high-gain antennas and secondary loop checks, pericynthion burns and the morning news. *Pravda* had called Armstrong the "Czar of the Ship." Capcom had added, "I think maybe they got the wrong mission," and there would be jokes

Opposite: July 20. *Eagle* and *Columbia* undocked while over the lunar far side, just before coming into view of Earth. For half an hour, they glided in close formation 68 miles (110 km) above the surface. Collins remained alone in his streamlined spacecraft, seen here by his crewmates against the expanse of Mare Fecunditatis (the Sea of Fertility). In a few minutes he would maneuver away to leave them to their task. *Photo, NASA.*

about this later in the day — Collins would remark that the Czar was brushing his teeth.

No, they would not dwell overlong on descriptions of the moon. It lived outside the hatch window, it filled almost all the view, its roughed-up hide paraded below — that skin of craters set upon craters which would inspire every simile from the popholes in pancakes cooking to barnacles upon a rock. One could say it looked like molten metal or blistered paint, one could speak of the erosions of bacteria culture in a Petri dish, or leukemia cells in an electron micrograph — one could also be looking at the heavens on a hazy night for the rays from the crater Tycho and the crater Copernicus spread out in such profusion that the moon also looked like a photograph taken across space of the streams of the Milky Way, even its dark *maria* — those dark seas of moon plain — Imbrium, and Tranquillitatis, Nectaris, Fecunditatus, Nubium, Humorum, Serenitatis, especially the vast dark plain of the Oceanus Procellarum looked like the dark and empty spaces of the sky where one saw no stars. And the multitude of craters were like a multitude of dots and rings of light, were like the overlapping luminescence of stars, as if the moon, properly read, could betray as much of the real character of the heavens as the lines on a man's hand could enrich an eye which understood a world where histories might be written in the hieroglyphics of some universal form neatly concealed in the crack of the palm.

The moon traveled around the earth and both traveled around the sun; the moon moved therefore in a path, which if drawn, would have been not unreminiscent of the outline of an old gear with rounded teeth. The moon had a period of twenty-seven

What you read here is not science fiction. It is serious fact. Moreover it is an urgent warning that the U.S. must immediately embark on a long-range development program to secure for the West "space superiority." If we do not, somebody else will. That somebody else very probably would be the Soviet Union. — The Editors, Collier's, *March 22, 1952 Opposite:* For the general public, the idea that space travel could be a reality first gained widespread acceptance with a series of authoritative articles in *Collier's* magazine, beginning with the March 22, 1952, issue. Assembled under the leadership of editor Cornelius Ryan and Dr. Wernher von Braun, the series was lavishly illustrated by prominent space artist Chesley Bonestell and others. *Illustration, Chesley Bonestell/*Collier's.

days seven hours forty-three minutes, and eleven plus seconds — one could be tempted to predict that the interval of normal period of all the women in the world if taken for average would come to the same eleven-plus seconds, forty-three minutes, seven hours and twenty-seven days — there was a hieroglyphic from the deep!

There were others hidden no doubt on the far side of the moon. As she turned about the earth, the moon kept herself like a subject before the king — her face was always presented, her back always hidden — so from earth one saw only her face. The far side had remained a mystery until the first unmanned Soviet spaceships passed around the satellite and sent back photographs by television. Since then Apollo 8 and Apollo 10 had taken scores of pictures.

Now, the far side of the moon was no longer a complete mystery. But it was different from the face seen on earth, it was powerfully different, and the astronauts would soon see the far side — they were indeed approaching toward rendezvous with the leading edge of the moon. Before too long, their trajectory, caught by the accelerating pull of the moon's gravity, would begin to bend about the moon — at the appropriate moment they would be drawn into orbit around the back, they would see the far side, they would be the seventh, eighth and ninth men ever to see the far side of the moon, and then flying motors first, they would fire their main engine to brake their speed. When they came around the moon again they would not go whipping back to earth — rather they would be in lunar orbit, there to circle the moon ten times and more while preparing for the descent.

So they would be in orbit about a moon which was in orbit about an earth, and if moon and earth were

04:04:37:31 COLLINS: *I think you've got a fine-looking flying machine there, Eagle, despite the fact you're upside down.* **ARMSTRONG:** *Somebody's upside down.* Opposite: After *Eagle* separated from *Columbia*, Armstrong announced, "The *Eagle* has wings," and Mike Collins gave it a visual check. The LM's pared-down, minimalist form was often derided as ungainly, but its beauty was in its function, for it took men to another world for the first time in the history of the human race, and it did so in the spirit of peaceful exploration. *Photo, NASA.*

Opposite: H. G. Wells's
classic novel *First Men in
the Moon* was adapted
into a movie in 1964
by director Nathan
Duran. By being based
on a Victorian novel,
the film deviates from
the cultural line that
leads through Fritz
Lang's *Frau im Mond,
(Destination Moon),* and
2001: A Space Odyssey.
Film still, Nathan Duran.

both in orbit about the sun, well the moon would soon have its satellite as well, a tiny satellite with three men.

Different, however, were the orbits. If the moon took twenty-seven days and some hours to go around the earth, that period was its lunar year just as it took the earth a year to go around the sun. Yet this lunar year of twenty-seven days plus seven hours was also the moon's lunar day. Since the moon kept its face always to the earth, then as it went around the earth, the sun would shine on our visible side of the moon when the earth was between the sun and the moon, but then the sun would shine on the far side of the moon when the moon was between the earth and the sun. So daylight on any area of the moon lasted for fourteen days, a long fourteen days of sun beating on the desert and the craters and the plains of the dead seas, shining on the pinnacles and turrets of the mountains, and the temperature went up as the fourteen days went by, those fourteen earth days which were but one day of sunlight to the cloudless moon. Each terrestrial day here on earth was then by lunar measure of time no more than the rough equivalent of an hour, and the heat increased each lunar hour, each part of the fourteen continuous days of sunlight.

At any given point on the moon, the temperature went up to as high as 243 degrees Fahrenheit when the sun was at zenith. Then the moon, always wheeling with her face to the earth, would pass that face out of the sun and into the dark of earthshine and the long fourteen-day night of the lunar night would begin and the temperature would drop. Down to 279 degrees Fahrenheit below zero it would drop in the depth of the long night, cold as the liquid oxygen in the tanks of Apollo-Saturn before lift-off, and the cold of that one

night would last for the equivalent of two weeks of days and nights on earth. And there was no air and no wind.

Perhaps the moon had been once in rotation, and had had a day and a night not unlike the earth. But there were signs to indicate that the moon on approaching the gravitational grasp of the earth had had its cooling skin seized and twisted by the ferocious tides of the earth's pull. Lines of mountain had been pulled up and the moon's rotation had slowed. The moon staggered away into space, went out nearer to Mars, then caromed back and was captured again. One history of the moon conceived of it entering relations with the earth three times in much such a way before its final capture; what spirit of earth and lunar forces must have been released, exchanged and conceivably not lost forever? It was a theory among others, but it was not without relation to the difference between the near side of the moon and the far, and it offered an explanation for the moon's craters, since the molten lavas and boiling waters of the young moon's interior would have been profoundly disturbed in such a courtship of the spheres, and volcanic eruptions would have been the predominant order of events. That was one of the major theories, but in fact there were two fundamental and antagonistic hypotheses to account for the terrain of the moon: each was in difficulties before the critics of the other. There were men who believed the craters of the moon had come in their entirety, or almost entirely, from the impact of meteors in those remote ages when meteors abounded as planets formed. Such theorists were termed lunar impact men, and their thesis had to live with objections so thoroughgoing as the fact that craters sometimes presented themselves in a clean row like strings of artillery shells; worse! impact men were obliged to explain how craters could be spaced like pearls

Opposite: Released the same year as Kubrick's epic, Roger Vadim's eroto-sci-fi film *Barbarella* starred Jane Fonda in the film adaptation of Jean-Claude Forest's comics of the same name. *Poster,* Barbarella*/ private collection.*

around the rim of a larger crater: how indeed could the meteors have landed in such order? But the largest of the objections was to be found in the size of the dead seas. The Oceanus Procellarum was better than a thousand miles across — a meteor comparable in size to a moon for our moon might have had to collide for such a scar to be left.

The masters of the meteoric hypothesis had other difficult answers to give. Most craters were not a simple bowl, rather a bowl with an umbilical at its core — a separate mountain peak at the center of the bowl surrounded by a ring of plain. Even the smaller craters were rarely without a pit, a core, a vertical elevation at the center, or a root like the pintle on an old bottle. Such centers suggested a now extinct fountain of lava. So theories of impact were not comfortable, no more than the scientists who believed the craters of the moon were the product of volcanoes could explain with ease why even the largest volcanoes on earth were small in comparison to moon craters, and why the floor of a terrestrial volcano was elevated clear above the surrounding countryside, was often indeed a steep cone with no more than a modest vent for crater, and so most unlike the terrain of the moon. On the other hand the largest meteoric crater seen on earth was only two miles across. Models drawn from the earth simply did not suffice for either vulcanists or impact men. How to explain that the moon was either the subject of vast meteoric bombardments from ages past which the earth had somehow escaped, bombardments with an occasional perfection of aim equal to shooting pearls onto the circular points of a crown; or equally how to convince others that the moon was the product of its wanderings between the earth and

Opposite: Stills from Stanley Kubrick's 1968 film *2001: A Space Odyssey,* based on the 1948 short story "The Sentinel" by respected science-fiction author Arthur C. Clarke, who in 1945 introduced the idea of placing communication satellites in geo-stationary orbit. *Stills,* 2001: A Space Odyssey.

Mars, child of regimens of boiling and cooling, geysers of water, mud and lava, a world of subterranean seas and trapped gases, a cauldron of upheavals and subsidences in some romantic, even catalytic relation to the earth, a theory therefore in furious conflict with the ideas of all meteoric theories, for the impact men were attached to the idea that the moon was ancient and unchanging, and the major bombardments had occurred eons ago, billions of years ago. It was the best explanation why such bombardments were not to be found on earth — the earth, equally pitted then, had had its face subsequently altered by geological upheavals went the hypothesis. It allowed one to induce that the impact men were classicists, positivists, traditionalists, upholders of the public common sense (since the moon by all common sense *looked* as if it had been bombarded). The vulcanists were romantics, Dionysiacs, existentialists, animists — at their most adventurous they would even search for some faint hope of life on the moon.

Neither could secure an explanation for the contradictory facts, and before the phenomenon of the rays, no meteorite man nor apostle of the geyser-volcano could offer an embattled theory. The rays had no explanation which could explain all the facts attached to them. The rays emanated from the craters, but before one could even speak of a stream of white powder flying out, it was necessary to note that the rays were sometimes tangential to the ring of the crater and sometimes radiated out from the center. Sometimes a crater had but a single ray which led to a particular place, often to another crater. Yet if the rays were some physical embodiment of an idea or a communication, they were yet singularly sensitive to

There were boulders big as Volkswagens strewn all around. The rocks seemed to be coming up at us awfully fast, although of course the clock runs about triple speed in a situation like that. . . At about 400 feet it became clear that I would have to take over a hybrid mode of manual control — that is, a manual altitude control with a partially automatic throttle.
— Neil Armstrong,
LIFE, August 8, 1969
Opposite: After a tense final approach phase in which Armstrong flew past a large crater and surrounding boulder fields, the spacecraft has finally touched down. Armstrong's transmission announced their arrival: "Houston, Tranquility Base here. The *Eagle* has landed." The pristine lunar surface is seen through Aldrin's LM window before the moonwalk. *Photo, NASA.*

obstacles — even a low ridge across their path could stop them short — yet in other places they would extend across a thousand-mile sea. They were even described like "snow thinly drifted by a strong wind across a black frozen lake."

Imperfect, unhappy, unsatisfactory theories abounded within the two schools of theory. And other theories abounded, even the theory that the moon was a dead civilization, its endless rings the record of a last atomic war — it was said the earth would look like the moon after a nuclear holocaust had destroyed us.

Yet it was with the partial hope that their projected experiments on the moon and the rocks they brought back would begin to apply answers to these questions that the astronauts doubtless now reviewed for the thousandth time the order of their assignments on the moon ground and the probabilities of vulcanism, formation by meteor, or some other theory altogether. Revolving below them, coming each minute nearer was the dead beast of the moon ground, the mute mysteries locked in the formation of form itself. Would the moon yet answer the fundamental question of form — that all forms which looked alike were in some yet undiscovered logic thereby alike? — which is to say that if the skin of the moon was reminiscent of boiled milk and cancer cells and acne, so then — would a theory yet emerge which could revolve at some case through the metaphors of the moon and find the link of metaphysical reason between cancer, acne, blisterings of paint and the wrinkled ridges of a boiled and skin-thick milk?

03:22:50:00 ALDRIN: Houston, Apollo 11. We just had a very good view of the landing site. We can pick out almost all of the features we've identified previously.

Opposite: On the morning of landing day, the LM passed over the landing site, and Aldrin took the chance to photograph terrain that had become very familiar to them over months of training. He looked past one of *Eagle*'s maneuvering jets toward the southwest corner of Mare Tranquillitatis (Sea of Tranquility) lit by a morning sun, and to two small isolated hills that the crews had named Boot Hill and Duke Island in the foreground. *Eagle*'s eventual destination, Tranquility Base, is very near the line between lunar night and day. *Photo, NASA.*

The Greatest Week

So one got ready for the climax of the greatest week since Christ was born. An hour and twenty minutes later, the Lem having flown around the moon and gone behind it again, the braking burn for the Descent Orbit Initiation would be begun in radio silence. An hour later the final ignition for the final descent would commence. Aquarius, bereft of personal radar or gyroscope, bereft even of the sniff-sensors of his poor journalistic nose, wandered from point to point in the Press Center, rushed back to Dun Cove to look at color television — there were no color sets in the Press Room — then, bored with listening to commentators, and finally incapable of witnessing the event alone, went back to the movie theater and settled in with about a hundred other reporters for the last half hour.

It was as if. . .a man were descending. . .into the kingdom of death itself. — Norman Mailer
Opposite: The world watched as Neil Armstrong climbed down the LM ladder toward his first step onto the surface of the moon. The slow-scan Westinghouse camera mounted to the side of the LM sent transmissions back to Earth via radio receiver/transmitters at Goldstone Deep Space Communications Complex in California's Mojave Desert; the Parkes Observatory in South Wales, Australia; and the Honeysuckle Creek Tracking Station near Canberra, Australia, which captured the clearest image of Armstrong's descent. *Photo, NASA.*

Opposite: Buzz Aldrin's boot leaves a sharp imprint in the lunar soil. The surface is composed of rock fragments — most no bigger in width than the finest of human hair — that have been broken off larger rocks during meteorite impacts, and then broken into smaller and smaller pieces in subsequent impacts. This regolith is firm and well compacted in flat, relatively undisturbed spots. In some other areas such as the rims or bottoms of fresh craters, the surface is softer and the astronauts leave much deeper footprints. *Photo, NASA.*

Like many men who lived comfortably for years, he had always taken it for granted that he was superior to his surroundings and could dwell anywhere. Well, maybe one could still dwell anywhere with love, but loveless this week he was obliged to recognize that his basement apartment installed in an interlocking lay-out of ranch-style apartments, inner patios and under-ground garages was no place for him to thrive. Not on this job. If he had become a little obsessed with the meanings of a trip to the moon — going on now full attraction into its first night and second day and second night while he languished in his dun coop — if he had come to recognize that the more one brooded on this trip, the more fantastic it became, there was still the thundering and most depressing fact that it was a cancer bud for a journalist to cover. There were assignments which could make a reporter happy — he sometimes thought it would be impossible for a good quick-working novelist to be unable to write a decent piece about a political convention or a well-organized anarchy of the modern young. Give Aquarius a great heavyweight championship fight, and he would give you a two-volume work. There was so much to say.

One's senses threatened to sear one's brain with excess of perception. The people at the cen-ter of such events nourished you with the tragi-comedy of the traps they entered and sometimes escaped. But in NASA-land, the only thing open was the technology — the participants were so overcome by the magnitude of their venture they seemed to con-sider personal motivation as somewhat obscene. He had never before encountered as many people whose modest purr of efficiency apparently derived from being cogs in a machine — was this the perspective of

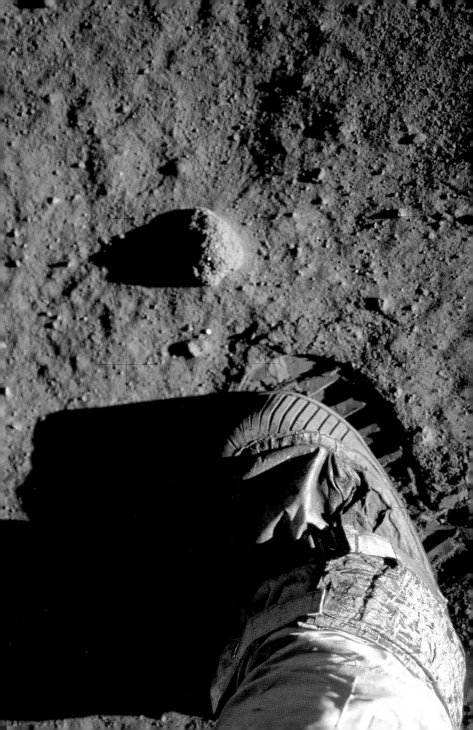

the century to come or was this the end of a long and insane road? He did not know, and the fact that he did not know depressed him further. Usually when one did a journalistic piece, the events fit in advance into some part of one's picture of the world. Most interesting about such events was the way they obliged you to make modest or delightful adjustments in the picture. Or even grim adjustments. But you did not have to contemplate throwing the picture away. Aquarius, now plucked up from the circus bonanzas and flaming cathedrals of lift-off, was in Houston dropped smack into the fact that the best way to do the rest of this damnable story was probably to go home and cover the works by television. He simply did not feel himself coming closer in Houston to the value or horror of the oncoming achievement; he did not see that there was any way to come closer. Occasionally, which is to say, five or six times a day, he would drive over to the Press Center at MSC on the other side of the highway, and skulk around the movie theater with the marcelled ceiling. When there was no press conference on — and usually there wasn't — he would look at a blank screen and listen to talk on the squawk box go back and forth between the Capcom and the spacecraft, the astronauts' voices wiped as clean of emotion as a corncob shucked of kernels. In the interim, distances increased. When he got back to Houston that first night, they were fourteen hours out, so their journey had already covered sixty-six thousand nautical miles!

Opposite: A 16-mm film camera operated by Buzz Aldrin through his LM window records Neil Armstrong's first steps on the lunar surface. After commenting on his surroundings and the nature of the soil, Armstrong configures the lunar equipment conveyor (a clothesline-like strap that he had employed as a safety tether for the first few moments) to bring a Hasselblad camera down to the surface. *Television stills, NASA/ Copp.*

Following spread: An audience estimated at 600 million — one-fifth of the world's population at the time — watched the televised broadcast of the moonwalk. *Television stills, NASA/ Wood. First still, CBS. Last still, private collection.*

* * *

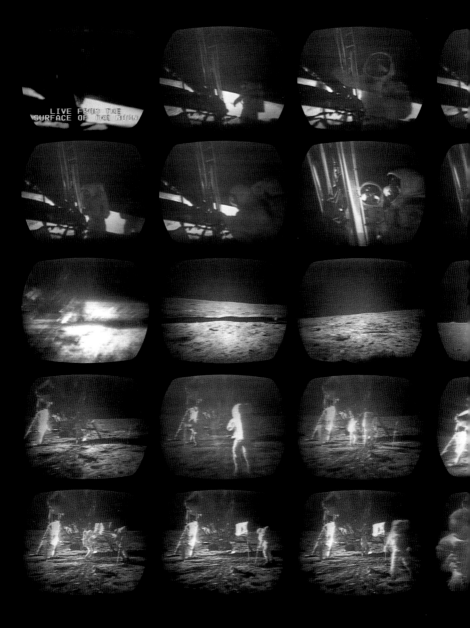

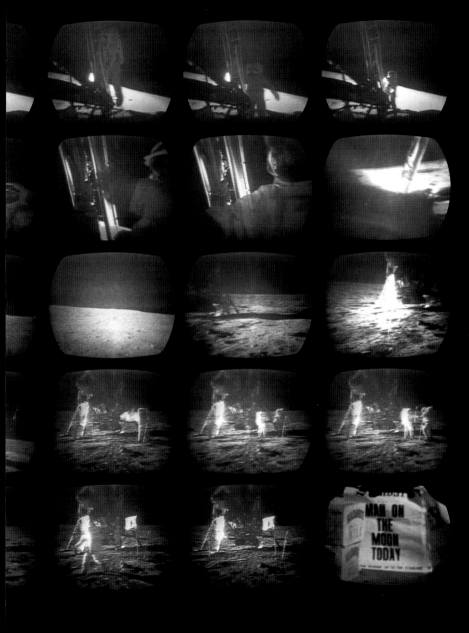

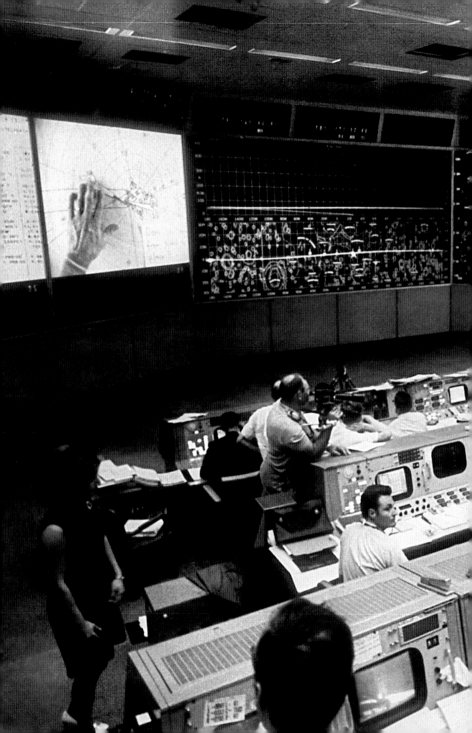

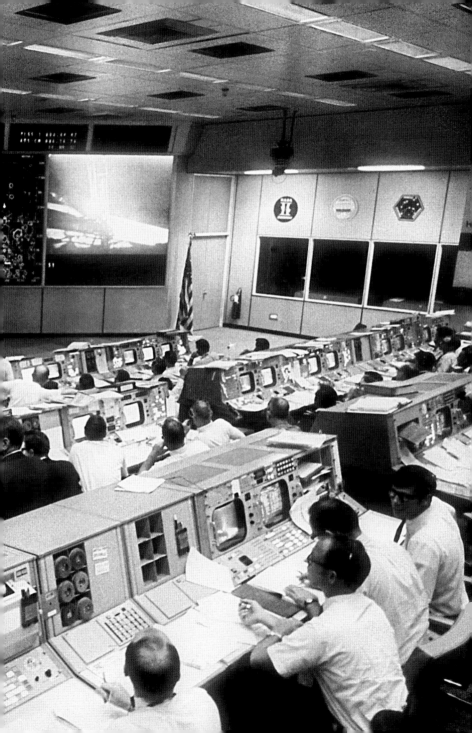

A number of feature stories had been written in anticipation of the moment when the astronauts would pass behind the moon. Having turned the spacecraft around to go tailfirst, they would then fire the propulsion motor on the Service Module. That would brake the speed of the flight, and put them in orbit. Since they would be out of radio communication when it happened, no one would know for the next half hour if the burn had been successful, not until they came around the invisible side of the lunar sphere and their antennae were in unobstructed line with the earth again. It promised to offer excitement. Would the motor start? Or were there lunar emanations no physicist had ever conceived?

Actually, Aquarius was bored. Sitting in the Manned Spacecraft Center movie theater, he noticed that the Press was also bored, for few were listening to the squawk box. They all knew the burn would succeed and Apollo 11 would go into proper orbit. There seemed no question of failure, and indeed the burn and the re-acquisition of radio communication went on schedule. Aquarius could detect surly traces in himself, as if he were annoyed with the moon — it should not be so simple to trespass her zones. He was, of course, no longer thinking in any real way — what passed for thought were the dull whirrings of his depression, about as functional to real intellectual motion as the turning over of a starter when the battery is almost dead. In fact he could not forgive the astronauts their resolute avoidance of a heroic posture. It was somehow improper for a hero to be without flamboyance as if such modesty deprived his supporters of any large pleasure in his victories. What joy might be found in a world which would

have no hope of a Hemingway? Or nearest matters first, of a Joe Namath, or Cassius Clay, Jimmy Dean, Dominguin? — it was as if the astronauts were there to demonstrate that heroism's previous relation to romance had been highly improper — it was technology and the absence of emotion which were the only fit mates for the brave. Yesterday, or one of the days which had already become interleaved in the passage of time at Dun Cove, he had read a newspaper story where Armstrong's wife, Jan, had been quoted: "What we can't understand, we fear." Even the ladies of brave men spoke like corporation executives on this job. His heart went dull at the thought of the total take-over implicit in the remark, so neat, so ambitious, so world-vaulting in its assumption that sooner or later everything would be understood — "I paid a trip to death, and death is a pleasant place and ready for us to come in and renovate it." Abruptly Aquarius realized that for years he had thought of death as located in the milieu of the moon, as if our souls, those of us who died with one, might lift and rise, be free of the law of gravity and on trajectory to the satellite of the craters. Yes, wouldn't it be in the purview of the Wasp, damn corporate Wasp, to disturb the purlieus of the dead? He did not know. His thoughts were always furthest out when he was most depressed, as though like a bird half drowned, the only way to lift was by the wildest beating of wings.

The real heroism, he thought, was to understand, and because one understood, be even more full of fear at the enormity of what one understood, yet at that moment continue to be ready for the feat one had decided it was essential to perform. So Julien

Sorel had been brave when he kissed Madame de Rênal, and Jimmy Dean been brave in *Rebel Without a Cause*, and Namath when he mocked the Baltimore Colts knowing the only visions he would arouse in his enemy were visions of murder. So had Cassius Clay been brave — to dare to be rude to Liston — and Floyd Patterson brave to come back to boxing after terrible humiliation, and Hemingway conceivably brave to continue to write in short sentences after being exposed to the lividities of the literary world.

But the astronauts, brave men, proceeded on the paradoxical principle that fear once deposed by knowledge would make bravery redundant. It was in the complacent assumption that the universe was no majestic mansion of architectonics out there between evil and nobility, or strife on a darkling plain, but rather an ultimately benign field of investigation which left Aquarius in the worst of his temper.

Next morning came the news of Teddy Kennedy's accident at Chappaquiddick. Dead was the young lady who had been driving with him. How subtle was the voice of the moon. Aquarius remembered a speech Kennedy had given two months earlier at Clark University in Worcester. Mrs. Robert H. Goddard, widow of the father of American rocketry, had been there, and Buzz Aldrin as well. Kennedy had urged that future space funds be moved over to such problems as poverty, hunger, pollution and housing. The chill which came back from NASA was as cold as the architecture at the Manned Spacecraft Center. "We won't be including this item in the daily news reports we send up to the Apollo 10 astronauts on their voyage to the moon," Thomas O. Paine, administrator of NASA had said. Now the reverberations of this

As the two men walked on the moon, Pat Collins exclaimed, "Why aren't they cheering? That's why they don't send a woman to the moon — she'd jump up and down and yell and weep!" — LIFE

Opposite: Armstrong's parents, Stephen and Viola Armstrong, interviewed at their home in Wapakoneta, Ohio, shortly after landing. *Television still, CBS.*

Following spread: Often mistaken to be a picture of Neil Armstrong's first footprint on the moon, this is actually one in the series of photos taken later by Aldrin to document properties of the lunar soil that are important in the design of future lunar vehicles, tools, and even buildings, and in estimating walking, running, and driving speeds. *Photo, NASA.*

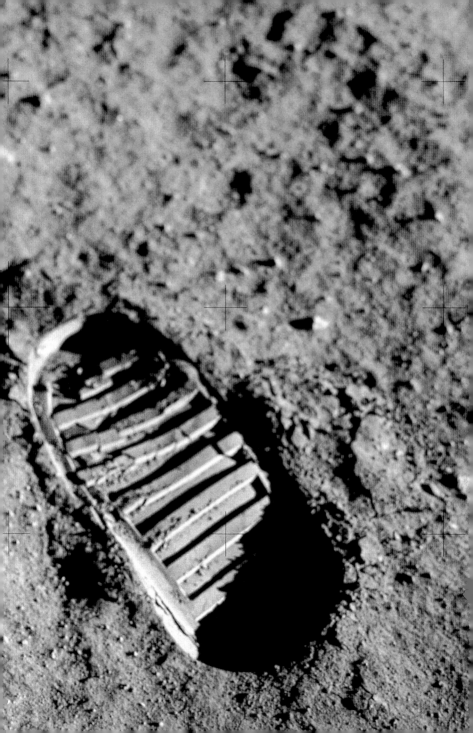

Opposite: Eagle's rear footpad, with its bent lunar contact-probe jutting out to the right. All of the lander's legs (except the one with the ladder) had these six-foot-long probes that would detect contact with the lunar surface and trigger a blue "Contact" light in the cockpit, telling the crew to cut the descent engine and allow the LM to drop the final few feet to the surface. For Apollo 11, however, Armstrong didn't get the engine shut down until the LM had landed. Scattered reflections of the pad's gold-colored foil can be seen in front of the pad on the regolith. *Photo, NASA.*

accident at Chappaquiddick went off in Aquarius' brain. As happens so often when a motive is buried, Aquarius felt excitement around the hollows of his depression. For if the blow to the fortunes of the Kennedys was also a blow to one hundred interesting possibilities in American life, if the accident was of such benefit to Richard Nixon that the Devil himself if he had designed the mishap (which is what every liberal Democrat must secretly believe) could have awarded himself a medal for the artistry, yet there was at least a suggestion that the moon had thought to speak. Perhaps that was why there was still a trace of stimulation in the gloom — magic might not be altogether dead.

The day went by, a cloudy day in southeastern Texas. From time to time, Aquarius checked in at the Press Center. Excitement was now divided between Kennedy and the moon. Or was Kennedy even more interesting? The separate phases of the preparation for landing were certainly without high tension. Indeed the Lem even undocked from the Command Module while both were behind the moon. When they came around and signal was picked up again, the voice of Armstrong came over the squawk box. "The *Eagle* has wings," he said, or was it Aldrin who said it? — there was discussion on this for the remark was universally quotable. Yet the happy buzz of conversation among the reporters at the thought of an oncoming climax was dampened considerably by the dialogue which followed:

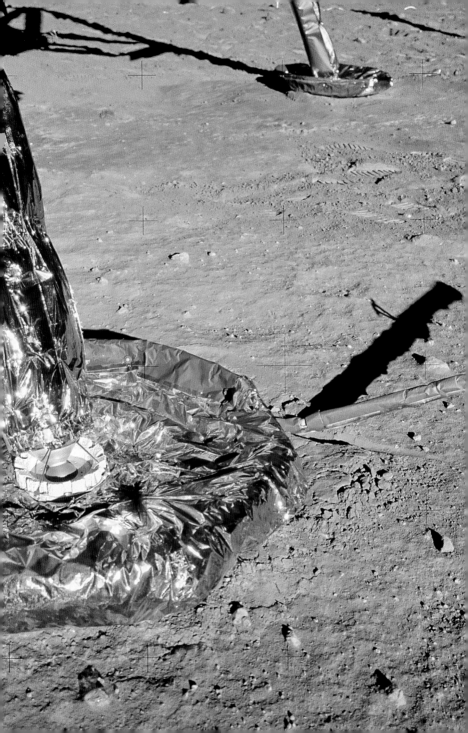

CAPCOM: . . . Coming at you with a DOI pad. 101361407981 minus 00758 plus all balls plus 00098 plus corrections 00572 perigee plus 00085 00764 030000293 986 minus 00759 plus all balls plus 00090 rest of the pad is NA. Stand by on your read-back. If you are ready to copy the PDI data, I have it for you. Over

ALDRIN: . . . Go ahead with the PDI.

CAPCOM: Roger. PDI pad, PIG 102330436 0950 minus 00021 182287000 plus 56919 —

Opposite: Looking east toward the southern strut of the LM. The deep, sharp shadow cast by the spacecraft in the lunar vacuum darkens the virgin moonscape. In the foreground, a discarded trash bag. *Photo, NASA.*

So one got ready for the climax of the greatest week since Christ was born. An hour and twenty minutes later, the Lem having flown around the moon and gone behind it again, the braking burn for the Descent Orbit Initiation would be begun in radio silence. An hour later the final ignition for the final descent would commence. Aquarius, bereft of personal radar or gyroscope, bereft even of the sniff-sensors of his poor journalistic nose, wandered from point to point in the Press Center, rushed back to Dun Cove to look at color television — there were no color sets in the Press Room — then, bored with listening to commentators, and finally incapable of witnessing the event alone, went back to the movie theater and settled in with about a hundred other reporters for the last half hour.

Phrases came through the general static of the public address system. "*Eagle* looking great. You're go," came through, and statements of altitude. "You're go for landing, over!" "Roger, understand. Go for landing. 3000 feet." "We're go, hang tight, we're go. 2000 feet." So the voices came out of the box. Somewhere a quarter of a million miles away, ten years of engineering and training, a thousand processes and a

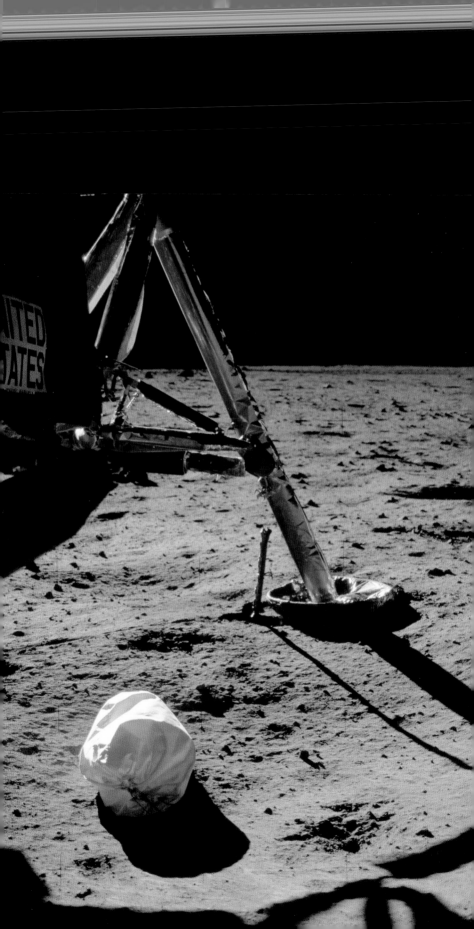

An inspection photo of the back of *Eagle* provides a view, at center, of a wrinkled plume deflector that has protected the Descent Stage from the exhaust of the downward-pointing nozzle. Also visible are some of the LM's lightweight, thermal-insulation panels and blankets, foil-thin at 0.002 to 0.005 inches (.005 to .013 cm). The cabin walls were thicker at 0.012 inches (.3 cm). The LM did its job flawlessly every time it flew; and, on Apollo 13, gave the crew a way to get home safely. *Photo, NASA.*

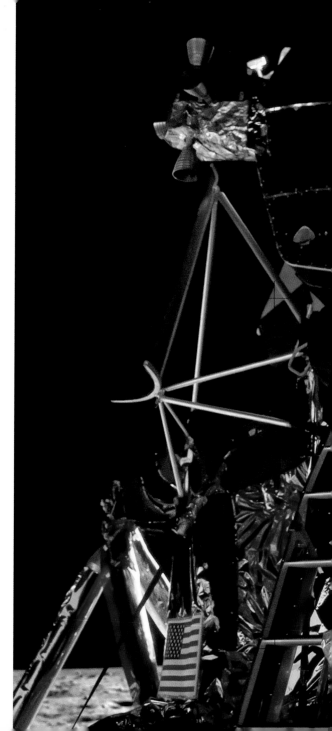

04:13:41:28 ALDRIN: *Okay. Now I want to back up and partially close the hatch. [Long pause] Making sure not to lock it on my way out.* **ARMSTRONG:** *[Laughs] A particularly good thought.* **ALDRIN:** *That's our home for the next couple of hours and we want to take good care of it.* *Opposite:* Following the "PHOTO EGRESS" line on his checklist, Armstrong captures Buzz Aldrin's progress through the hatch and down the LM ladder. *Photo, NASA.*

04:13:42:28 ARMSTRONG: *You've got three more steps and then a long one. . .* **ALDRIN:** *That's a good [last] step.* **ARMSTRONG:** *Yeah. About a three-footer.* **ALDRIN:** *Beautiful view!* **ARMSTRONG:** *Isn't that something! Magnificent sight out here.* **ALDRIN:** *Magnificent desolation.* *Following spread: Photos, NASA.*

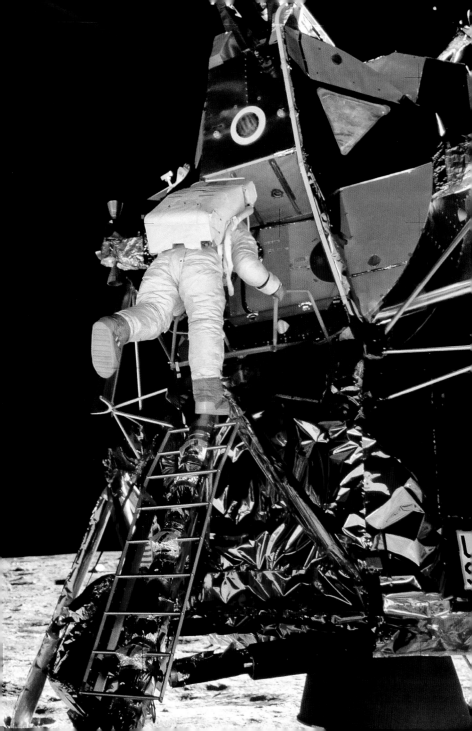

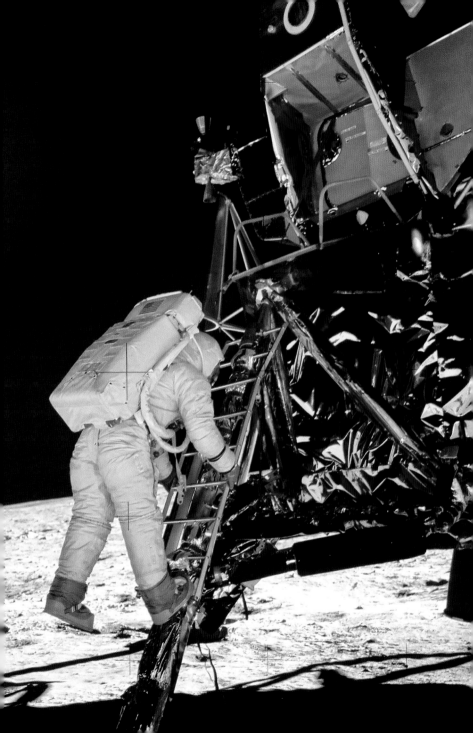

million parts, a huge swatch out of twenty-five billion dollars and a hovering of machinery were preparing to go through the funnel of a historical event whose significance might yet be next to death itself, and the reporters who would interpret this information for the newsprint readers of the world were now stirring in polite if mounting absorption with the calm cryptic technological voices which came droning out of the box. Was it like that as one was waiting to be born? Did one wait in a modern room with strangers while numbers were announced — "Soul 77-48-16 — you are on call. Proceed to Staging Area cx — at 16:04 you will be conceived." So the words came. And the moon came nearer. "3½ down, 220 feet, 13 forward, 11 forward, coming down nicely. 200 feet, 4½ down. 5½ down. 160, 6½ down. 5½ down. 9 forward. 5 percent. Quantity light. 75 feet. Things looking good. Down a half. 6 forward." "Sixty seconds," said another voice. Was that a reference to fuel? Had that been the Capcom? Or was it Aldrin or Armstrong? Who was speaking now? The static was a presence. The voice was almost dreamy. Only the thinnest reed of excitement quivered in the voice. "Lights on. Down 2½. Forward. Forward. Good. 40 feet. Down 2½. Picking up some dust. 30 feet, 2½ down. Faint shadow. 4 forward. 4 forward. Drifting to the right a little. 6...down a half." Another voice said, "Thirty seconds." Was that thirty seconds of fuel? A modest stirring of anticipation came up from the audience. "Drifting right. Contact light. Okay," said the voice as even as before, "engine stop. ACA out of detente. Modes control both auto, descent engine command override, off. Engine arm, off. 413 is in." A cry went up, half jubilant, half confused. Had they actually landed?

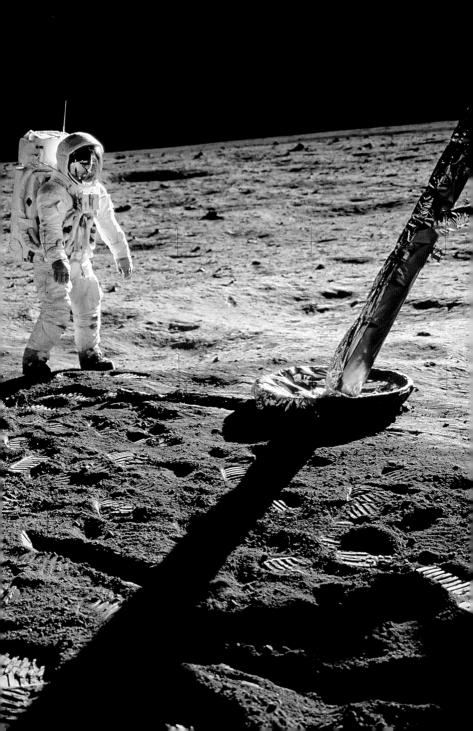

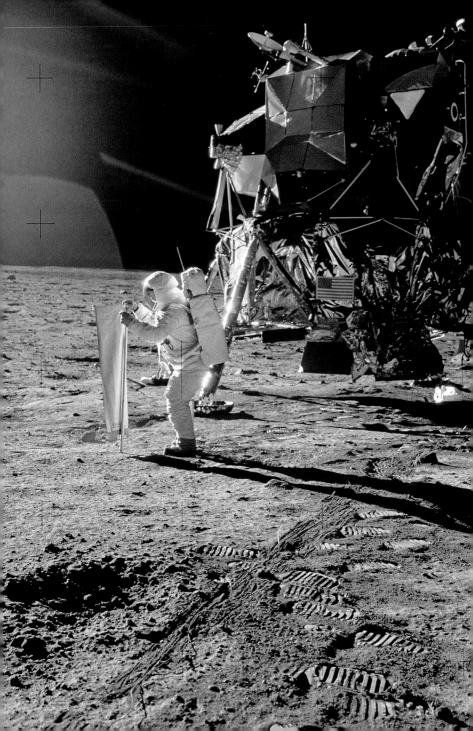

The Capcom spoke: "We copy you down, *Eagle*." But it was a question. "Houston, Tranquility Base here. The *Eagle* has landed." It was Armstrong's voice, the quiet voice of the best boy in town, the one who pulls you drowning from the sea and walks off before you can offer a reward. The *Eagle* has landed — it reached the Press. They burst into applause. It was the kind of applause you used to hear in the packed film houses of the Thirties when the movie came over the hill of the last reel, and you heard the doctor say the star would live after the operation. Now, a small bedlam of actions began, some of the Press sprinting from the room — could they pretend it was necessary to phone the City Desk? — others talking to each other in babble, others still listening to the squawk box as technology took up again. A few minutes later: "*Eagle*. Houston. You loaded R2 wrong. We want 10254." "Roger — that is V horizontal 5515.2." "That's affirmative."

Aquarius discovered he was happy. There was a man on the moon. There were two men on the moon. It was a new feeling, absolutely without focus for him. If he felt a faint graveling on the surface of this sentiment, a curdle of emotional skin which formed from his effort to advance heroes he could not find altogether admirable, still he knew he had been dislocated as profoundly by the experience as the moment he learned in the fathers' waiting room at the hospital that his first child had indeed and actually just been born. "Well, think of that," he had said. What a new fact! Real as the presence of immanence and yet not located at all, not yet, not in the comfortable quarters one afforded for the true and real facts of the life of the brain.

Opposite and following spread: Aldrin sets up the first of the scientific experiments that will be deployed on the surface: the Solar Wind Composition Experiment. This pristine foil sheet, hung on a mast so it was perpendicular to the direction of the sun, would collect some of the tiny particles spewed from the sun and hurled through the solar system as solar wind. Near the end of the moonwalk he would retrieve the experiment, roll it up, and stow it in one of the Sample Return Containers for study by researchers on its arrival at the Lunar Receiving Laboratory. *Photos, NASA.*

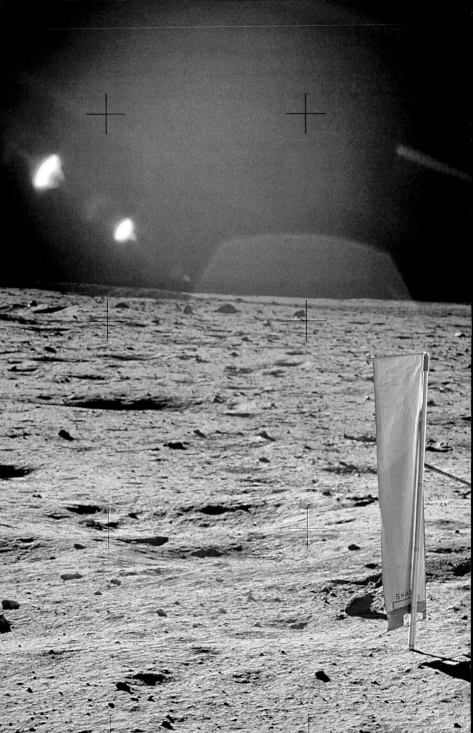

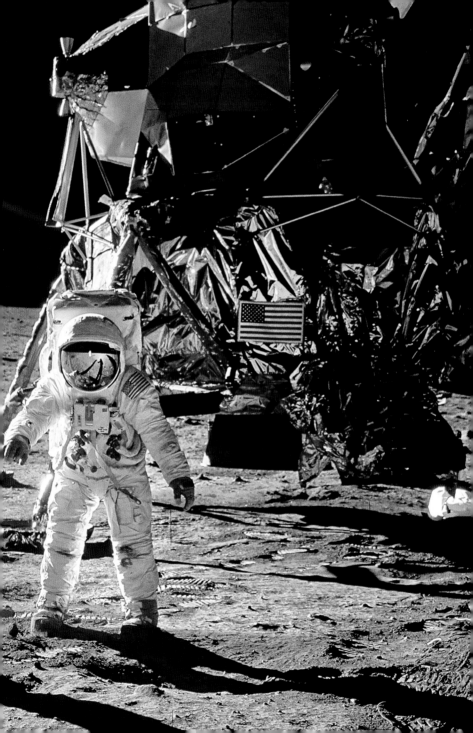

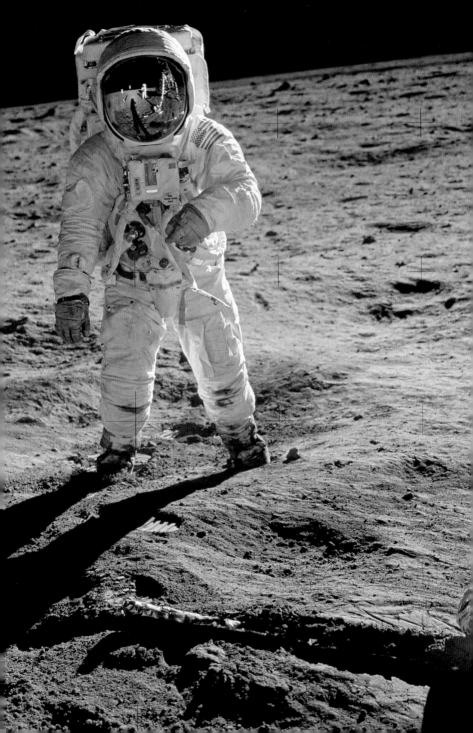

A Day in Space and Another Day

A cheer not unmixed with mockery came at the announcement at 9:40 in the evening that the hatch was open. Still no image on the screen. Now followed long incomprehensible instructions back and forth, talk of window clanks and water valves, high-gain antenna and glycol pumps. Out of all this, quiet exhortations from Aldrin to Armstrong. Through the words emerged the realization that Armstrong, made twice bulky by his space suit and the Portable Life Support System on his back, was trying to push through the open hatch of the Lem out onto the small metal porch which led to the ladder which in turn he could descend to the moon ground. It was obviously a very tight fit to get through the hatch. As Aldrin gave instructions there was an inevitable suggestion of the kind of dialogue one hears between an obstetrician and a patient in the last minutes before birth.

Opposite: Buzz Aldrin consults his wrist checklist, which lists 30 tasks planned for his 90 minutes on the moon's surface. In Aldrin's visor we see reflections of the TV camera, the flag, Armstrong, the LM, and the Earth. This photograph is usually reproduced with Aldrin centered in the image and an expanse of black sky above his head, but the black sky was enlarged on the released prints, presumably by someone in NASA Public Affairs for aesthetic reasons. The photo is shown here as Armstrong shot it. *Photo, NASA.*

That night, the walk on the moon had been scheduled to begin long after midnight, so plans had been laid for late moon-watching parties. But the astronauts, to no one's surprise, were in no mood to sleep, and the moon walk was rescheduled for eight in the evening. Yet, this once, the astronauts were not on time.

Waiting in the movie theater, the Press was in a curious state of mingled celebration and irritation. It was hard not to feel like a fool. They were journalists, not movie critics, and tonight they would be taking notes on the events which transpired upon a video screen. Of course, the climax of days of the most difficult kind of reporting was finally at hand, but it was a little as if one's nervous system had been appropriated and the final shake would take place in somebody else's room.

The psychology of journalists is not easy to comprehend — they scurry around like peons, they have the confidence of God. Over the years they develop an extraordinary sense of where the next victory is located. If a man gives a press conference and is not surrounded by reporters when it is over, he need not wonder how his fortunes are moving — the reporters have already told him. It is for this reason journalists pick up the confidence that they shape events — in fact they are only sensors in the currents of the churn, Venturi tubes to give you the speed of the history which passes. Nonetheless, there is no psychological reality like a man's idea of himself. Even if a writer has lost the best reaches of his talent by putting out facts for years which have been stripped of their nuance — writing newspaper stories in short — still he retains an idea of himself: it is that his eye on an event may be critical to correct reportage of it. Now put five

Because of what you have done, the heavens have become part of man's world. . . . For one priceless moment in the whole history of man, all the people on this Earth are truly one; one in their pride in what you have done, and one in our prayers that you will return safely to Earth. — President Richard Nixon, July 20, 1969 Opposite: Buzz Aldrin takes a moment from the busy timeline to salute the American flag, a familiar splash of patriotic colors on the moonscape. Moments later, Armstong will join him to take a call from President Nixon. *Photo, NASA.*

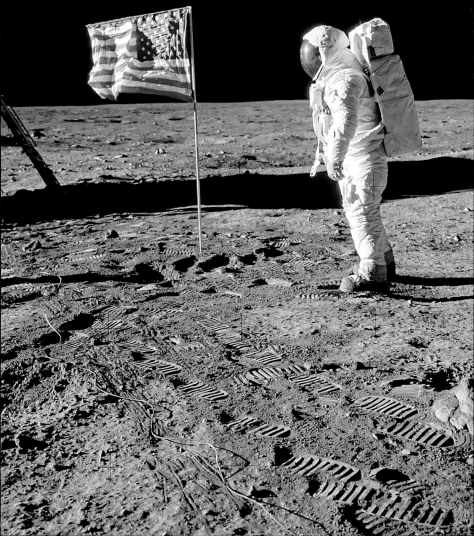

hundred reporters in a room to report on the climax of an event "equal in importance to that moment in evolution when aquatic life came crawling up on the land," and put a movie screen in front of them, and a television transmission on that screen which is not only a pioneer effort in communication from a satellite one good quarter of a million miles away, but is also, you may be sure, wildly out of focus. Reporters wear eyeglasses in order not to miss the small print — bad focus on the screen puts a new injury right inside the wound of the previous injury. Something in them reverted. Watching the mooncast, they were like college kids on Friday night in the town movie house — one never knew what would make their laughter stir next, but their sense of the absurd was quick and furious. Like college students who roar with disgust because by God they were being trained to run a supposedly reasonable world with highly reasonable skills, and yet the fools who made this movie had the real power, so the press took the mooncast on its own literal terms of spectacle — where it was good as spectacle they loved it, where it was poor they mocked.

But let us take it from the start. The screen was dark when the voices began, and since it stayed without image for many minutes while one heard the voices of the astronauts working to get ready, a strain developed in the audience. Would the picture ever come on tonight, or had something gone wrong?

Then one learned from the Public Affairs Officer that the Portable Life Support Systems were working — the astronauts were now connected by umbilical tubes to the big white box on their back, that box which could cool them, clear the fog from their helmets, give them oxygen to breathe, and

As Astronauts, we believe they should leave the flying to us. And they are. Both Gemini and Apollo are designed with man as a vital part of the controls. In Mercury, you stayed in a predetermined and fixed orbital path until it was time to fire the retro-rockets and come home. But flying to the moon is a lot more complicated than orbiting around the earth and the pilot will have some choice over the flight path he's taking. — Deke Slayton, LIFE, *September 27, 1963 Opposite:* The scene in Mission Control as Armstrong and Aldrin raise the U.S. flag for the first time on the lunar surface. *Photo, NASA.*

absorb the wastes of their exhalation. But the minutes went by. There was no image on the screen. Oxygen was being used. They had only a few hours of Life Support in the system — would they be obliged to use it overcoming the difficulties of opening the hatch? Hoots and a hum of restlessness worked through the theater. The journalists were nervous. That rare hysteria which is generated by an inability to distinguish between the apocalyptic and the absurd was generating. What if — assuming they could actually see something — what if Armstrong were to take a step on the moon and simply disappear? Whatever would one do in this theater? The event would be a horror to watch if tragedy occurred; yet it would be a humiliation if it all went on schedule.

Opposite: Capcom Charlie Duke, Backup Commander James Lovell. *Television stills, NASA/Copp.*

A cheer not unmixed with mockery came at the announcement at 9:40 in the evening that the hatch was open. Still no image on the screen. Now followed long incomprehensible instructions back and forth, talk of window clanks and water valves, high-gain antenna and glycol pumps. Out of all this, quiet exhortations from Aldrin to Armstrong. Through the words emerged the realization that Armstrong, made twice bulky by his space suit and the Portable Life Support System on his back, was trying to push through the open hatch of the Lem out onto the small metal porch which led to the ladder which in turn he could descend to the moon ground. It was obviously a very tight fit to get through the hatch. As Aldrin gave instructions there was an inevitable suggestion of the kind of dialogue one hears between an obstetrician and a patient in the last minutes before birth.

ALDRIN: Your back is up against the (garbled). All right, now it's on top of the DSKY. Forward and up, now you've got them, over toward me, straight down, relax a little bit.

ARMSTRONG: (Garbled)

ALDRIN: Neil, you're lined up nicely. Toward me a little bit, okay down, okay, made it clear.

ARMSTRONG: To what edge?

ALDRIN: Move. Here roll to the left. Okay, now you're clear. You're lined up on the platform. Put your left foot to the right a little bit. Okay that's good. Roll left.

The Press was giggling. Sanctimony at NASA was a tight seal. A new church, it had been born as a high church. No one took liberties. Now, two of the heroes of NASA were engaged in an inevitably comic dialogue — one big man giving minute adjustments of position to another. The Press giggled.

Armstrong spoke out suddenly. "Okay, Houston, I'm on the porch." The audience broke into applause. There was mockery, as if the cavalry had just come galloping down the ridge.

A few minutes went by. Impatience hung in the air. Then a loud bright cheer as a picture came on the screen. It was a picture upside-down, blinding in contrast, and incomprehensible, perhaps just such a kaleidoscope of shadow and light as a baby might see in the first instants before silver nitrate goes into its eyes. Then, twists and turns of image followed, a huge black cloud resolved itself into the bulk of Armstrong descending the ladder, a view of confusions of objects, some roughhewn vision of a troglodyte with a huge hump on his back and voices — Armstrong, Aldrin and Capcom — details were being offered of the descent down the ladder. Armstrong stepped off the

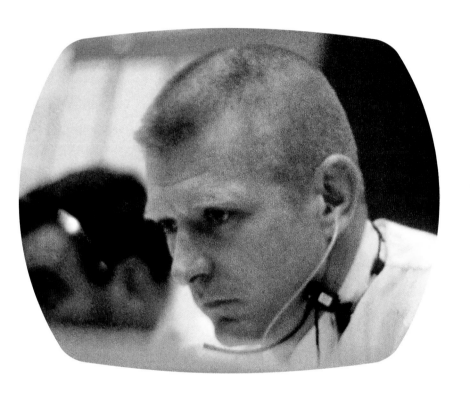

pad. No one quite heard him say, "That's one small step for a man, one giant leap for mankind," nor did anyone quite see him take the step — the TV image on the movie screen was beautiful, but still as marvelously abstract as the branches of a tree, or a painting by Franz Kline of black beams on a white background. Nonetheless, a cheer went up, and a ripple of extraordinary awareness. It was as if the audience felt an unexpected empathy with the sepulchral, as if a man were descending step by step, heartbeat by diminishing heartbeat into the reign of the kingdom of death itself and he was reporting, inch by inch, what his senses disclosed.

Everybody listened in profound silence. Irritation was now gone as Armstrong described the fine and powdery substance of the surface: "I can see the footprints of my boots and the treads in the fine sandy particles." Every disclosure for these first few minutes would be a wonder. If it would have been more extraordinary to hear that the moon had taken no imprint in soft powder, or the powder was phosphorescent, still it was also a wonder that the powder of the moon reacted like powder on earth. A question was at least being answered. If the answer was ordinary, still there was one less question in the lonely spaces of the human mind. Aquarius had an instant when he glimpsed space expanding like the widening pool of an unanswered question. Was that the power behind the force which made technology triumphant in this century? — that technology was at least a force which attempted to bring back answers from questions which had been considered to be without answers? The image was becoming more decipherable. As Armstrong moved away from the ladder in a hesitant

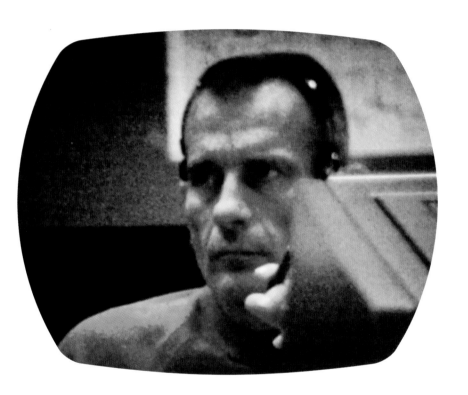

There was no air, of course, and so no wind, nor clouds, nor dust, nor even the finest scattering of light.... They were discovering the powder of the moon soil was curious indeed...between sand and snow. — Norman Mailer Opposite: This frame from Aldrin's first panorama was taken "down-sun," with the sun behind him. The surface features are almost indistinguishable because from this viewpoint at a low sun angle, all but the nearest rocks and craters hide their own shadows. The "halo" around Buzz's shadow is a trick of the light in this direction opposite the sun. *Photo, NASA.*

loping gait, not unlike the first staggering steps of a just-born calf, he called back to Mission Control, "No trouble to walk around," but as if that were too great a liberty to take with the feelings of the moon, he came loping back to the ladder.

Activities went on. There were photographs to take, descriptions of the appearance of the rocks, of the character of the sun glare. One of Armstrong's first jobs was to pick up a sample of rock and put it in his pocket. Thus if something unforeseen were to occur, if the unmentionable yak or the Abominable Snowman were to emerge from a crater, if the ground began to rumble, if for any reason they had to reenter the Lem and take off abruptly, they would then have the chance to return to earth with at least one rock. This first scoop of moon stone and moon dust was called the contingency sample, and it was one of Armstrong's first tasks, but he seemed to have forgotten it. The Capcom reminded him subtly, so did Aldrin. The Capcom came back again: "Neil, this is Houston. Did you copy about the contingency sample? Over?" "Rog," said Armstrong, "I'm going to get to that just as soon as I finish this picture series." Aldrin had probably not heard. "Okay," he asked, "going to get the contingency sample now, Neil?" "Right!" Armstrong snapped. The irritability was so evident that the audience roared with laughter — don't we laugh when we glimpse a fine truth and immediately conceal it? What a truth! Nagging was nagging, even on the moon.

The television image was improving. It was never clear, never did it look any better in quality than a print of the earliest silent movies, but it was eloquent. Ghosts beckoned to ghosts, and the surface of the moon looked like a ski slope at night. Fields of a

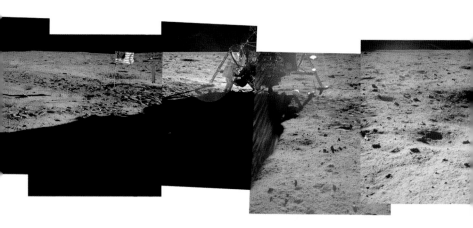

To provide views of their surroundings in context, the moonwalkers intentionally took series of slightly overlapping pictures, such as this series by Buzz Aldrin, which could be pasted together into panoramas for later study by researchers. Taken just a couple yards (a few meters) west of the LM, this is the first of Aldrin's two panoramas. *Photos, NASA/Byrne.*

Following spread: A frame from Aldrin's first panorama shows Armstrong packing samples in an open rock box. Remarkably, of the 121 photographs taken during the moonwalk, this is the only clear Hasselblad image of Armstrong. *Photo, NASA.*

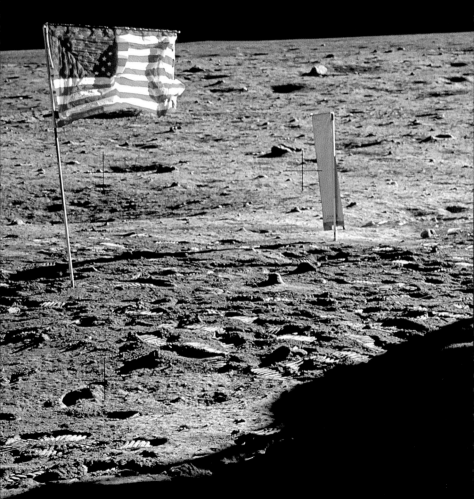

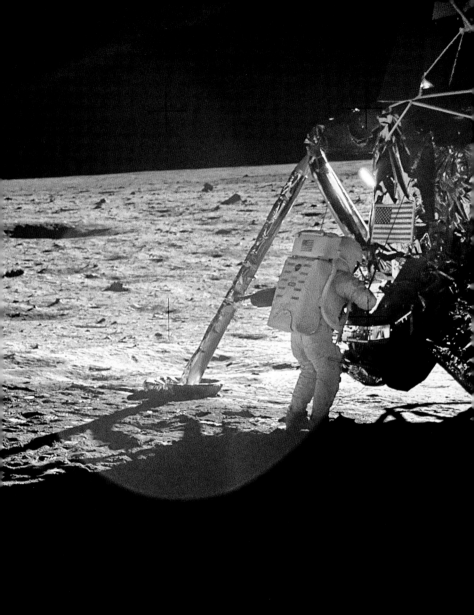

Opposite: Apollo 11's moon photography shows a black sky but never any stars. On Earth our atmosphere preferentially scatters blue light, making the daytime sky blue and bright. At night, the effect is lost because the bulk of Earth obscures the sun, and away from city lights our eyes adapt to the dark and we can see stars. The moon has no atmosphere, so there is no scattering and the sky is the black of deep space. The stars are there, but in lunar daylight the intensity of the sun across the landscape forces our eyes and cameras to deal with the brilliance. As a result, film has no hope of capturing the dim stars. Here, against the black lunar sky, Buzz Aldrin has begun to remove components of the Early Apollo Scientific Experiment Package from a stowage bay in the descent stage of the LM. Once they are carried to a site away from the LM, they will be deployed on the lunar surface to send data to anxious scientists waiting on Earth. *Photo, NASA.*

dazzling pale ran into caverns of black, and through this field moved the ghost of Armstrong. There were moments when one had the impression it was possible to see through him. His image was transparent.

Aldrin descended the ladder, then jumped back on the lowest rung to test his ability to return to the Lem. The abruptness of the action broke the audience into guffaws again, the superior guffaw a sophisticate gives to a chair creaking too crudely in a horror movie. Now two ghosts paraded about, jogging forward and back, exchanging happy comments on the new nature of hopping and walking, moving faster than a walk but like much-padded toddlers, or overswathed beginners on skis. Sometimes they looked like heavy elderly gentlemen dancing with verve, sometimes the sight of their boots or their gloves, the bend of their backs setting up equipment or reaching for more rocks gave them the look of beasts on hindquarters learning to think, sometimes the image went over into negative so that they looked black in their suits on a black moon with white hollows, sometimes the image was solarized and became positive and negative at once, images yawing in and out of focus, so the figures seemed to squirt about like one-celled animals beneath a slide — all the while, images of the Lem would appear in the background, an odd battered object like some Tartar cooking pot left on a trivet in a Siberian field. It all had the look of the oldest photographs of expeditions to the North Pole — there was something bizarre, touching, splendid and ridiculous all at once, for the feat was immense, but the astronauts looked silly, and their functional conversations seemed farcical in the circumstances. "What did you say, Buzz?" "I say the rocks are rather slippery."

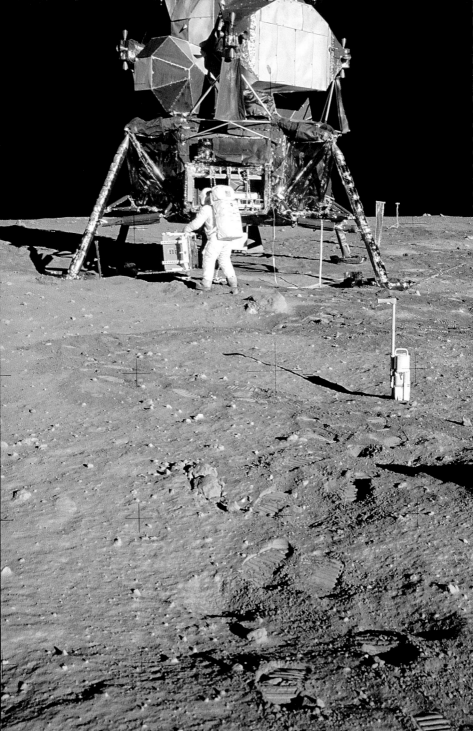

Huge guffaws from the audience. When the flag was set up on the moon, the Press applauded. The applause continued, grew larger — soon they would be giving the image of the flag a standing ovation. It was perhaps a way of apologizing for the laughter before, and the laughter they knew would come again, but the experience was still out of register. A reductive society was witnessing the irreducible. But the irreducible was being presented with faulty technique. At that they could laugh. And did again and again. There were moments when Armstrong and Aldrin might just as well have been Laurel and Hardy in space suits.

The voice of Collins came into the public address system. He had been out of radio contact for almost an hour during his trip around the back of the moon, so he did not know how the Extra Vehicular Activity was proceeding. He had left communication before Armstrong had reached the lunar surface. Now he asked, "How's it going?"

CAPCOM: Roger. The EVA is progressing beautifully. I believe they are setting up the flag now.
COLLINS: Great.

The audience laughed at this hard pea of envy beneath twenty mattresses of NASA manners.

CAPCOM: I guess you're about the only person around that doesn't have TV coverage of the scene.
COLLINS: That's right. That's all right. I don't mind a bit.

Now, the Press roared.

COLLINS: How is the quality of the TV?

People keep asking me if I was lonely up there in Columbia while Neil and Buzz were on the moon. I wasn't. I've been flying airplanes by myself for about 17 years, and the idea of being in a flying vehicle alone was in no way alarming. In fact, sometimes I prefer to be by myself.
— Michael Collins,
LIFE, *August 8, 1969*

Opposite and pages 455-456: Although Mike Collins did not operate the Command Module television while Neil and Buzz were on the surface, he did film himself during his solo orbits in the CM. Photos, NASA/Copp.

CAPCOM: Oh, it's beautiful, Mike. Really is.
COLLINS: Oh, gee, that's great.

The video continued, the astronauts worked on styles of gait, ordinary walking, half-run, kangaroo hops. There was a sense of the astronauts' happiness as they loped about, and now a delicate envy, almost tender in its sensibility, went to them from the crowd. There was finally something marvelous. This old-fashioned indistinct movie of comedians in old-fashioned suits was in fact but a cover upon the curious happiness everyone was feeling. It was the happiness which comes from a wound. For with the pain, and there was pain in the thought of the moon — so private a body to the poet buried in every poke of a head — the moon being now invaded, there was also the happiness that accompanies the pain, for the landing was a straight-out wound to every stable disposition of the mind. Yet a wound in that period when we do not know which flesh is severed forever and what is recuperable is an hour of curious happiness. Change may give life. So the world was watching the loping bumbling skittering low-gravity movements of these men with the kind of concentration we offer to the study of our own wound. Something in the firmament was being operated upon.

Well, the flag was up. The Capcom spoke. He asked the astronauts to stand in view of the camera, then announced that the President of the United States wanted to say a few words.

ARMSTRONG: That would be an honor.
CAPCOM: Go ahead, Mr. President, this is Houston. Out.

It had been announced in advance that the President would speak to the astronauts, but the liberal portion of the Press groaned, to be answered by a pattering of stiff hands from the patriots in the room.

PRESIDENT NIXON: Neil and Buzz, I am talking to you by telephone from the Oval Room at the White House. And this certainly has to be the most historic telephone call ever made.

Large jeers from the audience. The most expensive telephone call ever made! Stentorian hand clapping.

PRESIDENT NIXON: I just can't tell you how proud we all are of you. For every American this has to be the proudest day of our lives. And for people all over the world, I am sure they too join with Americans in recognizing what a feat this is. Because of what you have done, the heavens have become a part of man's world. And as you talk to us from the Sea of Tranquility, it inspires us to double our efforts to bring peace and tranquility to earth. For one priceless moment in the whole history of man, all the people on this earth are truly one. One in their pride in what you have done. And one in our prayers that you will return safely to earth.

Every word had its function. It could be said that the psychology of machines begins where humans are more machinelike in their actions than the machines they employ.

"Thank you, Mr. President," answered Armstrong in a voice not altogether in control. What a moment for Richard Nixon if the first tears shed on the moon flowed on the consequence of his words! "It's a great honor and a privilege," Armstrong went on, "to be

representing not only the United States, but men of peace of all nations." When he finished, he saluted.

Some of the crowd jeered again. The image of Nixon faded on home TV screens, his voice was gone from the theater. The moon walk continued. In fact, it was not half done, but the early excitement had ebbed in this last play of rhetoric — the minds of the Press had gone on to the question of whether Nixon was considering it politically advantageous to support a future program of space. As the astronauts continued to walk, to hop, to flit and to skip from one vale of moon ground to another, as the experiments were set out and the rocks picked up, so the temper of the audience shifted. It was a Twentieth Century audience when all was said, and quick in its sense of fashion. By an hour and a half of the moon walk they were bored — some were actually slipping out. All over the room was felt the ubiquitous desire of journalists for the rescue of a drink. Boredom deepened. Now the mood was equal to the fourth quarter of a much anticipated football game whose result had proved lopsided. Now it looked as if rookies were out on the chill field running fumbles back and forth. More and more reporters departed. Even Aquarius left before the end.

* * *

It was the event of his lifetime, and yet it had been a dull event. The language which now would sing of this extraordinary vault promised to be as flat as an unstrung harp. The century had unstrung any melody of words. Besides — the event was obdurate on the surface and a mystery beneath. It was not at all easy

In one-sixth gravity, on the moon, you have a distinct feeling of being somewhere and you have a constant, though at many times illdefined, sense of direction and force. . . Our best simulations on earth, the water tank and the 16-G aircraft, are both somewhat misleading. The resistive forces in water are too high to permit any rapid movement, and the experiences in the aircraft are too brief. — Buzz Aldrin, LIFE, *August 8, 1969*
Opposite: Aldrin carries two experiment modules — the passive seismometer and the lunar ranging retro-reflector ("LR**3**") — to the deployment site approximately 60 feet from the LM. His boot prints are particularly deep on the soft rim of the crater just to his left. *Photo, NASA.*

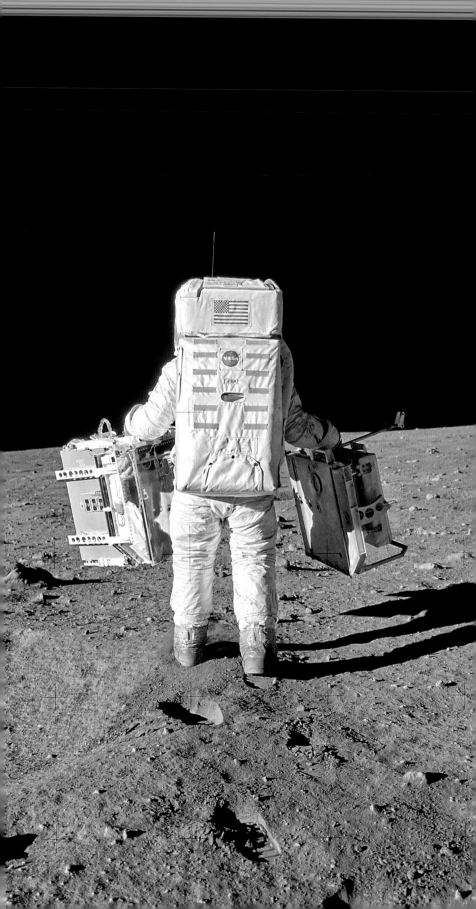

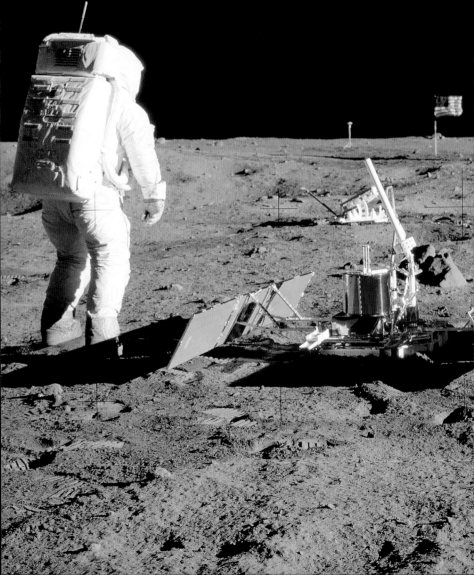

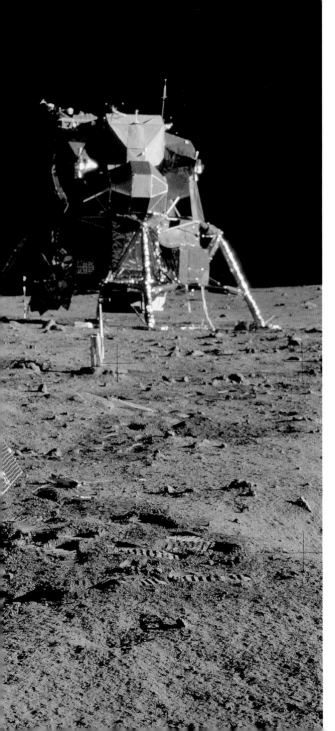

Next to the freshly deployed seismic experiment, Aldrin surveys the scene. In the foreground, just beyond the seismometer are, from left to right, the laser range reflector (which is pointed at Earth and will bounce back laser pulses sent from observatories, allowing precise measurement of the distance between the Earth and the moon) and the close-up stereo camera, which would allow scientists to characterize the structure of the regolith's topmost layer. In the distance are the TV camera on its tripod stand, the U.S. flag, and the LM. *Photo, NASA.*

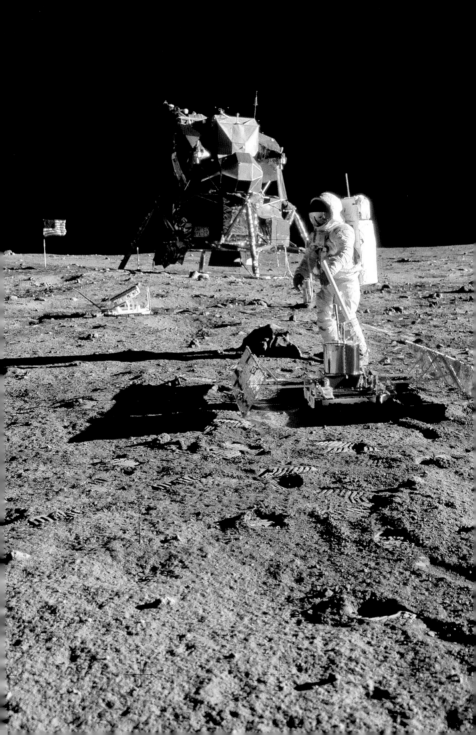

to comprehend. Like an adolescent married before he could vote, the congratulation, "You're a married man," had no reality to the brand-new groom. So America and the world would be in a round of congratulations — we had landed a man on the moon. The event was so removed, however, so unreal, that no objective correlative existed to prove it had not conceivably been an event staged in a television studio — the greatest con of the century — and indeed a good mind, product of the iniquities, treacheries, gold, passion, invention, deception and rich worldly stink of the Renaissance could hardly deny that the event if bogus was as great a creation in mass hoodwinking, deception and legerdemain as the true ascent was in discipline and technology. Indeed, conceive of the genius of such a conspiracy. It would take criminals and confidence men mightier, more trustworthy and more resourceful than anything in this century or the ones before. Merely to conceive of such men was the surest way to know the event was not staged. Yes, the century was a giant and a cretin. Man had become a Herculean embodiment of the Vision, but the brain on top of the head was as small as a transistorized fist, and the chambers of the heart had shrunk to the dry hard seeds of some hybrid future.

To make sense of Apollo 11 on the moon, to rise above the verbiage (like extinguishers of foam) which covered the event, was to embark on a project which could not satisfy his own eye unless it could reduce a conceptual city of technologese to one simplicity — was the venture worthwhile or unappeased in its evil?

If Marx had done his best to gut the past of every attachment to the primitive, the sacramental and

Opposite: After experiencing some difficulty leveling the device in the low gravity field — and trying to keep it clean from the clinging dust — Aldrin has successfully deployed the passive seismic experiment. Its two solar arrays provide it with the power it needs to send "moonquake" data back to researchers on Earth via its tubelike antenna. The instrument would begin, almost immediately, to pick up the vibrations of the moonwalkers' footsteps. Once two more seismometers were placed on the surface by subsequent crews, researchers could use signals generated by intentional, targeted impacts of LM Ascent Stages and S-IVB rocket stages to help determine the structure of the moon's interior. *Photo, NASA.*

the magical, if the Marxian formula that history was a reflection of the state of productive relations had thereby elevated reason to that vertiginous even insane eminence out of which technology had been born, then the task now appeared in reverse: one was obliged to make a first reconnaissance into the possibility of restoring magic, psyche, and the spirits of the underworld to the spookiest venture in history, a landing on the moon, an event whose technologese had been so complete that the word "spook" probably did not appear in twenty million words of NASA prose.

* * *

Early on the afternoon of July 21, the Lunar Module fired its ascent motor, lifted off Tranquility Base, and in a few hours docked with *Columbia*. Shortly after, the astronauts passed back into the Command Module and *Eagle* was jettisoned. It would drift off on a trajectory to the sun. A little before midnight, out of communication for the last time with Mission Control, traveling for the final orbit around the back of the moon, Apollo 11 ignited the Service Module engine and accelerated its speed from 3,600 miles to 5,900 miles per hour. Its momentum was now great enough to lift it out of the moon's pull of gravity and back into the attractions of the earth — the spacecraft was therefore on its way home. Since the trip would take sixty hours, a quiet two and a half days were in store and Aquarius decided to get out of Nassau Bay and visit some friends.

His host and hostess were wealthy Europeans with activities which kept them very much of the time in Texas. Since they were art collectors of distinction,

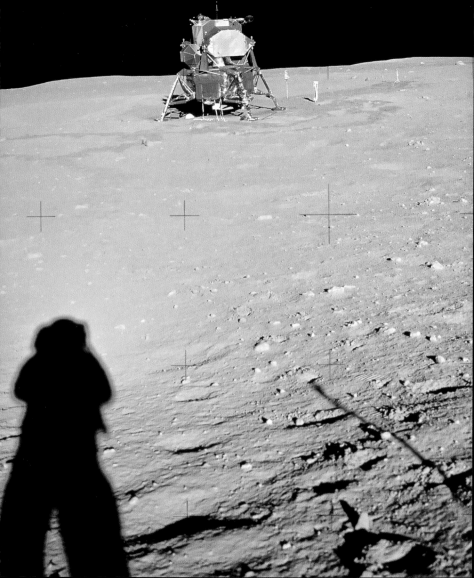

Opposite: Sitting on the lunar surface with the ascent stage still fully fueled for the return to lunar orbit, the LM weighs in at 16,000 pounds (7,257 kg). A gibbous Earth, with Australia visible, hangs in the lunar sky above the rear of the LM. With the Hasselblad camera attached to the astronauts' chest-mounted Portable Life Support System control units, bending back far enough to get this picture was all but impossible; which may be what Aldrin was talking about when he said, one hour and 54 minutes into the EVA, "Just too big an angle, Neil." *Photo, NASA.*

invariably served a good meal and had always been kind to him, the invitation was welcome. To go from the arid tablelands of NASA Highway 1 to these forested grounds now damp after the rain of a summer evening was like encountering a taste of French ice in the flats of the desert. Even the trees about the house were very high, taller than the tallest elms he had seen in New England — "Wild pigs used to forage in this part of Houston," said his host, as if in explanation, and on the lawn, now twice-green in the luminous golden green of a murky twilight, smaller tropical trees with rubbery trunks twisted about a large sculpture by Jean Tinguely which waved metal scarecrow arms when a switch was thrown and blew spinning faucets of water through wild stuttering sweeps, a piece of sculpture reminiscent of the flying machines of La Belle Epoque, a hybrid of dragon and hornet which offered a shade of the time when technology had been belts and clanking gears, and culture was a fruit to be picked from a favored tree.

The mansion was modern, it had been one of the first modern homes in Houston and was designed by one of the more ascetic modern architects. With the best will, how could Aquarius like it? But the severity of the design was concealed by the variety of the furniture, the intensity of the art, the presence of the sculpture and the happy design in fact of a portion of the house: the living room shared a wall with a glassed-in atrium of exotics in bloom. So the surgical intent of the architect was partially overcome by the wealth of the art and by the tropical pressure of the garden whose plants and interior tree, illuminated with spotlights, possessed something of that same silence which comes over audience and cast when there is a moment

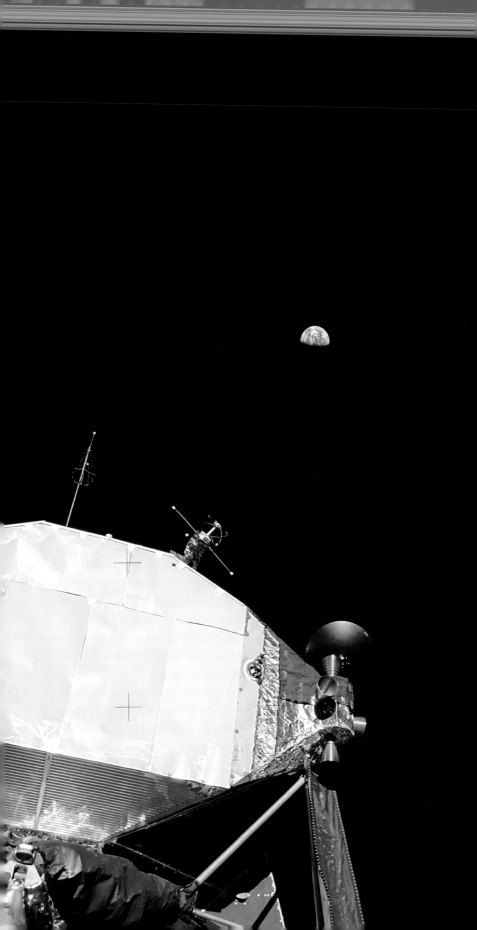

of theater and everything ceases, everything depends on — one cannot say — it is just that no one thinks to cough.

There had been another such moment when he entered the house. In the foyer was a painting by Magritte, a startling image of a room with an immense rock situated in the center of the floor. The instant of time suggested by the canvas was comparable to the mood of a landscape in the instant just before something awful is about to happen, or just after, one could not tell. The silences of the canvas spoke of Apollo 11 still circling the moon: the painting could have been photographed for the front page — it hung from the wall like a severed head. As Aquarius met the other guests, gave greetings, took a drink, his thoughts were not free of the painting. He did not know when it had been done — he assumed it was finished many years ago — he was certain without even thinking about it that there had been no intention by the artist to talk of the moon or projects in space, no, Aquarius would assume the painter had awakened with a vision of the canvas and that vision had he delineated.

Something in the acrid breath of the city he inhabited, some avidity emitted by a passing machine, some tar in the residue of a nightmare, some ash from the memory of a cremation had gone into the painting of that gray stone — it was as if Magritte had listened to the ending of one world with its comfortable chairs in the parlor, and heard the intrusion of a new world, silent as the windowless stone which grew in the room, and knowing not quite what he had painted, had painted his warning nonetheless. Now the world of the future was a dead rock, and the rock was in the room.

In the foyer was a painting by Magritte, a startling image of a room with an immense rock situated in the center of the floor. The instant of time suggested by the canvas was comparable to the mood of a landscape in the instant just before something awful is about to happen, or just after, one could not tell. The silences of the canvas spoke of Apollo 11 still circling the moon: the painting could have been photographed for the front page—it hung from the wall like a severed head.
—Norman Mailer
Opposite: Le monde invisible (The Invisible World), 1954. Painting, René Magritte.

There was also a Negro in his host's living room, a man perhaps thirty-five, a big and handsome Black man with an Afro haircut of short length, the moderation of the cut there to hint that he still lived in a White man's clearing, even if it was on the very edge of the clearing. He was not undistinguished, this Negro, he was a professor at an Ivy League college; Aquarius had met him one night the previous year after visiting the campus. The Negro had been much admired in the college. He had an impressive voice and the deliberate manner of a leader. How could the admiration of faculty wives be restrained? But this Black professor was also a focus of definition for Black students in the college — they took some of the measure of their militancy from his advice. It was a responsible position. The students were in the college on one of those specific programs which had begun in many a university that year — students from slum backgrounds, students without full qualification were being accepted on the reasonable if much embattled assumption that boys from slums were easily bright enough to be salvaged for academic life if special pains were taken. Aquarius had met enough of such students to think the program was modest. The education of the streets gave substantial polish in Black ghettos — some of the boys had knowledge at seventeen Aquarius would not be certain of acquiring by seventy. They had the toughness of fiber of the twenty-times tested. This night on the campus, having a simple discussion back and forth, needling back and forth, even to even — so Aquarius had thought — a Black student suddenly said to him, "You're an old man. Your hair is gray. An old man like you wants to keep talking like that, you may have to go outside with

I guess this day has given us our biggest story. . . . We've covered World War II. . . and the conflicts since then and the comings and goings of heads of state. But, I don't think anything compares with this. — Walter Cronkite, CBS News Space Headquarters, July 20, 1969 Opposite: Cronkite was on the air for 27 of the 30 hours it took to reach the moon. *Television stills, CBS.*

me." The student gave an evil smile. "You're too old to keep up with me. I'll whomp your ass."

It had been a glum moment for Aquarius. It was late at night, he was tired, he had been drinking with students for hours. As usual he was overweight. The boy was smaller than him, but not at all overweight, fast. Over the years Aquarius had lost more standards than he cared to remember. But he still held on to the medieval stricture that one should never back out of a direct invitation to fight. So he said with no happiness, "Well, there are so many waiting on line, it might as well be you," and he stood up.

The Black boy had been playing with him. The Black boy grinned. He assured Aquarius there was no need to go outside. They could talk now. And did. But what actors were the Blacks! What a sense of honor! What a sense of the gulch! Seeing the Black professor in this living room in Houston brought back the memory of the student who had decided to run a simulation through the character of Aquarius' nerve. It was in the handshake of both men as they looked at each other now, Aquarius still feeling the rash of the encounter, the other still amused at the memory. God knows how the student had imitated his rise from the chair. There had been a sly curl in the Black man's voice whenever they came across each other at a New York party. Tonight, however, was different. He almost did not recognize the professor. The large eyes were bloodshot, and his slow deliberate speech had become twice-heavy, almost sluggish. Aquarius realized the man had been drinking. It was not a matter of a few shots before this evening, no, there was a sense of somebody pickling himself through three days of booze, four days of booze, five, not even drunk, just the heavy taking of

Opposite: The televised view of the moon from Earth the night of the landing. *Television still, CBS.*

the heaviest medicine, a direct search for thickening, as if he were looking to coagulate some floor between the pit of his feelings at boil and the grave courtesies of his heavy Black manner. By now it showed. He was normally so elegant a man that it was impossible to conceive of how he would make a crude move — now, you could know. Something raucous and jeering was still withheld, but the sourness of his stomach had gotten into the sourness of his face. His collar was a hint wilted.

He had a woman with him, a sweet and wispy blond, half plain, still half attractive, for she emitted a distant echo of Marilyn Monroe long gone. But she was not his equal, not in size, presence, qualifications — by the cruel European measure of this richly endowed room, she was simply not an adequate woman for a man of his ambitions. At least that was the measure Aquarius took. It was hard not to recognize that whatever had brought them together, very little was now sustaining the project. The Black man was obviously tired of her, and she was still obviously in love with him. Since they were here enforcedly together, that was enough to keep a man drinking for more than a day. Besides — if he was a comfortable house guest of these fine Europeans, he might nonetheless wish to leave the grounds. Being seen with her on Houston streets would not calm his nerves.

But there were other reasons for drinking as well. America had put two White men on the moon, and lifted them off. A triumph of White men was being celebrated in the streets of this city. It was even worse than that. For the developed abilities of these White men, their production, their flight skills, their engineering feats, were the most successful part of that

Opposite: While the crew spent more than 21 hours on the lunar surface, they were only outside for two and a half of them. Back in the LM, Armstrong began to photograph the view outside his window. The LM's dark shadow falls across footprints that should, on the weatherless moon, remain virtually unchanged for thousands of years. Over longer periods of time, the slow, steady rain of tiny impactors will churn and stir the soil layer enough to wear down the footprints. "Microgram impactors" each disturb a small area of soil to a depth of only 1,25 inches (1 mm). Far less frequent, "milligram impactors" reach down 0,39 inches (1 cm) or so. The latter are common enough that in a million years, the top soil layer will be thoroughly stirred and all of the footprints badly worn or gone. *Photo, NASA.*

"We came in peace for all mankind." *Opposite:* The message inscribed on the plaque mounted on the ladder strut of the LM Descent Stage will be left behind. *Photo, NASA.*

White superstructure which had been strangling the possibilities of his own Black people for years. The professor was an academic with no mean knowledge of colonial struggles of colored peoples. He was also a militant. If the degree of his militancy was not precisely defined, still its presence was not denied. His skin was dark. If he were to say, "Black is beautiful" with a cultivated smile, nonetheless he was still saying it. Aquarius had never been invited to enter this Black man's vision, but it was no great mystery the Black believed his people were possessed of a potential genius which was greater than Whites. Kept in incubation for two millennia, they would be all the more powerful when they prevailed.

It was nothing less than a great civilization they were prepared to create. Aquarius could not picture the details of that civilization in the Black professor's mind, but they had talked enough to know they agreed that this potential greatness of the Black people was not to be found in technology. Whites might need the radio to become tribal but Blacks would have another communion. From the depth of one consciousness they could be ready to speak to the depth of another; by telepathy might they send their word. That was the logic implicit in CPT.

If CPT was one of the jokes by which Blacks admitted Whites to the threshold of their view, it was a relief to learn that CPT stood for Colored People's Time. When a Black friend said he would arrive at 8 P.M. and came after midnight, there was still logic in his move. He was traveling on CPT. The vibrations he received at 8 P.M. were not sufficiently interesting to make him travel toward you — all that was hurt were the host's undue expectations. The real logic of CPT was

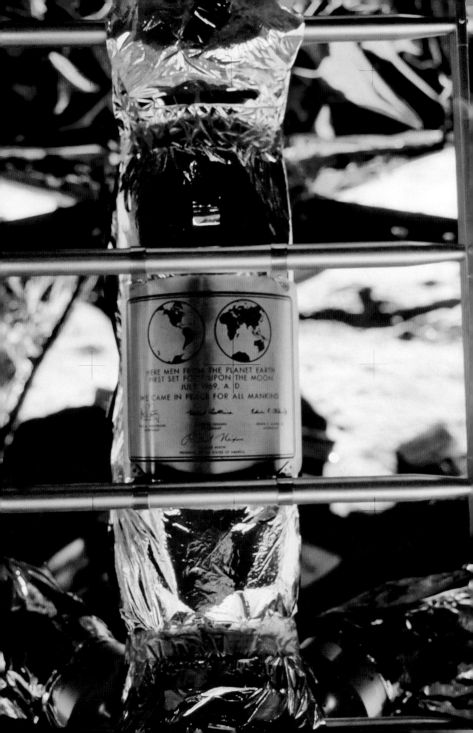

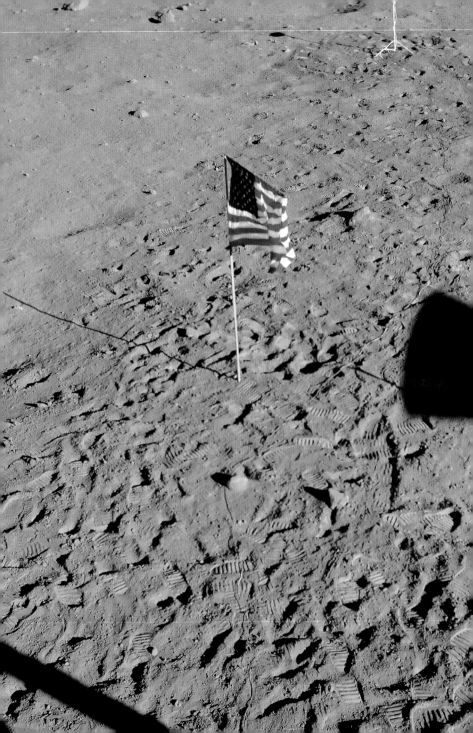

that when there was trouble or happiness the brothers would come on the wave. Well, White technology was not built on telepathy, it was built on electromagnetic circuits of transmission and reception, it was built on factory workers pressing their button or monitoring their function according to firm and bound stations of the clock.

The time of a rocket mission was Ground Elapsed Time, GET. Every sequence of the flight was tied into the pure numbers of the timeline. So the flight to the moon was a victory for GET, and the first heats of the triumph suggested that the fundamental notion of Black superiority might be incorrect: in this hour, it would no longer be as easy for a militant Black to say that Whitey had built a palace on numbers, and numbers killed a man, and numbers would kill Whitey's civilization before all was through. Yesterday, Whitey with his numbers had taken a first step to the stars, taken it ahead of Black men. How that had to burn in the ducts of this Black man's stomach, in the vats of his liver. Aquarius thought again of the lunar air of technologists. Like the moon, they traveled without a personal atmosphere. No wonder Blacks had distaste for numbers, and found trouble studying. It was not because they came — as liberals necessarily would have it — from wrecked homes and slum conditions, from drug-pushing streets, no, that kind of violence and disruption could be the pain of a people so rich in awareness they could not bear the deadening jolts of civilization on each of their senses. Blacks had distaste for numbers not because they were stupid or deprived, but because numbers were abstracted from the senses, numbers made you ignore the taste of the apple for the amount in the box, and so the use

They have been as far as Achilles and Odysseus, as far as Jason. . . as far as Magellan and Columbus, they have been far. — *Norman Mailer* Opposite: Outside Aldrin's LM window, the flag and television camera remain rooted amongst the footprints on the lunar surface. A portion of a conical LM thruster is in the foreground on the right, and around the camera is a circle of slightly darker footprints made by Armstrong during the TV panorama he shot when he first moved the camera out from the LM. *Photo, NASA.*

of numbers shrunk the protective envelope of human atmosphere, eroded that extrasensory aura which gave awareness, grace, the ability to move one's body and excel at sports and dance and war, or be able to travel on an inner space of sound. Blacks were not the only ones who hated numbers — how many attractive women could not bear to add a column or calculate a cost? Numbers were a pestilence to beauty.

Opposite: An artist's impression of the LM Ascent Stage launching from its "pad," the Descent Stage. In reality, the rocket plume was transparent. *Television stills, CBS.*

Of course this particular Black man, this professor, was in torture, for he lived half in the world of numbers, and half in the wrappings of the aura. So did Aquarius. It was just that Aquarius was White and the other Black — so Aquarius could not conceal altogether his pleasure in the feat. A little part of him, indefatigably White, felt as mean as a Wasp. There was something to be said after all for arriving on time. CPT was excellent for the nervous system if you were the one to amble in at midnight, but Aquarius had played the host too often. "You know," said the professor, "there are no Black astronauts." "Of course not." "Any Jewish astronauts?" "I doubt it." The Black man grunted. They would not need to mention Mexicans or Puerto Ricans. Say, there might not even be any Italians. "Did you want them," asked Aquarius, "to send a Protestant, a Catholic and a Jew to the moon?" "Look," said the Black professor, "do they have any awareness of how the money they spent could have been used?" "They have a very good argument: they say if you stopped space tomorrow, only a token of the funds would go to poverty." "I'd like to be in a position to argue about that," said the Black. He sipped at his drink. It trickled into his system like the inching of glucose from a bottle down a rubber tube. "Damn," he said, "are they still on the moon?" "They took

Opposite: A smiling — but clearly tired — Neil Armstrong, still wearing his "Snoopy" cap in the LM cockpit after the moonwalk. The chart duct-taped to the wall behind him indicates the desired switch positions for the illuminated circuit-breaker panels below, similar to the ones on Aldrin's side of the cabin. When they were getting back in the cabin after the EVA, Buzz accidentally hit one of the breakers with a corner of his PLSS. "We discovered during a long checklist recitation that the ascent engine's arming circuit breaker was broken off on the panel," said Buzz Aldrin in his book, *Men From Earth.* "The little plastic pin simply wasn't there. This circuit would send electrical power to the engine that would lift us off the moon.... We looked around for something to punch in this circuit breaker. Luckily, a felt-tipped pen fit into the slot." *Photo, NASA.*

off already," said Aquarius. "No trouble?" "None." If the Blacks yet built a civilization, magic would be at its heart. For they lived with the wonders of magic as the Whites lived with technology. How many Blacks had made a move or inhibited it because the emanations of the full moon might affect their cause. Now Whitey had walked the moon, put his feet on it. The moon presumably had not spoken. Or had it, and Richard Nixon received the favor and Teddy Kennedy the curse? Was there no magic to combat technology? Then the strength of Black culture was stricken. There would not be a future Black civilization, merely an adjunct to the White. What lava in the raw membranes of the belly. The Black professor had cause to drink. The moon shot had smashed more than one oncoming superiority of the Black.

* * *

That night Aquarius had trouble falling asleep, as if the unrest of the Black professor at the passage of men's steps on the moon had now passed over to him. Nothing in the future might ever be the same — that was cause for unrest — nor could the future even be seen until one could answer the obsessive question: was our venture into space noble or insane, was it part of a search for the good, or the agent of diabolisms yet unglimpsed? It was as if we had begun to turn the pocket of the universe inside out.

He had had at the end a curious discussion with the Black professor. "It's all in the remission of sin," the Black man had said. "Technology begins when men are ready to believe that the sins of the fathers are not visited on the sons. Remission of sin — that's what it's

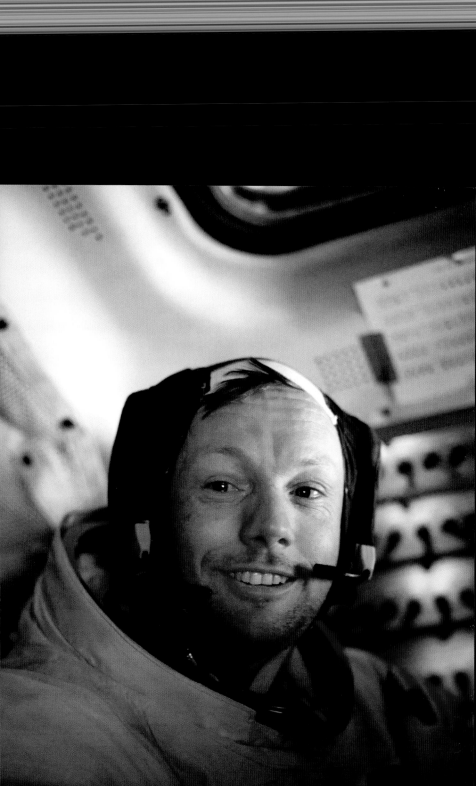

The docking process begins when the two vehicles touch and the probe slides into the drogue. They're held together then by three tiny capture latches, and it's almost like tiny little paper clips holding together two vehicles, one of which weighs 30,000 pounds and the other 5,000. It's a tenuous grasp. — Michael Collins, LIFE, August 8, 1969 *Opposite:* At rendezvous, view to the west. The relatively large, subdued crater behind the LM is Saha C, 1°4' N, 107°8' E. The small, fresh crater on the right at about two o'clock from the LM is Al-Khwarizmi M, 3°1' N, 107° E. *Photo, NASA.*

all about," he said in his Black slow voice. Yes, if the sons were not punished, then the father might dare, as no primitive father had dared, to smash through a taboo. If the father was in error, or if he failed, the sons would be spared. Only the father would suffer. So men were thereby more ready to dare the gods. So that love on the cross which had requested that the sons not pay for the sins of the fathers had opened a hairline split which would finally crack the walls of taboo. And the windowless walls of technology came through the gap. Back to Sören the Dane. You could not know if you were a monster or a saint of the deep.

In the Nineteenth Century, they had ignored Kierkegaard. A middle-class White man, living on the rise of Nineteenth Century technology was able to feel his society as an eminence from which he could make expeditions, if he wished, into the depths. He would know all the while that his security was still up on the surface, a ship — if you will — to which he was attached by a line. In the Twentieth Century, the White man had suddenly learned what the Black man might have told him — that there was no ship unless it was a slave ship. There was no security. Everybody was underwater, and even the good sons of the middle class could panic in those depths, for if there were no surface, there was no guide. Anyone could lose his soul. That recognition offered a sensation best described as bottomless. So the Twentieth Century was a century which looked to explain the psychology of the dream, and instead entered the topography of the dream. The real had become more fantastic than the imagined. And might yet possess more of the nightmare. Lying there, unable to sleep, lost in the caverns of questions whose answers never came

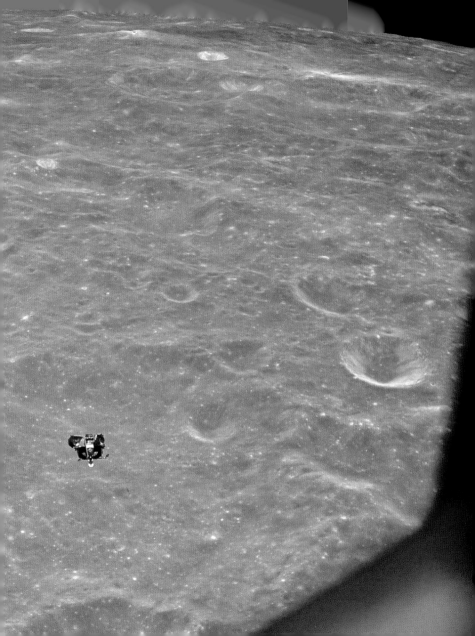

(Mr. Answer Man, what is the existential equivalent of infinity? — Why insomnia, Sandy, good old insomnia) Aquarius knew for the first time in years that he no longer had the remotest idea of what he knew. It was the end of the decade, and the fashion was rising in New York literary lakes to inquire after the nature of the decade to come. He had been a poor prophet of the Sixties, but it was not a century for prophets — poor as he had been, he had still been one of the few who had some sense of what was coming. He had known that marijuana was on its way, and Hip, and the Kennedys, and a time of upheaval, and in the center of the Establishment: loss of belief.

Now they asked him what he thought of the Seventies. He did not know. He thought of the Seventies and a blank like the windowless walls of the computer city came over his vision. When he conducted interviews with himself on the subject, it was not despair he felt, or fear — it was anesthesia. He had no intimations of what was to come and that was conceivably worse than any sentiment of dread, for a sense of the future, no matter how melancholy, was preferable to none — it spoke of some sense of continuation in the projects of one's life. He was adrift. If he tried to conceive of a likely perspective in the decade before him, he saw not one structure to society but two: if the social world did not break down into revolutions and counterrevolutions, into police and military rules of order with sabotage, guerrilla war and enclaves of resistance, if none of this occurred, then there would certainly be a society of reason, but its reason would be the logic of the computer. In that society, legally accepted drugs would become a necessity for accelerated cerebration, there would be inchings toward

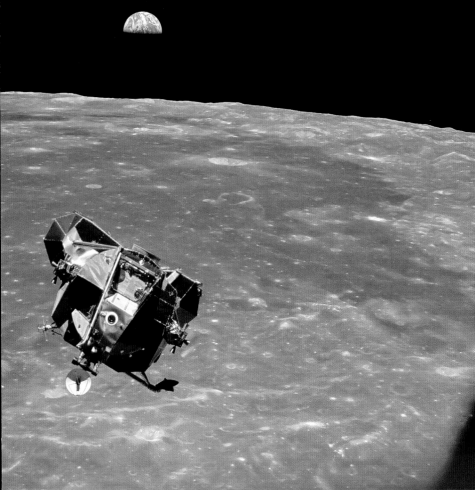

nuclear installation, a monotony of architectures, a pollution of nature which would arouse technologies of decontamination odious as deodorants, and transplanted hearts monitored like spaceships — the patients might be obliged to live in a compound reminiscent of a Mission Control Center where technicians could monitor on consoles the beatings of a thousand transplanted hearts. But in the society of computer-logic, the atmosphere would obviously be plastic, air-conditioned, sealed in bubble-domes below the smog, a prelude to living in space stations. People would die in such societies like fish expiring on a vinyl floor. So of course there would be another society, an irrational society of the dropouts, the saintly, the mad, the militant and the young. There the art of the absurd would reign in defiance against the computer.

In the society of the irrational would be found the weather of the whirlpool. Accelerations and torpor would ride over one another with eyes burned out by visions no longer recalled, motorcycles would climb the trees, a night of freakings when all the hair would be burned for the bonfire of the goat, and bald as the moon would be the skins of the scalp. Hare Krishna! A part of the American world, gassed by the smog of computer logic, would live like gurus, babas and yogas in the smallest towns, the small towns of America would be repopulated with the poets of the city, and mysticism would live next to murder, for murder was love in freak newspeak, and the orgy was the family. Because the computer was the essence of narcissism (the computer could not conceive of its inability to correct its own mistakes) a view of the Seventies suggested a technological narcissism so great that freak newspeak was its only cure — only the threat of

Opposite and page 483: Rendezvous.Television still, NASA/Copp.

Following two spreads:
The Apollo 8 crew
was electrified by the
unexpected sight of
a colorful Earth rising
over the barren moon
and immediately
photographed what
they saw. From then on,
every crew to orbit the
moon could not resist
taking their version
of the Earthrise. The
Apollo 11 crew was
no exception. *Photos,
NASA.*

a murderous society without could keep computer society from withering within. How those societies would mingle! Acid and pot had opened the way.

Yet even this model of the future was too simple. For the society of the rational and the world of the irrational would be without boundaries. Computersville had no cure for skin disease but filth in the wound, and the guru had no remedy for insomnia but a trip to the moon, so people would be forever migrating between the societies. Sex would be a new form of currency in both worlds — on that you could count. The planner and the swinger were the necessary extremes of the computer city, and both would meet in the orgies of the suburbs. But was this a vision of the future or the vertigo of the early hours?

Aquarius got out of bed. He was a disciplinarian about insomnia. Having suffered from it years before, he had learned how to live with an occasional bad night. He took no pill, he took no drink, he looked to ride it out. Sometimes he indulged in a game of formal optimism, carrying over from artillery training the injunction to bracket a target. So now if his sense of the future was too pessimistic — he could only hope it was too dark! — he would look for the formal opposite: try to regard science as reasonable, religion as rewarding. He could see — sitting in a kitchen chair, reading by a lamp — how new religions might crystallize in the Seventies, they could give life, for their view of God might be new. And science... But he could not regard science apart from technology. Aquarius began to think of Dr. George Mueller.

* * *

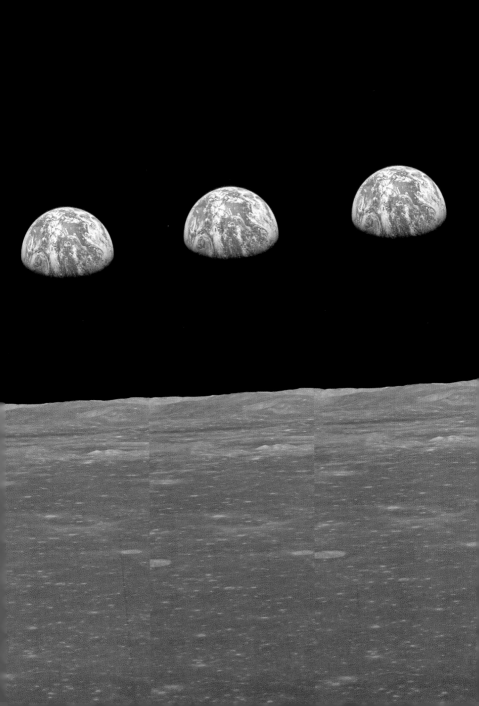

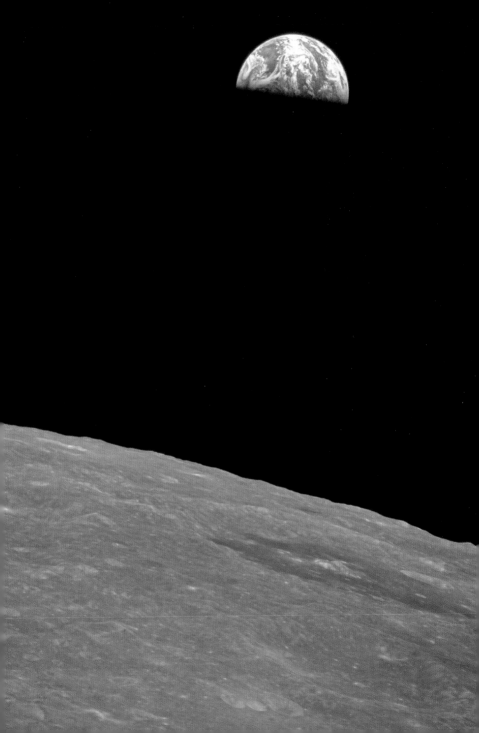

He had had an interview with the head of the Manned Space Program when he was back at Kennedy. Once a professor of electronics, Mueller had become the second highest man in NASA, indeed nobody was higher than him but Dr. Thomas O. Paine, yet Mueller was in appearance a very modest man, an archetype to Aquarius of the technician. Mueller — whose name was pronounced Miller — was not tall, certainly he was not short, he was slim in weight, in fact without excess weight, he looked forty-five although he had to be older, and he had a long thin face, a high forehead, straight black hair which he combed straight back — so his black horn-rimmed glasses jutted forth, so did the blade of his nose, the blade of his jaw. He spoke with mild icky-dicky Midwest expletives like "Golly gee, gee whiz, gosh!" that modest but central sense of presence one might find in a YMCA secretary on the night desk — the manner friendly, impersonal and on an astral plane, a manner to indicate that of course one is used to talking to all sorts of people — golly gee, you ought to see some of the characters who come in here.

Mueller had the reputation of being tremendously determined when he wanted to get something done, and one could believe it, for he emitted the gentle but total impersonality of a man for whom obstacles if irrational were unforgivable. Perhaps for this reason he was curiously reminiscent of Hugh Hefner. The publisher of *Playboy* was a little in relation to ordinary men like a guy who had been to the moon and back and Dr. Mueller could have been his older brother.

Aquarius met him in Mueller's motel at Cocoa Beach, a room as modest as his pretensions. There had been a photographer taking pictures. Mueller

05:15:35:14 CAPCOM CHARLIE DUKE: *Hello, Apollo 11. Houston. How did it go? Over.* COLLINS: *Time to open up the LRL [Lunar Receiving Lab] doors, Charlie.* DUKE: *Roger. We got you coming home. It's well stocked. Opposite:* A half Earth greeted *Columbia* after it made the rocket burn that sent it homeward. To the left, the northern fringes of Mare Smythii (Smythe's Sea) are visible, and to the right the 120-km dark-floored crater Neper. *Photo, NASA*

Opposite: On the way home, but still two days out from splashdown, the astronauts captured this half Earth, with the light-colored sands of the Sahara clearly visible on the right, extending up from the terminator halfway to the limb. *Photo, NASA.*

apologized, explaining that he had been so busy for so many years that he had hardly had a picture taken — now they had discovered there weren't enough pictures of him for the NASA files. So he posed for a few more, in some degree as pleased and flustered as a man walking into a room, and crack! flashbulbs! they are giving him a birthday party.

Yet once the interview began, Mueller was sensitive to every change about him. Did Aquarius, searching for his next question, feel some intensity of motive or charge of energy, then Mueller was there to respond as quickly as the needle on any of the measuring instruments he had used in all the electrical labs of his youth and academic career. Dart! would go his head; up! would fly a finger; sway! would swing his torso. How alert he must have been to signs of overload or impedance in all the human circuits about his field position in the room. Yes, Dr. George Mueller was certainly one full academic counterpart to the Black professor. Having seen Apollo-Saturn rise from the drawing board to an orbit of the moon, it was as natural for him to live with comfort in the future as it was flesh and drink for the Black to brood upon the past. So Mueller was looking beyond this landing to the uses of space in the future. He talked of rocket shuttles which could be fired up to rendezvous with space stations in orbit and yet be able to return through the heats of reentry to land at spaceports in order to be used again; he spoke of lowering the cost of transport in space from $100,000 a pound to $200 a pound; he outlined future projects for nuclear power plants on the moon whose heats would melt the permafrost and so make available a supply of water. The electrical output of the power plant could then separate the water into hydrogen

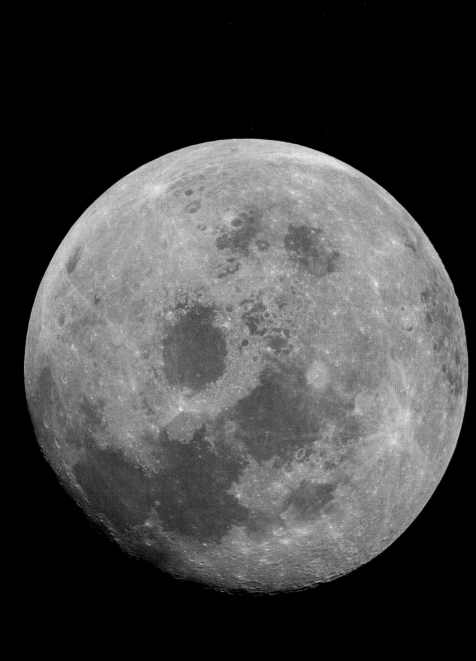

and oxygen — some of that product would be used to make Lox and LH2 for rocket fuels; the rest would be mixed with nitrogen extracted from the rocks so they would have the elements necessary to create a livable atmosphere within an enclosed space. Perhaps they would even grow plants. Would it be Aristotle Onassis or Richard Burton who would be first to spring for a bouquet of moon roses?

The space station orbiting the earth could go in for a "total earth sensing program," doubtless as comprehensive for the earth, Aquarius decided, as a thorough physical examination conducted daily for a man. The space station would also set up a high-energy physics laboratory. It would certainly accelerate every technique in the manufacture of cameras, telescopes, radars, lasers, and that was just the beginning. Mueller went on in full sentences. He had spoken of these matters a hundred times, but like all high bureaucrats he was equal to a professional actor in his ability to repeat the same dialogue with verve another hundred times. If any reporter had brought a tape recorder, he could by transcribing Mueller's remarks directly have had a printable feature story for a Sunday section. As though unwinding a scroll, Mueller indicated the possibility of a new wonder with each paragraph. Since the space stations would have a weightless environment at their command, it would be possible to grow crystals which would be molecularly perfect. As a corollary, one would be able to build up flawless diamonds of any size. Before Aquarius could ask if the diamond would be as big as the Ritz, Mueller assured him in his cheerful small-town voice that the diamond could be as big as a basketball anyhow — such a cargo might be

Yes, the moon was a centrifuge of the dream. . . . One takes a breath when one looks at the moon. — Norman Mailer Opposite: A full moon, but not a moon familiar to humans. This is a new moon in the sense that it was one that had been walked upon by humans. This is the moon that Mike Collins photographed as Apollo 11 departed for Earth. The Earthward face is to the lower left, the far side is to the upper right, and the geometry of the situation meant that on Earth — located off-camera to the lower left — anyone looking would see a half-moon. The large, isolated dark marking near the center is Mare Crisium (the Sea of Crisis) with which humans are familiar as appearing near the moon's limb. Photo, NASA.

worth much more than two hundred dollars a pound. Thus the perspective of space factories returning the new imperialists of space a profit was now near to the reach of technology. Forget about diamonds! The value of crystals grown in space was incalculable: gravity would not be pulling on the crystal structure as it grew, so the molecules would line up in lattices free of shift or sheer. Such a perfect latticework could serve to carry messages for a perfect computer. Computers the size of a package of cigarettes would then be able to do the work of present computers the size of a trunk. So the mind could race ahead to see computers programming go-to-school routes in the nose of every kiddie car — the paranoid mind could see crystal transmitters sewn into the rump of every juvenile delinquent — doubtless, everybody would be easier to monitor. In the Systematized Detection Systems of the future, Big Brother could get superseded by Moon Brother the major monitor of them all might yet be sunk in a shaft on the back face of the lunar sphere.

The possibilities of the new technology glowed in the enthusiasms of Mueller's voice. "Ball bearings," he said holding up a finger like an antenna to focus all scattered waves of random thought, "it's fascinating to consider what possibilities are opened in the manufacture of ball bearings." He went on to explain in his careful considerate feature-story paragraphs that ball bearings which were cast in a weightless environment would come out as perfect spheres; the deviation on their skin need be no greater than the thickness of a molecule. Earth ball bearings were of course imprecise. In the instant it took the shot to cool, gravity was pulling on the molten ball. So to obtain

Weightlessness: a picture of great happiness . . . matter released from the bondage of its weight.
— *Norman Mailer*

Opposite: Buzz Aldrin, during a TV broadcast on the trip home, shows that it is possible to have an Earth-style meal by using his scissors to unpack a slice of bread, open a tin of ham, and apply the spread to the bread slice. *Photo, NASA.*

Page 497: Using the same can of ham spread, Aldrin demonstrates gyroscopic principles in weightlessness by spinning the can and then, by applying offsetting forces with his fingertips, causes it to rotate about an altered axis. *Photo, NASA.*

precision they must be polished, a relatively imprecise technique. Aquarius was to think again of the ball bearings after he said good-by to Dr. Mueller.

Such creations of a weightless environment could yet prove monumental for the manufacturer, since ball bearings were as crucial to every load bearing or load-transporting machine as the valves of the human heart to the flow of blood. Out of the imperfections of ball bearings (which were located after all around the center of every high-speed moving part) came the multiplication of all the other imperfections, since each moving part added the scope of its imprecision to the next moving part. Once perfect ball bearings could be installed, the action of the machines might become a whole order of efficiency closer to the laws of physics, rather than to the adjustments and counterbalances of engineering. That meant a world of future machines whose view of present-day machines might be equal to nothing less than our view of Piltdown man. Or would it merely mean that plastic could now be employed for the ball bearings in order to maintain the built-in obsolescence of machines? Indeed the center of the problem of capitalism's morale was in the perfect ball bearing. Machines built on perfect ball bearings would have a life duration so much greater than present machines that modern capitalism living with the vice of built-in obsolescence as the poison-stimulant to its blood, would be face to face with problems greater and more inescapable than automation. For once space explorers, seeking economic justification, would be forced to develop perfect ball bearings, their use would be bound to explode the sustaining fevers and indulgences of the economy. What then would they all do? Then, capitalism would be as much at war

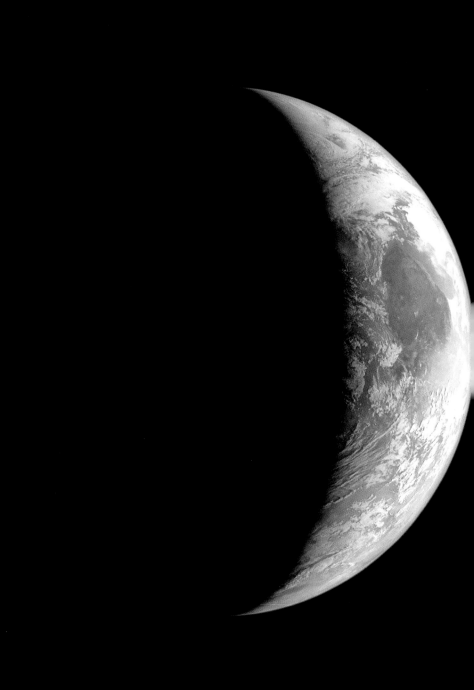

with itself over the continuing nature of the economy as world communism was at war with itself over the direction of its ideology.

So the mood of space which remained with Aquarius after talking to Mueller, that mood elegant and austere as the perfect laws of physical principle, was still a force for disruption. Sitting in the spaced-out colors of Dun Cove, inhabiting the shank end of ruminations like this, was the thought that the moon shot was conceivably the first voyage of the very cancer of the world, for indeed the first journeys of the cancer cell in a body, taken from the point of view of the cancer cell, were certainly bold and dangerous. Not by little effort did a cell leave its own organ and learn how to survive in another. Cancer cells, seen in relation to ordinary cells, were often extraordinary in the variety of their form, as different as a view of Las Vegas at night is different from a village in the Bluegrass, or as different as the internal works of Apollo were in comparison to the works of the family car. Did that account for the curious depression, the sobriety mixed in so many faces with the pride of the achievement? Aquarius did not know.

That was still another reason why he did not perceive the decade to come with any clear picture of events. A dull sense of disaster pushed at the compass of the picture. He was not so certain the decade would have a life like other decades. If space was benign, then on we would continue into space, and the artists would yet be voyaging with the astronauts — think of that happy day when he would nominate himself to be first writer to visit the moon. (Not a chance! NASA would opt for Updike!) But what if space were not so benign? What if we did not act upon space, explore into space,

Opposite: Three hours and 31,000 miles (50,000 km) from home, on July 24, the crew viewed and photographed Earth as it presented a sweeping crescent phase with north at the bottom and the coastal deserts of Namibia. As they continued to fall, Earth's increasing gravity would more than triple their speed by the time they met the atmosphere. *Photo, NASA.*

but space rather acted upon us, drew us toward her dispositions, her plans for us, her intent upon human life, what if we thought we moved up but were drawn up, what if the moon was as quiet as the fisherman when he lays the fly on the water...

Having journeyed to the center of his gloom, Aquarius went to sleep. In his dreams a country doctor he had known for years murmured, "I don't know about all of this. Recognize that the moon could be some kind of catchall simple as the tonsils to protect us here on earth. Maybe those craters come from catching all the cess." In his dream Aquarius answered back, "It depends on your idea of God, that's what it must depend on." Out into sleep he went again, ringings of ether in his ear.

* * *

In the morning after breakfast, he found himself rereading a transcript of the postlaunch briefing, a curious activity, but he was like a man on the cusp of a clue. To fall asleep in pursuit of the answer to a mystery was to awaken with the fire in a new place. It had burned beneath the ground while he was sleeping. So he dallied over the substance of the transcript as if some hint of smoke could linger here in the words of men taken down for posterity four hours after the launch.

PUBLIC AFFAIRS OFFICER: I'd like to introduce Mr. Rocco A. Petrone, Director of Launch Operations for the Kennedy Space Center and Launch Director for the Apollo 11 flight. Rocco?
PETRONE: Thank you. Well, this is our sixth Saturn V, the Apollo aboard, to go up in a row on time. But I'm not saying,

07:09:41:42 ARMSTRONG: *The responsibility for this flight lies first with history and with the giants of science who have preceded this effort; next with the American people, who have through their will indicated their desire; next, to four administrations, and their Congresses, for implementing that will; and then, to the agency and industry teams that built our spacecraft: the Saturn, the Columbia, the Eagle, and the little EMU, the space suit and backpack that was our small spacecraft out on the lunar surface. We would like to give a special thanks to all those Americans who built the spacecraft, who did the construction, design, the tests, and put their hearts and all their abilities into those crafts. To those people, tonight, we give a special thank you; and to all the other people that are listening and watching tonight, God bless you. Good night from Apollo 11.*
Opposite: Television still, CBS.

of course — this meant a lot more to us. This is the big one. This is the one we've been working for eight years.

The mission is just getting started. I'm sure you all know. But the first step in this historic mission has been just the step we've wanted to take.

08:01:02:32 BACK-UP COMMANDER JIM LOVELL: *This is Jim, Mike. Backup crew is still standing by. I just want to remind you that the most difficult part of your mission is going to be after recovery.* COLLINS: *Well, we're looking forward to all parts of it. The Earth is really getting bigger up here and, of course, we see a crescent. We've been taking pictures and we have four exposures to go, and we'll take those and then pack the camera. Opposite:* With a little over two hours to splashdown, the Arabian Peninsula comes into view, with north at the bottom of the frame. *Photo, NASA.*

Every detail of the launch, Aquarius recollected, had been Petrone's responsibility. Four hours after lift-off, matters now comfortably out of his hands, he was by the evidence of the transcript as tired as a boxer in his dressing room after a fifteen-round fight.

PETRONE: From the moment of truth here, from the moment of ignition and lift-off, lots and lots of equipment have to work for a number of starts to come on our side. We had a few difficulties in the count. I'm sure they already fed it to you. I'd be glad to answer questions. I'm pleased to say that the team was able to handle the problems, keeping the count rolling, and very obviously start this historic mission off. I say on the right first step, which I can assure you is most pleasing to me. And for the team that's worked so hard to get to this point...
PUBLIC AFFAIRS OFFICER: Okay, thanks, Rock.

At NASA, the eleg ance was in the design of the engineering systems rather than in the manners of the men. Which future student of language, unfamiliar with Saturn V, Apollo 11 or lift-off, would have any idea, encountering this scrap of Petrone's transcript, that the man was describing the emotions he felt after having led thousands of men in Launch Control through the nine hundred hours, the ninety and the nine hours of the preparations and countdowns which put his ship into the air. Who was to know by such a speech — thought Aquarius sipping his breakfast

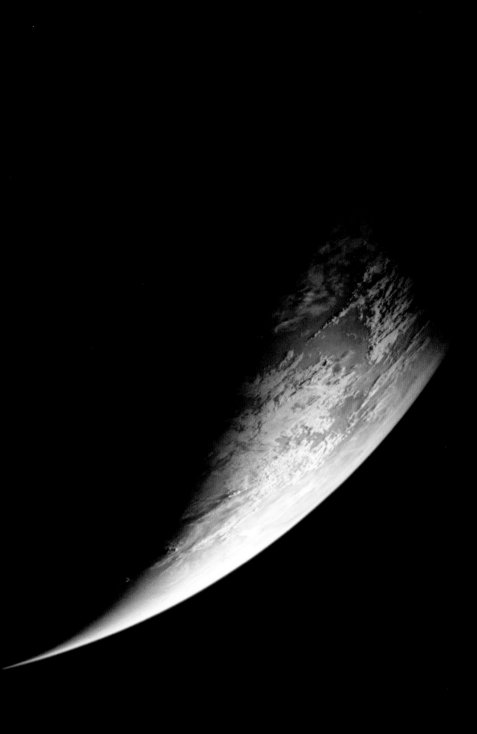

tea — that Petrone had been midwife to the most momentous week, and the mightiest hour. Yes, and that was not so ridiculous if one recognized that to believe in progress and believe in God as well might make it necessary to conceive of our Lord as a vision of existence who conceivably was obliged to compete with other visions of existence in the universe, other conceptions of how life should be. But this had brought him to the heart of the question. It was as if his mind, knowing the style of his thoughts, had directed him to the transcript in the confidence that his sense of irony once aroused, his sense of apocalypse could never be far behind. He was, after all, quick to hunt for reason in absurdity. So to read the language of men who were not devoid of mechanical genius and yet spoke in language not even fit for a computer, of events which might yet dislocate eternity, was a fine irony — the banality of the verbal reaction was an indication of the disease of our time, so advanced in one lobe, so underdeveloped in the other, a fine irony! Unless one was encountering the very desperation of the Lord — there might not be time to develop men to speak like Shakespeare as they departed on heavenly ships.

To believe in God and to believe in progress — what could that mean but that the desire for progress existed in the very creation of man, as if man were designed from the outset to labor as God's agent, to carry God's vision of existence across the stars. If this were true then the intent of the Lord could hardly be to reveal His goodness to us; rather He must employ us to reveal His vision of existence *out there*, somewhere out there where His hegemony came to an end and other divine conceptions began

Opposite: Less than 50 minutes from Earth, the CSM's engine faces the viewer, still 6,200 miles (10,000 km) out and traveling at over four miles (7 km) per second. *Page 507:* At the moment of reentry, the shallow flight path and tilt of the spacecraft allows it to steer itself to its planned point of splashdown. Extremely hot gases, known as plasma, mask the spacecraft's radio communications for approximately three minutes. Soon, a hefty deceleration of more than six G's will quickly reduce their speed. *Page 508:* Less than two minutes to splashdown and the TV director has live pictures to go to as TV cameras on the U.S.S. *Hornet* scan the skies for a spacecraft descending on its parachutes. *Television stills, CBS.*

to exist, or indeed were opposed to us. If God finally was the embodiment of a vision which might cease to exist in the hostilities of the larger universe, a vision which indeed might be *obliged* to prevail or would certainly cease to exist, then it was legitimate to see all of human history as a cradle which had nurtured a baby which had now taken its first step. Intended by divine will to travel across the heavens, we were now at least on our way to the moon, and who could know if we were ahead or behind of some schedule the Lord had presented us, a schedule which presumably each man and woman alive would keep in the depths of their unconscious along with everything else most vital for the preservation of life. A large and uncomfortable thought, for if it were so, then the flight of Apollo 11 was a first revelation of the real intent of History. So this much, anyway, had been revealed: one could not make a judgment on the value or absurdity of devoting such effort to go to the moon unless one was ready to recognize that eschatology had conceivably been turned on its head. For if eschatology, that science of "the four last things: death, judgment, heaven and hell," was now to be considered in the light of God's need for supermen to negotiate His passage quickly through the heavens, then how much more value might He give to courage than to charity, how much harsh judgment to justice itself if the act to be considered was not expeditious but merely just, yes if speed were of the essence then Hell's Angels were possibly nearer to God than the war against poverty.

This last suggested a step Aquarius was not prepared to take: the idea was as disruptive to a liberal philosophical system as tartar emetic and mustard to a glutton. For it offered a reason why the heroes

of the time were technologists, not poets, and the art was obliged to be in the exceptional engineering, while human communication had become the routine function. It was because the Power guiding us had desired nothing less. He was looking to the day when all of mankind would yet be part of one machine, with mechanical circuits, social flesh circuits, and combined electromagnetic and thought transponder circuits, an instrument of divine endeavor put together by a Father to whom one might no longer be able to pray since the ardors of His embattled voyage could have driven Him mad.

Sweet thoughts for Aquarius to have as a sequel to the ascent, but the questions were grand at least, they could occupy the consciousness of the century. It was somehow superior to see the astronauts and the flight of Apollo 11 as the instrument of such celestial or satanic endeavors, than as a species of sublimation for the profoundly unmanageable violence of man, a meaningless journey to a dead arena in order that men could engage in the irrational activity of designing machines which would give birth to other machines which would travel to meaningless places as if they were engaged in these collective acts of hugely organized but ultimately pointless activity because they had not the wit, goodness or charity to solve their real problems, and so would certainly destroy themselves if they did not have a game of gargantuan dimensions for diversion, a devilish entertainment, a spend-spree of resources, a sublimation, yes, the very word, a sublimation of aggressive and intolerably inhuman desires, as if like a beast enraged with the passion of gorging nature, we looked now to make incisions into the platinum satellite of our lunacy, our

Opposite: View to the west during the final approach to Earth, two hours and 15 minutes to splashdown. The sunset terminator is near the east coast of Africa and south is at the top, with a clear view of South Africa and Namibia. They are traveling east, going into darkness, and half a world away will land southwest of Hawaii in the early morning light. *Photo, NASA.*

Following spread: The reentry and disintegration of the Service Module, which had been jettisoned from the Command Module carrying the crew before its own decidedly less destructive return to Earth. *Photo, NASA.*

Next spread: Helicopter *Swim Two,* piloted by Lieutenant Richard J. Barrett, hovers next to *Columbia* as frogmen prepare for the crew's egress from the spacecraft. Despite its base having endured heat approaching 3,000 degrees centigrade, the spacecraft's upper surface still has strips of reflective Mylar plastic adhering to it. *Photo, NASA.*

love, and our dreams. Aquarius would have given much to find a truly revealing face at NASA, for that could have given a clue to these questions, but it was in the logic of such endeavor that no answers be apparent on the surface. If it would take the rest of the century to begin to disclose the real intent of the act, no lightning raid on the evidence, no single happy disclosure, could possibly offer a reply.

Still, Aquarius preferred the first assumption, that we were the indispensable instruments of a monumental vision with whom we had begun a trip. On that conclusion he would rest his thoughts. Having come back at last to earth from the orbits of the dream with such a hypothesis in his pocket, Aquarius was a little more ready to head for home, the writing of a book and conceivably the pouring of a drink. The study of more than one technical manual awaited him.

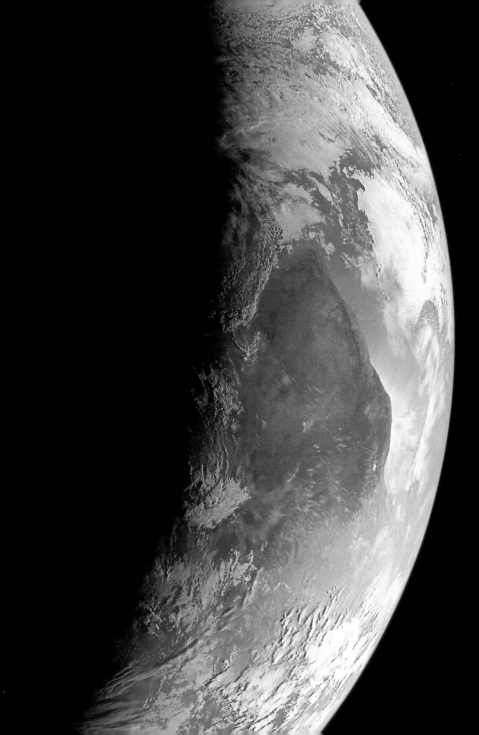

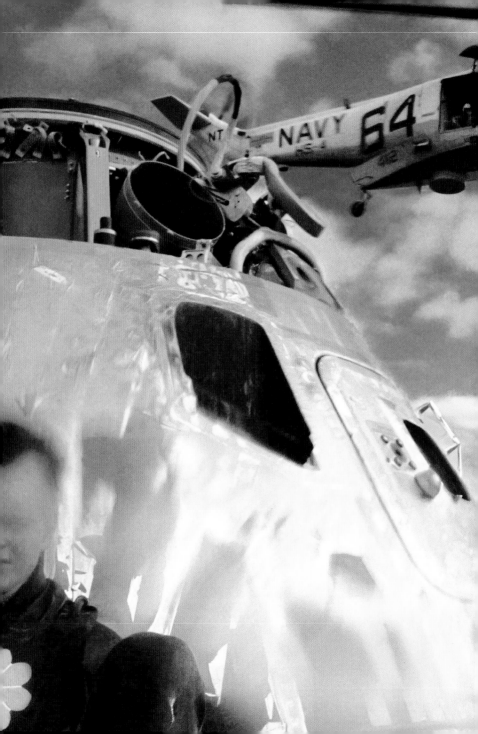

There was a melancholy
the French, who were the f
tichelah seats for every e
for mood which was find
the only name to give his oe
for Aquarians was in a depression
rest of the summer, a cu
forebodings, the hardest
sense that the century u
in the summer of 1969.

If he had had his tycha
in Houston, and had thoug

the end of a century,
... to give numbered and
...tion, I would speak of the
...iècle. ... It was
mood, ... thought,
which was ... for the
depression ... of fevers,
...d of work, and a general
...done — it had ended
Sunday — type ↑ on a certain day,
many night of insomnia
...way out of all the
that was just for one

Age of Aquarius

What better for the symbol of a new age than a landing on the moon before the decade was out? It was a blind push, equal to the hot sobs of the Oklahoma land grabber who plunked down his marker and said, "Mah land runs from this stone to that tree," before he even knew if he had bottom lands or water. Before the decade was out. Why? Because the trip to the moon had to serve as the embodiment of a new vision and visions are obliged to be neat. Kennedy, like many an enterprising young man before him, knew the best approach to large and complex mysteries was to plunge your hands into the short hair. "This is a new ocean," he said, "and I believe the United States must sail upon it."

Hot dog! There they are and they're all right! Hot dog! Apollo 11 has made it! — Walter Cronkite, CBS News Space Headquarters, July 24, 1969 Opposite: Joan Aldrin, surrounded by friends and family in Houston, applauds as she watches splashdown. *Photo, Vernon Merritt.*

Hannibal had taken his legions across the Alps, Cortez had conquered the mighty armies of the Aztecs with less than a thousand conquistadors, Castro landed in Cuba with eighty-two men, lost seventy in ambush on the beach, and five days later, hiding in the jungle, said to the survivors: "the days of the dictatorship are numbered." Now Apollo 12 had landed on the moon, for if Apollo 11 was down, Apollo 12 could not be far behind. A new age of man had probably begun: just conceive of those purifications of discipline and cooperation that ordinary technicians working for most ordinary if immense corporations had shown. What an abstention from intrigue, treachery and betrayal had been forged in the million links of the chain.

Yet the question remained. Apollo was the god of the sun, so NASA did not fail to use his name for the expedition to the moon. Was the voyage of Apollo 11 the noblest expression of a technological age, or the best evidence of its utter insanity? It was the question which would dog Aquarius into the tenderest roots of his brain. So any spirit of impatience which would now have the astronauts open the hatch may as well burn its fumes — six hours are to go by before a man's boot comes off the Lem and puts the mark of sneaker cleats on the moon. In the meantime, moon conceivably all quivering in its finest registers from the four landing feet of the Lem, the question persists — are we witness to grandeur or madness? So the mind casts back to the source of Project Apollo and the birth of NASA, back into the warlock's pot of high politics in that hour after American prestige drooped in the eyes of the world because the Russians had put Sputnik into orbit and Soviet technology was in

Opposite: With the U.S.S. *Hornet* recovery ship some twelve miles (21 km) away, a team of frogmen deployed from the recovery helicopters attached a flotation collar around the spacecraft and brought two life rafts alongside. Taken from helicopter Recovery One, this aerial view shows the "Billy Pugh" net above the left life raft ready to hoist a crewman aboard. "The helicopter pilot was real good," explained Collins after the mission. "You put one hand or foot anywhere near that basket, though, and they start pulling. They don't wait for you to get in and get all comfortable. . . . Just like a fisherman, they felt a nibble on the end of that line, and he started cranking." *Photo, NASA.*

some ways at least superior to American. Eisenhower complained. If he had signed the bill which created NASA in 1958, he still did not know, he would announce, why everyone was thus inflamed about space. And in 1961, on the way out, in his last message to Congress a few days in January before John F. Kennedy would be inaugurated, Ike gave the word that he would not advise any extension of space flight after Mercury, no, not unless — and here came Elixir of Eisenhower — not unless "further experiment and testing" gave go to good reason. Can we be certain it was altogether out of Eisenhower's reach to realize that a vain young President from an opposing party, consumed with the large desire to do things his way, was not going to take the ex-President's advice? But then we never give credit to Eisenhower for being so sly a man he was not even aware of it himself.

If it is natural to assume Kennedy was sympathetic to a moon shot when Eisenhower was publicly opposed, Kennedy was also a man with a regard for consensus; a national poll showed fifty-eight percent of the public sample were opposed to spending forty billion dollars in a race against the Russians to the lunar sphere. Kennedy was therefore not about to make a push. Not then. After the Bay of Pigs, however, the national desire may have moved up to the stars; certainly, after Alan Shepard's flight in Mercury-Redstone 3, public opinion took a full shift. It shifted with a rush. All the while, Johnson had not been chairman of the Senate Space Committee and head of the National Aeronautics and Space Council for nothing, no, and had not personally picked James E. Webb to be head of NASA for no reason, nor looked upon fast-expanding Houston without plans for even

Opposite: At 08 days, 03 hours, 18 minutes, 18 seconds into the mission, the U.S.S. *Hornet*'s recovery team confirmed splashdown to a televised audience of more than 500 million. *Television still, CBS.*

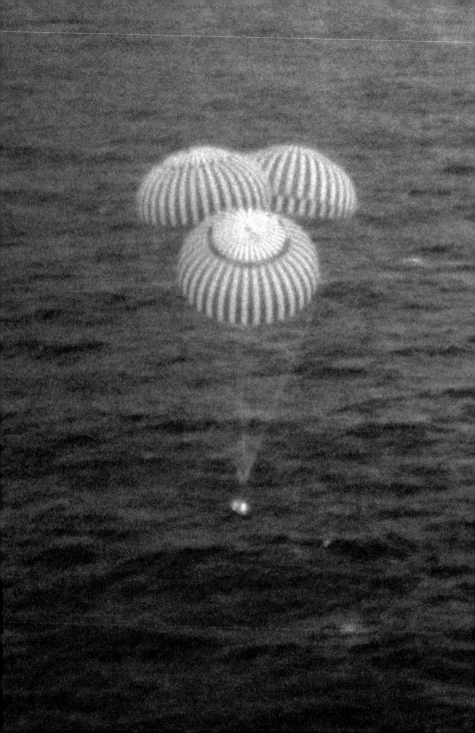

more rapid expansion. It is not hard to conceive of how fast the tip of his tongue could flicker in and out of Kennedy's ear when public opinion began to turn. Indeed the President had to agree with the Vice President about something. And Space was congenial to Kennedy, congenial to the metaphor of a new frontier, congenial to his love of doughty ships and mysterious seas; besides, the brightest of his economists were fond of the absurdity of space. The most advanced of them had come to the conclusion that economics was a phenomenon which resisted planning — the Soviet Union had been giving its unwilling demonstration of this point for thirty years: yes, economies were most interesting when they developed off the target. It was as if one did not achieve a career in the theater by studying how to act but by mountain-climbing or road racing. The effort, not the technique, seemed to prepare the result, or if not the intended result, another equally desirable. The voyage to the moon came to be seen by many of Kennedy's liberal advisers as the most imaginative way to prime an economic pump in a time of relative prosperity and no war. Who cared if it succeeded? When the decade was out, there might be no moon rocks in the hand, but a new kind of prefabricated housing could well have been discovered instead, or some new fuel for automobiles. Plastics were bound to accelerate themselves into products and industries not yet conceived. Advances in metallurgy and electronics would inspire huge new plants of higher education, boom them up from swamps newly filled by the exudations of the cities. The technological age, bloated with waiting, was ready to burst on the landscape of America. That technological age would solve all the old

Opposite: The deployment of Apollo's red-and-white-striped parachute canopies was probably the most welcome sight of any mission. Weighing nearly five tons (4.5 t), *Columbia* gently descended to its splashdown in the Pacific Ocean, 13°19´ N, 169°09´ W. Impact with the water was always a jarring event: "I felt a solid jolt," said Collins. "It was a lot harder than I expected." Upon landing, *Columbia* assumed an apex-down, or upside-down, flotation until the crew deployed a set of inflatable bags that would return it to a normal floating position. *Photo, John D. McLachlan, U.S. Underwater Demolition Team No. 12, NASA/NGS.*

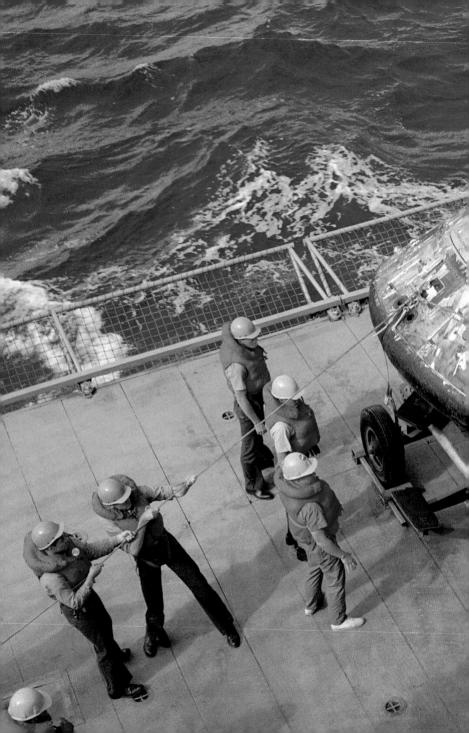

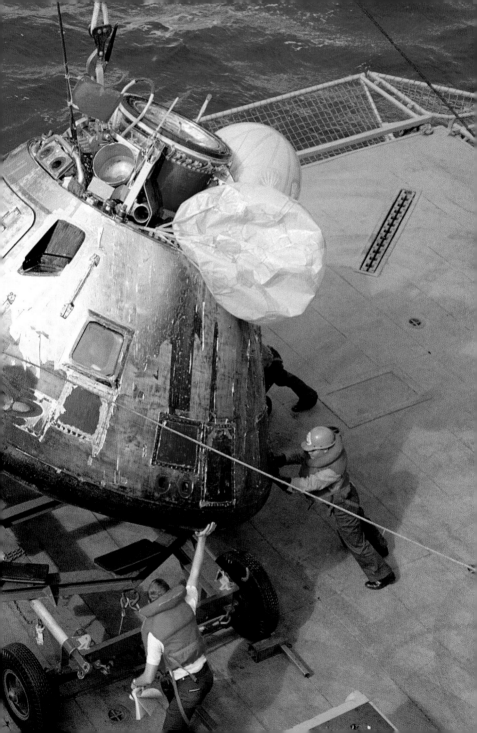

Opposite and previous spread: Original plans for the spacecraft's recovery had called for the crew to remain inside while *Columbia* was winched aboard. These were changed amid fears of the spacecraft being dropped. Instead, after the crew had been lifted by helicopter, U.S.S. *Hornet* pulled alongside and a crane brought *Columbia* and its precious cargo of moon rocks aboard. At this point the spacecraft was potentially hazardous, its propellant tanks having recently held the toxic propellant hydrazine. The flotation ring has been removed, and it is being lifted for transport to the lower deck. *Photos, NASA.*

problems — so declared the confidence of Kennedy's elite. What better for the symbol of a new age than a landing on the moon before the decade was out? It was a blind push, equal to the hot sobs of the Oklahoma land grabber who plunked down his marker and said, "Mah land runs from this stone to that tree," before he even knew if he had bottom lands or water. Before the decade was out. Why? Because the trip to the moon had to serve as the embodiment of a new vision and visions are obliged to be neat. Kennedy, like many an enterprising young man before him, knew the best approach to large and complex mysteries was to plunge your hands into the short hair. "This is a new ocean," he said, "and I believe the United States must sail upon it."

Opposite: Standing by in midocean throughout the mission, the Apollo Instrumentation Ships (including the U.S.N.S. *Vanguard,* pictured here) were positioned to supplement the radar and communication coverage provided by the land-based Goldstone, Madrid, and Honeysuckle Creek stations. *Photo, NASA.*

Following spread: Wearing a Biological Isolation Garment designed to protect against "moon bugs," Diver Clancy Hatleberg swam in to open the CM's hatch, and helped the crew change into similar garments. Here, after a simulation exercise of the recovery a few days before splashdown, four Navy frogmen strip off their BIG suits and lay them out to dry on the deck of the *Hornet. Photo, Don Blair.*

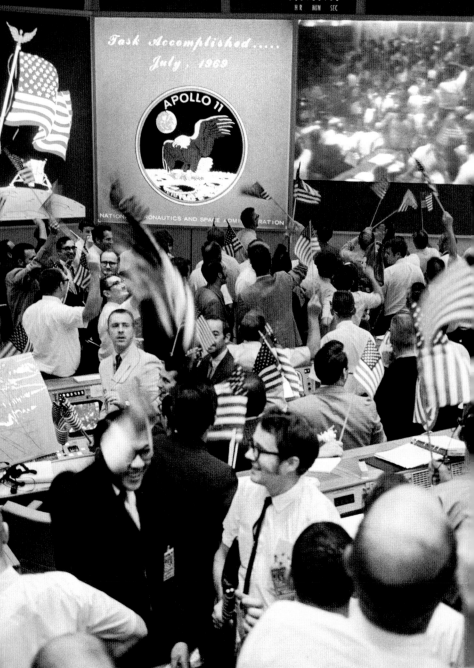

"The World Is Bigger Infinitely"

Who among all the people he knew well had the remotest say on the quality of these lunar expeditions whose results might yet enter the seed of them all with concentrates worse than their collective semen already filled with DDT. An abominable army. A debauch. And he hated his good friend Eddie Bonetti for this, hated him for drinking at the post. "You've been drunk all summer," he felt like saying to him, "and *they* have taken the moon."

A few hours after splashdown. . . the parties began; they had begun in effect from the moment technicians from the Staff Support rooms began to fill the Mission Operations Control Room, and people wet cigars and waited for the astronauts to come in on the helicopter and land on the carrier, and when they did, little flags came out and were waved in everyone's hand. — Norman Mailer Opposite: Photo, NASA.

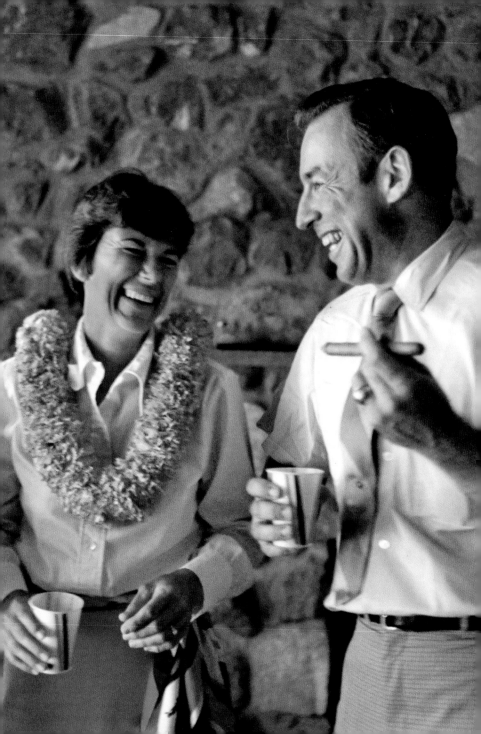

He had come home the day before the astronauts came back to earth. There were splashdown parties promised all over Houston, and he was tempted to remain, for there would be portraits in plenty to paint of Texas drinking and poolside brawls, but he was also in a panic to get back and start work — his first deadline was not three weeks off. Each extra day at this end could be a reprieve at the other. Still much in the middle of the event, mental digestions churning, he returned to the bosom of his family.

The house was sour; the milk gave every intimation that it had curdled. His wife and he were getting along abominably. They had had hideous phone calls these last few weeks while he was away. Several times, one or the other had hung up in the middle of a quarrel. It was impossible to believe, but they each knew — they were coming to an end. They could not believe it for they loved their two sons as once they had loved each other, but now everything was wrong. It was sad. They had met on a night of full moon, and would end in the summer of the moon. Sometimes his wife seemed as if deranged by Apollo's usurpation of the moon. She was extraordinarily sensitive to its effects; she was at best uneasy and at worst unreachable when the moon was full. Through the years of their marriage Aquarius had felt the fullness of the moon in his own dread, his intimations of what full criminality he might possess, had felt the moon in the cowardice not to go out on certain nights, felt the moon when it was high and full and he was occasionally on the side of the brave. And she was worse. Call her Pisces for the neatness of the scheme. Beverly, born sign of Pisces. She was an actress who now did not work. An actress who does not work is a

From there, parties spread in all directions. Out through the computer-designed suburbs around the Manned Spacecraft Center spread the celebrations, and up the highway to Houston. —Norman Mailer Opposite: Jan Armstrong and Apollo 11 Backup Commander Jim Lovell celebrate at her home in Houston. *Photo, John Olson.*

What a shock down the block to the habituated eye to see that gaggle of Press all straining at a rope, TV men and still photographers in their customary war for position with word-men. . . this invasion of hippie journalist gogglers and foreigners with cameras, beards, sideburns, Nehru jackets, turtlenecks, love beads, medallions, shades, tape recorders and foreign tongues. . . . —*Norman Mailer* Pat Collins greets reporters outside her home on July 24. *Photo, Bob Peterson.*

Pat Collins (in red), celebrating splashdown at end of mission with a houseful of friends. *Photo, Bob Peterson.*

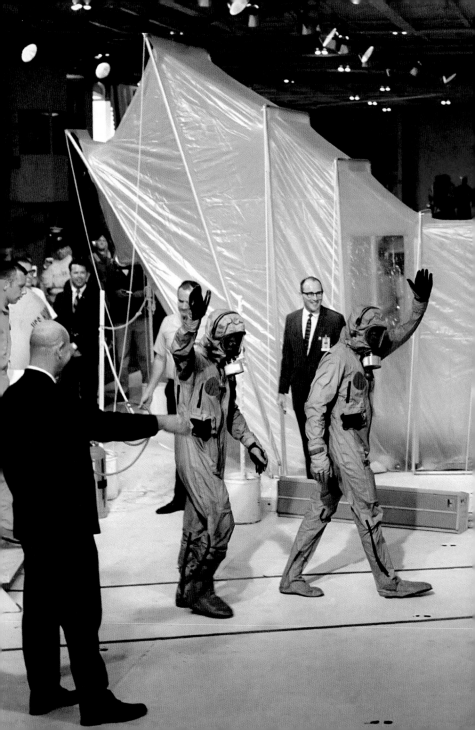

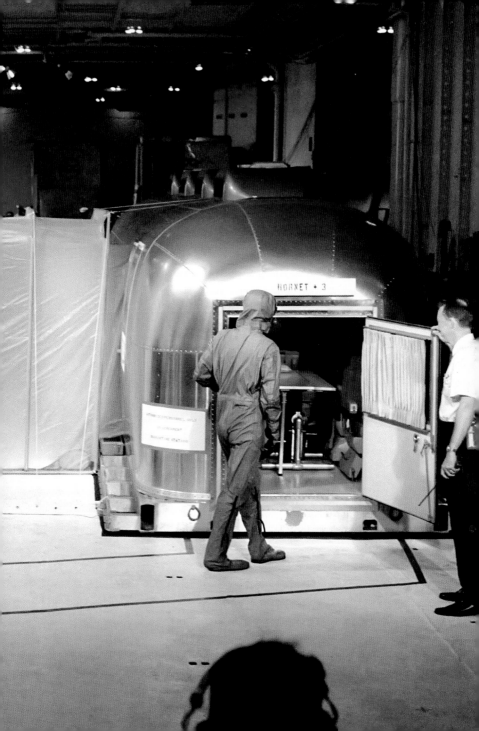

maddened beast. His lovely Pisces, subtle at her loveliest as silver, would scream on nights of the full moon with a voice so loud she sounded like an animal in torment. They were far and away the noisiest house on the street.

It hardly mattered in Provincetown. That was the land of the free. At the very tip of Cape Cod, a fishing town curled around a spiral of land whose sand dunes separated the bay and the sea, it was a town of Portuguese and Yankees in winter, of artists, faggots, hippies, bikers, debs, dikes, off-course jets, groupies, and beefed-up beer-drinking tourists from Jersey in summer, not to mention hordes of middle-class professionals with progressive views and artistic liens. An isthmus of quiet in the calm months, it was no island of the mind in July, no, it was the Wild West of the East, and it took forty-five minutes in the middle of August to drive a car half a mile down the one-lane main street. Marijuana was as available in Provincetown in the hideous hocks of summer as popcorn is plentiful in a drive-in movie in Iowa. Aquarius, of course, had none of it, not these years, not when working. He could not afford it. His brain was always lost for the following day. But now he had to work in its presence. There was hardly a dentist, a psychoanalyst, a townie, or a narco agent who was not turned on half the time, and the drinking parties among the most sedate began at five and ended at five with the dawn coming up his window on the bay, the gulls croaking their readjustments to all the twisted vertebrae of sand and sea. Stoned out of the very head of sensation, the summer populace was still groping and brooding and pondering its way down the gray and lavender beach in the

red-ball dawn, sun coming over the water in one long shot of fire — Provincetown was the only place in the East he knew where the land spiraled so far around that you could see the sun rise out of the dunes in the east and set in water to the west. What a town! There was not one of his wrong and ill-conceived books he had not written in part here, and all of his good books as well, all of his books. He had learned how to work in summer if he had to, but one needed the skill of a contemplative who pitched his tent by a hot dog stand. So he hated his beloved Provincetown this summer above all.

It had been bad from the moment he was back. One of the early nights after his return, perhaps two or three days after splashdown, he had taken his wife and one of his best friends to a restaurant for dinner. The friend was Eddie Bonetti, a battered knob-nosed working writer out of South Boston, handsome as an old truck to those who knew him well, a small rugged prodigy of talent who had boxed a few fights professionally and been given working lessons in the gym by Willie Pep. Bonetti wrote poetry, perhaps he was the best working poet in Provincetown, certainly the best Aquarius had heard, and he had written a very good short novel about an old Italian making wine, a manuscript which was always on the edge of getting published by editors who were almost ready to put up with its brevity and its chastity — like many an Italian before him, Eddie Bonetti did not swear in print.

"Norman, I'm so fucking glad you're back," he declared for the fourth time in his loudest voice five minutes after they sat down in the restaurant.

Bonetti stored his talent in many places. He had acted in two of Aquarius' movies, memorable in a

small part in one, unforgettable in another. He had
played an axe murderer who killed his wife after fif-
teen years of marriage; Aquarius was fond of saying
that Bonetti was as good an actor as Emil Jannings
for one night in his life. But that had been in passing.
Bonetti also grew the best tomatoes in town, and had
been known to play his flute to them in the middle
of the night. Eddie was also capable while riding a
bicycle down the main street (if he saw a friend driving
behind him) of jumping his bike off the street across
the sidewalk and into the bushes, where he would take
a wild dive over the handlebars into the grass, just to
give his friends the craziest laugh of the week. Bonetti
could say, "I'm worried about my heart," and fall
immediately on his back, there to wink at you. Bonetti
was a prodigy of talent.

But he was drunk this night. He was drunk before
the evening began. Because he had a big punchy
sepulchral voice even in the quietest of times, it was
booming everywhere tonight on his drinks. "Fuck,
Norman, I didn't know whenna fuck you were gonna
get back," he bellowed again in his best Savin Hill
South Boston tones and the carnal communicant qua-
vered like an organ pipe with a crazy nonstop over-
tone in the clean white tablecloth Wasp spa to which
they had gone, an error of incomparable dimension,
for Eddie in his dungarees and blue sweat shirt was
as funky as the upholstery in the last used car on the
lot. His clothes were in line for nine out of ten restau-
rants in town, but not where they were now — indeed
Aquarius had picked it to obtain some afterthoughts
on the moon shot. But Bonetti had a good century-
old stiffening of his drunken proletarian senses when
they walked in. No restaurant was going to put *him*

down. So Aquarius, proud Aquarius, iconoclast of the last two decades, was obliged to act as a middle-class silencer, "Will you keep your voice down," he blasted in a hopeless murmur. "Norman, this place is filled with drunken assholes. Fucking drunken assholes." "Eddie, I'll give you two to one you can't go through the meal without saying fuck." "Norman, I don't want to take your money."

The bet was made. Eight dollars to four dollars. Before three minutes had passed, Bonetti had lost. Aquarius bet him again. Another two minutes and Eddie said, "These shrimp are fucking good shrimp."

Down eight dollars, his good mood cracked. Bonetti's wife was meeting them later. She worked as a waitress while Bonetti wrote — the lost eight dollars was now salt in his sores. Bonetti lived with his wounds. So he grew morose, and the meal took solid conservative steps. The Wasps at the neighboring tables recovered a few of the harmonies which had been blasted out of their bite. The sense of being stitched across the back by rays of displeasure abated. Aquarius did not know how many pinholes had been left in him, but the air in the restaurant was like the awful air of America on its perpetual edge, nihilisms gathering at the poles, dreams of extermination in all the camps. He looked at the Wasp at the adjoining table, a sturdy worthy with silver-rimmed glasses, red righteous ire in the flat red washes of his cheeks, the mottling of his neck. Two mature ladies with silver-rimmed glasses and silver curls and cones of marcel in their beauty parlor lacquer sat in court upon his specimen of the great unwashed, Bonetti, eating lobster right next to them. He felt suddenly as if he had betrayed Eddie — to calm him down was to leave

PRESIDENT NIXON: *You look great. Do you feel as great as you look?* ARMSTRONG: *We feel great.* THE PRESIDENT: *Frank Borman feels you are a little younger by reason of having gone into space. Is that right? Do you feel a little bit younger?* ARMSTRONG: *We are younger than Frank Borman.* THE PRESIDENT: *He is over there. Come on over, Frank, so they can see you. Are you going to take that lying down?* ASTRONAUTS: *It looks like he has aged in the last couple weeks.* Following spread: At 8:55 A.M. The astronauts appeared at the window of their trailer, now showered, shaved, and changed into flight suits. Collins sported a much-talked about "moon moustache," and the president joined the three in a joke at the expense of Apollo 8 astronaut Frank Borman, also on board. *Photo, NASA.*

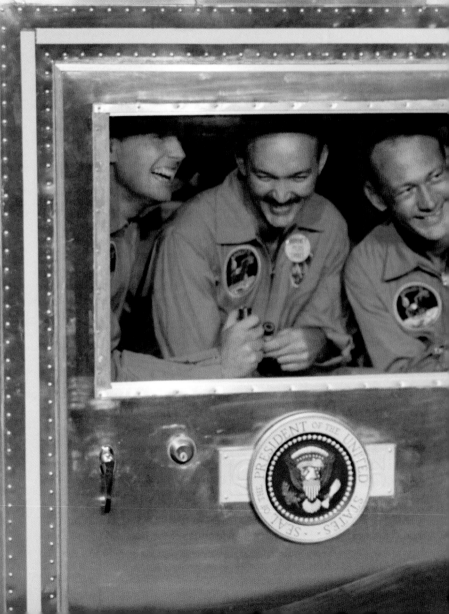

him a target for every wild nihilism of the Wasp, that same laser of concentration and lack of focus on consequence which had taken us up to the moon.

Later, Aquarius was livid. At another place, listening to music, Bonetti's wife joined them, and he told her with keen cruelty, "I hope Eddie bleeds over those eight bucks. He ruined the meal." What he could not give voice to was a voice large and endless in its condemnations of himself and all the friends of his generation and the generations which had followed, an indictment of the ways they had used their years, drinking, deep into grass and all the mind illuminants beyond the grass, princelings on the trail of the hip, so avid to deliver the sexual revolution that they had virtually strained on the lips of the great gate. They had roared at the blind imbecility of the Square, and his insulation from life, his furious petulant ignorance of the true tremor of kicks, but now it was as if the moon had flattened all of his people at once, for what was the product of their history but bombed-out brains, bellowings of obscenity like the turmoil of cattle, a vicious ingrowth of informers, police agents, militants, angel hippies, New Left totalists, entropies of vocabulary where they would all do their thing — but "thing" was the first English word for anomaly — an unholy stew of fanatics, far-outs and fucked-outs where even the few one loved were intolerable at their worst, an army of outrageously spoiled children who cooked with piss and vomit while the Wasps were quietly moving from command of the world to command of the moon, Wasps presenting the world with the fact after prodigies of discipline, while the army he was in, treacherous, silly, overconfident and vain, haters and despisers of everything tyrannical, phony, plastic and

overbearing in American life had dropped out, goofed and left the goose to their enemies. Who among all the people he knew well had the remotest say on the quality of these lunar expeditions whose results might yet enter the seed of them all with concentrates worse than their collective semen already filled with DDT. An abominable army. A debauch. And he hated his good friend Eddie Bonetti for this, hated him for drinking at the post. "You've been drunk all summer," he felt like saying to him, "and *they* have taken the moon." Yes, there was a wild nihilism in his own army: the people were regurgitating the horrors of the centuries, looking to slip the curse out of their seed and into the air, while the curse reentered their seed through every additive in every corporate food. And on the other side, heroes or monsters, the Wasps had put their nihilism into the laser and the computer, they were out to savage or save the rest of the world, and were they God's intended? Looking at his drunken own, Aquarius did not know. He was one judge who would write willy-nilly out of his desolations this year.

* * *

To make everything worse, he was forced to see the end of the mission on television . He had applied months ago to cover the splashdown from the *Hornet*, but NASA and the Pentagon limited that number of reporters to a pool of three. So the end of the greatest week was seen by him in his living room in Provincetown, glaring at the television set — there was nothing to see. The sky was fogged. He was left to watch a succession of commentators. [...] So he felt somehow deprived of the last beauties of the Command Module and the flight

Lord God, our Heavenly Father, our minds are staggered and our spirits exultant with the magnitude and precision of this entire Apollo 11 mission. We have spent the past week in communal anxiety and hope as our astronauts sped through the glories and dangers of the heavens. . . . A man on the moon was promised in this decade, and though some were unconvinced, the reality is with us this morning in the persons of the astronauts: Armstrong, Aldrin, and Collins. We applaud their splendid exploits, and we pour out our thanksgiving for their safe return to us, to their families, to all mankind. — Lieutenant Commander John A. Piirto, chaplain of the U.S.S. Hornet *Opposite:* After President Nixon's remarks, the astronauts bowed their heads while the *Hornet*'s chaplain said a prayer of thanks for the safe completion of the Apollo 11 mission. *Television stills, CBS.*

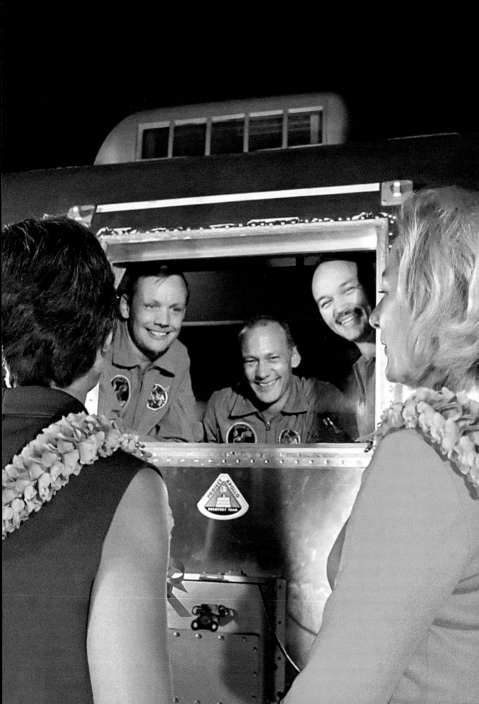

plan. Reentry was now the most predictable part of the mission and if, in relative terms, it was safe, still with that part of his brain which would insist on remaining a technological child of his century, he had to admire the splendors of the design for reentry. There would after all have been never a trip to the moon if there had not been a means to set back to earth discovered years ago — the atmosphere surrounding the planet offered the friction of a Carborundum wheel toward any object which approached from space. The heat generated was sufficient to consume everything but an occasional meteor. Yet a means had been evolved for safe reentry. Apollo 11 would come back at the speed it left, come back at seven miles a second, 25,000 miles an hour. The Command Module would separate from the Service Module back of it, and the Service Module would burn in the atmosphere to leave only the little cone ten and a half feet high, twelve feet ten inches wide, the mini-cathedral holding the three astronauts strapped in their couches, just ten and a half feet to come back out of three hundred and sixty-three feet, that alone to come back out of all that mighty ship of Apollo-Saturn which had first gone up. The Command Module would come skipping into the atmosphere on a carefully measured route, guided by its thrusters, which were controlled in turn by the computer, or in event of malfunction, by the men. Approaching base-first, its rounded circular base slapping into the atmosphere like a flat stone popping along the surface of a pond, it would sear a path through the sky from eighty miles up and fifteen hundred miles away from the site of splashdown, singeing through the outer air in an incandescent deceleration down to a horizontal speed of

Opposite: Almost home, the crew arrives at Houston's Ellington Air Force base, where they were welcomed by their wives, who had endured nearly as much media scrutiny as the astronauts. They will spend the rest of their 21-day quarantine period at the Johnson Space Center's LRL, subjected to physiological examination and myriad postflight interviews with NASA personnel and the press. *Photo, NASA.*

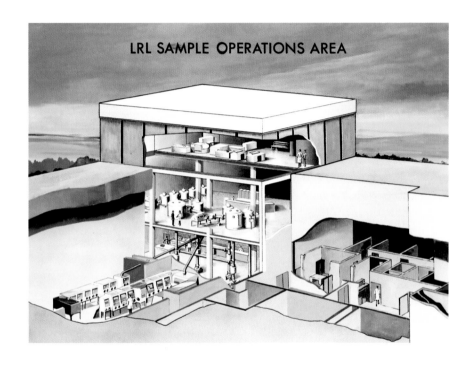

a few hundred feet a second, slow enough for a pair of drogue parachutes to open and turn its horizontal path down over to a line of descent. That would occur four miles up. At ten thousand feet, the drogue chute would be released and three little pilot chutes would deploy three larger parachutes, each of a diameter of eighty-three feet. They would slow the vertical descent from one hundred seventy-five miles an hour to twenty-two miles an hour, and the Command Module, swinging on suspension lines one hundred and twenty feet below her three canopies (which had previously been packed in a ring around her docking tunnel), would be deposited in the water in an area within a few miles of the carrier *Hornet*. Immediately, a built-in cutter would sever the parachute lines. If the Command Module ended upside down in the water — a position called Stable II — then three inflatable bags in the forward compartment, blown up by compressors on board, would proceed to float the cone over so she was riding on her base. Swimmers, dropped from approaching helicopters, would attach a flotation collar and bring up a raft. The astronauts would emerge from the hatch. After decontamination procedures they would be lifted in a sling to the helicopters and brought to the *Hornet*. It was neat. It had been as carefully worked out as the deployment of the Navy of Recovery over thousands of miles of the Pacific. Still, the foundation of all reentry remained the heat shield at the base of the Command Module, nothing but an epoxy resin, a species of phenolic plastic injected in a honeycomb screen. It was not even three inches thick at its widest but it would bear a reentry temperature of 5000 degrees Fahrenheit, hotter than the fiercest kiln, hotter than the melting point

Opposite: An artist's rendering of the Sample Operations Area of the Lunar Receiving Laboratory from 1966 showed NASA's substantial efforts at mitigating the potential risk of exposure to hazardous materials that might lurk on the lunar surface. These efforts included the three-week quarantine period for the crew and culminated with a safe house in which to store and process the rock samples. The expensive LRL was finished in 1967. *Illustration, NASA.*

Opposite: During the two and a half hours of exploration, the crew collected 47 pounds (21 kg) of lunar surface material for analysis. NASA bosses show off the first of Apollo 11's Sample Return Containers, or "rock boxes," at Ellington Air Force Base near Houston upon arrival. Each box was made from a single block of 7075 AA aluminum alloy, padded on the interior, and closed with an airtight seal. Left to right: George Low, manager of the Apollo Spacecraft Program Office; Lieutenant General Sam Phillips, Apollo program director; George Trimble (behind Phillips), deputy director, Manned Spacecraft Center; Eugene Edmonds, MSC; Richard Johnston (behind Edmonds), MSC; Dr. Thomas O. Paine, NASA administrator; and Dr. Robert Gilruth, director, MSC. *Photo, NASA.*

of all metals but tantalum and tungsten and they in alloy with anything but themselves would also have softened, so the heat shield of phenolic epoxy was a virtuoso piece of engineering. Indeed, it left no residual problem of cooling down from high temperatures once velocity had slowed. The material heated in chips which turned white-hot, charred, melted and then flaked away leaving no ember behind, but only a chip of fresh material to be charred in its turn. The epoxy once gone, the spaceship was through reentry as well, its brazed-steel honeycomb heat shield back of that char layer no hotter than 600 degrees at touchdown, and the interior of the Command Module remained at 75 degrees. Yet on the way down, the spacecraft would gleam like a comet, a pale violet flame would flare behind it for hundreds of yards in a galaxy of molecules, a nebula of heat and light.

CRYOGENIC VENT

US GOVERNMENT QUARANTINE

CONTAINER

NASA

AUTHORIZED PERSONNEL ONLY

NOMENCLATURE ALSRC #2
PART N° SEM 34MN16-01
SERIAL SW1004
CONTRACT NC
MANUFACTURER
NASA-MSC-USA

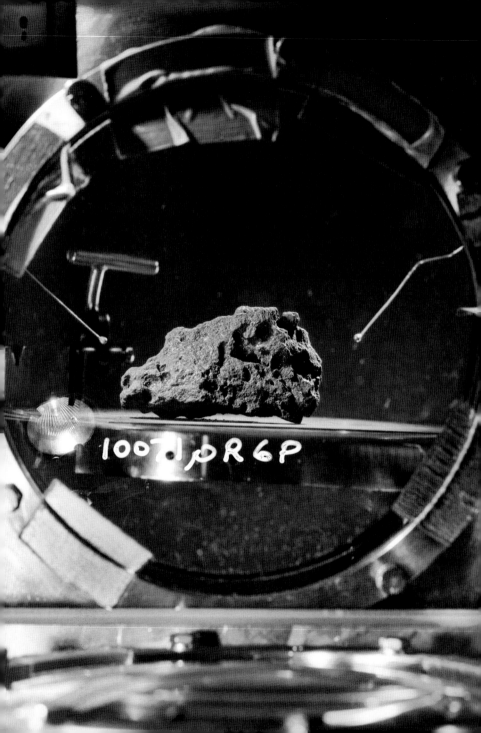

A Burial by the Sea

In the several trips to Houston, he was like a man looking for the smallest sign. For the moon book which he had begun that summer idled now in the gap of Pisces' absence, and he did not know where to put his feet. One lifted a book like a boulder out of the mud of the mind, and his mind was a pit of wrenched habits and questions which slid like snakes. Where did you put your feet so that finally you might begin? He found the answer at last in company with his favorite saying. "Trust the authority of your senses," Aquinas had said. He could repeat it again, for there was an object at last for his senses, there in the plastic vaults and warehouses of the Manned Spacecraft Center at Houston was a true object, a rock from the moon.

He saw the lunar piece through not one glass but two, rock in a hermetically tight glass bell on the other side of another glass with still another hermetic seal. Yet she was not two feet away from him, this rock to which he instinctively gave gender as she—and she was gray, gray as everyone had said, gray as a dark cinder and not three inches across nor two inches high nor two inches for width. . . . He liked the moon rock, and thought—his vanity finally unquenchable—that she liked him.
—Norman Mailer

Opposite: Mounted for photo-documentation is sample 10071, a fine-grained basalt rock collected by Armstrong. Photo, NASA.

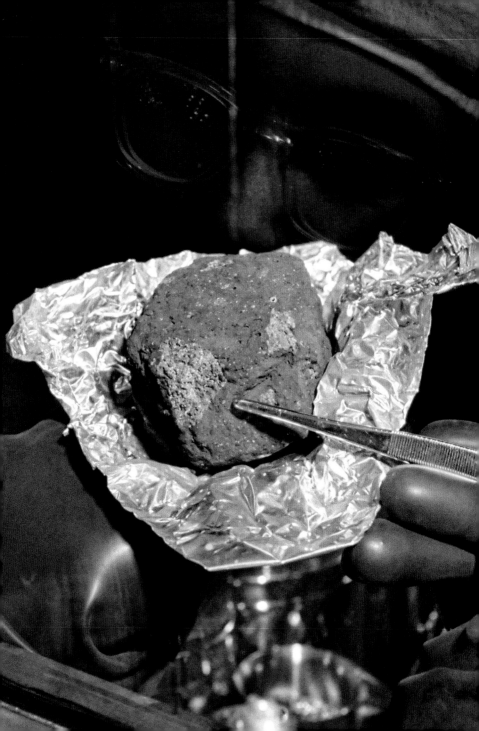

He did not know if he learned any more when word came back to him of the splashdown parties. Like a true journalist he was on the phone for full sessions with his informants, and the accounts had that essential wonder which speaks of the exaggeration of the journalist overcome by the exaggeration of events. In deference to the mission it had been a quiet week in Nassau Bay until splashdown — night after night it was as if no one connected with NASA dared to get too drunk for fear of fudged responses in the morning. A few hours after splashdown, however, the parties began; they had begun in effect from the moment technicians from the Staff Support rooms began to fill the Mission Operations Control Room, and people wet cigars and waited for the astronauts to come in on the helicopter and land on the carrier, and when they did, little flags came out and were waved in everyone's hand. The aisles jammed between the consoles with scores of personnel who now were crowding in the door.

From there, parties spread in all directions. Out through the computer-designed suburbs around the Manned Spacecraft Center spread the celebrations, and up the highway to Houston. There was a large and formal ball in Houston that night at the Marriott Hotel from seven to nine, put together by the twenty-five main contractors in the Apollo Program, North American, Grumman and General Electric to lead the rest, a huge orchestration and libation with paté de foie gras, pigs in blankets, shrimp and eggs and olives, and ice carvings on the tables of antelope, pumpkin and dolphin tails, plus two thousand guests, the cream (selected by the twenty-five corporations) of nabobs from NASA, king contractors and bona-fide River

Opposite: The LRL staff opened the lunar-sample containers in chambers using gloves that allowed access from outside. Many of the Apollo 11 rock samples are pieces of basalt, dug out of the local bedrock by impacts such as the one that created the large crater Armstrong had to avoid during the approach to the landing site. This sample is called a breccia, and is made up of pieces of more than one type of rock that were compressed together during a very large impact somewhere else on the moon. A technician uses tweezers to point to one of many glassy pinhead-sized craters that micrometeorites have blasted in the rock surface. *Photo, A. Patnesky, NASA.*

Opposite: Specimens from the second rock box returned by Apollo 11, opened up for the first time at the LRL on August 5, 1969. Though the moon looks bright and silvery to us, in reality much of its surface is as black as asphalt, as witnessed by these dark-colored, dust-covered samples. Apollo 11 had landed on Mare Tranquillitatis, one of the dark blotches visible to the naked eye in a night sky, and the rocks the astronauts collected proved to be similar to basalts on Earth—essentially solidified volcanic lava. Their difference lay in being richer in minerals that have a high melting point, an important clue in the story of our planet's genesis. They also yielded ages that went back three billion years when the Solar System was only a third of its present age. *Photo, NASA.*

Oaks Houston. It was a proper party, and the bar closed at nine-thirty. There were even ladies wearing red-white-and-blue Ed White scarves (autographed by every astronaut) which were sold by astronauts' wives to make money for the "Ed White Memorial Fund."

Word was out, however, of another party which had begun in the Nassau Bay Motor Inn, the motel off NASA Highway Number 1 with the round red velvet beds where Aquarius had stayed weeks before. There everybody was welcome — $1.50 bought barbecue beef and drinks were $1.15 if you did not bring your own. Three thousand people came not in beards and not with sideburns, rather in short-sleeve shirts with neckties, the ladies in cocktail dresses, scarce were the ladies in décolletage and miniskirts and pants suits — it was a regiment of office workers, engineers, technicians, secretaries, and people wandering in off the highway, the sun burning the pool until nightfall, then the night itself with all of young NASA-land driving into the great trough of all-out recreation, rebel yells finally tearing the Texas air. At seven-thirty in the evening two men threw a blond into the pool. A man followed immediately. The heats of the party were on. A go-go dancer got up on the diving board and worked to the gut rhythm of a band called the Astronauts — six Blacks.

The Blacks were finally at NASA. Men climbed up the diving board, went flying past the go-go girls and into the pool, beer cans followed, and broken whisky bottles, chairs and shoes and pieces of clothing, bodies thumped in with the splat of mortars, and toilet paper was slung over the bushes and the lawn. A bouncer with a fire extinguisher went prowling the corridors in the main body of the inn looking for teeny boppers who had

Opposite: One of the oldest analytical techniques used by geologists to identify minerals is to pass polarized light through a thin specimen of rock and view the result through a second polarizing filter. The mineral composition of the various crystals in the sample is revealed, and the result is often quite beautiful. In this photomicrograph of lunar sample 10044, bluish tones indicate plagioclase, a mineral that dominates in the light-toned regions of the moon. *Photo, NASA.*

jammed the elevator. It went on until four in the morning. Listening to his informants, Aquarius had a pang for not being there, as if some knowledge more revelatory than the rest might have come his way, some better sense of what resided in the computer men of the windowless walls, but he did not really know that it would have mattered any more than being on the *Hornet*. What did it matter finally if one were anywhere but on the moon for this story? God or Devil at the helm — that was the question behind the trip, and any vulgarities or fine shows of spirit on the good carrier *Hornet*, any verdict decided by the detritus in the pool on the morning after, would hardly reveal the core of the event. That core was buried in the nerve ends of everyone's life. One might as well judge the event from an armchair, for a species of apocalypse was upon us. This was, after all, repeat, the year in which a couple had fornicated on the stage and we had landed on the moon, this was the decade in which we had probed through space, and who knew which belts of protection had been voided and what precisely they had protected. A revolution was in the air which could overthrow every living establishment, an organization of society was also building which might march men daily through aisles monitored by computer probes, there to measure the individual deviations and developments of the night. That was equally on its way. We had contracted for a lunar program in 1961 and what a decade had followed! The times were loose, and no scientist alive could prove that the moon was wholly a dead body any more than they could show that death was a state of being totally dead. Teddy Kennedy's car went off the bridge at Chappaquiddick with Mary Jo Kopechne and the hopes of the Democratic Party

REPORTER: *Gentlemen, you're about to take some tours. I wonder what your feelings are. Is that perhaps the most difficult part of the mission or are you looking forward to it?* ARMSTRONG: *It's certainly the part that we're least prepared to handle. — Transcript of the Apollo 11 Press Conference, August 12, 1969* Opposite: New York City, August 13, hours after the astronauts were released from their 21-day quarantine. That same day, ticker-tape parades were held in their honor in New York, Chicago, and Los Angeles. Other American cities were to honor the men in the coming weeks before the astronauts left with their wives on a 24-city Presidential Goodwill Tour, dubbed "Project Giant Step" and commonly referred to as the "Giant Leap" tour. *Photo, Neil Leifer.*

went with them as a proper end to a period which had begun with the suicides of Ernest Hemingway and Marilyn Monroe; the younger brother of Martin Luther King was found dead in his swimming pool the day after men walked the moon. And Provincetown was like a province of the moon in these days of a moon-crazy summer through which he was obliged to work, marriage with Pisces foundering around him, Provincetown, where Eugene O'Neill had lived in the dunes and Anna Christie's father cursed "that ole debbil sea." Did the seagulls call these bronze mornings of August dawn with a special fright across the long flats? He could not rid himself altogether of the thought that the moon might be a resting place for more than the hounds of the tide. Perhaps the mysterious magnetosphere had been designed to hold back all those streams of ignoble dead who did not deserve the trip, perhaps the belts of protection were now being voided in all of afterlife, and so anomalies were rising from hell — he was obliged to wonder if man had finally become a cancer in the forms of the Lord. Yet, equally, the fullness of the moon in Provincetown these nights after the landing was more radiant with lunacy than ever. What if the moon had been drawing us to her for years, what if the plastic amphitheaters of NASA were nothing less than the intimations of her call? It was obvious that if he were without compass to the designs of the Father, then of course he had no clue to the nature of the moon: she could be a disguise of Heaven or as easily the Infernal Shades. For another man, such thoughts might have been dangerous, as dangerous as for Aquarius to drive a sports car with a loose wheel down a mountain road, but it was his profession to live alone with thoughts at the very edge

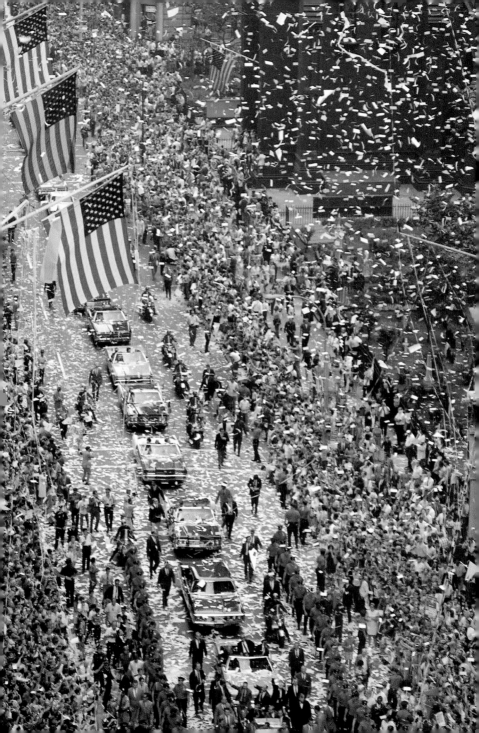

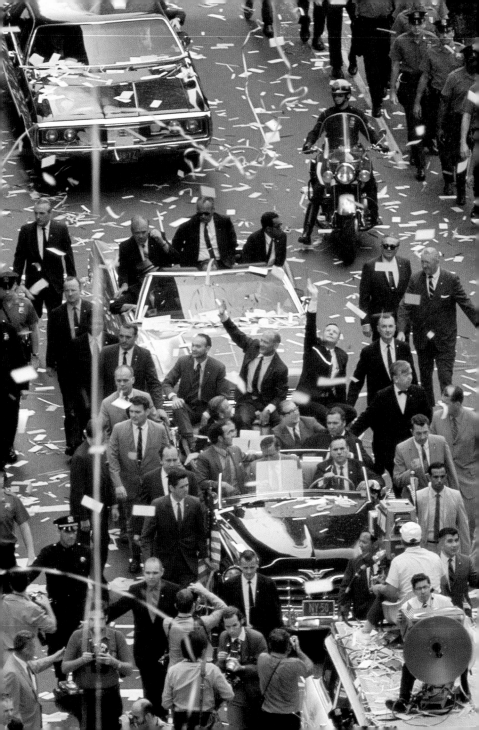

of his mental reach. If brooding over unanswered questions was the root of the mad, however, and sanity was the settling of dilemmas, then with how many questions could one live? He would answer that it was better to live with too many than too few. Rave on, he would. He would rave on.

* * *

The strain of the summer did not abate. He went back to Houston in the middle of August to see the astronauts at a press conference when they came out of quarantine, and they looked astonishingly the same as they had in the last conference eleven days before they left for the moon. He had long held the theory that experts were men who had the least sensitivity to their subject and so experienced the smallest difficulty in memorizing a huge number of facts concerning their topic. He had only to think of some of the sports writers, literary critics and pornographers he had known, to be confirmed in his thesis. Now he wondered if that was why the astronauts were the first experts in walking on the moon.

Back in New York next evening, he was again a student of TV as he watched the dinner party President Nixon gave for the crew of Apollo 11 and several thousand NASA men, contractors and guests.

When Nixon got up to speak, Aquarius' host switched on a projector loaded with a color film of a boy and girl making love. But the television set was made to serve as the screen. Soon a vagina fluttered butterfly wings over the nose and mouth of the speaker. The laughter that came up from the toils and locks of the company's hard-hearted plumbing was close to

Office workers perched precariously on parapets. Inspired by the astronauts, some of them seemed to be trying to defy gravity as they leaned out over the street to snap photographs. — The New York Times, *August 14, 1969* Opposite: Photo, Neil Leifer.

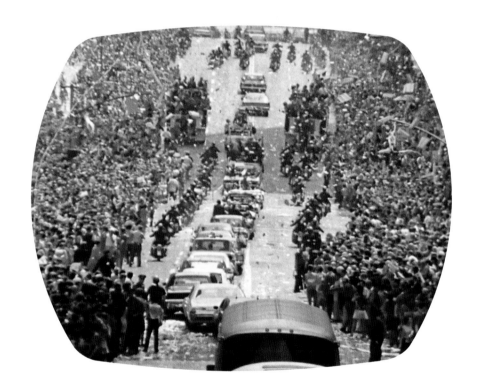

apocalyptic. With astonishment Aquarius found himself laughing as hard as the rest. Jokes at the expense of Nixon usually bored him. If Aquarius thought Nixon's most striking effect upon America was as a blood-letter who would reduce all passions, Aquarius was on the other hand not so certain that America had not needed a leech for its fever. From across a political divide, he admired what he had come to decide was Nixon's grasp on political genius — to be so unpopular and yet successful — that was genius! So Aquarius was bored with liberals who thought politics was equal to loathing Nixon. But the sight of that young and wide-open pussy fluttering back and forth over the dish antenna of Richard Nixon's endlessly inquiring face touched off some explosion of frustrations in all of them, battered, bewildered, dislocated New Yorkers roaring now like college kids doubly in love with themselves for the success of the prank.

Back in Provincetown, however, marriages were breaking up as fast as tires blowing in a long race. The most astonishing couples — a man and woman, for example, who had been married unhappily and most tenaciously for twenty years — were breaking up. He counted at least five such surprising dissolutions where one, or at most two, might be par for a warm season. He didn't know if all those marriages had ended because the principals felt ridiculous before the serious actions of men in other places this summer, or whether the marriages had smashed on the outraged waves of some unmeasurable radiation from the roiled invisible waters of Tranquility Base.

As if answer to the moon landing, the Woodstock Music Festival came and went, and four hundred thousand children sat in the rain for two days and nights

Opposite: An estimated four million people turned out to watch the Apollo 11 heroes ride down New York's "Canyon of Heroes" route, from Broadway to Park Avenue to City Hall to the United Nations headquarters. Later that evening in Los Angeles, President Nixon presented Aldrin, Armstrong, and Collins with the Presidential Medal of Freedom at a state dinner attended by 44 governors, dozens of members of Congress, the chief justice, and ambassadors from 83 nations. *Television still, NASA/Copp.*

The shower of ticker tape and public enthusiasm that greeted the Apollo 11 astronauts has not dispelled the uncertainty hanging over the U.S. Space Program. With the stupendous feat of getting to the moon safely accomplished and festively acknowledged, there is now wide disagreement over what priorities and financial resources the U.S. should assign new space challenges.
—LIFE, August 8, 1969
Opposite: Chicago, August 13. Between New York and Los Angeles, the first day's tour included a stop in Chicago, where the parade route coursed through the Loop to the Civic Center. Photo, NASA.

and listened to rock music, the electronic amplifications elevating the nerves beneath the fingernails of the musicians to the Holy of Holies; Sharon Tate, three friends, and an employee, plus her unborn baby seven months in the womb, were murdered in a guttering of blood all over the walls of her jewel-box of a dwelling in the whimpering Hollywood hills. He felt no shock in further weeks to come when Manson and his family were arrested, for like many novelists Aquarius had a few stray powers of divination, and had projected a novel two years before about a gang of illumined and drug-accelerated American guerrillas who lived in the wilds of a dune or a range and descended on Provincetown to kill. A year later, parts of four girls had been found in a common grave in Truro eight miles away. They would bring to trial a young man from the town who was steeped by report in no modest depths of witchcraft. Yes, drugs to expand consciousness were detonating the banks of fires burning beneath these hundreds of years, and Provincetown was country for witches: here the Pilgrims had landed, here first in the weeks before they moved to Plymouth, Provincetown was the beginning of America for Americans, an immense quadrangle of motel to prove it now on the ground where the Pilgrims first sailed around the point, anchored and rowed an explorer's boat to shore.

* * *

His friends, the Bankos, buried a car as Labor Day approached. They had purchased a heap for the summer, purchased it with a request of the salesman that he sell them a piece of well-used automobile which would

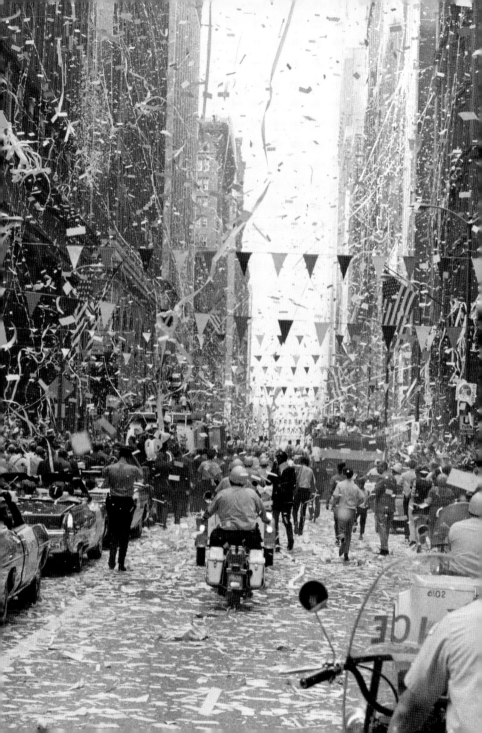

manage to survive through August and into the first weeks of September, but it died before Labor Day was on them, bearings gone, valves gone, oil pan cracked and broken crankshaft — it was gone. Something in the mood of the summer brought every neighbor in for the burial. The sculptor Jack Kearney became the master of the rites, and poets living near became sacramental officers of the day. Friends came with drinks, while Harold McGinn, local contractor with bulldozer and earth digger, was there to scoop a hole six feet by eight feet by eight feet deep. A rope was put up to hold the neighbors and children from cavorting too near the abyss. And the car, a two-tone sedan of apricot and cream of a long-gone year with mourns of chromium now pitted by salt air and eight years of sun, such faded vehicle, was pushed back by the pallbearers, Aquarius among them, to land with its rear bumper, trunk and differential in the hole and its hood to the sky. The bulldozer leaned it up to a near vertical, and the pallbearers shoveled in earth and tamped sand at the base of the hole. Children ate cake and candy. A boy dressed in the black robes of a Byzantine priest read somber verses from Virgil, the Latin passing like a wash of coagulants over the car still settling in its half-buried grave, and Heaton Vorse in a cape and long-brimmed loose-hinged hat read from the Song of Solomon, sounds of mirth going up as the lines fell like hoops on the promontories of the apricot and cream Ford.

Opposite: Mexico, September 29–30. At President Nixon's request, the astronauts and their wives departed Washington, D.C., aboard the president's plane, Air Force One, for the Giant Leap tour. The first stop was Mexico, where crowds dressed them in sombreros and ponchos. From there they headed south to Bógota, Columbia; Buenos Aires, Argentina; and Rio de Janeiro, Brazil. *Television stills, NASA/Copp.*

I compare you, my love,
to a mare of Pharaoh's chariots.
Your cheeks are comely with ornaments,
your neck with strings of jewels.

Vorse was the son of Mary Heaton Vorse, a lady radical who had participated in such events as the Paterson strike now fifty years gone, and Heaton Vorse had a long Yankee nose which virtually touched his plank of a chin. He read to the Ford:

Your navel is a rounded bowl
that never lacks mixed wine.
Your belly is a heap of wheat,
encircled with lilies.
Your two breasts are like two fawns,
twins of a gazelle.
Your neck is like an ivory tower.
Your eyes are pools in Heshbon . . .

The crowd applauded, and Aquarius felt the proper warmth a funeral should evoke, a sorrow in the pit of merriment and the humor of the very sad — all these Provincetown neighbors out to applaud the burial of an old oil-soaked beast, and the Bankos circulated beer while children ran around the edge of the event, impatient for the ceremony to cease so that they might begin to paint the half of the auto protruding from earth. A child reached in through the open window and turned a switch. The windshield wipers went on in a flick. "My God, it's not dead yet," said a voice. But as if in a throe of its last effluents, the washers began to spurt a final lymph.

Eddie Bonetti read his poem, "Duarte Motors giveth, and terminal craftsmanship taketh away." Bonetti had worked all summer on a truck, finding the pieces he needed in the town dump, had worried over the Chevrolet manual for pickup trucks of the year of his buy the way a medical student in

Opposite: Paris, July 21. Celebrations the world over took many forms. In Paris the Moon Shot cocktail made its debut at Harry's New York Bar on July 21. Owner Andrew MacElhone holds up the morning edition of the *International Herald Tribune* while a barman shakes up a drink "guaranteed to make anybody take off." *Photo, Bettmann/ Corbis.*

[Cardinals and bishops] burst into applause when Neil Armstrong gave a brief theological commentary after being asked how the moon walk had affected his personal relationship to God.... When the astronauts left the papal audience they went to the meeting room of the synod, and the theological discussion gave way to the crisp talk of Apollo 11 and an illustrated talk of the moonwalk.... Questions from the bishops ranged from technical matters, including the surface temperature of the moon, to the theological twist that Armstrong answered.
— Los Angeles Times, October 17, 1969
Opposite: Vatican City, October 16. Photo, NASA/NARA.

first-year anatomy goes through strings of flesh which might be nerves, Bonetti had lived with the mysteries of a working transmission through all of this summer, a dungeon of grease by evening to the groans of his pale blond Missouri wife, and Eddie read in his deep cockeyed booming voice, eloquent as the wind which announces a shift in the omens, played with his poetic humors, which moved ponderous phrases through turns of silver by the shift of weight, and his poem continued, honoring this buried friend, conceived in cynicism and sold in exhortation on the floor of Duarte Motors, agent of promises too huge for its fealty to the domains of work, too large for its embarkation back into the particulars of the soil. It was a heroic poem for the occasion (bound to have been printed if it had not been lost) and Aquarius, finding himself drunk unexpectedly on this afternoon of curious frolic, unable for once to resist the noise and calls of the last of summer and the ferments of the town, had come wandering out of his studio to attend half aghast, half sympathetic, to the idiocies of his friends — they would chop up a lawn mower to serve a salad.

The last of the poets, Walter Howard, was reading Numbers 16.

But if the Lord creates something new, and the ground opens its mouth, and swallows them up, with all that belongs to them, and they go down alive into Sheol, then you shall know that these men have despised the Lord.

The children were out with brushes and paints, drawing figures, figure-drippings and inchoate totems on the vertical roof of the car, and Kearney was limning the exposed bottom of the crankcase and chassis with

lights of green luminescent pigment in slashes through the grease, hints of war paint — slowly the radiant ribbings of an insert's belly emerged from the dark and open works.

And as he finished speaking all these words, the ground under them split asunder; and the earth opened its mouth and swallowed them up, with their households and all the men that belonged to Korah and all their goods.

Now the children were slinging paint through the open windows onto the vinyl of an old upholstery. Aquarius watched his wife at the other end of the lawn and knew again as he had known each day of this summer that their marriage was over. Something had touched the moon and she would be never the same. The sense of love as a balm for the vacuums of the day was departed from them — they were sealed from one another, a run of seven years was done, and his heart throbbed like a bruise in the thigh.

So he mourned the hour as well as any man would when his pains were not small, even mourned for the beast who cried out in Banko's half-burned Ford, mourned him like the skull of poor Yorick, and came back often in the next day and the next to watch Kearney the sculptor work with his torch and goggles to weld bumpers and angles of chromium into mandibles and legs while insect's antennae reached up in a mute's catalepsy to the sky. And they put floodlights at the base. The funeral had ended in an artifact for the summer of the moon in the East End of Provincetown not a hundred feet off the street which runs around the bay, not a half-mile in from the edge of town, Metamorphosis, titled by Kearney, a massive Yorick of

Opposite: When the Bolivian government refused permission for Air Force One to enter its airspace, an unscheduled stop was made in Brasília. While the plane was refueled Collins and Armstrong toured Brazil's space-age capitol complex. *Photo, J. Cardoso.*

half a Ford standing twelve feet high, first machine to die with burial in the land of the Pilgrims and the cod.

And in those days men will seek death and will not find it; they will long to die, and death will fly from them.

That was from Revelations 9:6 an d gives a clue to Aquarius' thoughts at the funeral. It was a day for more than a little to seek to die, for his work had him studying colonizations on the moon, conversion of oxygen from moon rocks and cities of moon-based energy derived from radiations of the sun. Moon vegetables huge in size would grow in the reduced gravity of the field, the plants to thrive in hydroponic waters (also extracted from moon rocks) while algae proliferated in gardens of new-made atmosphere beneath a dome. The effort of these colonies would offer no less than the cheap manufacture on the moon vacuum of products of mass consciousness — electronics, communications, pharmaceuticals, yes, Sartre might be right and consciousness the conversion of Being to Nothingness, yes, the tools of the future mind seemed to be forged best in a vacuum — soon they would be orbiting rocket trains of cancer patients to take the cure in space, for the growth of malignancy was slowed apparently by radiation in weightless condition. Pain appeared at the thought of a new species of men born in lunar gravity, bodies grown in lunar gravity — what form would appear to their figures, pilot men of an electrical and interplanetary world which could speak across the ages of a failure of human potential, a smashing of mood, some loss of that other means of communication which once had lived in the carnal grasp of the roots of that earlier

human so much closer to an animal in the ecological scheme, early human who had survived pregnancy, birth, first-year diseases, syphilis, loss of teeth — what a strength and substance to that earlier and lost human race Aquarius brooded as the dirt flew in on the dead Ford, what a nice balance of food consumed and material used, equilibrium of lives, and deaths, and wastes in fair balance, as opposed to the oncoming world of parallel colostomies draining into the same main line, and the air of earth cities become carbon monoxide and lead, sulphur dioxide and ash, nitrogen oxide and other particulates of the noxious, earth staggering with sewages which did not rot, synthetics, aluminums, oils and pesticides, fertilizers, detergents and nuclear spews, acids and plastics and salt in the soil, cakes of suffocation in the rivers, hazes of nitrogen effluent to cut off the light from the sky, a burgeoning of artificials to addict the crops, another year of pollutions to choke the planet. And the population ready to double in four decades, no, less. One knew with the worst sense of bottoms disgorging into bottomless bottoms that if the military-industrial establishment was beginning to accept the idea that funds might be taken eventually from them and given over to the solution (or the barest hope of a solution!) to the critical symptoms of ecology, the nauseas of pollution, then the statistics presented to their private councils must have been incredible indeed. Was the end of the world at hand? Was that the message they now received? Io, Europa, Ganymede and Callisto! — we might be safer far on the moons of Jupiter. What did we know of what we did? Why the very organs of disease which once would kill a man were now delivered by surgeons to the womb of the open day, organs

Opposite: Tehran, Iran, October 28–31. Now over halfway through their tour, the astronauts and their staff began to call the familiar Air Force One home. With one- or two-day stops in Madrid, Amsterdam, Tehran, Kinshasa, Bangkok, and Sydney, the rigorous travel and event schedule took its toll; and when several delegation members came down with a virus their attending staff doctor had to go on television to dispel the rumor that the astronauts had spread a "moon bug." *Photo, NASA.*

of disease reborn for an instant in a half-life, yes, cancer organs removed probably became the cancer communicants of ether yet unglimpsed.

Only a generation ago, they would have thought it was the essence of an insane heart to personify an organ, attribute a soul to the part, believe that a cancer of liver or cancer of lung was not extinguished so soon as its malignancy was removed. It would have been considered the core of psychosis to speak of the post-operative cancer communicants of the organ removed. Yet we were infants who tickled the navel of the moon while suffocating in the loop of our diaper. A line from a poem of Hemingway burned across the funeral festivities of the day.

In the next war we shall bury the dead in cellophane
The Host shall come packaged in every Kration.

He broke up with his wife on Labor Day night and knew they would not be together for many a month, many a year, maybe forever. In the morning, after a night of no sleep, he was on a plane to Houston and the sifting of haystacks of technological fact for the gleam of a needle or a clue. And no computer named HAYSTAQ to serve as horse.

* * *

It was a long September. He went back and forth between Houston and the mournful memories of the land of the Pilgrims and the cod. Pisces was away, and traveling. In the mend of Indian summer with the crowds gone and the rose-hip bushes in bloom on the dunes, their flowers artful as violet in a pearl, he

A tumultuous reception was given the three Apollo 11 astronauts and their wives today when they arrived here on their round-the-world goodwill tour. At Dacca airport the crowd stormed barricades to get near the Americans. — The New York Times, October 28, 1969 *Opposite:* Dacca, Bangladesh, October 25–26. Crowds unexpectedly ran out onto the airstrip when Air Force One touched down in Dacca, now Dhaka, requiring waiting cars to pull right up to the plane to ferry the delegation to their hotel. Embassy officials estimated around a million people attended the parade in the Bangladeshi capital. By tour's end, at least 100 million people saw the astronauts in person, and as many as 25,000 had shaken at least one of their hands. *Photo, NASA.*

Opposite: Seoul, South
Korea, November 3–4.
The tour now coming
to a close, a few stops
in East Asia were on the
agenda before heading
back to Houston via
Hawaii. *Photo, NASA/
NARA.*

bought a Land Rover for consolation and took long
rides through lands of sand back of town, a corner
of Sahara. In the bay, the flats at low tide heard the
singing of the clams — dreams of glory at the majesty
of oceans emerged in a sigh, a whistle, one could not
quite hear the buried song of the clam. And the light
dazzled across mirrors of inch-deep water and lumi-
nosities of glistening sand — he could almost have
packed the literary equipment in for one good year of
oil and gesso ground.

There were contracts however. Prose was never
so much prose as when constructed with obligation.
The more he visited Houston, the more he knew
with what unhappiness is not automatic to tell that
he might have blundered in accepting the hardest
story of them all, for it was a sex-stripped mystery of
machines which might have a mind, and mysterious
men who managed to live like machines, and more
than once in airplanes, high enough above the clouds
to give a hint of other worlds in the gatherings and
demarcations of airy attenuated farewell, he came
to think again, as he had brooded again and again,
on that simple conception of God as an embattled
vision which had terrified him from the hour he first
encountered the thought around one of the bends of
marijuana fifteen years ago. Every other one of his
notions had followed from that, for if God were a
vision of existence at war with other visions in the
universe, and we were the instruments of His endeavor
just so much as the conflicting cells of our body were
the imperfect instrument of our own will, then what
now was the condition of God? Was He trapped in the
wound of nature, severed from our existence as com-
pletely as the once exquisite balances of the shattered

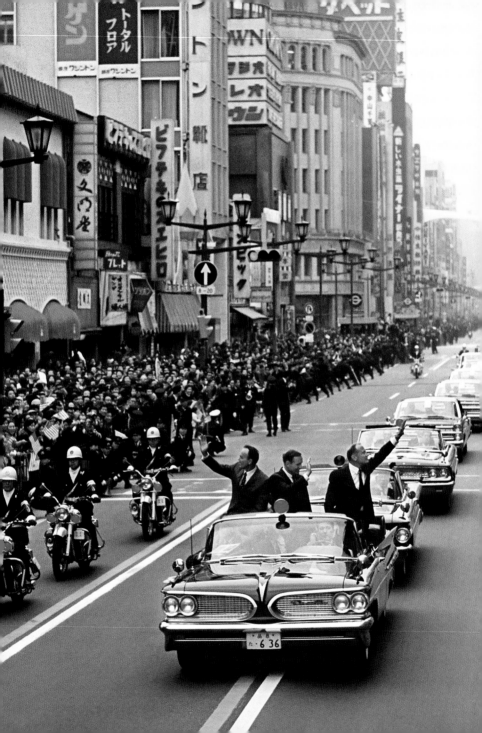

ecology? had that vision He wished to carry across the universe depended altogether upon human mind and flesh in sensuous communication with nature? had radio-by-machine been the cancer of communication? had the savage lived in a set of communions with the invisible messages of nature which we had pulverized with our amplifiers? These days Aquarius carried Frazer's *Golden Bough* on long trips by plane.

<div style="text-align:center">* * *</div>

Bechuana warriors wear the hair of a hornless ox among their own hair because the ox, having no horns, is hard to catch...a South African warrior who twists tufts of rat hair among his own curly black locks will have just as many chances of avoiding the enemy's spear as the nimble rat has of avoiding things thrown at it...When you are playing the one-stringed lute, and your fingers are stiff, the thing to do is catch some long-legged field spiders and roast them, and then rub your fingers with the ashes; that will make your fingers as lithe and nimble as the spiders' legs — at least so think the Galalereese. To bring back a runaway slave an Arab will trace a magic circle on the ground, stick a nail in the middle of it and attach a beetle by a thread to the nail, taking care that the sex of the beetle is that of the fugitive. As the beetle crawls round and round, it will coil the thread about the nail, thus shortening its tether and drawing nearer to the center at every circuit. So by virtue of homeopathic magic the runaway slave will be drawn back to his master.

About 120,000 persons line the route of the motorcade from the airport through the city's bustling Ginza district to cheer the astronauts. Prime Minister Eisaku Sato pinned Japan's Cultural Medals on each astronaut. They were the first foreigners ever to be awarded the decorations. — The New York Times, *November 5, 1969* Opposite: Tokyo, Japan, November 4–5. A crowd of 120,000 lined the streets of Tokyo's Ginza district to watch the motorcade's progress. *Photo, Bettmann/Corbis.*

* * *

It was the magic of savage metaphor, the science of symbol, it married spiders' legs to the music of the fingers and the useful frenzy of the rat to the sensors in his hair. It made a wedding between the spiraled-in will of insects forced to focus on a point of tether and the loss of any will-to-escape in the slave. It was pretty, poetic and nonsensical, it was nonsensical. Unless it were not. What if some real exchange between insects, trees, crops, and grains, between animals and men, had lived with real if most distorted power in the first hours of history? What if that Vision of the Lord which had gone out to voyage among the stars had obtained the power to be carried up by the artwork of a bounteous earth exquisite in the resonance of all psyches in its field? — what if radio, technology and the machine had smashed the most noble means of presenting the Vision to the universe?

What if God wrestled for the soul of man in some greased arena with the Devil, who was now fortified by every emanation from baleful stars beyond the sun — could that be so? What if God, losing cruelly here, and yet gaining there, was in a combat just so crude as the counts of point in a contest. What if, for the sake of a premise, one would assume that the Devil was reconstructing nature with every electronic, plastic, surgery and computer and so had forced the Lord in desperation to descend into the earth and come back with His life in the grass of that most mysterious marijuana, a drug which made one aware of life in the veins at what severe price was not yet known? What if God, aghast at the oncoming death of man in man-deviled pollution, was finally ready to relinquish some

Opposite: Carrying signs of congratulations for a successful lunar landing, bikini-clad dancers from a Tokyo cabaret shout "Banzai" with their manager in front of the U.S. embassy. *Television still, NASA/Copp.*

part of the Vision, and substitute a vision half machine, and half of man, rather than lose all? What indeed if the Lord was allowing Himself to be consumed so that the angels and swine of His children who swallowed Him promiscuously each day and night on drugs were able to embark on journeys into the land of the dead, little journeys in through the first gates of the palace of death, and thus giving Himself to the children in the milk of their drugs was, yes, consumed by them each night and thereby relinquished the largest dreams of His future. Such thoughts were an agony of pain if one held them truly, for responsibility was then like a burning of blood, and the time of apocalypse was certainly near. [...]

In the several trips to Houston, he was like a man looking for the smallest sign. For the moon book which he had begun that summer idled now in the gap of Pisces' absence, and he did not know where to put his feet. One lifted a book like a boulder out of the mud of the mind, and his mind was a pit of wrenched habits and questions which slid like snakes. Where did you put your feet so that finally you might begin?

He found the answer at last in company with his favorite saying. "Trust the authority of your senses," Aquinas had said. He could repeat it again, for there was an object at last for his senses, there in the plastic vaults and warehouses of the Manned Spacecraft Center at Houston was a true object, a rock from the moon. Looking at it, answers came, answers strong enough to send him back to Provincetown for the fall and winter haul of his book, and a little of the spring. He finished in fact on a day when Apollo 13 was limping back to earth in wounded orbit with two fuel cells gone, its Lunar Module Aquarius never to

I felt a successful lunar landing might inspire men around the world to believe that impossible goals really are possible, that there really is hope for solutions to humanity's problems....
— *Neil Armstrong, LIFE, August 8, 1969*

Opposite: December 28, 1969, Long Binh, Vietnam. With the Giant Step Tour on hiatus by early November, Armstrong joined Bob Hope on his annual U.S.O. Christmas Tour, entertaining American troops stationed in Vietnam, as well as in Germany, Italy, Turkey, Taiwan, Guam, and Thailand. After this the crew reunited for a few last stops in Canada. *Photo, Bettmann/ Corbis.*

reach the moon, yes, he finished in an hour when he did not know if the astronauts would return in safety or be lost, but he had written the ending in his mind long before; it came on the day he stood in quiet before that object from the moon, that rock which gave him certitude enough to know he would write his book and in some part applaud the feat and honor the astronauts because the expedition to the moon was finally a venture which might help to disclose the nature of the Lord and the Lucifer who warred for us; certainly, the hour of happiness would be here when men who spoke like Shakespeare rode the ships: how many eons was that away! Yes, he had come to believe by the end of this long summer that probably we had to explore into outer space, for technology had penetrated the modern mind to such a depth that voyages in space might have become the last way to discover the metaphysical pits of that world of technique which choked the pores of modern consciousness — yes, we might have to go out into space until the mystery of new discovery would force us to regard the world once again as poets, behold it as savages who knew that if the universe was a lock, its key was metaphor rather than measure.

Marvelous little moon rock. What the Devil did it say?

It was not so much. They led Aquarius through one back room after another, and up and down a stone stair or two. The week of exhibiting the rock at MSC was over — it was now on its way to the Smithsonian — and special favors were needed this particular afternoon to obtain a peek. But he reached a place at last he had been in months before, the room with the plate-glass window across its middle where magazine writers had hounded Armstrong

until Armstrong confessed that man explored out as salmon swim upstream, and there on the other side of the glass was no astronaut today, but a small case vacuum-tight on the other side of the divide. He saw the lunar piece through not one glass but two, rock in a hermetically tight glass bell on the other side of another glass with still another hermetic seal. Yet she was not two feet away from him, this rock to which he instinctively gave gender as she — and *she* was gray, gray as everyone had said, gray as a dark cinder and not three inches across nor two inches high nor two inches for width, just a gray rock with craters the size of a pin and craters the size of a pencil point, and even craters large as a ladybug and rays ran out from the craters, fine white lines, fine as the wrinkles in an old lady's face, and maybe it was the pain of all these months of a marriage ending and a world in suffocation and a society in collapse, maybe it was just the constant sore in his heart as the blood pumped through to be cleared of love, but he liked the moon rock, and thought — his vanity finally unquenchable — that she liked him. Yes. Was she very old, three billion years or more? Yet she was young, she had just been transported here, and there was something young about her, tender as the smell of the cleanest hay, it was like the subtle lift of love which comes up from the cradle of the newborn, and he wondered if her craters were the scars of a war which had once allowed the earth to come together in the gathered shatterings of a mighty moon — there was something familiar as the ages of the bone in the sweet and modest presence of this moon rock, modest as a newborn calf, and so he had his sign, sentimental beyond measure, his poor dull senses had something they could trust, even if he and

the moon were nothing but devils in new cahoots, and child of the century, Nijinsky of ambivalence, hanging man Aquarius, four times married and lost, moved out of MSC with the memory of the moon, new mistress, two feet below his nose, and knew he would live with the thought of a visit. All worship the new science of smell! It was bound to work its way through two panes of glass before three and a half billion more years were lost and gone.

Part of the impulse to get into space was, indeed, to determine the chances of making man viable across the universe. If mankind got to the point where we had to recognize that we were destroying ourselves, the next step would be finding a way to colonize space. But if we destroy this planet, then the question is: do we have the right to travel across space and infect it? But knowing human nature, we never look back. . . .
—Norman Mailer, OMNI, July 1989 Following spread: Houston, Texas, August 16, 1969. *Photo, Houston Post.*

Norman Mailer: A Life
J. MICHAEL LENNON

Norman Mailer was one of the most prolific, outspoken, and accomplished writers of the second half of the 20th century. A relentless innovator and connoisseur of narrative forms and techniques, he published over 40 books in virtually every literary genre, and was acclaimed as one of the pioneers of the New Journalism, a mode of writing in which fictional techniques are used in nonfiction works. He was also a leading public intellectual who spoke out on a broad range of issues, from the dangers of plastic and television's deadening effects to the Women's Liberation Movement and the Iraq War. His dramatic interpretations of American cultural phenomena and his idiosyncratic views on sex, violence, power, technology, architecture, identity, and the art of writing appeared in a 60-year run of novels and nonfiction narratives, plays, poems, sports reporting, political essays, biographies, and countless media interviews.

Born in Long Branch, New Jersey, in 1923 to Jewish immigrant parents, he grew up in Brooklyn, New York, and graduated from Harvard University in 1943, where he studied engineering. Mailer was drafted into the U.S. Army in 1944 and served as a rifleman and cook in the Pacific theater from 1944–46. While attending the Sorbonne on the G.I. Bill after the war, he published his first novel, *The Naked and the Dead* (1948). The book traces the campaign to take a Japanese-held island, and is widely considered to be one of the finest novels of WWII. It has never gone out of print and has been translated into a score of languages. Other major

I began to realize that the moon landing was an event no man could ever dominate with his ego and I realized I was going to have to work twenty times harder on the book than I thought I would.... There are areas of ambiguity about the landing on the moon as least as large as when Columbus came back from the discovery of the new world. — Norman Mailer, *quoted in* Publisher's Weekly, *January 25, 1971 Opposite:* August 29, 1969: Mailer's portrait made the cover of *LIFE* for the first in his three-part series on the moon shot. *Photo, Bob Peterson.*

Caroline 627-7877
Sunday 116 Henry 2D

2nd draft
later replaced of various pages

~~THE~~ CHANGING OF THE GUARD

"Now sleeps he with that old whore death . . .
"Do thee take this old whore death for thy
 lawful wedded wife? . . .
 Ernest Hemingway

I.

Norman, born sign of Aquarius, had been in Mexico when the news
came, about Hemingway. He had gone through the New York Times to read the well-turned

remarks of notables who for the most part had never cared about Papa, not

that much! and had one full heart-clot of outraged vanity himself that

the Times never thought to ask his opinion. In fact, it was not certain

he could have given it. He was sick in that miasmal and not quite dis-

coverable region between the liver and the soul. Hemingway's suicide left

him wedded to horror. It was possible that in the eight years since, he had

never had a day which was completely free of dread.

Of course, he finally gave a statement. His fury that the world

was not run so well as he could run it, encouraged him to speak. The

world could always learn from what he had to say--his confidence was

built on just so hard a diamond. Besides, a British lady columnist ~~also~~

passing through Mexico, with him, thought it would be appropriate to get his remarks

on the death. This, after all, was special stuff--the ~~remarks~~ reactions of one of

novels include *The Deer Park* (1955), *An American Dream* (1965), *Why Are We in Vietnam?* (1967), *Ancient Evenings* (1983), and *Harlot's Ghost* (1991). His eleventh and final novel, *The Castle in the Forest*, an exploration of Adolf Hitler's boyhood, was published in 2007, months before his death. Mailer is the only major American author to have best sellers in six consecutive decades.

A cofounder of *The Village Voice* in 1955, Mailer also wrote for *Life*, *Esquire*, *The New Yorker*, *Playboy*, *Harper's*, *Partisan Review*, *The Paris Review*, and *Vanity Fair*, as well as many counterculture and underground publications. His magazine work appears in several collections, including *Advertisements for Myself* (1959), the book where he established his characteristic voice—bold, acerbic, and self-referenced.

In the late 1960s he made three experimental films, including *Maidstone*, his most famous movie, in which the action and dialogue were improvised. All three were influential, as was his 1987 film *Tough Guys Don't Dance* (based on his 1984 mystery novel of the same name), his only foray into commercial film-making. He also ran for mayor of New York City in the 1969 Democratic Primary, campaigning on a platform that called for New York to become the 51st state. That same year, his nonfiction narrative about the anti-Vietnam War movement, *The Armies of the Night*, won the Pulitzer Prize and the National Book Award. Mailer discovered in the 1960s that he needed a new way to see the fantastic and unpredictable events of the decade and that the optics of conventional journalism were too clumsy. He decided to interleave reportorial perseverance, fictional technique, and the urgent promptings of his own intuition into a new narrative mode that would capture

Opposite and page 611: Norman Mailer wrote his first drafts for LIFE magazine in longhand in 1969, before the manuscript was typed. His papers reside in the Mailer Archive at the Harry Ransom Center of the University of Texas at Austin. Manuscript pages, courtesy HRC.

the momentous happenings of the era, while seeking, as he said of Picasso, "to reach into mysteries of existence that no one else had perceived."

Mailer is the only person to win Pulitzers in both fiction and nonfiction. Five of his books have been nominated for National Book Awards, including *Of a Fire on the Moon* (1971), his nonfiction narrative of the Apollo 11 moon shot, which was serialized in *Life*. Aquarius, as he referred to himself in *Fire*, solidified his position as the most acute observer of contemporary American reality with his sensuous and analytic examination of the space program. He won a second Pulitzer for *The Executioner's Song* (1979), an account of the life and death of Utah murderer Gary Gilmore. Other biographical works include portraits of Marilyn Monroe, Muhammad Ali, Henry Miller, Pablo Picasso, Lee Harvey Oswald, Madonna, and Jesus Christ. In 2006 he was recognized for his many contributions to literature and culture with the National Book Award Foundation's Lifetime Achievement Award. Married six times, he was the father of nine children and had ten grandchildren. For the last 33 years of his life, he and his sixth wife, the painter and novelist Norris Church Mailer, lived in Brooklyn Heights, New York, and Provincetown, Massachusetts.

for years, he had always taken it for granted that he was superior to his surroundings and could do well anywhere. Well, maybe one could still do well anywhere with love, but lovelier than words, working hard at an unfamiliar job, surrounded by faces he could with the best will find no more congenial than they with the best will could accept his mellow head, he was obliged to recognize that this basement apartment in a curious warren of Los Angeles ranch style apartments, inner patios and underground garages — the modern style of living of the comfortable Vicleris of the West — was no place for him to thrive. The simple truth was that if he had become a little obsessed with the incredible meanings of his trip to the moon — now going on full attraction into its first night and second day and second night while he languished in his dim coop — if he had come to recognize that the more one brooded on this trip to the moon, the more fantastic it became, there was still the thundering and more depressive fact that it was a concrete and stubborn fact for a journalist to cover. There were assignments which could make a reporter happy — he sometimes thought it would be impossible for a good liquid-working novelist not unduly interested, not to be able to write a good piece about any number of big brassy majestic somewhat vulgar and half crazy historical occasions like a political convention or a well-organized anarchy of the modern young. Give Aquarius a great heavyweight championship of jagged, and he would give you a two-volume work. There was so much to say. One's senses threatened a person's brain with excess of perception. The people who were acting at the center of such events nourished you with their presence and the comedy or tragedy of the traps they entered and sometimes escaped. But in NASA-land, the only living

Acknowledgments

The publisher gratefully acknowledges the coop-
eration of numerous individuals at the archives
represented in this book: Time Life Pictures:
Regina Feiler and Amy Wong; Getty Images:
Joelle Sedlmeyer and Michelle Butnick Press;
NASA Headquarters: Constance Moore and
Bertram Ulrich; NASA Johnson Space Center,
Houston: Adam Caballero, Will Close, Warren
Harold, James Hartsfield, Irene Jenkins, Jody
Russell, and, especially, Mike Gentry; NASA
Kennedy Space Center, Florida: Chuck Brown,
Elaine Liston, Margaret Persinger, Robert Stratton,
and Sandy Van Hooser; National Archives Photo
Response: Joe McCary; BBC Motion Gallery:
Helen Higbee; National Geographic Society:
Wendy Glassmire; JPL: Charlene Nichols;
Houston Public Library: Joel Draut; Kobal
Collection: Phil Moad; NASA Glenn Research
Center, Cleveland: Marvin Smith; The Menil
Collection: Erh-Chun Amy Chien; U.S. Space
Walk of Fame: Lee Starrick and Charlie Mars;
Northrop Grumman: Bob Bishop and John
Vosilla; Hulton Archive: Luigi Di Dio; Brasil
Midia Digital Ltda: Ana Paula Amorim.

Our gratitude to all the photographers,
researchers, and archivists who supported this
volume: Don Blair, Duncan Copp, Howie Leifer,
Neil Leifer, Ulli Lotzmann, Colin Mackellar, Bob
Peterson, Anna Skinner, Michael Soluri, Gary
Truman, Bill Wood.

Special thanks to Colum McCann for his
insight into Mailer's work, and to Ken Glover,
Eric Jones, and Dave Woods of the *Apollo Lunar
Surface Journal* for sharing their historical and
technical knowledge.

TASCHEN salutes three of the great heroes
of the 20th century, Dr. Buzz Aldrin, Neil
Armstrong, and Michael Collins. Additional
thanks to Lois Driggs Aldrin, and Lisa Cannon,
Christina Rasch, and Renee Topper of StarBuzz
Enterprises; and to Peter Arnell, for introducing
Benedikt Taschen to Buzz Aldrin.

Finally, without the kind blessing of Mrs. Norris
Church Mailer, editorial expertise of
J. Michael Lennon, and enthusiastic support and
collaboration of Larry Schiller, this edition would
never have been possible. Thank you.

Mailer text edited for this edition by J. Michael
Lennon

Lee Balterman, Ralph Crane, J.R. Eyerman, Bob Gomel, Fritz Goro, John Iacono, Yale Joel, Vernon Merritt, Ralph Morse, John Olson, Bob Peterson/*LIFE,* Michael Rougier, Lawrence Schiller/*LIFE,* Hank Walker, courtesy Time & Life Pictures/Getty Images. Hulton Archive, courtesy Getty Images.

NASA, courtesy the National Aeronautics and Space Administration. NASA/Byrne, courtesy NASA, compiled by David Byrne. NASA/Copp, courtesy Duncan Copp. NASA/JPL, courtesy NASA/JPL–Caltech. NASA/Lotzmann, courtesy Ulli Lotzmann. NASA/NARA, courtesy National Archives, Washington D.C. NASA/Space Walk courtesy U.S. Space Walk of Fame. NASA/Wood, courtesy Bill Wood.

Don Blair © 2009 Don Blair. Neil Leifer © Neil Leifer 2009. René Magritte, © 2008 C.Herscovici, London/Artists Rights Society (ARS), New York/ The Menil Collection, Houston. Bob Peterson © 2009 Bob Peterson. Lawrence Schiller © 2009

Lawrence Schiller, Polaris Communications, Inc. Flip Schulke © Flip Schulke 2009. Garry Winogrand © The Estate of Garry Winogrand, courtesy of the Fraenkel Gallery, San Francisco.

Jim Kerlin, courtesy AP/Wide World Photos. University Library Istanbul, Dagli Orti, courtesy The Art Archive. Bettmann/Corbis © Bettmann/CORBIS. J.Cardoso, courtesy Brasil Midia Digital Ltda. CBS, courtesy of CBS News Archive. Houston Post, courtesy Houston Public Library. Nathan Duran, Méliès, and George Pal Prods, courtesy Kobal. LPI, courtesy Lunar Planetary Institute. John D. McLauchlan, Luis Marden, NASA/NGS, and A. Patnesky courtesy National Geographic Stock. *2001: A Space Odyssey* © Turner Entertainment Co. A Warner Bros. Entertainment Company. All Rights Reserved. TRW, courtesy Northrop Grumman Corporation. USGS, courtesy U.S. Geological Survey. Additional film posters and magazine covers, courtesy private collections.

Imprint

EACH AND EVERY TASCHEN BOOK PLANTS A SEED!
TASCHEN is a carbon neutral publisher. Each year, we offset our annual carbon emissions with carbon credits at the Instituto Terra, a reforestation program in Minas Gerais, Brazil, founded by Lélia and Sebastião Salgado. To find out more about this ecological partnership, please check: www.taschen.com/zerocarbon Inspiration: unlimited. Carbon footprint: zero.

To stay informed about TASCHEN and our upcoming titles, please subscribe to our free magazine at www.taschen.com/magazine, follow us on Twitter and Facebook, or e-mail your questions to contact@taschen.com.

© 2015 TASCHEN GmbH
Hohenzollernring 53, D-50672 Köln
www.taschen.com

Original edition: © 2009 TASCHEN GmbH

Editorial management and photo research:
Nina Wiener, Los Angeles
Art direction: Josh Baker, Los Angeles
Design: Birgit Eichwede, Cologne
Layout: Claudia Frey, Denise Graetz, Cologne
Production: Frank Goerhardt and
Stefan Klatte, Cologne
Editorial coordination: Meike Nießen, Cologne

Printed in China
ISBN 978-3-8365-5622-4

1000 Chairs

1000 Lights

Decorative Art 50s

Decorative Art 60s

Decorative Art 70s

Design of the
20th Century

domus 1950s

Logo Design

Scandinavian Design

100 All-Time
Favorite Movies

The Stanley Kubrick
Archives

Bookworm's delight:
never bore, always excite!

TASCHEN
Bibliotheca Universalis

20th Century
Photography

A History of
Photography

Stieglitz.
Camera Work

Curtis. The North
American Indian

Eadweard Muybridge

Karl Blossfeldt

Norman Mailer.
MoonFire

Photographers A–Z

Dalí. The Paintings

Hiroshige

Leonardo.
The Graphic Work

Modern Art

Monet

Alchemy & Mysticism

Braun/Hogenberg.
Cities of the World

Bourgery. Atlas of
Anatomy & Surgery

D'Hancarville.
Antiquities

Encyclopaedia
Anatomica

Martius.
The Book of Palms

Seba. Cabinet of
Natural Curiosities

The World
of Ornament

Fashion. A History from
18th–20th Century

100 Contemporary
Fashion Designers

Architectural Theory

The Grand Tour

20th Century
Classic Cars

1000 Record Covers

1000 Tattoos

Funk & Soul Covers

Jazz Covers

Mid-Century Ads

Mailer/Stern.
Marilyn Monroe

Erotica Universalis

Tom of Finland.
Complete Kake Comics

1000 Nudes

Stanton.
Dominant Wives